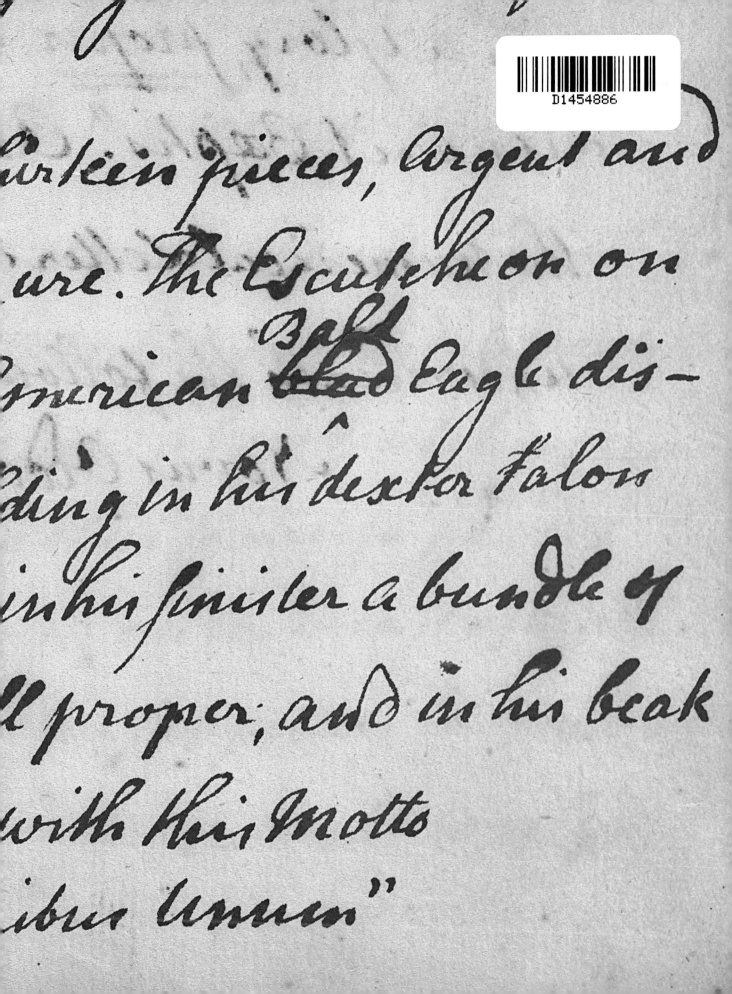

...rteen pieces, Argent and

...ure. The Escutcheon on

...merican ~~~~ ^Bald Eagle dis-

...ding in his dexter Talons

...in his sinister a bundle of

...l proper; and in his beak

...with this Motto

...ibus Unum"

COLONISTS
CITIZENS
CONSTITUTIONS

Creating the
American Republic

THAT the happiness of mankind depends very much on the Form and Constitution of Government they live under, and that the only object and design of Government should be the good of the People, are truths well understood at this day, and taught by reason and experience, very clearly at all times. And yet, by far the greater part of mankind are governed only for the advantage of their masters, and are the miserable slaves of a single or a few despots, whose ideas or humanity never extend beyond the limits of their own grandeur or interest; and indeed among the multitudes of mankind who have lived, and the variety of people who have succeeded each other in the several ages of the world, very few have even had an opportunity of choosing and forming a Constitution of Government for themselves.

This is a great privilege, and such an opportunity, the good People of this State, by the distinguishing favor of a kind Providence, now enjoy, and which, the interest and happiness of themselves and posterity, loudly call upon them to improve with wisdom and prudence. The infatuated policy of Britain, instead of destroying, has rather, by the goodness of God, promoted and accelerated the happiness of the People of the *United States of America*. The injustice and cruelty of Britain has driven us to a Declaration of Independence, and a dissolution of our former connections with them, and put it in the power of each of the *United States*, to form and constitute a Mode of Government for themselves. And whereas it is our peculiar duty to consult and promote the happiness of the good people of this State, having duly considered the advantages of forming, as soon as may be, a new Constitution of government; and conceiving it to be the expectation of many, that we should recommend the most suitable method for effecting this valuable and important purpose: We do *Resolve*,

That it be, and hereby is recommended to the several towns and places in this State, impowered by the laws thereof, to send Members to the General Assembly, that, at their next election of a Member or Members to represent them, they make choice of men, in whose integrity and abilities they can place the greatest confidence; and, in addition to the common and ordinary powers of Representation, instruct them in one Body with the Council, to form such a Constitution of Government, as they shall judge best calculated to promote the happiness of this State; and when compleated, to cause the same to be printed in all the *Boston* News Papers, and also in Hand Bills, one of which to be transmitted to the Selectmen of each Town, or the Committee of each Plantation, to be by them laid before their respective Towns or Plantations, at a regular meeting of the inhabitants thereof, to be called for that purpose; in order to its being by each Town and Plantation, duly considered. And a return of their approbation or disapprobation to be made into the Secretary's Office of this State, at a reasonable time to be fixed on by the General Court, specifying the numbers present in such meeting, voting for, and those voting against the same: And if upon a fair examination of the said returns by the General Court, or such Committee as

COLONISTS
CITIZENS
CONSTITUTIONS

Creating the American Republic

Selections from the Collection of
the Dorothy Tapper Goldman Foundation

James F. Hrdlicka
Foreword by Justice Ruth Bader Ginsburg

With contributions by
Dorothy Tapper Goldman
Robert McDonald Parker

Scala Arts Publishers, Inc.

This book accompanies the exhibition *Colonists, Citizens, Constitutions: Creating the American Republic*, at the New-York Historical Society, February 28–May 31, 2020.

The exhibition will travel to the Museum of the American Revolution, Philadelphia, June 12–July 5, 2020.

First published in 2020 by Scala Arts Publishers, Inc.
c/o CohnReznick LLP
1301 Avenue of the Americas
10th floor
New York, NY 10019
www.scalapublishers.com
Scala – New York – London

Distributed in the book trade by
ACC Art Books
6 West 18th Street
Suite 4B
New York, NY 10011

ISBN: 978-1-78551-207-0

Library of Congress Cataloging-in-Publication Data

Names: Colonists, Citizens, Constitutions (Exhibition) (2020 : New York, N.Y.) | Hrdlicka, James F., curator, author. | Ginsburg, Ruth Bader, writer of foreword. | Goldman, Dorothy Tapper, writer of preface. | Dorothy Tapper Goldman Foundation, owner. | New-York Historical Society, host institution.
Title: Colonists, citizens, constitutions : creating the American republic / James F. Hrdlicka ; foreword by Justice Ruth Bader Ginsburg.
Description: New York, NY : Scala Arts Publishers, Inc., 2020. | Includes bibliographical references and index.
Identifiers: LCCN 2019013822 | ISBN 9781785512070 (hardback)
Subjects: LCSH: Constitutional history—United States—Sources—Exhibitions.
Classification: LCC KF4541 .C5527 2019 | DDC 342.73009/03—dc23
LC record available at https://lccn.loc.gov/2019013822

Edited by Kate Norment
Designed by Rita Jules, Miko McGinty Inc.
Typeset by Tina Henderson
Printed in China

10 9 8 7 6 5 4 3 2 1

Photography by Ardon Bar-Hama

Front cover: Constitution of the United States of America, 1787 (cat. 11)
Endpapers: Charles Thomson Description of the Great Seal of the United States, 1782 (cat. 4)
Frontispiece: Resolve of the Massachusetts General Court of May 5, 1777 (cat. 8)
Page 6: Bill of Rights as Proposed by the House of Representatives (17 Amendments), 1789 (cat. 14)
Back cover: Massachusetts Constitution of 1780 (cat. 9)

Contents

CONGRESS OF THE UNITED

In the House of Representatives,

Monday, 24th August,

RESOLVED, BY THE SENATE AND HOUSE OF REPRESENTATIVES, OF THE UNITED STATES OF AMERICA IN CONGRESS ... thirds of both Houses deeming it neceſſary, ... les be propoſed to the Conſtitution of the Legiſlatures of the United ... ts to the Conſtitution of the United ... s, when ratified by three four... to all intents and purp...

dams

Foreword

Dorothy Tapper Goldman's decision to share her rich, wide-ranging history of constitution-making in our nation and states is cause for celebration. Constitutions in the United States, unlike many the world has seen, are not just aspirational documents. They embody laws to be applied on the ground, here and now. Constitutions are our highest laws against which ordinary legislation and executive actions are measured.

As James F. Hrdlicka's introduction to *Colonists, Citizens, Constitutions* informs us, the founding constitutions were imperfect. But the overriding aim, realized over time, was to form ever more perfect unions, in service of "We the People."

The constitutions on display in this exhibition rest on twin pillars. First, they establish governments of limited powers. Those governments can exercise only the authority expressly conferred by the highest law. And second, constitutions set out fundamental rights to be enjoyed by all who dwell in the United States of America. Those rights are our nation's hallmark. They are set forth in bills of rights and, later, in other constitutional amendments. By limiting government, specifying rights, and empowering the people, the founders of our nation and states proclaimed that the heart of America would be its citizens, not its rulers.

To form more perfect unions is the enduring aim. At the start, it is true, our fundamental instruments of government very much needed perfection. Original constitutions permitted slavery and severely limited who counted among "We the People." When the nation was new, only white, property-owning men had the right to vote, the most basic right of citizenship. But over the course of our history, people left out at the start—people held in human bondage, Native Americans, and women (half of the adult population) came to be embraced as full citizens. A French observer of early America, Alexis de Tocqueville, wrote that "the greatness of America lies not in being more enlightened than . . . other nation[s], but rather in her ability to repair her faults." Through amendments to our constitutions, and court decisions applying those amendments, we abolished slavery, prohibited racial discrimination, and recognized men and women as people equal in dignity and citizenship stature.

Though we have made huge progress, the work of perfection is scarcely done. Many stains remain. In this rich land, nearly a quarter of our children live in poverty, nearly half of our citizens do not vote, and we still struggle to achieve greater understanding and appreciation of each other across racial, religious, and socioeconomic lines. Yet we strive to become a more perfect union.

We sing of America, "sweet land of liberty." Newcomers to our shores have come here, from the earliest days of our nation to today, seeking liberty—freedom from oppression, freedom from want, freedom to be you and me. Guided by our fundamental instruments of government and knowledge of their history, we the people can play a vital part in perfecting our unions, first and foremost by voting in elections, but also by participating in the administration of justice by serving on juries and by engaging with our representatives and fellow citizens in civic discourse.

The education you will experience by reading this book will make you proud of our heritage, and ever more ready to contribute to keeping the United States a blessed land where people can realize their full potential as humans while contributing to the common good.

Ruth Bader Ginsburg
Associate Justice
Supreme Court of the United States

Preface

I have been a collector since childhood. What began as a young girl's hobby turned into a lifelong passion for collecting on a rather large scale. As a nine-year-old trading cards with my friends, I only wanted to collect Lippizaner white horse cards. Then, over the years, I turned to late nineteenth-century Native American baskets, hand-colored nineteenth-century illustrated books, drawings from the first half of the twentieth century, American furniture, Chinese Ming furniture, Song and Tang sculpture, and Ming and Qing monochromes. Last, but hardly least, is the rare and important Americana that I have focused on and collected for over twenty-five years.

I first got involved in collecting historical American documents when my late husband, S. Howard Goldman, bequeathed to me his Dunlap and Claypoole printing of the United States Constitution, dated September 17, 1787. Although my husband had intended for that remarkable document to eventually be donated to an institution, the gift was ultimately rejected—and so began my own pursuit of constitutional material. State constitutions in various stages of development and early federal constitutions from the eighteenth century were my preoccupation then.

As with many collectors, ignorance is often bliss, and I had no idea what I was getting myself into. Having always loved history, both European and American, I thought I could begin collecting with a bit of knowledge. What I learned from collecting Americana was that my knowledge at that early point was a bit rudimentary. While collecting with my husband in the early 1990s, I had the very good fortune of being introduced to the extraordinary bookseller William (Bill) Reese. Little did I know at the time that Bill would help me to acquire an extraordinary amount of rare Americana. He always knew what my collection needed and where to find that special piece.

Reading the Reese Company's catalogues of Americana and Revolutionary items fascinated me even more than the history textbooks from my school years. They were about the people who wrote the documents, the places where they lived, and what inspired the documents in the first place. I was captivated by the idea that so much Americana was still available to collect. I marched through American history in my acquisitions, from George III's early decrees to his colonies all the way to the Hawaiian and Alaskan state constitutions of the twentieth century. Did I ever think that there was such a thing as a Choctaw or Cherokee constitution? Had I ever imagined a sammelband of Confederate papers containing the Confederate Constitution, or a diary entry by Charles Thomson with the first-ever description of the Great Seal of the United States? Learning about

this part of our American past has truly been a wondrous adventure.

Forming a collection can be a very scattered process. Nothing comes to you in chronological order but rather more randomly—here a piece and there another odd item. When I came across a French dealer with a bound copy of the United States Constitution and the Declaration of Independence printed in raised letters—before Braille was invented—I snapped it up. It must have been serendipity, as I have never seen another copy like that. I found a very small book from 1864 at an antiquarian book fair titled *The Last Men of the Revolution*, which features photographs of the last living survivors who fought in the American Revolution. Each man's photo is accompanied by a short biography followed by a lithographic image of his home. It is absolutely captivating.

My love of history was inspired by several truly marvelous teachers and professors, both at my high school in Shaker Heights, Ohio, and at Tufts University. But my studies were never as fascinating as the material I have discovered during my years of collecting. Through my collection and exhibitions of some of these rare documents, I have been fortunate to meet presidents, vice-presidents, senators, and most members of the United States Supreme Court since 1990. Even from their exalted positions they have been touched to see original documents and learn how they were printed and distributed. The men who wrote the Constitution believed the first printing was so important that they had it printed in Philadelphia on British paper, which was of better quality than American paper.

Of all the various materials I have collected over the years, it is my Americana that resonates most strongly for me. All of our important American documents were written by ordinary citizens who were engaged enough in their new country to have a hand in developing it. Our republic was an experiment in hope, assembled by men who knew more about what they did not want in a government than what it could be.

It is my deepest wish that this exhibition of highlights from my collection of Americana at the New-York Historical Society will inspire everyone to believe in our institutions, our rule of law, and our historical transformation from colonists to American citizens. All of us must learn that we can have an impact on our future simply by voting; participation in the governance of the United States is open to any and all citizens. This is how we became a nation, and this is how we will keep our republic strong.

Dorothy Tapper Goldman

Collecting Evidence: The Making of an American Collection

Robert McDonald Parker

Documents outlive people. Some serve as our only witnesses—the remaining witnesses—to history, and their pages breathe with all the lives that have touched them. Yet their physical existence depends on generations of individuals who have protected and preserved them, and continue to do so. Without both the documents and their stewards, there would be no history.

Undoubtedly, it is a miracle that historical works on paper survive, given the fragility of the medium, susceptible as it is to elements such as moisture and light as well as countless years of handling. Many documents are also casually discarded or misplaced, victims of human oversight; others are lost to destruction or natural deterioration. Even though, as objects, these documents are delicate in nature, their messages often are not: their voices become amplified with age and the perspective offered by time. Handwritten or printed, bound or unbound, these fragile papers speak from the past to inform the present and the future, granting us greater insight into the larger questions of human society and civilization.

This catalogue and the exhibition it accompanies feature a selection of important and often rare historical documents from Dorothy Tapper Goldman's collection of American federal and state constitutions, spanning from colonial times to the twentieth century. One of the most comprehensive such collections in the country, these documents are among more than four hundred items related to the creation of the United States and its governments acquired by Goldman and her late husband, S. Howard Goldman (1930–1997),[1] starting in the late 1970s. In the following pages, historian James F. Hrdlicka provides us with a thorough and innovative examination of these original materials, which Supreme Court Justice Ruth Bader Ginsburg refers to in her foreword as "the history of constitution-making in our nation and states."

The study of history demands knowledge, reflection, and context, and no one understood these intellectual challenges better than the antiquarian bookseller William S. Reese (1955–2018), who played a fundamental role in shaping Dorothy and Howard Goldman's collection of American constitutions. Many of the forty-two documents in the current exhibition and catalogue were acquired through Reese's company over a period of more than thirty years. "Reese shaped tastes, cultivated collectors, advised museums and libraries, and made and moved markets," wrote Andy Newman in the *New York Times*. "Many of the nation's leading collections of Americana bear his stamp."[2] From the company's founding in 1975 until his death, Reese worked closely not only with the Goldmans but also with other individual collectors, such as the late Frank T. Siebert and Bruce McKinney, as well as some of the most prestigious museums and libraries in the world.[3]

A pivotal moment in the formation of the Goldmans' collection of American constitutions occurred in 1988, when Reese encouraged Howard Goldman to bid on one of nine then-known originals of the first official printing of the United States Constitution of 1787 (cat. 11): "I urged him to pursue it as a cornerstone [. . .] and the Constitution was his greatest purchase as a collector."[4] In the ensuing years it became the centerpiece around which Dorothy Goldman, with Reese's help, would build, document by document, this collection of constitutions and related items. According to his associate

Nick Aretakis, Reese was "always looking for materials to add to and complement the current collection, first with Howard, then with Dorothy. To Reese, they were the 'ideal' collectors, because they were both passionate about the subject and knew it well."[5]

The role of an individual collector of items of Americana is similar to that of museums and libraries that specialize in American holdings and strive to "preserve books, manuscripts and other precious materials that sustain the national conversation about who we are as Americans and also who we have been."[6] Each document has the potential to contribute to or even change our vision of history. The role of a dealer in creating a collection, especially of rare items, is often to persuade, cajole, and convince a collector of the "need" to both possess and preserve these objects—in essence, to "complete" a process that has no finite end. There is always one more object to find. Both dealer and collector must constantly ask themselves: How important is a particular item? Which documents should be specifically sought out or selected over others?

Any type of collecting is a labor of love, and collections like this don't just happen. They stem from an idea, a concept, an interest—a joy or a passion—and are a sort of journey, a treasure hunt, that can take a collector on a fulfilling pursuit to meet new people and exchange new ideas and knowledge. Often the impetus for a collection is highly personal and singular; sometimes it can start with the acquisition of a single document. In other cases, a collection's theme may reveal itself over time as the documents accumulate like clues. In general, items such as manuscripts or printed materials of diverse origins are united piecemeal, which requires patience and perseverance over many years.

But why collect these pieces of paper? Why preserve them? As a preeminent bookseller of Americana, Reese understood the importance of the physical possession of an object in any form. He searched everywhere to find these American treasures, scouting items in used bookshops, dealer and collector inventories, auction catalogues, and book fairs. In his legendary road trips across the United States he unearthed disregarded books and castaway documents to study, then market and sell. Reese knew the power of the printed word, and he devoted his life to America's printed heritage because, as he said in a 2012 interview, "a

piece of paper tells a story." He elaborated: "I always had a concept as a person dealing in Americana that I was selling evidence in one form or another."[7] Whether it was a photograph, a manuscript, a letter, a journal, a broadside, a pamphlet, or a multi-volume set, he considered them all "evidence."

Reese was insistent that certain documents—such as the 1780 Massachusetts Constitution (cat. 9) and 1861 Confederate Constitution (cat. 34), which respectively inspired and were inspired by the 1787 United States Constitution, and the 1776 Virginia Declaration of Rights (cat. 5), which served as a precursor to the U.S. Constitution's Bill of Rights—all become part of the Goldman collection.[8] These objects provide us with a more complete understanding of how, in function and form, this family of historical documents is closely interwoven, and they illustrate Reese's invaluable contribution—a sort of historical double vision in which he never lost sight of the bigger story. What can a single document reveal about the American experience as a nation? Each constitutional item here performs a specific role in the context of the collection as a whole, and together they illustrate "the development of constitutional thought."[9] Reese knew, as a determined historian and a dealer, not only which documents to gather and where to find them, but also what the collection and collector "needed." "An object can sit for two hundred years and nobody can know why it's needed," he said. "No scholar can put it in context until that moment when that piece of paper tells a story—provides a connection. You never know when some scholar is going to need that single connective piece that's going to make the whole story fall into place."[10]

For individual collectors, even experienced ones like Dorothy Goldman, the quest for a specific item, although highly rewarding, can be a slow, painstaking process as documents are sought from multiple sources over long periods of time. Works from the current collection were acquired from public auctions and private owners and dealers over more than three decades. Both the decisions and pace surrounding the acquisition process remain as unique as each individual collector as he or she considers each item to enter—or sometimes leave—the collection. Working together, dealer and collector evaluate how each acquisition will enhance the

collection overall. How is one to make a coherent whole from what at first may appear to be disparate and unrelated items? Creating an important collection of anything, particularly documents, demands a certain degree of luck, to be sure—there are often as many instances of lost opportunities as there are of successful acquisitions. But it is the concentration of knowledge, passion, and determination that makes for a truly great collection.

These qualities have been at the heart of the Goldman collection from the beginning. In spite of the broad range of her collecting interests,[11] Dorothy Goldman has been fascinated by history since high school. Reese noted that this kind of passion drives many collectors who "are really going back to what their first love was" to collect in those areas.[12] For his part, Reese certainly had an extraordinary knowledge of American history. He understood not only how the colonists' early state constitutions had an impact on the writing of the U.S. federal constitution and the government it would lead to, but also, as the country grew, how the constitutions of newly admitted states would revive vivid national debates that resulted in amendments to both state and federal constitutions. In helping to conceive this collection of historical documents, Reese kept his sights focused on the continuing American experiment in the role of citizens shaping their own government.

Dealers and collectors fuel each other, and in this case both shared a voracious appetite for learning about American history. This was the motivation behind the collection they built over the years, and the documents featured here allow us to better interpret and understand our country's special history. In 2016 Dorothy Goldman remarked that Reese "not only taught me about collecting but also about American history" and that without his guidance there likely would be no Goldman collection of constitutional materials today.[13] Reese not only helped locate these items, but also provided the historical context from which the collection would emanate. As a driving force behind the Goldmans' acquisitions, he was as instrumental in the genesis of the collection as they were in its fulfillment.

Together, they gathered constitutional "evidence" to tell a story: each of the books and documents here reveals the continuum of America's endless aspiration to achieve "a more perfect union" through its state and federal governments. This collection is a testament to their efforts and, specifically, to Reese's profound historical knowledge and desire to share his passion for Americana. As these documents bear witness, William Reese was a hero for history—our history, America's history, and the history of our constitutions.

1. S. Howard Goldman was a prominent collector of American manuscripts, books, pamphlets, and broadsides. During his lifetime, he purchased and owned a rare copy of the original Dunlap and Claypoole 1787 printing of the U.S. Constitution (cat. 11) and acquired materials related to the U.S. Supreme Court.

2. Andy Newman, "William Reese, Leading Seller of Rare Books, is Dead at 62," *New York Times*, June 15, 2018.

3. Reese provided and sold Americana to both Siebert and McKinney. Siebert's important library of material on the North American Indian and the American frontier was dispersed in two sales: Sotheby's, New York, May 21 and October 28, 1999. McKinney sold his collection in two parts: "The American Experience, 1492–1625" was dispersed at Bloomsbury Auctions, New York, on December 3, 2009, and "The American Experience, 1630–1890" at Bonhams, New York, on December 2, 2010. Nick Aretakis, conversation with the author, January 30, 2019.

4. William S. Reese, obituary of S. Howard Goldman, *Proceedings of the American Antiquarian Society* 107, part 2 (October 1997), 218–20. The constitution was acquired at Sotheby's, New York, on April 16, 1988. The sale catalogue notes that although the edition size was probably between "275 and 330 copies," the official edition is rare because copies were distributed among the delegates to the Continental Congress and few survive. Today, only thirteen such complete examples, including the present one, are known. A current census provided by the Center for the Study of the American Constitution (CSAC) at the University of Wisconsin, Madison, lists ten such copies; https://csac.history.wisc.edu/document-collections/foundational-documents-of-american-constitutionalism/first-printing (accessed May 21, 2019). Three other complete copies of the original 1787 printing are in the following collections: Rare Books and Special Collections, William H. Scheide Library, Princeton University Library, New Jersey; Huntington Library, San Marino, California; The Papers of Benjamin Franklin, Yale University Library, New Haven. The author would like to thank Nick Aretakis for his help in identifying these examples.

5. Aretakis, conversation with the author, January 30, 2019.

6. "Letter in Support of the NEH, IMLS, and NHPRC from the Directors of Independent Research Libraries," signed by numerous research library directors, https://www.themorgan.org/about/letter-in-support-of-NEH-IMLS-NHPRC (accessed January 10, 2019).

7. William Reese, in the American Antiquarian Society's "Orientation Film," produced and directed by Lawrence Hott and Diane Garey, written by James David Moran, 2012, http://www.americanantiquarian.org (accessed January 9, 2019).

8. The Massachusetts Constitution entered the collection in 1998, the Confederate Constitution in 2006, and the Virginia Declaration of Rights in 2014. Notably, the collection also includes two early 1789 drafts (cats. 14, 15) of the U.S. Constitution's Bill of Rights, prior to its March 1792 ratification; one, featuring the twelve amendments approved by Congress in 1789 (cat. 15), was acquired from Reese in 1989.

9. Nick Aretakis, correspondence with the author, March 14, 2019.

10. William S. Reese, filmed interview with Michael Ginsberg, Antiquarian Booksellers' Association of America, April 10, 2010, http://www.abaa.org/bookseller_interview/details/william-reese (accessed January 10, 2019).

11. In addition to rare books and documents of Americana, Goldman also collects twentieth-century American and European drawings as well as American and Chinese furniture and decorative arts.

12. Reese, filmed interview with Michael Ginsberg.

13. Dorothy Goldman, conversation with the author, November 26, 2016.

THE CONSTITUTION

OF THE

STATE OF NEW-YORK.

—

WE THE PEOPLE of the State of New-Yor
to Almighty God for our freedom: in or
its blessings, DO ESTABLISH this Consti

ARTICLE I.

SECTION 1. No member of this State
deprived of any of the rights or privi
hereof, unless by the law of the

Introduction

The procession began in fog on the morning of November 19, 1863. At the stroke of ten, military officers, soldiers, governors, local dignitaries, the secretary of state, and President Abraham Lincoln—among others—made their way the short distance from the town of Gettysburg, Pennsylvania, to the newly established National Cemetery, where, according to a reporter from the *New York Times*, 15,000 people gathered around a central platform. Just months before, on the first three days of July, Union and Confederate armies had fought over this ground in what would prove to be the bloodiest battle of the American Civil War. Although United States forces had compelled the Confederates to retreat to Virginia, the outcome of the war remained very much in doubt. The graves of 3,500 Union soldiers bore silent testament to the human cost of the ongoing struggle. Thousands more Americans lay in fields elsewhere; countless others suffered from wounds and illness. The day's ceremonies paid tribute to these citizens. The program included music, prayers, and dedicatory addresses. Edward Everett of Massachusetts gave the main speech, and the nineteenth-century audience was not at all surprised when the great orator's remarks lasted approximately two hours. President Lincoln's brief address, although destined to become far more famous than Everett's, echoed many of the same themes. The crowd's remarkable silence allowed many in attendance to hear Lincoln's words; many more Americans read them the following day in the *Times* and in other newspapers. "That the Nation shall under God have a new birth of freedom," Lincoln concluded, according to the *Times*, "and that Governments of the people, by the people and for the people, shall not perish from the earth."[1]

This final line of Lincoln's Gettysburg Address is most often transcribed as "government of the people, by the people, and for the people," and that is almost certainly what Lincoln said.[2] That some heard or read the singular "government" and others the plural "governments" was not of great importance at the time. What did Americans understand by these phrases?

For Americans, the words "government by the people" brought to mind the fundamental idea of democracy that had been so powerfully asserted in the Revolution. Lincoln, after all, had begun his address by harking back "four score and seven years"—that is, to 1776, the year of the Declaration of Independence. To justify their separation from Britain, the Revolutionary generation had stated "self-evident" "truths," including the "proposition," as Lincoln called it, that "all men are created equal." It followed that government existed not to benefit one particular class of people more than another, but to secure the rights and opportunities of all people equally. The people alone had the right to "alter or to abolish" government whenever and however they wanted as they pursued "their Safety and Happiness"—though, as the Revolutionaries were quick to point out, "Prudence" would restrain them from introducing changes without careful consideration.

This notion—that ordinary people should and could govern themselves—contradicted what most of the great authorities on the subject had written through the ages. History afforded precious few examples of "the people" ruling themselves successfully for any length of time, and those experiments had never ended well. In contrast, both the past and the present offered an overwhelming record of societies organized into strict hierarchies and of regimes whose governing institutions had been hammered out across centuries of brutal conflict. In the first edition of *The Federalist*, a series of essays supporting ratification of the United States Constitution, Alexander Hamilton identified the

OPPOSITE: Cat. 23. New York Constitution of 1846

central debate that the Declaration of Independence had set in motion. The question, Hamilton wrote, was "whether societies of men are really capable or not of establishing good government from reflection and choice, or whether they are forever destined to depend for their political constitutions on accident and force."[3]

When Edward Everett referred in his oration to the heroes "of the revolutionary and constitutional age," he elegantly suggested how Americans had responded to Hamilton's challenge.[4] By devising a method to create, debate, approve (or reject), amend, and even completely replace written constitutions for their states and for the United States itself, Americans had translated the abstract ideas of democracy and human equality into tangible political systems. The concept of government by the people resonated with those Americans standing around the platform at Gettysburg precisely because they and many of their parents had lived in such governments all their lives. Many of them had even participated in the continuing work of crafting and adopting constitutions. As a result, "government by the people" referred not merely to a hypothetical possibility, but to actual governments and real places—Pennsylvania, New York, Texas, California, the United States.

For their states and nation, Americans did not aim to establish forms of government that resembled a pure democracy on the model of ancient Athens. They did not favor mass gatherings of citizens who would decide all issues by a simple majority vote. Virtually no one believed that to be a practical way to govern a complex, modern society. Instead, through constitution-making, Americans found a way to stay true to the bedrock democratic principle that all power derives from the people while also crafting institutions and fundamental rules they believed would best advance the people's security, prosperity, and happiness.

Constitution-making involved large numbers of Americans. History remembers most vividly the fifty-five delegates who met in Philadelphia in the hot summer of 1787 to write the United States Constitution. These "framers" did indeed comprise a remarkable group that managed to address a series of challenging issues and produce an impressive plan of government. But the convention's achievements would have come to nothing had it not been for the widespread and serious engagement of thousands of Americans who

considered the convention's proposal with intelligence and passion. Hamilton, along with James Madison and John Jay, wrote *The Federalist* in 1788 as part of this continent-wide debate. Nor did the people's engagement cease after they voluntarily consented to live under the Constitution's provisions. Methods existed by which they could amend this fundamental law whenever they thought necessary. Americans added twelve amendments to the federal Constitution within two decades of its implementation. Most of those present at Gettysburg in November 1863 would soon see the addition of three more important amendments. Future generations would adopt another twelve before the close of the twentieth century.

Ongoing popular engagement in constitutional matters becomes even more clear when we examine the state level. Everett expressed the common sense of the day when he praised as "one of the most beautiful features of our mixed system of government" the fact that "the separate States are clothed with sovereign powers for the administration of local affairs."[5] Indeed, through much of the nineteenth century, state governments remained a more visible presence in the lives of most Americans than the federal government did. It is hardly surprising, then, that citizens took a keen interest in how their states were constituted. They exercised their sovereign power to alter their forms of government with remarkable frequency. "All told," the political scientist John J. Dinan notes, as of 2009 "the fifty states have held 233 constitutional conventions, adopted 146 constitutions, and ratified over 6,000 amendments to their current constitutions."[6] Americans who lived through the Civil War witnessed no fewer than fifteen states hold at least twenty-six conventions between 1861 and 1865, with many more conventions and constitutions to come in the decades immediately following. A Missouri convention even adjourned on July 1, 1863—the first day of the Battle of Gettysburg.

What kinds of governments did the people create through their constitutions? All state constitutions resembled the United States Constitution in some respects. In other ways, many looked quite different. All of the constitutions must be viewed in light of the rapidly changing circumstances affecting every facet of national life. In 1776, the United States consisted of thirteen political communities along the Atlantic

seaboard. By the turn of the twentieth century, the nation possessed much of the North American continent and stood as the hemisphere's dominant power. The expansion of the United States could not have occurred in the same manner without its distinctive method of constitution-making. Settlers eagerly colonized new territories in which they would have the opportunity to draw up their own constitutions, run their own governments, and be incorporated into the federal union on a basis of full equality with the existing states. The vast western expanse that Thomas Jefferson confidently predicted in 1801 would furnish "room enough" for Americans "to the thousandth and thousandth generation" was completely divided into states in a little over a century.[7]

Americans assumed that their constitutions should enable them to improve their material conditions, promote their understandings of freedom and justice, and expand the range of opportunities for themselves and their descendants. They embraced constitutional government's capacity to transform the economy, society, and political landscape for the benefit of the people—though they invariably disagreed over what exactly this meant and how exactly to do it. Disagreement was inevitable in the face of astonishing geopolitical, demographic, and technological changes (to name just a few categories). Between 1776 and 1860, the population of the United States increased from about 2.5 million to 31.4 million. By 1900, despite the Civil War, the population stood at 76.2 million. New cities sprang up, and established cities grew to extents previously unimagined. When it hosted the Constitutional Convention in 1787, Philadelphia had perhaps 40,000 to 50,000 inhabitants; in 1900, the city boasted a population of nearly 1.3 million. New industries emerged; others faded. New technologies radically altered how Americans experienced both time and space. A few hours after giving his address at Gettysburg, for instance, Lincoln sat in a train car that carried him swiftly back to the nation's capital. The text of Lincoln's speech traveled even faster thanks to the telegraph, which enabled millions around the country to read it the next day—a luxury earlier generations of Americans could not have fathomed. These and other transformations prompted Americans to consider alterations, both large and small, to their constitutions.

These governments by the people undoubtedly extended benefits and opportunities to millions. They represented marked departures from the political systems under which most of humanity had lived since antiquity. Partly for this reason, generations of Americans have gravitated toward a convenient interpretation of their history as a steady march of liberty, a gradual realization of all the promises enshrined in the Declaration of Independence. In this view, any injustices, discrimination, or oppression directed toward any elements of American society represent aberrations, instances in which Americans diverged from the clear dictates of their principles and from the inexorable path of progress.

The historical record and Americans' own constitutions tell a far more complicated and unsettling story. The mere fact that American governments were established and run "by the people"—that they were democratic by any comparative standard of the day—has never guaranteed that they would extend prosperity, liberty, and opportunity to ever more people. In fact, from the start, constitutional governments proved capable of perpetuating many forms of injustice with enhanced tenacity. Because American governments rested on firm foundations of popular consent, and because anything those governments did was assumed to reflect the legitimate wishes of the people, oppressive laws and policies became all the more difficult to overturn. Who, after all, could dispute the will of the majority?

A majority of politically empowered Americans have, at various times, supported a highly limited definition of "the people." Early American constitutions precluded women of all backgrounds—comprising fully one-half of the total population—from formal participation in government, and they also allowed numerous forms of gender-based legal, social, and economic discrimination to continue. Governments by the people sanctioned the enslavement of millions of African Americans. This racialized labor regime had been introduced in the early days of colonization, but it was hardly put on the path to inevitable extinction by the creation of the United States. At the time of the Revolution, the enslaved population of the thirteen states numbered around half a million. Four score and seven years later, the number of men, women, and children held in bondage had increased 700 percent, to around four million. And, after one part of "the

people," including African Americans, destroyed slavery in order to preserve the Constitution and save the nation, a majority of Americans either acquiesced to or enthusiastically advocated a system of racial oppression whose legacies endure to the present. If this system sometimes appeared more overtly severe in some places than in others, it was, nevertheless, pervasive and consequential everywhere.

When Americans rushed west to establish ever more governments by the people, they dispossessed Native Americans. Americans reassured themselves that this process included attempts to gain Native Americans' consent, which seemed to render their mode of expansion more legitimate by the standards of democratic constitutionalism they so passionately espoused. But the larger context of these negotiations, the ultimate disparity in power between the parties, left Native Americans with a starkly limited range of genuine options, most of which favored white settlers. Declared to be members of "domestic dependent nations" and subject to the jurisdiction of the federal government, Native Americans experienced suffering, violence, and many other consequences of deliberate policies. At the same time that Americans chose to treat indigenous inhabitants in this manner, they also, in many cases, chose to discriminate against immigrants arriving on the continent's shores. Although the United States became home to millions of immigrants seeking to share in the opportunities of American life, governments by the people often favored members of certain groups over others, thereby ensuring that some new arrivals would truly become part of "the people" more quickly and easily than others. In all cases, factors such as gender and race combined to produce an even broader variety of experiences and perspectives.

The constitutions of the United States clearly empowered some people at the expense of others, but all Americans, even those denied their full dignity and status as citizens, exerted a profound influence on the course of the nation's democratic constitutionalism. These Americans pointed out the inconsistencies and hypocrisies of the ruling majority and insisted that the people use their sovereign authority to rectify such injustices. Sometimes these efforts proved successful; too often, through no fault of their proponents, they failed to overcome deeply rooted attitudes and interests.

Nor was progress always permanent. The same constitutional means by which some Americans secured their rights could be used by others to reverse those gains.

As he spoke to his fellow citizens at Gettysburg, Lincoln understood all the ironies and tensions that lay at the heart of the American experiment in government by the people. The Civil War itself, brought on by Americans' inability to resolve through constitutional means a central issue in the nation's history, demonstrated the experiment's fragility and volatility. Yet Lincoln concluded by reaffirming the importance of constitutional democracy. It must not, he warned, "perish from the earth." Lincoln did not indulge in hyperbole; these were indeed the stakes. Ever since Americans had declared their independence, observers around the world had confidently predicted the collapse of the United States and the permanent discredit, they hoped, of its ill-conceived constitutions and of the democratic proposition on which they rested. Oligarchy, aristocracy, monarchy, authoritarianism—all appeared at this moment more likely than democracy to define the future of the world's nations. Critics latched onto every shred of evidence that suggested that the people could never be trusted to govern themselves.

For all their flaws, Lincoln believed, governments by the people, as established in the constitutions of the United States, offered the last, best hope for human freedom. If citizens erred, as they often did, they had no one to blame but themselves. No king, no dictator, no cabal of elites existed in the United States to force Americans to do anything that they did not consent to do. The promise of government by the people was that it always lay in the people's power to correct their course, to use their constitutions to address any problem and overcome any challenge that an ever-changing world might present. Citizens must choose to act, however. Apathy guaranteed the experiment's failure. Only through constant and meaningful engagement could constitutional democracy be handed down through the generations. Fittingly, in a speech commemorating those who had died at Gettysburg, Lincoln made a point to address "us, the living." In governments by the people, there would always be "unfinished work" and "great task[s] remaining" in the years ahead.

The forty-two objects from the collection of the Dorothy Tapper Goldman Foundation that are

illustrated in the pages that follow begin to tell the story of how American colonists-turned-citizens created governments by the people in their state and federal constitutions. These documents offer an excellent opportunity to explore many of the ideas, events, and people that form the rich tapestry of American history. But they matter for more than just their contents. Their material existence—their nature as tactile objects produced, circulated, and preserved—remains crucial to understanding American democracy.

Americans did not invent the notion of a "constitution." From their English forebears they inherited the idea that certain fundamental laws underlay any social compact. Yet as long as these constitutional agreements remained largely unwritten—constellations of implicit assumptions rather than texts made up of explicit provisions—unproductive discord, abuses of power, or even violations of basic rights were liable to occur. And, what is more, when such arrangements were held to be the products of impersonal historical processes rather than the work of identifiable human actors, they often became resistant to beneficial changes favored by the very people from whom governments were supposed to derive their authority.

Americans' distinctive contribution lay in their emphasis on creating written constitutions, discrete documents that spelled out—as clearly as possible—both the forms of government the people would consent to establish and all the inviolable rights citizens would enjoy. Printing these constitutions, along with many documents related to the transparent process of drafting and approving them, became essential. Citizens needed to feel these texts in their hands and read them for themselves or for others. In the course of their debates, Americans wanted to cross words out and pencil new phrases in. They wanted copies for their shelves and copies sent to the remotest settlements, all the better to strengthen the bonds between citizens in a common community. Having these texts at hand ensured that everyone would be able to hold the powerful to account and that groups of citizens would understand the steps they could take to effect necessary changes to the political system. When Americans rewrote their frames of government, or when their old copies of these documents simply wore out, they reprinted them.

American political theory, then, depended to a large extent on citizens' inclination to make their constitutional handiwork a material reality. The documents belonging to the Dorothy Tapper Goldman Foundation pay homage to this revolutionary idea. As the illustrations here reveal, some of the collection's objects remain in pristine condition, as though they just came off the press, ready for dissemination to parts near or far. Others show the wear and tear that accompanies age, heavy use, and multiple owners. Whatever their physical appearance—or, indeed, because of it—all merit display and should command our attention.

Note: In this book, endnotes provide the sources of direct quotations, although those taken from well-known public documents, such as the Declaration of Independence, are not cited. Notes are also omitted for quotations taken from documents in the book and from other state constitutions or the materials related to their adoption. In most cases, the text identifies the document(s) being quoted, and the full versions can be found in the volumes edited by Francis Newton Thorpe listed in the Selected Bibliography. Minor variations in spelling and punctuation exist among published editions of many documents.

1. *New York Times*, November 20, 1863. For the program of the ceremonies at Gettysburg, see *Address of Hon. Edward Everett, at the Consecration of the National Cemetery at Gettysburg, 19th November, 1863. . .* (Boston: Little, Brown and Company, 1864), 24–25. For the larger context of nineteenth-century cemetery dedications, see Alfred L. Brophy, "'These Great and Beautiful Republics of the Dead': Public Constitutionalism and the Antebellum Cemetery" (August 12, 2013). UNC Legal Studies Research Paper No. 2304305, https://ssrn.com/abstract=2304305 or http://dx.doi.org/10.2139/ssrn.2304305.
2. This was how it appeared, for example, in *Address of Hon. Edward Everett*, 84 (which also added "the" before "government": ". . . and that the government of the people, . . .") Other versions contain slight differences in punctuation and phrasing.
3. "Federalist 1," Avalon Project, Yale Law School, http://avalon.law.yale.edu/18th_century/fed01.asp (accessed July 30, 2018).
4. *Address of Hon. Edward Everett*, 71.
5. Ibid., 67.
6. John J. Dinan, *The American State Constitutional Tradition* (Lawrence: University Press of Kansas, 2009), 1.
7. Merrill D. Peterson, ed., *Thomas Jefferson: Writings* (New York: Library of America, 1984), 494.

GEORGIA
CHARTER

GRANTED BY

His prefent MAJESTY,

In the Fifth Year of his Reign.

GEORGE the Second, by the Grace of God, of *Great Britain*, *France* and *Ireland*, King, Defender of the Faith, *&c.* To all to whom thefe Prefents fhall come, Greeting. Whereas We are credibly informed, that many of Our poor Subjects are, through Misfortunes, and Want of Employments, reduced to great Neceffities, infomuch as by their Labour they are not able to provide a Maintenance for themfelves and Families; and if they had Means to defray the Charge of Paffage, and other Expences incident to new Settlements, they would be glad to be fettled in any of Our Provinces in *America*, where, by cultivating the Lands at prefent wafte and defolate, they might not only gain a comfortable Subfiftence for themfelves and Families, but alfo ftrengthen Our Colonies, and increafe the Trade, Navigation and Wealth of thefe our Realms: And whereas Our Provinces in *North America* have been frequently ravaged by *Indian* Enemies, more efpecially that of *South Carolina*, which in the late War, by

A the

I

Experiments in Self-Government

Colonial Beginnings

CAT. 1. GEORGIA CHARTER OF 1732

Eighty-seven years separated the Declaration of Independence and Lincoln's remarks at Gettysburg in 1863. A period nearly twice as long, 169 years, lay between the 1607 establishment of Jamestown, the first permanent English settlement in North America, and 1776. During the vast majority of this time, few settlers seriously contemplated that the colonies would one day form "a new nation." White colonists lived under a set of governments that, with rare exceptions, they had played no direct role in forming and could not easily change. All these colonial governments did, however, ultimately allow for some degree of popular participation. By the mid-eighteenth century, colonists assumed that their initiative and their voice in these governments had been the decisive factors in the establishment of thirteen diverse, rapidly expanding, and economically prosperous British colonies on the North American mainland.

When it came to colonizing the Americas, England lagged behind Spain by more than a century. England also lacked the wealth and power of its European rivals.

Eager to share in the opportunities that the "New World" still presented, the English crown empowered groups of its subjects to establish settlements in its name. The king began to issue charters, documents that granted the authority to govern a specified territory. In important ways, charters represented the forerunners of the constitutions Americans would begin to write for themselves in 1776. Groups of private investors received some of the first of these charters. In 1606, King James I authorized the Virginia Company and the Plymouth Company to "plant" settlements on the eastern coast of North America. The Massachusetts Bay Company received a charter in 1629. In return for fronting the money and resources to found colonies, investors gained the right to profit from what they discovered, extracted, or developed in them. For his part, the king gained new possessions overseas, inhabited by his loyal subjects. Although charters allowed recipients considerable latitude in their operations, they also outlined the basic institutional structure of the colonial corporation, the constraints on its powers, and the obligations it had to meet to remain in the good graces of the crown.

If the king wanted to reward or pay back an individual or small coterie of men, he could grant a charter

OPPOSITE: Cat. 1. Georgia Charter of 1732

that made them a colony's sole "proprietors." In 1632, Charles I designated Cecil Calvert, Lord Baltimore, the proprietor of Maryland. By virtue of his charter, Baltimore and his heirs enjoyed powers that (on paper, at least) befitted a feudal lord. In 1663, the king granted eight of his favorites a charter to settle and govern Carolina. The following year, after English forces conquered the Dutch colony of New Netherland, Charles II made his brother, the Duke of York (the future King James II), the proprietor of New York. The Duke of York, in turn, granted a proprietorship for what would ultimately become New Jersey. In 1681, William Penn accepted a charter from Charles II as payment for a debt the king owed to his father. He thus became the proprietor of Pennsylvania.

Working within the limits laid out in their charters, many proprietors tried to impose on their colonies their own visions of government and society. For Lord Baltimore, this meant making Maryland a haven for his fellow Catholics. To create a refuge for his fellow Quakers, another persecuted religious sect, William Penn guaranteed freedom of conscience and worship. The Carolina proprietors drew up the most ambitious and comprehensive plan in 1669. Written with the help of the political philosopher John Locke, the Fundamental Constitutions of Carolina proposed to divide the colony into vast estates and to create a "hereditary nobility of the province." Three-fifths of the land would be set aside for "the people," a measure that would, in theory, help maintain "the balance of the government" and ensure a harmonious, hierarchical society.

The Carolina proprietors wanted to "avoid erecting a numerous democracy" in the colony under their jurisdiction. Yet even the Fundamental Constitutions would have granted (relatively) ordinary inhabitants the privilege of electing representatives to sit in a "parliament" and vote on proposals related to the administration of the colony. In fact, every colony eventually convened a body in which representatives of the people consented to taxation, passed laws, and influenced government policy. The first representative assembly met in Virginia in 1619. Within a few years of its founding, the Massachusetts Bay colony included a house composed of two deputies from every town. While Maryland's 1632 charter granted the proprietor "absolute Power" to make laws, it also stated that this was to be done with "the Advice, Assent, and Approbation of the Free-Men of the . . . Province." The Charter of Liberties that William Penn issued in 1701 mandated an annual assembly composed of four representatives from every county.

Allowing the populace a voice and role in the government of the colonies worked to the benefit of authorities and settlers alike. If corporate shareholders, proprietors, or royal governors hoped to exercise any sustained authority over the extensive territories under their control—and if they wished to obtain any money to administer and defend their colonies—they simply had to rule with the consent of a significant number of the settlers. Calling together the people's representatives promised short-term annoyances but long-term advantages. Moreover, the need to attract new settlers meant that once one colony established a representative assembly, all the other colonies needed one, too. Few emigrants would voluntarily choose to settle in a colony where they had no say in how things were run. For colonists, assemblies served as symbols of their rights as Englishmen. The king promised time and again in colonial charters that settlers in America would enjoy the same "privileges, franchises, and liberties" as subjects who had been born in England itself. The right to consent to taxation and other measures comprised a central pillar of English identity, and colonial assemblies offered an essential venue in which to exercise that right.

The extent to which white men could actually participate in governance varied from colony to colony. Inhabitants of Connecticut and Rhode Island enjoyed near autonomy in the direction of their own affairs, subject only to the crown's occasional oversight. Originally outgrowths of Massachusetts Bay, both had been issued corporate charters that confirmed frames of government colonists had already developed for themselves. The inhabitants of both colonies elected their own governors, deputy governors, and bicameral legislatures (in which two separate groups

OPPOSITE: Title page of *A List of Copies of Charters, from the Commissioners for Trade and Plantations...*, containing the Georgia Charter of 1732 (cat. 1)

A LIST

OF

Copies of CHARTERS,

FROM THE

Commiffioners *for* TRADE *and* PLANTATIONS,

Prefented to the Honourable the

Houfe of Commons,

IN

Purfuance of their ADDRESS to His MAJESTY, of the
25th of *April* 1740.

VIZ.

MARYLAND Charter, granted by King *Charles* I. in the 8th Year of His Reign.

CONNECTICUT Charter, granted by King *Charles* II. in the 14th Year of His Reign.

RHODE-ISLAND Charter, granted by King *Charles* II. in the 15th Year of His Reign.

PENSYLVANIA Charter, granted by King *Charles* II. in the 33d Year of His Reign.

MASSACHUSETS BAY Charter, granted by King *William* and Queen *Mary*, in the 3d Year of Their Reign.

GEORGIA Charter, granted by His prefent MAJESTY, in the 5th Year of His Reign.

LONDON:

Printed in the Year M. DCC. XLI.

of representatives both needed to approve proposed pieces of legislation). Throughout New England, elections for representatives occurred every year—even twice a year in the case of Connecticut and Rhode Island. The wealthy and prominent men of the community certainly tended to win provincial office, but the social distance between would-be representatives and average voters in New England, while real, often remained relatively modest. Elsewhere, colonial assemblies took on a more oligarchical cast. The Virginia House of Burgesses, for example, drew most of its members from the gentry, a class dominated by a select number of planter families. Only on election days, which occurred every few years or so, did these elites condescend to mingle with average voters at the county courthouse. Nor did that pool of voters include all white men. Every colony required voters to own a certain amount of property. This qualification notwithstanding, the number of men who could participate compared favorably with the situation in Great Britain, where fewer than a quarter of men could vote for members of Parliament. Perhaps 70 percent of white males in Virginia could vote, and the proportion was probably even higher in Pennsylvania and the New England colonies.

By failing to authorize or even hint at the establishment of a representative assembly, then, the 1732 charter for the new colony of Georgia appeared out of step with the rest of British America. King George II granted the colony to James Oglethorpe and nineteen other "trustees." An assembly would only have complicated Oglethorpe's plans to create a wholesome refuge for England's indebted and impoverished. Georgia's charter limited the amount of land any one person could own. This would ensure economic and social equality, and also encourage the development of compact settlements. Authorities could raise militia forces far more easily if inhabitants were concentrated in towns rather than spread out across the countryside—an important consideration given British hopes that the colony would protect Carolina against attacks from Indians and Spanish Florida. Oglethorpe accordingly laid out the town of Savannah and helped arrange transportation for 2,500 emigrants. Others, including a small contingent of Sephardic Jews (a group not otherwise numerous or particularly welcomed in militantly Protestant British America), paid their own way. The trustees banned liquor and slavery.

Georgia foundered so badly that within twenty years the trustees resigned their powers to the crown. Colonists in South Carolina openly mocked the trustees for trying to implement so many naïve policies. The attempt to prohibit slavery struck many colonists as especially impractical and even insulting. South Carolinians argued—and Georgians agreed—that slavery was absolutely essential for the economic and social development of the colony. The people clamored for its introduction and, after the crown made Georgia a standard royal colony—complete with a crown-appointed governor, appointed council of provincial notables, and popularly elected representative assembly—the people were in a position to establish slavery permanently on Georgia soil and to pursue other widely desired measures.

As Georgia's history suggests, in many instances British Americans cheered when the crown took a more direct role in the administration of their colonies. For a variety of reasons, many colonies founded on the authority of corporate or proprietary charters eventually reverted to the king's administration. Only the peculiar charters of the New England provinces remained popular, with colonists guarding them jealously. Virginia became a royal colony as early as 1624. The Carolina proprietors definitively surrendered their charter in 1729, having given up any hope of enforcing the Fundamental Constitutions long before that. (The separation of the territory into North and South Carolina became official upon the arrival of royal government.) New York, New Jersey, and New Hampshire also became crown colonies. Even Benjamin Franklin spent many years prior to the American Revolution unsuccessfully lobbying the king to remove the Penn family as proprietors of Pennsylvania. For many colonists, crown control signified a welcome release from self-interested proprietors and their idiosyncratic, impractical visions of government and society.

In a century and a half, the 105 men and boys who sailed for Jamestown had multiplied through natural increase and emigration—voluntary or, in the case of enslaved Africans, forced—to over two million people in the British colonies that would become the new United States. Colonial governments had enabled settlers to carve out a viable economic niche in the broader world

of Atlantic commerce. A large number of settlers owned land and enjoyed adequate material circumstances. Many—though not all—could worship according to the dictates of their consciences. All this had required colonists to dispossess and subjugate many groups of Native Americans, sometimes through negotiation but frequently through brutal warfare. Colonial governments also oversaw the creation of slave regimes—legal codes backed by the threat of force—that they justified by appealing to economic necessity and racial superiority. White colonists continued to squabble among themselves and with governors appointed by the king, who tried (and often failed) to get them to cooperate with imperial policies. Tensions existed, but on the whole colonists believed that their governments protected their rights and advanced their interests.

Government without Consent

CAT. 2. STAMP ACT OF 1765

At some point, however, people on both sides of the Atlantic were bound to ask how these colonial governments stood in relation to the government of Great Britain. Historians call this ill-defined set of transatlantic connections the "imperial constitution." The crown had always played an important role in America, with colonists there generally celebrating the king and proudly calling themselves his subjects. But the king formed just one part of the government of Great Britain. He ruled in conjunction with Parliament, a body composed of the House of Lords and the House of Commons. For "the people" of Great Britain—in general, a far more limited set of politically empowered white men than in North America—it was Parliament that represented popular influence over their government. The king, while still important, could not do whatever he pleased. Parliament, with the help of its supporters, had spent centuries (and had shed blood) reining in the monarch's powers and asserting its own. By the mid-eighteenth century, British subjects and foreign commentators alike praised this British "constitution" as the freest in the world. Yet did the British Parliament's authority to govern—its "sovereignty"—extend to the North American colonies as well?

The question remained largely hypothetical until, in the early 1760s, British politicians tried to raise tax revenue from the king's American dominions. In so doing they did not intend to be "tyrannical." Britain had spent huge sums to protect the colonies from France and Native Americans over the previous decade, thereby adding to the country's massive debt, and British ministers initially sought ways to pay for part of the cost of defending North America. Perhaps as the colonies continued to grow in population and wealth, they would one day contribute even more to the British treasury and help relieve overburdened British taxpayers.

After taking a step in this direction with 1763's Sugar Act, Parliament passed the Stamp Act in 1765. Modeled on similar measures already in force in Britain, the Stamp Act boldly asserted Parliament's power to tax the colonists—and in remarkably visible and symbolic ways. Starting on November 1, 1765, a wide range of items sold in the colonies would have to carry stamps indicating that taxes of various sums had been paid. If implemented, the tax would become a constant reminder of Parliament's authority. Attorneys' legal documents would need to be stamped, as would ship captains' clearance papers for their cargoes. Land deeds, liquor licenses, and college diplomas would not be valid unless they were on stamped paper. Colonists of humble backgrounds would see and feel the tax as well. Newspapers, pamphlets, calendars, and almanacs (which were popular among farmers) would all have to carry stamps. Lest anyone accuse Parliament of failing to promote morality, the act exempted religious tracts and schoolbooks but taxed playing cards and dice. Similarly, perhaps to reassure colonists of their English identity at a time when many were likely to feel as though their rights as Englishmen were being infringed, the act mandated that items written or published in a language other than English would be taxed at double the normal rates. All money collected, Parliament insisted, would be kept in a separate account and used only "towards further defraying the necessary expences of defending, protecting, and securing" the colonies.

Colonists' objection to the Stamp Act went far beyond a simple aversion to paying taxes. The crux of the issue lay in what the Stamp Act suggested about the colonists' status within the British Empire. It called into question how they would be governed, potentially

Anno quinto

Georgii III. Regis.

C A P. XII.

An Act for granting and applying certain Stamp Duties, and other Duties, in the *British* Colonies and Plantations in *America,* towards further defraying the Expences of defending, protecting, and securing the same; and for amending such Parts of the several Acts of Parliament relating to the Trade and Revenues of the said Colonies and Plantations, as direct the Manner of determining and recovering the Penalties and Forfeitures therein mentioned.

HEREAS by an Act made in the last Session of Parliament, several Duties were granted, continued, and appropriated, towards defraying the Expences of defending, protecting, and securing, the British Colonies and Plantations in America: And whereas it is just and necessary, that Provision be made for raising a further Revenue within Your Majesty's Dominions in America, towards defraying the said Expences: We, Your Majesty's most dutiful and loyal Subjects, the Commons of Great Britain in Parliament assembled,

Preamble.

4 A 2 have

5

For every Skin or Piece of Vellum or Parchment, or Sheet or Piece of Paper, on which shall be ingroſſed, written, or printed, any Declaration, Plea, Replication, Rejoinder, Demurrer, or other Pleading, or any Copy thereof, in any Court of Law within the Britiſh Colonies and Plantations in America, a Stamp Duty of Three Pence.

For every Skin or Piece of Vellum or Parchment, or Sheet or Piece of Paper, on which shall be ingroſſed, written, or printed, any Special Bail and Appearance upon ſuch Bail in any ſuch Court, a Stamp Duty of Two Shillings.

For every Skin or Piece of Vellum or Parchment, or Sheet or Piece of Paper, on which shall be ingroſſed, written, or printed, any Petition, Bill, Anſwer, Claim, Plea, Replication, Rejoinder, Demurrer, or other Pleading in any Court of Chancery or Equity within the ſaid Colonies and Plantations, a Stamp Duty of One Shilling and Six Pence.

For every Skin or Piece of Vellum or Parchment, or Sheet or Piece of Paper, on which shall be ingroſſed, written, or printed, any Copy of any Petition, Bill, Anſwer, Claim, Plea, Replication, Rejoinder, Demurrer, or other Pleading in any ſuch Court, a Stamp Duty of Three Pence.

For every Skin or Piece of Vellum or Parchment, or Sheet or Piece of Paper, on which shall be ingroſſed, written, or printed, any Monition, Libel, Anſwer, Allegation, Inventory, or Renunciation in Eccleſiaſtical Matters in any Court of Probate, Court of the Ordinary, or other Court exerciſing Eccleſiaſtical Juriſdiction within the ſaid Colonies and Plantations, a Stamp Duty of One Shilling.

for generations to come. If the British Parliament, a body in which they had no representatives, could tax them at will, then it could do anything else without their consent. What use, then, were the colonial assemblies that colonists so revered as symbols of their rights as Englishmen? If colonists truly did enjoy all the same liberties and privileges as those born in England, why should they have to submit to taxes levied by other people's representatives? Their understandable motives notwithstanding, Parliament and its defenders never offered colonists convincing answers to these questions. Their first impulse was to claim that Americans really were represented in Parliament, albeit "virtually." Not even Parliament's supporters bought this argument, however, and they soon fell back on claiming simply that Parliament necessarily served as the supreme sovereign body in the British Empire and that no limits could be placed on its authority.

In their protests against the Stamp Act, colonists set out to demonstrate the practical limits of Parliament's authority in North America and to assert their rights as they understood them. Colonial elites, whose status and power the Stamp Act threatened most immediately, took actions to prevent its implementation and to secure its repeal. The Virginia House of Burgesses adopted a series of statements proposed by Patrick Henry. These "resolves" circulated around the continent in newspapers. At the recommendation of the Massachusetts House of Representatives, most of the colonies sent delegates to New York, where a "congress" drew up a list of resolutions outlining the American view of the controversy and arranged to have petitions sent to the king and Parliament. Lawyers and judges avoided doing business with stamped paper. Hoping to exert economic pressure on Parliament, merchants in colonial cities agreed not to import goods from Britain. And, perhaps most notably, large groups of colonists forced every "stamp distributor" to resign. In August 1765, mobs in Boston went so far as to ransack the houses of Massachusetts's stamp distributor and lieutenant governor. Similar incidents occurred elsewhere, ensuring that the Stamp Act was already a dead letter by the date on which it was to go into effect. The amount the British spent trying to implement the tax

exceeded the money collected. At the urging of British merchants worried about colonial boycotts, Parliament reluctantly agreed to repeal the Stamp Act in early 1766.

Rights Worth Fighting For

CAT. 3. MASSACHUSETTS GOVERNMENT ACT OF 1774

Few of the American colonists who celebrated the repeal of the Stamp Act in 1766 believed that they would be ready to declare independence from Britain just a decade later. During these years, Americans continued to insist that they were merely trying to preserve their rightful voice in the governments under which they lived. Most still viewed monarchy (of the British constitutional variety) as fully compatible with liberty. The crown-appointed governors with whom the settlers in most colonies had to deal were irritating but manageable, not in themselves reason to launch a risky bid for independence. Parliament, they generally acknowledged, could continue to do such things as regulate trade between the various parts of the empire, as this did not clearly infringe on their rights. But they adamantly refused to accept any measures suggesting that their colonial governments, in which they granted the consent so important to the English constitutional tradition, could be cavalierly disregarded and made irrelevant by a Parliament sitting three thousand miles away.

As it repealed the Stamp Act, Parliament took pains to reassert its authority to legislate for the colonies "in all cases whatsoever." Just a year later it tried to impose another set of taxes. Named for their author, these Townshend Acts took the form of customs duties on a variety of goods, such as glass, paper, lead, painters' colors, china, and, most important, tea. Again, British ministers predicted small initial revenues. Moreover, because the money would be collected at the water's edge from colonial merchants, the taxes would be felt only indirectly by most colonists when they paid slightly higher prices for the goods in question. Yet this strategy backfired. Colonists accused Parliament of employing deceptive means to establish a precedent to tax them. The duties ultimately were taxes, after all,

OPPOSITE: Cat. 3. Massachusetts Government Act of 1774

ANNO DECIMO QUARTO

Georgii III. Regis.

C A P. XLV.

An Act for the better regulating the Government of the Province of the *Maſſachuſet's Bay,* in *New England.*

 HEREAS by Letters Patent under the Great Seal of England, made in the Third Year of the Reign of Their late Majeſties King William and Queen Mary, for uniting, erecting, and incorporating, the ſeveral Colonies, Territories, and Tracts of Land therein mentioned, into One real Province, by the Name of Their Majeſties Province of the *Maſſachuſet's Bay,* in *New England;* whereby it was, amongſt other Things, ordained and eſtabliſhed, That the Governor of the ſaid Province ſhould, from thenceforth, be appointed and commiſſionated by Their Majeſties, Their Heirs and Succeſſors: It was, however, granted and ordained, That, from the Expiration of the Term for and during which the Eight and twenty Perſons named in the ſaid Letters Patent were appointed to be the firſt Counſellors or Aſſiſtants to the Governor of the ſaid Province for the Time being, the

and Parliament clearly planned to expand its revenue program in the future. The issue remained the same: if colonists allowed the taxes to stand, they would be admitting that Parliament could govern them without their consent, and that their own colonial assemblies were of no consequence. Writers excoriated Parliament in essays and pamphlets, and assemblies denounced the duties. American merchants agreed not to import goods, and colonists, including many women, enforced these community-wide boycotts. Facing pressure once again from British merchants, Parliament eventually repealed all of the duties except the one on tea, which it symbolically retained as evidence of its authority to tax the colonies.

Colonists continued to boycott the tea sold by British merchants until Parliament made what colonists viewed as yet another underhanded attempt to force them to accept the tax and its authority. In 1773, Parliament engineered a way to lower the price of the tea British merchants sent to the colonies. Colonists would find the low prices too tempting to pass up, the thinking went, and each time they bought the tea they would be affirming Parliament's right to tax them. But again, colonists up and down the Atlantic coast saw through Parliament's strategy and prepared to oppose it. The most famous—though not the only—act of protest occurred in Boston in December, when colonists dumped a large quantity of tea into the city's harbor. With the situation in America apparently spiraling out of control, British ministers assumed they must take firm steps to bring the colonists into line.

Those steps only made things worse. In 1774, Parliament passed a series of measures known as the Coercive Acts—which the colonists, with an equal lack of subtlety, deemed the "Intolerable Acts." The Boston Port Act prohibited commercial shipping in New England's most important city. The Quartering Act empowered governors to house British troops in various types of buildings when colonial governments failed to provide adequate accommodations. The Administration of Justice Act allowed Massachusetts governors to order that the trials of government officials charged with serious crimes take place outside the colony, which would ostensibly protect the accused from unfair verdicts reached by unreasonably hostile colonial juries. To colonists, however, this seemed like an attempt to undermine the hallowed customs of jury trials and set certain individuals above the law. Crown officers would even be able to get away with murder, they claimed.

The "Act for the better regulating the Government of the Province of the Massachuset's Bay, in New England"—commonly known as the Massachusetts Government Act—offered colonists perhaps the clearest and most alarming indication of Parliament's disdain for their rights and for their voice in their governments. Along with Connecticut and Rhode Island, Massachusetts possessed one of the few remaining charters that colonists still revered. The 1691 charter stated that Massachusetts would have a crown-appointed governor and a bicameral legislature (or "General Court"): a House composed of representatives annually elected by the people in their respective towns; and a Council of twenty-eight. The Council was elected by each year's newly elected representatives and the previous year's councillors. The governor could "negative"—reject—the General Court's choices if he wished. This arrangement certainly appeared anomalous when compared with other royal colonies, but the crown had seen fit to grant Massachusetts this particular charter and to mandate this particular constitutional structure, and colonists were not about to give up an arrangement that allowed them so much control over provincial government. In the Massachusetts Government Act, however, Parliament unilaterally tried to alter the charter for the first time in over eighty years. It declared that from then on, the crown would appoint the councillors. It also limited towns to one town meeting per year and announced that jurors would no longer be elected by the inhabitants, but would instead be selected by governor-appointed sheriffs.

All this suggested that British officials planned to reduce colonists' role in government to the bare minimum. If, without the people's consent, Parliament could alter the Massachusetts charter as it related to the Council, then Parliament could alter or even abolish the powers of colonial assemblies anywhere, at any time, for any reason. Parliament, it seemed, clearly did not consider colonists in North America equal to subjects in Britain. Inhabitants saw confirmation of their fears in the governments that imperial authorities were trying to establish elsewhere. Passed around the same

time as the Coercive Acts, the Quebec Act vastly expanded the boundaries of that formerly French province and made clear that its government would not include a representative assembly. The Quebec Act also accommodated the Catholic Church and French forms of law, both considered by colonists to be inimical to traditional English liberties.

Colonists therefore interpreted all of the Coercive Acts, and especially the Massachusetts Government Act, as profound threats. They reacted with coordination and vigor. Communities across the continent sent supplies to relieve the inhabitants of Boston, who had suffered as a result of their port's closure. Committees of Correspondence circulated news. In September 1774, the First Continental Congress met in Philadelphia. It stated the colonial position and organized a nonimportation movement, the Continental Association, to be enforced by local committees. In these ways, thousands of Americans became engaged in the effort to repeal the Coercive Acts. They still hoped at this point to remain within the British Empire, in colonies where they would enjoy all the constitutional rights their fellow subjects enjoyed in England.

Events in Massachusetts made the possibility of reconciliation increasingly remote, however. In their attempts to prevent the Government Act from going into effect, Massachusetts inhabitants took actions that, while short of outright violence, created a volatile situation. They forced the resignations of men appointed to the new Council. They prevented courts from meeting. And they formed a "provincial congress" to pursue what they called "self-preservation." That the governor of Massachusetts was now Thomas Gage, commander of British military forces in North America, raised the stakes considerably. Gage commanded several thousand British troops in Boston, where they had been posted since 1768. Colonists believed the army's presence had always been part of Britain's efforts to coerce them into submitting to Parliament's authority, and the Boston Massacre of 1770, in which five colonists had been killed, illustrated the soldiers' destructive potential. Now, with most of the province opposed to his attempts to enforce the Coercive Acts, Gage ordered 1,800 of his troops to march out of Boston and seize military stores that colonists had been stockpiling. On the morning of April 19, 1775, British Regulars finally clashed with the colonial militia, first at Lexington, then at Concord. Thousands of colonists flocked to the scene and forced the British to retreat to the safety of Boston—but not before seventy-three British soldiers had been killed and one hundred more were left wounded or missing.

The Declaration of Independence and the Foundations of Self-Government

War had begun, and the developments of the ensuing year would convince a large number of Americans that their rights would never be secure until they departed the British Empire and constructed their own governments. Even as the newly formed Continental Army besieged British forces in Boston, many colonists hoped to avoid a final separation from the country whose political, legal, cultural, and religious traditions had so influenced their own senses of identity. They hoped that the king could be persuaded to intervene on their behalf. Although he would suffer from mental illness later in life, in 1775 George III was an active, intelligent, and well-educated man who took his responsibilities as constitutional monarch seriously. Unlike his predecessors, his German-born (and German-speaking) grandfather and great-grandfather, he was fully English. For that reason alone, colonists surmised, the king should sympathize with his subjects across the Atlantic as they contended with Parliament for their constitutional rights. They suffered a series of bitter disappointments, then, when the king rejected the Continental Congress's Olive Branch Petition, declared the Americans out of his protection, and strongly urged his ministers to fight the war.

If even as enlightened a monarch as George III could treat his subjects so callously, Americans increasingly concluded, perhaps monarchy itself was the problem. In early 1776, in his immensely popular pamphlet *Common Sense*, the English-born writer Thomas Paine depicted monarchy as a corrupt and even absurd form of government. If nature favored hereditary kingship, Paine asked, why would nature "so frequently turn it into ridicule by giving mankind an *ass for a lion*"? Paine reminded readers of the tragic consequences that incompetent, undeserving, and self-interested rulers inevitably brought upon their hapless subjects.

"Monarchy and succession have laid (not this or that kingdom only) but the world in blood and ashes," he declared. "'Tis a form of government which the word of God bears testimony against, and blood will attend it."[1]

In the spring and early summer of 1776, Americans met in town meetings, county conventions, provincial congresses, and other gatherings to voice their support for independence. They thereby lent credence to Paine's claim simply to express the "common sense" of the people on monarchy and the wisdom of separation. Indeed, the Declaration of Independence that the Virginian Thomas Jefferson drafted, and that the Continental Congress edited and adopted in Philadelphia in July, savagely condemned the king for a variety of offenses by which he had driven his faithful subjects to this momentous step. The king's underlying crime had been his failure to prevent the British Parliament's unconstitutional attempts to govern the colonists without their consent and in violation of their rights. Since Americans believed that Parliament had no authority over them, there was no point in addressing that body. Americans' connection to the empire lay in "the British Crown," an "allegiance" that they now repudiated.

Americans believed themselves fully justified in taking this step. "Governments are instituted among Men," the Declaration explained, to secure the people's "unalienable Rights" to "Life, Liberty and the pursuit of Happiness." They "deriv[ed] their just powers from the consent of the governed." It followed, then, that "whenever any Form of Government becomes destructive of these ends, it is the Right of the People to alter or to abolish it, and to institute new Government, laying its foundation on such principles and organizing its powers in such form, as to them shall seem most likely to effect their Safety and Happiness." Of course, responsible people would not undertake such far-reaching actions on the merest whim: "Prudence, indeed, will dictate that Governments long established should not be changed for light and transient causes; and accordingly all experience hath shewn, that mankind are more disposed to suffer, while evils are sufferable, than to right themselves by abolishing the forms to which they are accustomed." But while practical considerations may restrain the people from acting in certain circumstances and at certain times, the

unshakeable fact remains that the people always have the "right"—even the "duty," once one considered future generations—to change their governments when they feel it necessary.

Americans had arrived at the decision to declare independence after years of reflection provoked by "a long train of abuses and usurpations." Yet they could only begin to fathom the long-term implications of their actions and the enormous challenges that lay ahead. Once Americans severed their connections to Britain, they would need to forge new bonds among themselves and establish new governments.

A New Order of the Ages

CAT. 4. CHARLES THOMSON DESCRIPTION OF THE GREAT SEAL OF THE UNITED STATES, 1782

The length of time Congress needed to design the Great Seal of the United States, a mere symbol of the new political system, suggests the difficulties Americans would face as they attempted the far more complicated task of writing constitutions for their states and union. Congress wasted no time in starting the process. On July 4, 1776, it appointed Thomas Jefferson, Benjamin Franklin, and John Adams—fresh from their service on the committee charged with drafting the Declaration of Independence—to come up with an emblem to represent the United States as it assumed its place "among the powers of the earth." But Congress was unimpressed with the elaborate biblical and mythological images the three men proposed, and the project remained dormant until 1780, when another committee offered an equally unsatisfactory design. Two more years passed before yet another committee made its try, which Congress still found wanting. At this point, Congress asked its secretary, Charles Thomson, to make sense of the various proposals and finally complete the job that had vexed some of America's greatest statesmen.

The enterprising Thomson proved a good choice. Born in Ireland in 1729, Thomson arrived in Delaware when he was about ten years old. His mother had died in Ireland, his father on the voyage across the Atlantic. Taken in by a blacksmith, he attended school, received

a classical education, and became an accomplished tutor at Benjamin Franklin's Academy of Philadelphia. He pursued various business ventures, married well, and took an interest in politics. He rose to prominence during the controversies of the 1760s and early 1770s, serving as one of Philadelphia's leading revolutionaries. Congress appointed him secretary in 1774 and kept him in that important position until 1789; during those eventful years, Thomson earned the trust and esteem of his colleagues.

In 1782, Thomson sifted through designs for the seal, picking and choosing the best elements and contributing his own ideas when necessary. Thomson made the bald eagle the centerpiece of the design. (There is no truth to the story that Benjamin Franklin seriously preferred the turkey.) In its talons, the eagle held an olive branch and arrows, symbolizing the nation's ability to make peace and wage war. A shield on the eagle's breast with alternating red and white stripes, and a constellation of thirteen stars above the eagle's head, incorporated elements of the United States flag. In the eagle's beak, Thomson stuck a scroll on which was written a motto proposed in 1776 by the first committee. *E pluribus Unum*, "out of many, one," brilliantly described the experiment upon which Americans had embarked. Thirteen states—all with their own histories, political cultures, social structures, ethnic and racial makeup, religious beliefs, and economic interests—would need to unite and act as one. Even in 1782, several years after the American people had declared their independence, countless questions remained about the nature of this new union, and about each of the individual states that composed it.

Appropriately, then, for the obverse side of the seal, Thomson retained from an earlier proposal an unfinished pyramid of thirteen steps. The American republic was still under construction. The "Eye of Providence" (another borrowing from the first committee's proposal) hovered above reassuringly, along with the phrase *Annuit Cœptis* ("He has blessed our undertakings"). MDCCLXXVI, or 1776, appeared on the pyramid's base, and Thomson, drawing again on his expertise in Latin, added the phrase *Novus Ordo Seclorum*. The period after 1776 did indeed seem to

inaugurate "a new order of the ages" as Americans began, for the first time, to create their own governments. Now everything lay in their power. The people would decide what their governments looked like and what goals those governments would pursue. It would prove an exhilarating but immensely challenging—and often contentious—task, one that required the participation of countless Americans.

All Men Are by Nature Equally Free and Independent

CAT. 5. VIRGINIA DECLARATION OF RIGHTS OF 1776

In some places, Americans had already begun to write constitutions and to remake their governments. "This Day the Congress has passed the most important Resolution, that ever was taken in America," John Adams had written on May 15, 1776, a month and a half before the Declaration of Independence.[2] Never bashful about his contributions to the cause, Adams took great pride in the fact that Congress had adopted a statement he had written to accompany its resolution urging the colonies to form their own governments. For Adams, writing constitutions embodied the very spirit of the Revolution. He believed Americans needed to seize this incredible opportunity if they wished to defeat the British and secure their independence. He could hardly contain his excitement. "An whole Government of our own Choice, managed by Persons whom We love, revere, and can confide in, has charms in it for which Men will fight," he told his wife, Abigail. Two colonies, in fact, had already written provisional constitutions. With Americans no longer recognizing the authority of royal governors, many colonies were left without effective governments. The crisis had proven especially severe in New Hampshire and South Carolina. In early 1776 (with Congress's blessing), those colonies had quickly written frames of government that enabled inhabitants to maintain law and order and carry on the fight against the enemy. Adams received very encouraging reports about these early efforts. Two South Carolinians "who were in

FOLLOWING PAGES: Cat. 4. Charles Thomson Description of the Great Seal of the United States, 1782

33

Aug. 21. 1776

The com.tee appointed to prepare a device for a great seal brought in a device ~~of a great seal~~ with an explanation

By the United States in Congress assembled
June 20 1782

On a report of the Secretary of Congress, to whom were referred the several reports on a devise for a great Seal

The Devise for an armorial Achievement and reverse of a great Seal for the United States in Congress assembled is as follows

Arms

Paleways, of thirteen pieces, Argent and Gules; a Chief Azure. the Escutcheon on the breast of the American Bald Eagle displayed, proper, holding in his dexter talon an Olive branch & in his sinister a bundle of thirteen arrows, all proper, and in his beak a scroll inscribed with this Motto "Epluribus Unum"

For the Crest

Over the head of the Eagle, which appears above the Escutcheon, a <u>Glory</u>, <u>Or</u>, breaking through a cloud, <u>proper</u>, and surrounding thirteen Stars forming a Constellation, <u>Argent</u>, on an Azure field.

Reverse

A Pyramid unfinished

In the zenith an Eye in a triangle surrounded with a Glory, <u>proper</u>. Over the Eye these words "Annuit Cœptis". On the base of the pyramid the numerical Letters." MDCCLXXVI. and underneath the following Motto

Novus Ordo Seclorum. ———

Charlestown when their new Constitution was promulgated" told him that "when [South Carolina's] new Governor and Council and Assembly walked out in Procession, . . . they were beheld by the People with Transports and Tears of Joy. The People gazed at them, with a Kind of Rapture."[3] Replicate this scene in all thirteen colonies, Adams reasoned, and Americans will have laid a solid foundation for a new era of freedom.

Constitution-making also preoccupied Thomas Jefferson, Adams's colleague in Philadelphia. Although history would remember him for writing the Declaration of Independence, in May and June of 1776, Jefferson wanted to be in Williamsburg, helping to write Virginia's new constitution. As had occurred in many other colonies at the start of the war, a Revolutionary convention had assumed control in Virginia. In the sudden vacuum of authority, such a convention worked well enough as a short-term stopgap. But no one thought this ad hoc body could serve as a permanent government. What were its powers? How was it to be structured? What role would the people have? Without clear answers to these and other questions, Virginians would never entirely trust the new government. They needed reassurance that it was worth fighting and possibly dying for. And they needed it quickly, or else a lack of organization might cost them their best opportunity to defeat the British. A written constitution, a single document that outlined the structure and powers of government—the rules of the political system— offered Americans a way to create a new government almost instantaneously. Once the people read the constitution for themselves, they would recognize that the government was legitimate and worthy of their compliance. A government that people believed in, and saw as their own, would always prove far stronger and more formidable than one imposed on them from afar.

Before it sketched a frame of government, however, the Virginia convention first drafted another document that proved just as important and influential: a declaration of rights. After spending the last decade defending their rights against encroachments by British authorities, Virginians now saw the value in articulating some of those rights at the outset of this new era.

Doing so would ensure that their own government, by design or accident, could never deprive the people of their liberties or threaten their most cherished principles. It would also serve to remind thousands of ordinary Americans what they were fighting for, thereby binding the people ever more strongly to the Revolutionary regime.

Written primarily by George Mason and adopted on June 12, 1776, the Virginia Declaration of Rights comprised, in the words of historian Gordon S. Wood, "a jarring but exciting combination of ringing declarations of universal principles with a motley collection" of more specific legal customs that Americans had long prized.[4] It began by stating that "all men are by nature equally free and independent" and that "all power is vested in, and consequently derived from, the people." Because of this, "a majority of the community hath an indubitable, inalienable, and indefeasible right to reform, alter, or abolish" their government whenever they deemed the current one "inadequate." The similarity between these phrases and those found in the Declaration of Independence was no coincidence. Jefferson eagerly drew on Mason's drafts as he composed his own text in Philadelphia.

There would never be, the Declaration of Rights asserted, any legally recognized aristocratic class in Virginia, and no offices would be hereditary. Indeed, government officials— as "trustees and servants" of the people—should be periodically "reduced to a private station" so they would not become too out of touch with their constituents. Anyone who had an "interest" in and "attachment" to the "community" would be able to participate in free elections. The executive could not "suspend the laws" without the consent of the legislature. In both criminal and civil matters, everyone had a right to a speedy trial by a jury of his peers, and no one should face either "excessive bail" or "cruel and unusual punishments." Search warrants needed to be specific (otherwise they were apt to be abused by authorities). The Declaration also forcefully proclaimed that "the freedom of the press is one of the great bulwarks of liberty, and can never be restrained but by despotic governments." A "well-regulated militia" was

OPPOSITE: Cat. 4. Charles Thomson Description of the Great Seal of the United States, 1782
FOLLOWING PAGES: Cat. 5. Virginia Declaration of Rights of 1776

Howell, who is charged with murder, and now in her way from the county of *Berkeley*, is guilty thereof. And that they had come to several resolutions thereupon, which he read in his place, and afterwards delivered in at the clerk's table, where the same were again read, as follows:

Resolved, that the said *Thomas M'Cluskey*, and *Elizabeth* his wife, *Thomas Potter*, and *Benjamin Higgins*, be forthwith discharged out of custody.

Resolved, that some mode of trial be adopted for the delivering of *Samuel Flanagin*, *Manasses M'Gahey*, *Habakkuk Pride*, and *Mary Howell*.

The first resolution of the committee being read a second time, was, upon the question put thereupon, agreed to by the Convention.

The subsequent resolution of the committee being read a second time, was, on the question put thereupon, ordered to lie on the table.

Adjourned till to-morrow, 10 o'clock.

WEDNESDAY, June 12, 1776.

THE declaration of rights having been fairly transcribed, was read a third time, and passed as follows, *nem. con.*

A DECLARATION *of* RIGHTS *made by the representatives of the good people of* Virginia, *assembled in full and free Convention; which rights do pertain to them, and their posterity, as the basis and foundation of government.*

1. THAT all men are by nature equally free and independent, and have certain inherent rights, of which, when they enter into a state of society, they cannot, by any compact, deprive or divest their posterity; namely, the enjoyment of life and liberty, with the means of acquiring and possessing property, and pursuing and obtaining happiness and safety.

2. That all power is vested in, and consequently derived from, the people; that magistrates are their trustees and servants, and at all times amenable to them.

3. That government is, or ought to be, instituted for the common benefit, protection, and security, of the people, nation, or

community; of all the various modes and forms of government that is best, which is capable of producing the greatest degree of happiness and safety, and is most effectually secured against the danger of mal-administration; and that whenever any government shall be found inadequate or contrary to these purposes, a majority of the community hath an indubitable, unalienable, and indefeasible right, to reform, alter, or abolish it, in such manner as shall be judged most conducive to the publick weal.

4. That no man, or set of men, are entitled to exclusive or separate emoluments or privileges from the community, but in consideration of publick services; which, not being descendible, neither ought the offices of magistrate, legislator, or judge, to be hereditary.

5. That the legislative and executive powers of the state should be separate and distinct from the judicative; and that the members of the two first may be restrained from oppression, by feeling and participating the burthens of the people, they should, at fixed periods, be reduced to a private station, return into that body from which they were originally taken, and the vacancies be supplied by frequent, certain, and regular elections, in which all, or any part of the former members, to be again eligible, or ineligible, as the laws shall direct.

6. That elections of members to serve as representatives of the people, in assembly, ought to be free; and that all men, having sufficient evidence of permanent common interest with, and attachment to, the community, have the right of suffrage, and cannot be taxed or deprived of their property for publick uses without their own consent, or that of their representatives so elected, nor bound by any law to which they have not, in like manner, assented, for the publick good.

7. That all power of suspending laws, or the execution of laws, by any authority without consent of the representatives of the people, is injurious to their rights, and ought not to be exercised.

8. That in all capital or criminal prosecutions a man hath a right to demand the cause and nature of his accusation, to be con-

B b

the preferred means of defending the state, within whose bounds no other competing authorities could be established. Finally, "free government," the Declaration insisted, depended on "a firm adherence to justice, moderation, temperance, frugality, and virtue"—as well as to other "fundamental principles." All of these traits were presumably nurtured through the free exercise of religion, which the Declaration also guaranteed.

Importantly, the Declaration of Rights did not grant the people their rights but rather guaranteed them. Since all power came from the people, their rights were not limited to what they chose to emphasize and write down at this particular moment. Virginia's Declaration of Rights, then, did not purport to be a complete and comprehensive list. When other states subsequently adopted their own declarations of rights (or incorporated analogous provisions within the bodies of their state constitutions), they introduced their own variations. Maryland, for instance, included in its declaration of rights denunciations of ex post facto (retroactive) laws and of poll taxes (whereby all citizens paid the same flat sum, regardless of their wealth or income). In its article proclaiming the importance of freedom of the press, Pennsylvania elaborated that "the people have a right to freedom of speech, and of writing, and publishing their sentiments." Like all the other states, Pennsylvania thought that "standing armies" presented great dangers to free republics. Its declaration accordingly noted that "the people have a right to bear arms for the defence of themselves and the state." As their familiar language may suggest, many of the articles in these state declarations would influence the United States Constitution and its first ten amendments, known as the Bill of Rights.

After approving the Declaration of Rights, Virginia's convention went on to draft the Constitution or Form of Government for the state. On the one hand, the 1776 Virginia constitution—as would be the case with many early state constitutions—recreated some aspects of the restrictive political system that had been in place during the colonial period. It continued to require that voters meet a property requirement, and it kept local government largely in the hands of county elites. Thomas Jefferson, among others, pointed out

that the new government continued to overrepresent the older, wealthier, eastern parts of the state to the detriment of western inhabitants. On the other hand, the convention introduced many remarkably democratic changes to the Old Dominion's form of government. Voters would now directly elect members of a "house of delegates" annually and the members of a state "senate" every four years. Each year, the members of the two houses of the General Assembly would together elect a governor, who could serve a maximum of three consecutive terms. (He could serve again as governor after sitting out for four years.) The General Assembly would also elect a "privy council" of eight men who needed to approve most of the governor's important decisions and appointments. Compared with some of the initial proposals made by the convention— one, for instance, would have seen representatives elected only every three years, and the governor, council, and upper house appointed for life—this final version of the Virginia constitution clearly reflected a significant degree of popular influence. Many members of the convention may have been planter bigwigs reluctant to give up the power they had long wielded in Virginia. But these men heard and, in many instances, actively sympathized with the sentiments being expressed by large numbers of ordinary (white male) Virginians at a time of Revolutionary tumult. When the convention adopted the new constitution on June 29, 1776, it transformed Virginia's political landscape forever by giving the people an unprecedented role in running their government.

Power to the People

CAT. 6. PENNSYLVANIA CONSTITUTION OF 1776

Virginia's new constitution seemed revolutionary when compared with the colonial government that preceded it. Pennsylvania's constitution, adopted a few months later, seemed radical when judged against any existing standard—so radical, in fact, that even many revolutionaries harbored doubts about it. Political conditions in late provincial Pennsylvania help explain why the

OPPOSITE AND FOLLOWING PAGES: Cat. 6. Pennsylvania Constitution of 1776

THE
CONSTITUTION
OF THE
COMMON-WEALTH
OF
PENNSYLVANIA,

AS ESTABLISHED BY

THE GENERAL CONVENTION

ELECTED FOR THAT PURPOSE,

AND HELD AT PHILADELPHIA,

JULY 15th, 1776,

AND CONTINUED BY ADJOURNMENTS

TO SEPTEMBER 28, 1776.

PHILADELPHIA:

PRINTED BY JOHN DUNLAP, in MARKET-STREET.

M,DCC,LXXVI.

SECTION *the Eleventh.*

DELEGATES to represent this State in Congress shall be chosen by ballot by the future General Assembly at their first meeting, and annually forever afterwards, as long as such Representation shall be necessary. Any Delegate may be superseded at any time, by the General Assembly apponting another in his stead. No man shall sit in Congress longer than two years successively, nor be capable of re-election for three years afterwards : And no person who holds any office in the gift of the Congress shall hereafter be elected to represent this Common-Wealth in Congress.

SECTION *the Twelfth.*

IF any city or cities, county or counties shall neglect or refuse to elect and send Representatives to the General Assembly, two thirds of the members from the cities or counties that do elect and send Representatives, provided they be a majority of the cities and counties of the whole State when met, shall have all the powers of the General Assembly as fully and amply as if the whole were present.

SECTION *the Thirteenth.*

THE doors of the house in which the Representatives of the Freemen of this State shall sit in General

neral Assembly, shall be and remain open for the admission of all persons who behave decently, except only when the welfare of this State may require the doors to be shut.

SECTION *the Fourteenth.*

THE Votes and Proceedings of the General Assembly shall be printed weekly during their sitting, with the yeas and nays on any question, vote or resolution, where any two members require it, except when the vote is taken by ballot; and when the yeas and nays are so taken, every member shall have a right to insert the reasons of his vote upon the Minutes, if he desire it.

SECTION *the Fifteenth.*

To the end that Laws before they are enacted may be more maturely considered, and the inconvenience of hasty determinations as much as possible prevented, all bills of public nature shall be printed for the consideration of the people, before they are read in General Assembly the last time for debate and amendment; and except on occasions of sudden necessity, shall not be passed into Laws until the next session of Assembly; and for the more perfect satisfaction of the public, the reasons and motives for making such Laws shall be fully and clearly expressed in the preambles.

SECTION

state endorsed such a remarkable document in 1776. In the decades before the Revolution, some Pennsylvanians opposed the colony's proprietors, the Penn family, and many felt that the political system in general remained woefully unresponsive to their needs. A vocal contingent complained that the deeply entrenched and pacifist Quaker party had not taken sufficient measures to defend the populace against Native Americans. Tragically, in 1763, a gang of colonists took matters into their own hands and brutally murdered an innocent group of Indians. The colonial government lost even more of its credibility when it failed to support the movement to resist Parliamentary taxation. Throughout the 1760s and 1770s, Pennsylvanians read all about the statements and actions approved by the assemblies in other colonies. They wondered why their own elected officials seemed so comparatively quiet and weak in the face of such a grave threat to their rights. The final straw came after the outbreak of war, when the Pennsylvania Assembly demonstrated that it could not be trusted to defend the state against the British. Even worse, it clearly intended to block any attempts to reform the political system and bring it into line with the preferences of patriot Pennsylvanians.

To overcome this gridlock, revolutionaries decided that Pennsylvania needed a new constitution. In June 1776, as the Continental Congress just a block away prepared to declare independence, a provincial conference met in Philadelphia's Carpenters' Hall to make arrangements for a state constitutional convention. Given the pressing situation, Pennsylvania needed an effective government as quickly as possible. But revolutionaries knew that for any new government to be effective, it must appear legitimate. The constitution should try to incorporate the wishes of the entire populace—to whatever extent was feasible under the circumstances. The provincial conference did its best to balance these priorities. It called for each county as well as Philadelphia to elect eight delegates to come to the city the following month and write a constitution. It did not try to influence what kind of constitution the delegates would write. It also made an important decision regarding who would be eligible to vote for the convention delegates. As the historian Richard Alan Ryerson explains, "if the province were to draft a new constitution, those who would be called upon to defend it could reasonably expect to have some say in its creation."[5] Accordingly, all men at least twenty-one years old who supported the patriot militia and who had been assessed taxes—up to 90 percent of the adult male population—could participate in the election on July 8. (In an important caveat, voters could be required to swear an oath denying their allegiance to the king. This meant that loyalists—those who did not support the Revolution—would not have a role in creating the new government.)

The new constitution made clear that the people were now in charge in Pennsylvania. Voting would be permanently open to all "freemen" at least twenty-one years old who had resided in the state for one year and had paid taxes during the preceding year. (Twenty-one-year-olds could vote if their fathers had paid taxes.) Any man could run for a seat in the legislature as long as he had resided in the county or city he wished to represent for at least two years. If elected, however, a representative would need to "acknowledge [that] the Scriptures of the Old and New Testament" were the products of "Divine inspiration." This religious test effectively restricted office-holding to Christians—though, at the time, it was extremely unlikely that any non-Christian would be elected regardless.

The legislature that Pennsylvanians created was unlike anything else around. First, it was unicameral. There would be no upper house that also needed to approve bills before they became law. Pennsylvania's provincial assembly had essentially been unicameral as well—but that had always seemed like just a fluke of the colony's proprietary government. All the other colonies followed the traditional English pattern, exemplified by Parliament, in which there was both a lower and an upper house. Pennsylvanians now asked why any government based on the sovereignty of the people needed an upper house. In the conventional political theory of the day, the lower house of a bicameral legislature represented "the people," while the upper house represented an aristocracy of some kind. In Britain, for example, the House of Lords represented the country's nobility. Upper houses were thought to be inherently conservative in their outlook and predilections. They enabled "the few" to thwart the wishes of "the many"

by refusing to pass pieces of legislation that a majority of the people wanted. Dispensing with an upper house thus appeared consistent with the social structure of Pennsylvania. The state had no aristocracy whose special interests deserved recognition. All citizens were equal. A unicameral legislature would enable the people to realize their preferences that much more easily.

The Pennsylvania constitution did not stop there, however. Remarkably, the people did not completely trust even their directly elected representatives to enact wise laws without their constant oversight. Section 15 of the constitution announced that "all bills of public nature shall be printed for the consideration of the people, before they are read in general assembly the last time for debate and amendment." Even after the assembly approved a bill, it would not go into effect immediately (except on "occasions of sudden necessity"). Instead, a bill would become law only after it was passed by the following year's legislature as well. This provision guaranteed that every annual election would become a popular referendum on everything the legislature had proposed over the past year. If voters liked what their representatives had done, they would reelect those same men, or support others who held the same opinions. But if voters did not like what the incumbent representatives had done, they would elect alternative candidates with different views and the state would thus be spared "the inconvenience of hasty determinations." In this way, the Pennsylvania constitution demanded that citizens remain constantly attentive to public affairs.

The new Pennsylvania general assembly did not have to worry about the governor vetoing its legislation. In fact, the constitution did not authorize a governor at all. In his place the constitution provided for a "supreme executive council" of twelve men elected by the voters. Each year, the representatives of the general assembly and the council would combine and choose one of the men elected to the council as its "president" and one as its "vice-president." As the title implied, the president merely presided over the council. He needed the council's approval to carry out such necessary executive functions as communicating with other states, coordinating with state officials, appointing judges, and directing the state's military forces.

Rethinking the Powers of the Executive

CAT. 7. NEW YORK CONSTITUTION OF 1777

Pennsylvania's president and council typified one of the most important trends in early state constitutions: they all established relatively weak executives. By refusing to create an officer known as a "governor," Pennsylvania's constitution-makers followed the same reasoning that led them to view a legislative upper house as an unnecessary and potentially dangerous anachronism. In most American colonies, the crown had appointed the governor, who then represented the British king. Colonial governors had been able to appoint various officials, convene and dissolve the legislature, and even veto bills. In holding an absolute check on legislation passed by colonial assemblies, the powers of colonial governors had actually surpassed those of the crown in Britain. Although the crown formally retained the ability to prevent acts of Parliament from becoming law, for all practical purposes this power lapsed decades before the American Revolution. Queen Anne became the last monarch to refuse assent to an act of Parliament in 1708.

As Americans debated what kinds of executives to create in their new governments, then, their nearest points of reference were colonial governors, who had held extensive formal powers and had been appointed by the monarch to serve his or her—not necessarily the people's—interests. Moreover, in the 1760s and 1770s, many governors had taken prominent roles in trying to impose Parliament's authority on the colonists. Governor Gage had attempted to force Massachusetts inhabitants to accept the Coercive Acts at bayonet point. Perhaps even more troubling, Lord Dunmore, the last royal governor of Virginia, had promised freedom to slaves who rebelled against their patriot owners and fled to British lines. This had inspired the charge in the Declaration of Independence that the king—through his proxy Dunmore—had "excited domestic insurrections amongst us." It is a telling reminder that, depending on one's point of view, the Revolutionary cause could signify continued bondage as well as a fight for freedom. For these and other reasons, by 1776, most Americans did not hold governors in high regard.

THE

CONSTITUTION

OF THE

STATE

OF

NEW-YORK.

FISH-KILL:

PRINTED by SAMUEL LOUDON.

M.DCC.LXXVII.

ture, and meet once at leaft in every year for the difpatch of bufinefs.

III. AND WHEREAS, Laws inconfiftent with the fpirit of this conftitution, or with the public good, may be haftily and unadvifedly paffed; BE IT ORDAINED, that the Governor for the time being, the Chancellor and the Judges of the Supreme Court, or any two of them, together with the Governor, fhall be, and hereby are, conftituted a Council to revife all bills about to be paffed into laws by the legiflature. And for that purpofe fhall affemble themfelves, from time to time, when the legiflature fhall be convened; for which neverthelefs, they fhall not receive any falary or confideration under any pretence whatever. And that all bills which have paffed the Senate and Affembly, fhall, before they become laws, be prefented to the faid Council for their revifal and confideration; and if upon fuch revifion and confideration, it fhould appear improper to the faid Council, or a majority of them, that the faid bill fhould become a law of this State, that they return the fame, together with their objections thereto, in writing, to the Senate, or Houfe of Affembly, in whichfoever the fame fhall have originated, who fhall enter the objections fent down by the Council, at large, in their minutes, and proceed to reconfider the faid bill. But if after fuch reconfideration, two thirds of the faid Senate or Houfe of Affembly, fhall, notwithftanding the faid objections, agree to pafs the fame, it fhall, together with the objections, be fent to the other branch of the legiflature, where it fhall alfo be reconfidered, and if approved

ed by two thirds of the members prefent, fhall be a law.

And in order to prevent any unneceffary delays, BE IT FURTHER ORDAINED, that if any bill fhall not be returned by the Council, within ten days after it fhall have been prefented, the fame fhall be a law, unlefs the legiflature fhall, by their adjournment render a return of the faid bill within ten days impracticable; in which cafe the bill fhall be returned on the firft day of the meeting of the legiflature, after the expiration of the faid ten days.

IV. That the Affembly fhall confift of at leaft feventy members, to be annually chofen in the feveral counties, in the proportions following, viz.

For the city and county of New-York, nine;
The city and county of Albany, ten;
The county of Dutchefs seven;
The county of Weft-Chefter, fix;
The county of Ulfter, fix;
The county of Suffolk, five;
The county of Queens, four;
The county of Orange, four;
The county of Kings, two;
The county of Richmond, two;
The county of Tryon, fix;
The county of Charlotte, four;
The county of Cumberland, three;
The county of Gloucefter, two.

V. That as foon after the expiration of feven years, fubfequent to the termination of the pre-

OPPOSITE AND ABOVE: Cat. 7. New York Constitution of 1777

Once Americans declared independence from the king, they quite predictably moved to reduce the powers of the executive in their new constitutions. Most kept the office of governor while drastically weakening his authority and importance. If somebody had to perform the executive functions—of administering the government, enforcing the law, and coordinating defense—that individual ought to have as little independent discretion as possible, Americans decided. He should do the bidding of "the people" as conveyed through the legislature. Early state constitutions accomplished this goal in several ways. First, and most obvious, they provided for the executive to be elected by the members of the legislature. Naturally, the legislators selected men who shared their views. Second, the constitutions specified that governors serve short terms, usually one year. This way, the governor would always remain dependent on the legislature for his position. Third, the constitutions forced governors to get approval for their decisions from a council of some type, whose members the governor had no say in selecting. Legislatures decided who the councilors would be. Finally, the early constitutions did not allow the executive to veto bills passed by the legislature. Among early state

constitutions, only South Carolina's provisional frame of government permitted the governor, who was appointed by the legislature, to veto bills.

New York took the first step in restoring some of the governor's power. The state's plans to write a constitution were delayed when, in the late summer of 1776, the British army and navy occupied New York City and its environs. New York's Revolutionary government, the Convention of the People, scampered northward to White Plains, Fishkill, and finally Kingston. In March 1777, the committee tasked with drafting a constitution finished its work, and the full convention then spent a month debating and revising. The constitution adopted on April 20 contained several innovative features related to the executive. Notably, the governor would not depend on the legislature for his position, but would instead be elected by the people to a three-year term. Popular election and a longer term gave the governor more freedom to act on his own initiative. The constitution also granted him the power to prorogue—temporarily suspend—the legislature if he wanted to influence its deliberations. That bicameral legislature consisted of an "assembly" and a "senate." Once both houses passed a bill, one more hurdle remained. Article III of the constitution stated that the governor, along with the judges of the state supreme court and the chancellor (the presiding judge of the court of chancery), would form a "council of revision" to scrutinize all legislation. If the council deemed a bill "improper," it would return the bill to the house in which it originated, along with an explanation for why the council had rejected it. If two-thirds of both houses of the legislature wished, they could override the council's decision and enact the bill into law anyway.

Through the council of revision, the New York constitution returned to the governor a modified but still significant veto power. New Yorkers no longer thought the executive should exercise an absolute veto over legislation, which seemed too undemocratic. But the fact that the governor would now be elected directly by the people and would therefore also be, in some sense, one of the people's representatives, persuaded them that the governor could safely play a constructive role in the legislative process. Between 1777

and 1821, the council of revision vetoed a total of 165 bills—a small fraction of the total number passed in those years. Clearly, with all the members of the legislature directly elected, as well as the governor, New York's laws reflected the will of the people.

At least, they reflected the will of *some* of the people. The 1777 constitution allowed most adult males to vote for members of the assembly (the lower house) by requiring only a modest property qualification. But if a man wanted to vote for senators or governor, he needed to possess real estate worth the substantial sum of £100. At the time, only about 10 percent of men qualified.

A Better Way to Create a Constitution

CAT. 8. RESOLVE OF THE MASSACHUSETTS GENERAL COURT OF MAY 5, 1777

That such restrictive suffrage provisions could find their way into the New York constitution suggests the limitations—both conceptual and procedural—of American constitution-making in the years immediately surrounding independence. Delaware, Maryland, North Carolina, and New York all took a significant step by obtaining special authorization before writing a new constitution. Americans in those states had been told that the men they elected to their provincial congresses in 1776 would, in addition to their regular duties, craft their states' permanent frames of government. Presumably, people exercised even greater care when casting their votes for candidates who would soon face the awesome responsibility of writing these important documents. There were at least two major problems with this system, however. First, even though voters knew that their legislature was going to write a constitution and formally authorized it do so, many Americans still saw a danger in allowing a sitting governing body to write its own rules. What would stop those already in power from tightening their grip and expanding that power indefinitely? Perhaps there needed to be a clearer separation between the bodies tasked with writing constitutions and those charged with the ordinary business of government.

OPPOSITE: Cat. 8. Resolve of the Massachusetts General Court of May 5, 1777

STATE of MASSACHUSETTS-BAY.

In the House of Representatives, May 5, 1777.

THAT the happiness of mankind depends very much on the Form and Constitution of Government they live under, and that the only object and design of Government should be the good of the People, are truths well understood at this day, and taught by reason and experience, very clearly at all times. And yet, by far the greater part of mankind are governed only for the advantage of their masters, and are the miserable slaves of a single or a few despots, whose ideas or humanity never extend beyond the limits of their own grandeur or interest; and indeed among the multitudes of mankind who have lived, and the variety of people who have succeeded each other in the several ages of the world, very few have even had an opportunity of choosing and forming a Constitution of Government for themselves.

This is a great privilege, and such an opportunity, the good People of this State, by the distinguishing favor of a kind Providence, now enjoy, and which, the interest and happiness of themselves and posterity, loudly call upon them to improve with wisdom and prudence. The infatuated policy of Britain, instead of destroying, has rather, by the goodness of God, promoted and accelerated the happiness of the People of the *United States of America.* The injustice and cruelty of Britain has driven us to a Declaration of Independence, and a dissolution of our former connections with them, and put it in the power of each of the *United States,* to form and constitute a Mode of Government for themselves. And whereas it is our peculiar duty to consult and promote the happiness of the good people of this state, having duly considered the advantages of forming, as soon as may be, a new Constitution of government; and conceiving it to be the expectation of many, that we should recommend the most suitable method for effecting this valuable and important purpose: We do *Resolve,*

That it be, and hereby is recommended to the several towns and places in this State, impowered by the laws thereof, to send Members to the General Assembly, that, at their next election of a Member or Members to represent them, they make choice of men, in whose integrity and abilities they can place the greatest confidence; and, in addition to the common and ordinary powers of Representation, instruct them in one Body with the Council, to form such a Constitution of Government, as they shall judge best calculated to promote the happiness of this State; and when compleated, to cause the same to be printed in all the *Boston* News Papers, and also in Hand Bills, one of which to be transmitted to the Selectmen of each Town, or the Committee of each Plantation, to be by them laid before their respective Towns or Plantations, at a regular meeting of the inhabitants thereof, to be called for that purpose; in order to its being by each Town and Plantation, duly considered. And a return of their approbation or disapprobation to be made into the Secretary's Office of this State, at a reasonable time to be fixed on by the General Court, specifying the numbers present in such meeting, voting for, and those voting against the same: And if upon a fair examination of the said returns by the General Court, or such Committee as they shall appoint for that purpose, it shall appear, that the said Form of Government is approved of by at least two thirds of those who are free and twenty-one years of age, belonging to this State and present in the several meetings, then the General Court shall be impowered to establish the same as the Constitution and Form of Government of the State of *Massachusetts-Bay,* according to which the inhabitants thereof shall be governed in all succeeding generations, unless the same shall be altered by their own express direction, or that of at least two thirds of them. And it is further recommended to the Selectmen of the several Towns, in the return of their precepts for the choice of Representatives, to signify their having considered this Resolve, and their doings thereon.

Sent up for concurrence.

J. WARREN, Speaker.

In COUNCIL, May 5, 1777.

Read and concurred. JOHN AVERY, Dep. Sec'ry.

Consented to by a major part of the Council.

A true Copy. Attest. JOHN AVERY, Dep. Sec'ry.

To be sure, none of the representatives Americans sent to write their early state constitutions appear to have been aspiring despots or dictators. Yet many of them did hold views that reflected their elevated social or economic status. In New York, for example, power had long been monopolized by a relatively small group of men. Especially prominent were the owners of the large "manors" that existed throughout the Hudson River Valley and whose tenants were subject to the heavy-handed influence of their landlords. It is not surprising, then, that the men who wrote New York's constitution—and who wished to retain a good deal of political power for themselves and their class—would include high property qualifications that restricted some voting to the "better sorts."

The fact that New York's constitution was not subject to any form of popular ratification comprised the second major issue with American constitution-making in its early form. If the New York constitution had been put to a vote of the people—or, more realistically, a vote of all adult white men—it is fair to assume that many citizens would have raised objections to it. Although many Americans accepted the need for some property requirement to vote, it is difficult to imagine average citizens easily acquiescing to a requirement that restricted voting so starkly for senatorial and gubernatorial elections. But neither New York nor any of the other states that had written constitutions thus far had tried to gain the people's approval for a constitution after it had been drafted. The bodies that wrote constitutions simply proclaimed that they were now in effect. In the long term, this lack of popular ratification might limit a constitution's legitimacy. Whenever citizens disagreed with a given law or did not want to comply with a government policy, they would be able to point to the constitution and claim, quite accurately, that they had never truly consented to it.

In the course of writing its constitution, Massachusetts developed new procedures that addressed these key concerns and set the stage for unprecedented popular participation in American constitution-making. After Massachusetts became an independent state in 1776, citizens wanted the opportunity to create their own constitution. To the south, both Connecticut and Rhode Island simply converted their old corporate charters into constitutions by crossing out references to

the king. Massachusetts did not have this option. Its charter called for a governor appointed by the crown, and this officer's absence from the government after 1775 resulted in an awkward predicament. Although the charter worked well enough for the time being, sooner or later, citizens realized, they would need a new plan of government—one more clearly grounded on the sovereignty of the people.

Massachusetts started out as many other states did. The General Court, in its capacity as the sitting government, asked voters to grant permission for their representatives to write a new constitution. Ordinary citizens made sure that this would not be their only role in the process, however. When they read the September 1776 resolution of the Massachusetts House describing the constitution-making process, they noted that the General Court proposed to distribute the drafted constitution "for the Inspection and Perusal of the Inhabitants, before the Ratification thereof by the Assembly."[6] People were confused about what this phrase meant. Would the people have to approve the constitution for it to go into effect, or would they merely get to read it shortly before the General Court—the assembly— ratified it? The responses that towns sent to Boston in late 1776 indicated that a large number of people expected to vote on any proposed constitution. The town of Bridgewater, for instance, thought that "no Form of Government [should] be Ratified and Confirmed till it has been consented to by the major part of the Inhabitants of the Several Towns in this State."[7]

Whatever its initial intentions, in May 1777, after digesting the rich feedback from the towns, the General Court reassured citizens that they would indeed get their chance to approve or reject the new state constitution. The General Court issued a statement spelling out the rationale for this remarkable innovation in constitution-making. Although "the happiness of mankind depends very much on the Form and Constitution of Government they live under," the General Court began, it was common knowledge that "by far the greater part of mankind are governed only for the advantage of their masters, and are the miserable slaves of a single or a few despots, whose ideas of humanity never extend beyond the limits of their own grandeur or interest." This would not be the case in Massachusetts. The members of the General Court reminded their fellow

citizens just how fortunate they were. "Among the multitudes of mankind who have lived, and the variety of people who have succeeded each other in the several ages of the world," they noted,

> very few have even had an opportunity of choosing and forming a Constitution of Government for themselves.
>
> This is a great privilege, and such an opportunity the good People of this State, by the distinguishing favor of a kind Providence, now enjoy, and which the interest and happiness of themselves and posterity loudly call upon them to improve with wisdom and prudence.

After both houses of the General Court (technically meeting as a "convention") wrote the constitution, the resolve explained, the document would be "printed in all the *Boston* News Papers, and also in Hand Bills," and distributed throughout the state. Each town would hold a meeting at which the constitution would be "duly considered" and voted on. The General Court would collect these town returns and, if it determined that "at least two thirds of those who are free and twenty-one years of age" approved the constitution, "the General Court shall be impowered to establish" it.[8]

It did not take long for the people of Massachusetts to demonstrate the importance of this popular ratification requirement. Between June 1777 and March 1778, the General Court plodded along, drafting a constitution when it could spare the time from the ongoing war effort. Finally, as it had promised, it sent out its handiwork for the inspection of the people. Not all of the state's approximately 300 incorporated towns discussed it, but thousands of ordinary citizens in over 170 towns did. The small town of Edgecomb in Maine (which was part of Massachusetts at the time) even apologized that its turnout had not been larger: "it was an Extream Rainy Day and very Difficult Traveling," the town's selectmen explained.[9] Many people across the state did not like what they read. Different towns found fault with different parts of the constitution. Many objected that it did not include a declaration of rights. Many did not approve of the way representatives for the state legislature would be apportioned. Some towns even expressed outrage at a constitutional provision that

would prohibit "negroes, Indians and mulattoes" from voting. "We Concieve that the Depriving of any men or Set of men for the Sole Cause of Colour from giving there votes for a Representative, to be an Infringement upon the Rights of Mankind," the town of Spencer declared.[10] (Most towns, it should be noted, remained silent on this topic, which suggests they were willing to acquiesce to the racial restriction.) The most glaring flaw, for a number of towns, was that the constitution had been written by the sitting legislature. Only a convention called specifically for the purpose, many now believed, could affirm the principle that the people alone could write their fundamental law. Only a convention could be trusted to draft a frame of government that would protect the people's rights and serve their best interests.

Paradoxically, by rejecting the proposed state constitution in 1778, the people of Massachusetts made an enormously valuable contribution to American constitutionalism. They demonstrated that popular ratification would never be just a meaningless rubber stamp. The people really did have to consent to the fundamental laws that governed political life. And if they did not consent, no power on earth could force them to live under such a government. When the General Court tallied up the returns on the constitution, it acceded to the popular will and peacefully discarded the document on which its members had labored for months.

Putting Popular Sovereignty into Practice

CAT. 9. MASSACHUSETTS CONSTITUTION OF 1780

The people's rejection of the 1778 constitution also ensured that Massachusetts would now hold a true constitutional convention, establishing a crucial precedent that would be repeated on both the federal and state levels for years to come. In 1779, all freemen at least twenty-one years old could vote for delegates to represent them at a gathering in Cambridge. The convention's only job was to write a constitution and to arrange for its ratification by the people. When the convention met, it appointed a committee to produce a draft. The committee asked one of its members, John Adams, to handle the bulk of the work.

THE
CONSTITUTION
OR
FRAME OF GOVERNMENT
FOR THE
COMMONWEALTH
OF
MASSACHUSETTS.

Printed by BENJAMIN EDES and SONS,
Printers to His Excellency the Governor, the Council and
Senate of the Commonwealth of MASSACHUSETTS.

M,MCC,LXXXI.

ABOVE AND OPPOSITE: Cat. 9. Massachusetts Constitution of 1780

A Constitution or Frame of Government for the Commonwealth of MASSACHUSETTS.

PREAMBLE.

THE end of the institution, maintenance and administration of government, is to secure the existence of the body-politic; to protect it; and to furnish the individuals who compose it, with the power of enjoying, in safety and tranquility, their natural rights, and the blessings of life: And whenever these great objects are not obtained, the people have a right to alter the government, and to take measures necessary for their safety, prosperity and happiness.

The body-politic is formed by a voluntary association of individuals: It is a social compact, by which the whole people covenants with each citizen, and each citizen with the whole people, that all shall be governed by certain laws for the common good. It is the duty of the people, therefore, in framing a Constitution of Government, to provide for an equitable mode of making laws, as well as for an impartial interpretation, and a faithful execution of them; that every man may, at all times, find his security in them.

WE, therefore, the people of Massachusetts, acknowledging with grateful hearts, the goodness of the Great Legislature of the Universe, in affording us, in the course of His Providence, an opportunity, deliberately and peaceably, without fraud, violence or surprize, of entering into an original, explicit, and solemn compact with each other; and of forming a new Constitution of Civil Government, for ourselves and posterity; and devoutly imploring His direction in so interesting a design, DO agree upon, ordain and establish, the following *Declaration of Rights, and Frame of Government*, as the CONSTITUTION of the COMMONWEALTH of MASSACHUSETTS.

PART THE FIRST.

A DECLARATION of the RIGHTS of the Inhabitants of the Commonwealth of MASSACHUSETTS.

Art. I. ALL men are born free and equal, and have certain natural, essential and unalienable rights; among which may be reckoned the right of enjoying and defending their lives and liberties; that of acquiring, possessing, and protecting property; in fine, that of seeking and obtaining their safety and happiness.

II. It is the right as well as the duty of all men in society, publicly, and at stated seasons, to worship the SUPREME BEING, the great creator and preserver of the universe. And no subject shall be hurt, molested, or restrained, in his person, liberty, or estate, for worshipping GOD in the manner and season

most

Although no one in 1776 had been more excited about the prospect of writing constitutions, Adams had actually missed out on much of the constitution-making. He had spent several years in Europe at the request of the Continental Congress. In what must have seemed to him a remarkable stroke of luck, he returned to Massachusetts in August 1779, just in time to be elected a delegate to the constitutional convention. He soon found himself in the study of his modest home in Braintree, just south of Boston, writing his state's constitution. Adams held strong views on government and constitutions. Fundamentally, he insisted on "a government of laws, and not of men." By this he meant that a free government could never permit an individual or group to exercise arbitrary or unchecked power. Instead, government must consist of a system of rules that even the highest officials and the wealthiest men in a society were bound to follow. Adams wanted a powerful executive in the state's constitution, and he proposed a popularly elected governor with an absolute veto. He also favored a bicameral legislature. Adams turned in his draft, and by mid-November he was once again sailing across the Atlantic.

Adams had performed a great service, but the convention and the people wasted no time in making the state constitution their own. One of Adams's key innovations came in the organization and structure of the document. Unlike previous constitutions, which resembled jumbled lists of articles, the Massachusetts constitution was arranged in clear sections in which all the provisions related to a given branch of government were grouped together for easy reference. Adams also included a preamble that concisely summarized bedrock principles and goals. Of course, the convention took it upon itself to improve Adams's draft wherever necessary. It changed Adams's phrasing in the preamble from "We, therefore, the delegates of the people," to simply, "We, therefore, the people." It spent months debating every aspect of the constitution, altering numerous parts so that it accorded more closely with the likely preferences of the state's citizens. Adams, for instance, had envisioned a governor who was clearly too strong, and the convention therefore made the executive veto subject to a two-thirds override by the legislature. Indeed, one of the practical advantages of the convention was that its members could concentrate solely on constitutional matters. They never had to worry about routine government business, as had been the case when legislatures had written constitutions. A convention could do a much more thorough job, and its very existence also satisfied those who had argued that fundamental law could be written only by a special and temporary assembly of the people.

In the spring of 1780, people once again met in towns across Massachusetts to vote on a state constitution. In addition to copies of the constitution, they received an address the convention had written to explain how delegates had approached their work. The address reminded citizens that constitution-making would always remain an enormously challenging process for everyone involved. "In framing a Constitution, to be adapted as far as possible to the Circumstances of Posterity yet unborn," the convention wrote, "you will conceive it to be exceedingly difficult, if not impracticable, to succeed in every part of it, to the full Satisfaction of all." There was simply no way to achieve "a perfect Unanimity of Sentiments" on every aspect of something so complicated. The convention urged people to express their views "to each other with Candor" and to make "mutual Concessions" on small details in order to achieve a stronger "Union" with fellow citizens who, after all, agreed on all the "essential Principles."[11] Massachusetts citizens needed no prodding to express their sentiments, and as in 1778, they stated their opinions on a remarkable range of topics. Many towns clearly spent a great deal of time going through the constitution article by article, even line by line, debating its merits and proposing alternatives. Predictably, people raised countless quibbles and also some more serious objections.

In June, the convention read through the mass of returns written up in over 170 meetinghouses across the state. The convention had asked the towns to indicate the specific parts of the constitution to which a majority of citizens objected. The returns came in a bewildering array of formats that defied an easy tally. But as far as delegates could tell, over two-thirds of the people—a remarkably high bar that in future state constitutional ratifications would usually be reduced to a bare majority—approved every part of the constitution. The likely exception was Article III of the declaration of rights, which empowered the legislature to

require localities to support Protestant ministers. This article, not part of Adams's original draft, probably did not receive the requisite two-thirds approval but was nevertheless declared ratified by the convention.

There were clearly shortcomings in the constitution-making and ratification process in Massachusetts. For reasons impossible to discern, not all of the towns responded, and many inhabitants were thereby denied a voice. Women and the state's contingent of enslaved African Americans could not formally participate. In its eagerness to complete its task with minimal controversy, the convention acquiesced to Article III despite significant disapproval. And yet, these caveats notwithstanding, the state had built on the work of other Americans and had conducted a truly unprecedented experiment. Through the mechanisms of the constitutional convention and popular ratification, Massachusetts demonstrated that the "sovereignty of the people" could, in fact, find plausible expression. Imperfections in this process remained, but Americans were becoming increasingly confident that their new governments, and the written constitutions that lay at their foundations, truly reflected the desires of a majority. In his classic survey of the democratic revolutions that swept the Atlantic world in the late eighteenth and early nineteenth centuries, the historian R. R. Palmer identified these practical methods of constitution-making as "the most distinctive work of the [American] Revolution."[12] Palmer's insight is validated by the fact that Americans at the time also recognized the importance of these breakthroughs. In the years to come, Americans would continue eagerly to borrow from one another, demanding for themselves the most legitimate and promising forms of government available.

A Firm League of Friendship

CAT. 10. ARTICLES OF CONFEDERATION
AND PERPETUAL UNION, 1777

As Americans focused on writing new constitutions for their individual states, they also began to discuss what, exactly, those states now collectively composed. According to its principal author, the Declaration of Independence did more than sever the colonies'

connection to Britain and assert Americans' right to form their own governments. The Declaration, Jefferson wrote in 1825, served "as the fundamental act of union of these states."[13] In 1776, to defend themselves against one of the world's most fearsome military powers, the thirteen colonies had entered into a solemn alliance with one another. It did not take long for some Americans to propose that this "continental" polity needed a constitution of its own. Such a "Charter of the United Colonies," Thomas Paine explained in *Common Sense*, would replace and perform the same function as the now-banished king. After a continental constitution was written, Paine suggested, "let a crown be placed thereon, by which the world may know, that so far as we approve of monarchy, that in America THE LAW IS KING." Then, Paine continued, "let the crown at the conclusion of the ceremony be demolished, and scattered among the people whose right it is."[14] Paine offered a striking image of the relationship between the sovereignty of the people and constitution-making, one that Americans would, in time, realize on a continental level. Before that could occur, however, they needed to decide what kind of constitution they wanted for their new union. This proved to be the greatest challenge of the age.

When Americans wrote state constitutions, they had a relatively clear sense of the basic functions their state governments would need to perform. These included maintaining law and order, facilitating the pursuit of economic opportunities, protecting the inhabitants within their jurisdictions from internal and external threats, and collecting the relatively modest revenue needed to accomplish these ends. Colonial governments provided obvious and helpful blueprints. These older plans simply needed to be revised— often in accord with strikingly revolutionary designs, to be sure—and the updated structures rebuilt on foundations of popular sovereignty. But when it came to a continental union, no precedents—no blueprints— existed. As war raged, Americans knew only that they wanted a general government to coordinate defense, make the fiscal arrangements necessary to defeat the British, and negotiate with foreign powers who might offer Americans their assistance.

The pressing exigencies of the times forced the Continental Congress to make provisional rules to

ARTICLES

OF

CONFEDERATION

AND

PERPETUAL UNION

BETWEEN THE

STATES

OF

NEW-HAMPSHIRE, MASSACHUSETTS-BAY, RHODE-ISLAND
AND PROVIDENCE PLANTATIONS, CONNECTICUT, NEW-
YORK, NEW-JERSEY, PENNSYLVANIA, DELAWARE, MARY-
LAND, VIRGINIA, NORTH-CAROLINA, SOUTH-CAROLINA
AND GEORGIA.

———————

LANCASTER, (PENNSYLVANIA,) PRINTED:

BOSTON, RE-PRINTED BY JOHN GILL,
PRINTER TO THE GENERAL ASSEMBLY.
M,DCC,LXXVII.

ABOVE AND OPPOSITE: Cat. 10. Articles of Confederation and Perpetual Union, 1777

ARTICLES

Of Confederation and perpetual Union between the States of *New-Hampshire, Massachusetts-Bay, Rhode-Island* and *Providence Plantations, Connecticut, New-York, New-Jersey, Pennsylvania, Delaware, Maryland, Virginia, North-Carolina, South-Carolina* and *Georgia.*

ARTICLE I. THE Stile of this CONFEDERACY shall be " The UNITED STATES OF AMERICA.

ART. II. EACH State retains its sovereignty, freedom and independence, and every power, jurisdiction and right, which is not by this confederation expressly delegated to the United States, in Congress assembled.

ART. III. THE said states hereby severally enter into a firm league of friendship with each other, for their common defence, the security of their liberties, and their mutual and general welfare, binding themselves to assist each other, against all force offered to, or attacks made upon them, or any of them, on account of religion, sovereignty, trade, or any other pretence whatever.

ART. IV. The better to secure and perpetuate mutual friendship and intercourse among the people of the different states in this union, the free inhabitants of each of these states, paupers, vagabonds, and fugitives from justice excepted, shall be intitled to all priviledges and immunities of free citizens in the several states ; and the people of each state shall have free ingress and regress to and from any other state, and shall enjoy therein all the privileges of trade and commerce, subject to the same duties, impositions and restrictions as the inhabitants thereof respectively, provided that such restriction shall not extend so far as to prevent the removal of property imported into any state, to any other state of which the owner is an inhabitant ; provided also that no imposition, duties or restriction shall be laid by any state, on the property of the United States, or either of them.

I₂

govern its deliberations. Of these, the most important was that each state, regardless of its size or population, was given an equal voice when Congress voted. Americans may not have had any useful blueprints for a general government, but they knew that the states would comprise the basic materials. In raising any new continental edifice, the states would serve as the building blocks—preexisting units that could not be mangled or diminished during construction. Independence and the ongoing war heightened the need for a written document that clearly outlined the relationship among the states and the powers of Congress, which was commanding thousands of troops, borrowing large amounts of money, formulating crucial policies, and entering into important agreements with foreign powers. Americans naturally desired transparency from the authority making such momentous decisions. Everyone—including future generations—would ultimately live with the consequences of the continental government's actions. Congress got to work, but internal disagreements and the disruptions of war caused numerous delays.

In November 1777, Congress completed the Articles of Confederation and Perpetual Union. In many respects, the Articles simply formalized and described the powers that Congress was already exercising. Only Congress, the Articles stated, could negotiate with foreign (or Native American) nations, declare war, make peace, regulate coinage, maintain an interstate postal system, appoint high-ranking military officers, and establish a "common treasury . . . supplied by the several states." In granting Congress exclusive authority over these matters, the Articles necessarily prohibited the states from exercising certain powers.

And yet the Articles also contained a number of provisions that affirmed the importance of the states and left them with the latitude to determine their own degrees of cooperation. Article II epitomized this fundamental ambiguity. It declared that "Each state retains its sovereignty, freedom and independence, and every Power, Jurisdiction and right, which is not by this confederation expressly delegated to the United States, in Congress assembled." But if states could not do such things as declare war and negotiate with foreign countries, and if they were bound (as Article XIII stated) to "abide by the determinations of the united states, in congress assembled, on all questions [Congress]

submitted to them," then by definition the states would not be "sovereign"—at least not as that term was traditionally understood. Adding to the ambiguity, Article III described the American "Confederacy" as "a firm league of friendship," which implied that the states had entered something more closely resembling an international alliance. The Confederation's system of voting—each state continued to enjoy one vote—reinforced the sense that the states were all coequal, quasi-independent partners. At this stage, Americans simply could not agree on any other formula of representation. Pretending that all the states were equal seemed like the best way to ensure that each would comply with Congress's resolutions. For while the Articles gave Congress the authority to make decisions and issue directives on critical matters, they left it to the states to carry out those policies. Congress enjoyed widespread popularity, and in the midst of a life-and-death Revolutionary struggle, perhaps the states' voluntary cooperation would be forthcoming.

The Articles of Confederation were written and adopted with minimal popular participation. Although Americans recognized the importance of a continental government, they did not view the Confederation as a political community in the same way that they viewed their states as political communities. Americans in South Carolina and New Hampshire, for instance, were united in a common cause against Britain. But inhabitants assumed their respective states remained so different, in so many ways, that a political union more substantial than the "firm league of friendship" proposed in the Articles seemed impractical and probably undesirable. Americans did not expect the Articles to resemble one of their state constitutions. Most therefore took little issue with the Articles' wildly inequitable voting procedure and apportionment of representation, or with the fact that the sitting authority, Congress, had undertaken to propose a frame of government for itself. Most of the state legislatures quickly approved the Articles in 1778. Massachusetts asked the inhabitants of its towns to return their opinions on the Articles, and many did, but this was the exception rather than the rule.

In a portent of the tensions and problems that would grow worse over the course of the 1780s, a few states initially refused to approve the Articles.

Maryland, for example, demanded that states such as Virginia must first renounce their claims to western lands. Virginia would be able to sell this land and use the proceeds to pay its share of the continental taxes, an option not available to landless states. As a result of these controversies, the Articles did not achieve definitive ratification until 1781.

A Confederation in Crisis

That year also witnessed Lord Charles Cornwallis surrender a major British army to American and allied French forces at Yorktown, Virginia—a stunning development that led to the official end of the Revolutionary War two years later. Not only had Americans secured their independence from (what they had come to consider) an oppressive colonial regime, but they now lived under state governments of their own creation that would protect their rights and advance their interests. A continental union forged in the early days of the Revolutionary crucible now possessed a government that, because of the starkly limited powers granted to it in the Articles of Confederation, lacked the capacity to threaten the people's liberties. Yet the golden age of self-government that many Americans confidently predicted, and that all desired, never materialized.

The central problem grew out of the disparity between the Confederation government's nominal authority and its practical powers. Acting on behalf of all Americans, Congress could take on a range of massive and far-reaching obligations. These obligations included a very significant amount of money, about $27 million, owed to foreign and domestic creditors who had lent Congress the funds needed to wage the Revolutionary War. They also included the pledges made in the Treaty of Paris that ended hostilities with Great Britain. The United States agreed to settle accounts with loyalists whose property had been confiscated, for instance. While Congress found it relatively easy to enter into these obligations, it experienced profound and ultimately intractable difficulties trying to get the individual states to uphold their shares of the bargain. Congress remained utterly reliant on the states. Once it sent out its requests, it could only wait for the thirteen separate governments to enact the appropriate

policies and collect the necessary taxes. Predictably, the state governments—all of them, thanks to their new constitutions, more responsive than ever to the popular will—often decided against fulfilling Congress's requests. They did so for a variety of reasons, but their motivations generally stemmed from a desire not to inflict further hardships on people already shouldering immense burdens. Each state government did what appeared in the best interests of its own constituents. By pursuing short-term advantages in this manner, however, states inevitably took actions that harmed their neighbors and eroded the long-term viability of the Confederation as a whole.

State leaders and the ordinary Americans who elected them ignored Congress's requests with startling ease. Their deference toward Congress had faded along with the smoke over the battlefield at Yorktown. Americans now viewed the Articles of Confederation in a new light. Aspects of the continental charter that had been accepted out of wartime expediency now appeared to violate fundamental principles of republican government. Demands made by Congress—a body in which each state, regardless of its size or contributions, possessed an equal vote—could easily be dismissed as illegitimate. Americans found it entirely plausible that such a Congress would try to exact unfair quotas of taxes or propose policies disproportionately burdensome to their particular states. Faced with these impositions, Americans left no doubts about where their sympathies lay. Their state governments seemed to rest on far more legitimate foundations than did the Confederation. Ironically, Americans could justify noncompliance with Confederation authorities by invoking the very tenets of American constitutionalism that they had articulated in the course of writing and adopting their own state constitutions.

A genuine crisis was at hand. The American Confederation could not endure for long with these constitutional tensions at its core. Perhaps it would eventually break apart into thirteen distinct sovereignties (or a few regional confederacies), and the map of North America would come to resemble that of war-torn Europe. Or it would need to be rebuilt on a more legitimate foundation, one that would enable the most important principles of American constitutionalism to define the structure and operations of every level of government.

A Convention in Philadelphia, 1787

The status quo may have continued for a longer period had Congress not been at risk of defaulting on its loans and permanently marring the country's credit. The sums the states sent to Congress were proving inadequate to pay even the interest on the debt. The situation showed no sign of improving anytime soon. Various attempts to guarantee Congress a permanent revenue failed when one or more states refused to ratify the necessary amendments to the Articles of Confederation. The Articles' requirement of unanimous approval for any amendment enabled even the smallest state to thwart the wishes of the other twelve when it lay in its interests to do so. Because Congress proved such a frustrating forum in which to solve problems, some states began to send delegations to regional conferences.

The most important of these occurred in Annapolis, Maryland, in September 1786. There, representatives from five states needed just a few days to determine that all the states would benefit from sending delegations to a general meeting in Philadelphia to discuss comprehensive reforms to the continental constitution. Piecemeal changes to the Articles of Confederation, they believed, were unlikely to "render the constitution of the federal government adequate to the exigencies of the union."[15] Granting Congress additional powers in some areas would invariably affect other aspects of the government set up by the Articles. Delegates should be empowered to get to the root of the issues.

For its part, Congress responded unenthusiastically to the idea of a Philadelphia convention. Although no group of Americans was more familiar with the Confederation's defects, delegates to Congress naturally resisted measures that might disrupt the status quo. Here arose the same dilemma that Americans had identified a decade earlier when sitting legislatures had tried to write state constitutions. The people could never completely trust such bodies to overcome the institutional inertia that inclined them to do what was in their own interests instead of what was in the people's interests. Proposals made by special, temporary conventions—unburdened by any vested interest in preserving their own authority—appeared far more

legitimate and were more likely to attain popular consent. In a sign of Congress's dwindling stature, many states went ahead and selected delegates for the Philadelphia convention. A majority of states, moreover, ignored Congress's preferences for a limited discussion and empowered their delegates to consider wholesale constitutional revisions.

The convention's challenge lay in somehow creating a federal government with powers "adequate to the exigencies of the union" that was, at the same time, consistent with the constitutional principles Americans had already articulated and celebrated on the state level. Any new federal constitution must also respect the historical integrity of the states and their legitimate interests. If the majority of the American people was ever going to embrace this new constitution, it must appear to them to be, in key respects, the logical culmination—the fulfillment—of their efforts to realize the blessings of liberty and self-government. It must not appear to be a repudiation of, or attempt to overturn, those advances. As delegates got to work, they remained keenly aware of Americans' preferences on these and other points.

It is fair to ask if the convention's delegates truly represented the people's views and interests. The convention certainly included some of the new country's most distinguished characters. Fifty-five men participated, though not all were ever in attendance at the same time. The most important delegate was undoubtedly George Washington, the hero of the Revolution. His decision to abandon his cherished retirement and travel the bumpy roads to Philadelphia spoke volumes about the seriousness of the situation and lent the convention instant credibility. The convention wasted no time electing him as its president. Benjamin Franklin had a shorter distance to travel, his home lying only about a block away from the Pennsylvania State House where the convention met. Franklin's presence also enhanced the convention's stature. At eighty-one years of age, Franklin was easily the oldest delegate. Many delegates were younger than Washington (age fifty-five) as well. These were men who expected to live for some time under the frame of government they were about to write. Jonathan Dayton of New Jersey was only twenty-six. Like Washington and Franklin, most delegates were men of means, with

significant—and, in some cases, spectacular—wealth. Twenty-five delegates owned slaves. George Mason, the main author of Virginia's Declaration of Rights, owned more than three hundred, at least two of whom accompanied him to Philadelphia. Three slaves traveled with Washington.

Given its elite composition, it is natural to expect that the convention would write a constitution favorable to men of the upper class. And while instances of such biases can be detected, the overall record tells a far more complicated story—one in which the practical challenges of crafting a document acceptable to a broad cross-section of the American people took clear precedence. We are fortunate to know as much as we do about the convention's proceedings. As delegates were setting out the convention's rules, they agreed to maintain complete secrecy about their deliberations. No conspiracy was afoot, however. Secrecy would merely enable delegates to speak freely, to change their minds, and to advocate what they believed would be in the best interests of the country as a whole. The convention's official secretary, William Jackson, kept atrocious minutes, but fortunately a far more diligent, self-appointed secretary took copious notes—which, in keeping with the spirit of the convention's rule, he refused to publish until his death in 1836. A thirty-six-year-old bookish planter and Revolutionary politician from the Piedmont region of Virginia, James Madison came to Philadelphia well prepared to support greatly enhancing the powers of the continental government. By keeping track of delegates' views and votes, Madison hoped to formulate a strategy for securing the constitutional provisions he considered absolutely essential to the union's preservation.

Large States and Small States

That union, as we have seen, was made up of states that differed greatly in size and population. Early on, the convention made the crucial decision to give each state an equal vote in its proceedings. Without this concession, "small states" would have refused to participate. Rhode Island had already declined to send a delegation to Philadelphia out of fear that any convention would diminish that state's disproportionate influence in the continental government. Another small state, Delaware, had sent delegates, but these men carried instructions forbidding them to approve any measures altering the Confederation's rule of strict state equality.

If the small states held firmly to these demands, the convention's goal of strengthening the general government would become very difficult indeed. The general government, all agreed, needed greater powers to have any hope of being "adequate to the exigencies of the union." (Or, as some thought the main issue should be put more precisely, the government needed a greater capacity to carry out the responsibilities already formally assigned to it by the Articles of Confederation.) Such a general government's powers would necessarily include either the power to operate directly on the American people in certain cases—for instance, by collecting taxes from them without first going through the unreliable state governments—or, at least, the power to override state actions at odds with national policies—for instance, by compelling states that refused to collect taxes to contribute their shares of money (potentially through the threat of federal force).

But if Americans agreed to give powers of this kind to a general government, they needed assurances that national authorities would use that power appropriately and legitimately. Only by making the general government more truly representative, one group of delegates concluded, would the people be satisfied on this front. Through these representatives, the people could grant their consent to any number of important federal measures bearing directly on their lives. Representation in a general government with additional or enhanced powers could not remain as it was under the Articles of Confederation, with each state exercising the same equal vote. Representation would have to be more proportional—to population or, perhaps, to the amount of money each state contributed to the general treasury. If representation was proportional, no group of Americans could reasonably dismiss the general government's laws and policies as illegitimate, and cavalierly disobey them.

This proposal for a more recognizably "national" legislature and government came to be known as the Virginia Plan since it was written primarily by Madison

and presented to the convention on May 29 by the thirty-three-year-old governor of Virginia, Edmund Randolph. That Virginians should propose such a plan came as no surprise. With nearly 750,000 inhabitants, Virginia was by far the most populous state. Pennsylvania, North Carolina, and Massachusetts were the next most populous. For these four states in particular, the Articles of Confederation seemed extremely inequitable. The Articles made people residing in "large states" subject to the whims of a relative handful of Americans living in small states, who, it seemed fair to conclude, often had very different interests to protect. In a national government grounded on proportional representation, however, the large states would be able to dictate policy. And justly so, proponents reasoned. If all Americans were equal, should not the majority rule?

The argument for proportional representation laid out in the Virginia Plan was irrefutable in the abstract. But Americans did not live in the abstract. They lived in thirteen preexisting states—states with which they identified closely and that they wanted to preserve as coherent communities. Delegates from small states quickly pointed out that strictly proportional representation would effectively dissolve their states into the national polity and render them completely powerless. Delaware, its delegate John Dickinson estimated, would elect only about one-ninetieth of the representatives in a strictly proportional national house. What recourse would it then have if large state representatives collectively decided to enact policies that exploitatively targeted Delaware and states like it? Was this what Americans in small states had valiantly fought a revolution to establish? Had citizens invested great care and attention in their state constitutions only to see those celebrated documents made dead letters by a supreme national government controlled by others? These were reasonable concerns. After debating the Virginia Plan for a couple of weeks, William Paterson of New Jersey rose to offer an alternative plan on behalf of like-minded small-state delegates. Under Paterson's proposal, Congress would enjoy increased powers to do such necessary things as regulate commerce and collect import duties. The New Jersey Plan's distinguishing feature, however, was its retention of state equality in a unicameral Congress.

While both sides in this debate insisted on the justice of its own stance, each side also had to admit that the opposite position contained a fair bit of logic. Americans in large states, after all, had no desire to see their states reduced to meaningless units either. Once they acknowledged this, they were forced to grant that small states expressed valid concerns. Americans in small states, meanwhile, struggled to defend strictly equal state voting as the only arrangement consonant with republican principles, and instead fell back on accusing those who advocated a national government of exceeding the commissions issued to them by their state legislatures. The possibility for a compromise existed in theory, then, but a practical way to express mutual concessions needed to be found.

The convention discovered its ticket out of the large state versus small state deadlock in the form of a bicameral legislature. The Virginia Plan had proposed a bicameral national legislature, with a lower house composed of representatives directly elected by the people of the states in proportion to population and an upper house composed of a smaller number of representatives, still in proportion to population, but selected by their respective state legislatures. Almost all the state constitutions provided for a bicameral assembly of some kind, Pennsylvania's example notwithstanding, and it seemed reasonable to suppose that a national legislature could take this form as well. Roger Sherman of Connecticut initially proposed the key breakthrough for a compromise when he suggested making representation in the lower House proportional to population but giving the states equal representation in the upper house, or Senate. It took over a month of additional debate as delegates exhausted alternative possibilities, but on July 16 the convention finally agreed to this "Connecticut Compromise." A week later, it decided that each state would get two senators, who would vote individually (i.e., not as a single, state delegation).

The idiosyncrasies of American political development led the convention to adopt a novel justification for bicameralism. Whereas upper houses had traditionally been thought of as a means by which an aristocratic or elite class of individuals could protect their interests, the American Senate would enable the states, regardless of their geographical size, population, or

wealth, to maintain their identities and interests as historically rooted political communities. As a secondary consideration, the Senate's small size relative to that of the House allowed some—those who harbored anxieties about the potential pitfalls of simple "democracy"—to take solace in the fact that one half of the nation's legislature would, in all probability, be composed of an elite class of men who could vote down any radical schemes proposed by the more "popular" House of Representatives. The Philadelphia convention's solution to the problem of representation in the general government made the United States Constitution possible in the 1780s and exerted an incalculable influence on American history down through the present. It determined that the United States could not be described simply as a consolidated national government or as a loose confederation of separate states. It was to be a federal republic in which the national government and state governments were both essential. The ambiguities and tensions inherent in this settlement would play out in countless ways.

Slavery's Influence and Persistence

In the course of settling the representation issue, delegates were forced to wrestle with another divisive question: slavery. The presence of over half a million enslaved African Americans complicated any easy formula for determining proportional representation. If only free white inhabitants were counted, then states in which slaves comprised a large proportion of the total population would not receive as many representatives and would enjoy correspondingly less influence in Congress. Delegates for South Carolina, a state whose total population of 240,000 included 100,000 enslaved African Americans, therefore argued that a state's wealth—which would include slaves—should be recognized as a factor when calculating how many representatives it should receive. Although clearly self-serving, South Carolina's rationale drew on notions with some broader appeal. Because all legislatures made decisions that affected property, many Americans accepted the idea that the apportionment of representation should, to some degree at least, take into account the material interests or contributions of those being represented.

The Massachusetts constitution of 1780 apportioned senators in the state's upper house according to "the proportion of the public taxes" paid by its various senate districts. South Carolina's 1778 constitution (which replaced its provisional 1776 constitution) required the legislature to consider the number of white inhabitants and "taxable property" when adjusting the apportionment of representation within the state.

These eighteenth-century assumptions about property and representation help explain why states with relatively few slaves nonetheless accepted a compromise whereby slaveholding states gained a significantly greater voice in Congress and ultimately in the selection of the president. Predominantly non-slaveholding states objected to allowing slaveholding states to count all of their slaves for the purposes of representation. They countered by suggesting that three-fifths of a state's slaves be added to the number of a state's white inhabitants to determine the population figure used to apportion representation in the House. As the historian Richard Beeman explains, "the three-fifths compromise was not proposed because the delegates believed that African slaves were only 60 percent human." Indeed, in this specific instance, slaveholding states would have counted slaves as fully equal to white citizens if they could have. "Rather, the fraction 'three-fifths' was intended as a rough approximation of the measure of wealth that an individual slave contributed to the economy of his or her state."[16] To be sure, many Americans continued to find this justification unconvincing. If slave "property" deserved special recognition when apportioning representation, many non-slaveholding delegates wondered, why not accord similar recognition to forms of property, such as livestock, more prevalent in their states? Although slaveholders denied the humanity of their slaves constantly, they now seemed to argue that slaves' humanity made them a special kind of property—one that should augment the political power of their oppressors. In an effort to offset the gains in representation thus secured by the slaveholding states, non-slaveholding delegates insisted that Congress also use the three-fifths formula whenever it apportioned direct taxes. In the long run, however, this concession proved of little importance, as Congress rarely levied direct taxes during the remaining decades of slavery's existence.

The Philadelphia convention gave no consideration to abolishing slavery. Although slavery still existed in many parts of the north, it had only a marginal impact on society and the economy there. The institution had even been abolished in Massachusetts, in no small part because of the state constitution's pronouncement that "all men are born free and equal." But elsewhere slaves constituted a major proportion of the population, around 40 percent in such states as Virginia, South Carolina, and Georgia. The latter two remained so committed to the institution, in fact, that delegates from those states persuaded the convention to include a provision in the Constitution prohibiting Congress from interfering with the importation of slaves until 1808. The two decades between the convention and the closing of this international trade would see at least 200,000 additional African slaves forcibly brought to the United States.[17] Slave states also asked for and received a "fugitive slave clause" in the Constitution, which declared that slaves who escaped into other states—even ones in which slavery was prohibited—could be captured and returned to servitude.

A large number of delegates, including several slaveholders, appear genuinely to have lamented slavery's presence in the United States, hoped to see slavery's end, and therefore studiously avoided using the words "slave" or "slavery" in the Constitution. Yet the historical record is clear: the protections afforded to slavery in the Constitution and the concessions made in its interest at the convention hardly inhibited slavery's expansion in subsequent decades. Popular opinion either approved of this development or did not disapprove strongly enough to prevent it. The sanctions afforded to slavery in a constitution ratified by the people gave defenders of the institution a strong foundation on which to build their arguments.

The Making of the President, 1787

With the issues of representation and slavery settled, the convention could reach a final determination on the executive branch of the new government. As Americans had discovered in the course of writing their state constitutions, the method by which the executive

was chosen greatly affected his authority and role. Most state constitutions provided for the executive's election by the members of the legislature, which guaranteed that he would exercise few powers and little independent discretion. Unsurprisingly, the Virginia Plan, that bundle of resolutions presented by Edmund Randolph at the start of the convention, proposed a national executive elected by Congress in a manner similar to how Randolph himself had been elected governor according to Virginia's constitution. Such an executive would have been fairly weak as a result.

Other options existed, however. The state constitutions of New York and Massachusetts both provided for the direct election of a governor. James Wilson became the most vocal advocate of a national executive on this model: a single individual directly elected by the people. Born and educated in Scotland, Wilson had emigrated to British America in 1765, when he was in his early twenties. Although he represented Pennsylvania at the convention, he strongly disliked that state's 1776 constitution, which established an executive council headed by a "president" with little real authority or importance. Almost as if to illustrate his point, at the time of the convention, Wilson's colleague, the aged and often indisposed Benjamin Franklin, happened to be Pennsylvania's president. The experience of the Confederation had demonstrated the need for a more "energetic" and decisive executive, in Wilson's view. A single individual (instead of a council) would feel full responsibility for enforcing the laws and defending the country. Direct election by the people would grant the executive a great degree of legitimacy as well as an incentive to do what was in the best interests of everyone, not just of Congress.

The convention agreed with Wilson that the executive should be a single individual, but it overwhelmingly rejected the idea of electing him by popular vote. Delegates' opposition stemmed mainly from the belief, not unreasonable at the time, that ordinary people would not have access to enough information on candidates from distant states. Everyone had heard of George Washington, but lesser figures commanded far less name recognition. What did a Pennsylvania farmer know of John Adams or a Massachusetts fisherman know of

Thomas Jefferson? Without national political parties or any discernible national issues that might allow people to assess a candidate's fitness, ordinary people would probably vote for someone from their own state. And if that occurred, Connecticut's Roger Sherman suggested, then only candidates from the most populous states would ever get elected. Why should anyone from a small state agree to such a system? The convention continued to debate alternative methods of electing the executive, but all of them seemed flawed for one reason or another. Finally, the Connecticut Compromise establishing proportional representation in the House and equal state representation in the Senate offered a viable, if rather elaborate, possibility.

In an "electoral college," each state would receive a number of "electors" equal to its congressional representation: the number of its representatives in the House added to its two senators. This method gave slightly disproportionate weight to both smaller states (because each was represented by two senators regardless) and to slave states (because the number of a state's representatives was calculated by including three-fifths of the enslaved population). The states were permitted to choose their electors in any way they wanted. States might allow their legislatures to select them, but they could also mandate their selection by a popular vote of the state's citizens. However they got the job, these electors would be the ones actually voting for the president. The electors, delegates believed, would probably be better informed about the candidates and could make the best choice for their constituents. If no candidate received the support of a majority of electors—a distinct possibility, it was assumed—the election would then move to the House of Representatives, where each state's representatives would collectively receive one vote.

As complicated as this method appeared, the convention believed that it resolved a number of thorny issues and would ultimately prove acceptable to people throughout the country. It separated the executive from the legislative branch and gave him enough of a popular mandate to justify his extensive powers. These would include a qualified veto over acts of Congress—one that could, after the example of the New York and Massachusetts constitutions, be overridden by a two-thirds vote of both houses. Because he would not owe his position to Congress, the president would not require an especially lengthy term to insulate him from various influences and pressures. A four-year term, along with eligibility for reelection, would encourage responsible conduct in service of the American people writ large.

Delegates aimed to create a strong, decisive executive while avoiding the risks and negative associations of the monarchy they had just rejected. New York's Alexander Hamilton came perilously close to proposing a king-like executive. A brilliant, thirty-year-old lawyer raised by a single mother on the Caribbean islands of Nevis and St. Croix, Hamilton surprised many in Philadelphia by praising the aristocratic features of the British constitution and by suggesting that the president (and senators) serve for life. But Hamilton's colleagues understood that in a republic true authority depended on the existence of well-defined limits on power, and on that power's clear derivation from the people. The president would be a more effective magistrate precisely because the Constitution placed restraints on his authority and forced him, unlike a king, to gain his office from the people in frequent elections. Even his unpretentious title, "president," reminded Americans of the innocuous executives of Pennsylvania and the Confederation Congress, and suggested an officeholder merely performing a necessary public service at the people's request.

A Republic, If You Can Keep It

CAT. 11. CONSTITUTION OF THE UNITED STATES
OF AMERICA, 1787

Once it reached agreements on fundamental questions about representation, slavery, and the executive, the convention could settle countless other matters. Every part of the Constitution seemed to affect every other part. Delegates knew they wanted an appropriately independent judiciary, for instance, but only after they decided issues relating to the president and Senate could they agree on how to constitute that branch. The Constitution ultimately provided for a "supreme court" whose justices would be nominated by the president and confirmed by the Senate. The number of justices

as well as the structure of any inferior federal courts were questions left to the discretion of Congress.

These provisions concerning the judiciary were arranged by the convention's Committee of Style in the third of seven total articles, each of which contained various sections that outlined the proposed new government as precisely as possible. Constitution-writing had come a long way in a short period, since Americans had written somewhat disorganized state constitutions in the months and years surrounding independence. Clearly, though, the convention could not have written the United States Constitution if not for those earlier documents. The Philadelphia convention borrowed or adapted not only specific provisions from state constitutions, but also the conceptual principles that underpinned the convention's existence and would render its product legitimate in the eyes of Americans.

In the convention's waning days, the Committee of Style made a crucial revision that further aligned the convention and its work with the constitutional principles Americans had already developed. An early draft of the preamble had pronounced the Constitution the work of "We the people of the States of New Hampshire, Massachusetts, Rhode Island and Providence Plantations, Connecticut, New-York, New-Jersey, Pennsylvania, Delaware, Maryland, Virginia, North-Carolina, South-Carolina, and Georgia."[18] On the one hand, listing the individual states made a good deal of sense. Delegates had been selected by their respective states and, due to the convention's method of voting, the Constitution could be fairly described as the work of the states. On the other hand, the Constitution proposed to create a government that, while acknowledging the states, would represent the American people generally. The committee therefore changed the preamble to read simply, "We the People of the United States." The people of the states could create their respective state governments at the same time that the people of the United States at large could create a federal government. The people would always retain ultimate sovereignty.

On September 17, 1787, just four days after the Committee of Style reported its draft, the delegates were ready to sign the Constitution and adjourn. The debate over details continued until the very end, with convention president George Washington making his only recorded speech (in favor of reducing the ratio of representation in the House to one representative for every 30,000 persons). When the last delegate signed, Benjamin Franklin remarked that the Constitution gave him cause for much optimism, so much so that he believed the sunburst carved on Washington's chair symbolized "a rising and not a setting sun" for the new country.[19] Despite his advanced age, Franklin had taken an active part in the convention. His fellow delegates had listened to his speeches with unfailing politeness—and also, sometimes, with silent bemusement when the old philosopher had expressed opinions that were too impractical or unpopular. Delegate James McHenry reported that as Franklin left the State House, a woman named Elizabeth Powel asked him if the new government would be "a republic or a monarchy." Franklin responded, "A republic, if you can keep it."[20]

Whether Franklin spoke these exact words is impossible to know. If he did, perhaps he accorded the American people (Franklin's "you") too small a role in the creation of their republic. The convention, after all, had not yet created a republic for the people to "keep." It had merely proposed a plan that the people might adopt and implement as their own, if they chose to do so. The most important part of the process was yet to come. With the rule of secrecy no longer applying after the convention's adjournment, printers Dunlap and Claypoole got to work, producing by the morning of September 18 several hundred broadside copies of the Constitution for delegates to take with them and distribute. The day after that, the Pennsylvania *Packet* became the first of many newspapers throughout the states to publish the Constitution in its entirety. Americans now prepared to play out a scene very close to the one imagined by Thomas Paine in *Common Sense*. A constitution written in a cramped room in the Pennsylvania State House would be scattered to every corner of the United States, where the people would decide its fate.

OPPOSITE AND FOLLOWING PAGES: Cat. 11. Constitution of the United States of America, 1787

W E, the People of the United States, in order to form a more perfect union, establish justice, insure domestic tranquility, provide for the common defence, promote the general welfare, and secure the blessings of liberty to ourselves and our posterity, do ordain and establish this Constitution for the United States of America.

A R T I C L E I.

Sect. 1. A L L legislative powers herein granted shall be vested in a Congress of the United States, which shall consist of a Senate and House of Representatives.

Sect. 2. The House of Representatives shall be composed of members chosen every second year by the people of the several states, and the electors in each state shall have the qualifications requisite for electors of the most numerous branch of the state legislature.

No person shall be a representative who shall not have attained to the age of twenty-five years, and been seven years a citizen of the United States, and who shall not, when elected, be an inhabitant of that state in which he shall be chosen.

Representatives and direct taxes shall be apportioned among the several states which may be included within this Union, according to their respective numbers, which shall be determined by adding to the whole number of free persons, including those bound to service for a term of years, and excluding Indians not taxed, three-fifths of all other persons. The actual enumeration shall be made within three years after the first meeting of the Congress of the United States, and within every subsequent term of ten years, in such manner as they shall by law direct. The number of representatives shall not exceed one for every thirty thousand, but each state shall have at least one representative; and until such enumeration shall be made, the state of New-Hampshire shall be entitled to chuse three, Massachusetts eight, Rhode-Island and Providence Plantations one, Connecticut five, New-York six, New-Jersey four, Pennsylvania eight, Delaware one, Maryland six, Virginia ten, North-Carolina five, South-Carolina five, and Georgia three.

When vacancies happen in the representation from any state, the Executive authority thereof shall issue writs of election to fill such vacancies.

The House of Representatives shall chuse their Speaker and other officers; and shall have the sole power of impeachment.

Sect. 3. The Senate of the United States shall be composed of two senators from each state, chosen by the legislature thereof, for six years; and each senator shall have one vote.

Immediately after they shall be assembled in consequence of the first election, they shall be divided as equally as may be into three classes. The seats of the senators of the first class shall be vacated at the expiration of the second year, of the second class at the expiration, of the fourth year, and of the third class at the expiration of the sixth year, so that one-third may be chosen every second year; and if vacancies happen by resignation, or otherwise, during the recess of the Legislature of any state, the Executive thereof may make temporary appointments until the next meeting of the Legislature, which shall then fill such vacancies.

No person shall be a senator who shall not have attained to the age of thirty years, and been nine years a citizen of the United States, and who shall not, when elected, be an inhabitant of that state for which he shall be chosen.

The Vice-President of the United States shall be President of the senate, but shall have no vote, unless they be equally divided.

The Senate shall chuse their other officers, and also a President pro tempore, in the absence of the Vice-President, or when he shall exercise the office of President of the United States.

The Senate shall have the sole power to try all impeachments. When sitting for that purpose, they shall be on oath or affirmation. When the President of the United States is tried, the Chief Justice shall preside: And no person shall be convicted without the concurrence of two-thirds of the members present.

Judgment in cases of impeachment shall not extend further than to removal from office, and disqualification to hold and enjoy any office of honor, trust or profit under the United States; but the party convicted shall nevertheless be liable and subject to indictment, trial, judgment and punishment, according to law.

Sect. 4. The times, places and manner of holding elections for senators and representatives, shall be prescribed in each state by the legislature thereof; but the Congress may at any time by law make or alter such regulations, except as to the places of chusing Senators.

The Congress shall assemble at least once in every year, and such meeting shall be on the first Monday in December, unless they shall by law appoint a different day.

Sect. 5. Each house shall be the judge of the elections, returns and qualifications of its own members, and a majority of each shall constitute a quorum to do business; but a smaller number may adjourn from day to day, and may be authorised to compel the attendance of absent members, in such manner, and under such penalties as each house may provide.

Each house may determine the rules of its proceedings, punish its members for disorderly behaviour, and, with the concurrence of two-thirds, expel a member.

Each house shall keep a journal of its proceedings, and from time to time publish the same, excepting such parts as may in their judgment require secrecy; and the yeas and nays of the members of either house on any question shall, at the desire of one-fifth of those present, be entered on the journal.

Neither house, during the session of Congress, shall, without the consent of the other, adjourn for more than three days, nor to any other place than that in which the two houses shall be sitting.

Sect. 6. The senators and representatives shall receive a compensation for their services, to be ascertained by law, and paid out of the treasury of the United States. They shall in all cases, except treason, felony and breach of the peace, be privileged from arrest during their attendance at the

the feffion of their refpective houfes, and in going to and returning from the fame; and for any fpeech or debate in either houfe, they fhall not be queftioned in any other place.

No fenator or reprefentative fhall, during the time for which he was elected, be appointed to any civil office under the authority of the United States, which fhall have been created, or the emoluments whereof fhall have been encreafed during fuch time; and no perfon holding any office under the United States, fhall be a member of either houfe during his continuance in office.

Sect. 7. All bills for raifing revenue fhall originate in the houfe of reprefentatives; but the fenate may propofe or concur with amendments as on other bills.

Every bill which fhall have paffed the houfe of reprefentatives and the fenate, fhall, before it become a law, be prefented to the prefident of the United States; if he approve he fhall fign it, but if not he fhall return it, with his objections to that houfe in which it fhall have originated, who fhall enter the objections at large on their journal, and proceed to reconfider it. If after fuch reconfideration two-thirds of that houfe fhall agree to pafs the bill, it fhall be fent, together with the objections, to the other houfe, by which it fhall likewife be reconfidered, and if approved by two-thirds of that houfe, it fhall become a law. But in all fuch cafes the votes of both houfes fhall be determined by yeas and nays, and the names of the perfons voting for and againft the bill fhall be entered on the journal of each houfe refpectively. If any bill fhall not be returned by the Prefident within ten days (Sundays excepted) after it fhall have been prefented to him, the fame fhall be a law, in like manner as if he had figned it, unlefs the Congrefs by their adjournment prevent its return, in which cafe it fhall not be a law.

Every order, refolution, or vote to which the concurrence of the Senate and Houfe of Reprefentatives may be neceffary (except on a queftion of adjournment) fhall be prefented to the Prefident of the United States; and before the fame fhall take effect, fhall be approved by him, or, being difapproved by him, fhall be repaffed by two-thirds of the Senate and Houfe of Reprefentatives, according to the rules and limitations prefcribed in the cafe of a bill.

Sect. 8. The Congrefs fhall have power

To lay and collect taxes, duties, impofts and excifes, to pay the debts and provide for the common defence and general welfare of the United States; but all duties, impofts and excifes fhall be uniform throughout the United States;

To borrow money on the credit of the United States;

To regulate commerce with foreign nations, and among the feveral ftates, and with the Indian tribes;

To eftablifh an uniform rule of naturalization, and uniform laws on the fubject of bankruptcies throughout the United States;

To coin money, regulate the value thereof, and of foreign coin, and fix the ftandard of weights and meafures;

To provide for the punifhment of counterfeiting the fecurities and current coin of the United States;

To eftablifh poft offices and poft roads;

To promote the progrefs of fcience and ufeful arts, by fecuring for limited times to authors and inventors the exclufive right to their refpective writings and difcoveries;

To conftitute tribunals inferior to the fupreme court;

To define and punifh piracies and felonies committed on the high feas, and offences againft the law of nations;

To declare war, grant letters of marque and reprifal, and make rules concerning captures on land and water;

To raife and fupport armies, but no appropriation of money to that ufe fhall be for a longer term than two years;

To provide and maintain a navy;

To make rules for the government and regulation of the land and naval forces;

To provide for calling forth the militia to execute the laws of the union, fupprefs infurrections and repel invafions;

To provide for organizing, arming, and difciplining, the militia, and for governing fuch part of them as may be employed in the fervice of the United States, referving to the States refpectively, the appointment of the officers, and the authority of training the militia according to the difcipline prefcribed by Congrefs;

To exercife exclufive legiflation in all cafes whatfoever, over fuch diftrict (not exceeding ten miles fquare) as may, by ceffion of particular States, and the acceptance of Congrefs, become the feat of the government of the United States, and to exercife like authority over all places purchafed by the confent of the legiflature of the ftate in which the fame fhall be, for the erection of forts, magazines, arfenals, dock-yards, and other needful buildings;—And

To make all laws which fhall be neceffary and proper for carrying into execution the foregoing powers, and all other powers vefted by this conftitution in the government of the United States, or in any department or officer thereof.

Sect. 9. The migration or importation of fuch perfons as any of the ftates now exifting fhall think proper to admit, fhall not be prohibited by the Congrefs prior to the year one thoufand eight hundred and eight, but a tax or duty may be impofed on fuch importation, not exceeding ten dollars for each perfon.

The privilege of the writ of habeas corpus fhall not be fufpended, unlefs when in cafes of rebellion or invafion the public fafety may require it.

No bill of attainder or ex poft facto law fhall be paffed.

No capitation, or other direct, tax fhall be laid, unlefs in proportion to the cenfus or enumeration herein before directed to be taken.

No tax or duty fhall be laid on articles exported from any ftate. No preference fhall be given by any regulation of commerce or revenue to the ports of one ftate over thofe of another: nor fhall
veffels

vessels bound to, or from, one state, be obliged to enter, clear, or pay duties in another.

No money shall be drawn from the treasury, but in consequence of appropriations made by law; and a regular statement and account of the receipts and expenditures of all public money shall be published from time to time.

No title of nobility shall be granted by the United States:—And no person holding any office of profit or trust under them, shall, without the consent of the Congress, accept of any present, emolument, office, or title, of any kind whatever, from any king, prince, or foreign state.

Sect. 10. No state shall enter into any treaty, alliance, or confederation; grant letters of marque and reprisal; coin money; emit bills of credit; make any thing but gold and silver coin a tender in payment of debts; pass any bill of attainder, ex post facto law, or law impairing the obligation of contracts, or grant any title of nobility.

No state shall, without the consent of the Congress, lay any imposts or duties on imports or exports, except what may be absolutely necessary for executing its inspection laws; and the net produce of all duties and imposts, laid by any state on imports or exports, shall be for the use of the Treasury of the United States; and all such laws shall be subject to the revision and controul of the Congress. No state shall, without the consent of Congress, lay any duty of tonnage, keep troops, or ships of war in time of peace, enter into any agreement or compact with another state, or with a foreign power, or engage in war, unless actually invaded, or in such imminent danger as will not admit of delay.

II.

Sect. 1. The executive power shall be vested in a president of the United States of America. He shall hold his office during the term of four years, and, together with the vice-president, chosen for the same term, be elected as follows.

Each state shall appoint, in such manner as the legislature thereof may direct, a number of electors, equal to the whole number of senators and representatives to which the state may be entitled in the Congress: but no senator or representative, or person holding an office of trust or profit under the United States, shall be appointed an elector.

The electors shall meet in their respective states, and vote by ballot for two persons, of whom one at least shall not be an inhabitant of the same state with themselves. And they shall make a list of all the persons voted for, and of the number of votes for each; which list they shall sign and certify, and transmit sealed to the seat of the government of the United States, directed to the president of the senate. The president of the senate shall, in the presence of the senate and house of representatives, open all the certificates, and the votes shall then be counted. The person having the greatest number of votes shall be the president, if such number be a majority of the whole number of electors appointed; and if there be more than one who have such majority, and have an equal number of votes, then the house of representatives shall immediately chuse by ballot one of them for president; and if no person have a majority, then from the five highest on the list the said house shall in like manner chuse the president. But in chusing the president, the votes shall be taken by states, the representation from each state having one vote; a quorum for this purpose shall consist of a member or members from two-thirds of the states, and a majority of all the states shall be necessary to a choice. In every case, after the choice of the president, the person having the greatest number of votes of the electors shall be the vice-president. But if there should remain two or more who have equal votes, the senate shall chuse from them by ballot the vice-president.

The Congress may determine the time of chusing the electors, and the day on which they shall give their votes; which day shall be the same throughout the United States.

No person except a natural born citizen, or a citizen of the United States, at the time of the adoption of this constitution, shall be eligible to the office of president; neither shall any person be eligible to that office who shall not have attained to the age of thirty-five years, and been fourteen years a resident within the United States.

In case of the removal of the president from office, or of his death, resignation, or inability to discharge the powers and duties of the said office, the same shall devolve on the vice-president, and the Congress may by law provide for the case of removal, death, resignation or inability, both of the president and vice-president, declaring what officer shall then act as president, and such officer shall act accordingly, until the disability be removed, or a president shall be elected.

The president shall, at stated times, receive for his services, a compensation, which shall neither be encreased nor diminished during the period for which he shall have been elected, and he shall not receive within that period any other emolument from the United States, or any of them.

Before he enter on the execution of his office, he shall take the following oath or affirmation:

" I do solemnly swear (or affirm) that I will faithfully execute the office of president of the United States, and will to the best of my ability, preserve, protect and defend the constitution of the United States."

Sect. 2. The president shall be commander in chief of the army and navy of the United States, and of the militia of the several States, when called into the actual service of the United States; he may require the opinion, in writing, of the principal officer in each of the executive departments, upon any subject relating to the duties of their respective offices, and he shall have power to grant reprieves and pardons for offences against the United States, except in cases of impeachment.

He shall have power, by and with the advice and consent of the senate, to make treaties, provided two-thirds of the senators present concur; and he shall nominate, and by and with the advice and consent of the senate, shall appoint ambassadors, other public ministers and consuls, judges of the supreme court, and all other officers of the United States, whose appointments are not herein otherwise provided for, and which shall be established by law. But the Congress may by law vest the appointment of such inferior officers, as they think proper, in the president alone, in the courts of law, or in the heads of departments.

The president shall have power to fill up all vacancies that may happen during the recess of the senate, by granting commissions which shall expire at the end of their next session. *Sect.* 3.

Sect. 3. He shall from time to time give to the Congress information of the state of the union, and recommend to their consideration such measures as he shall judge necessary and expedient ; he may, on extraordinary occasions, convene both houses, or either of them, and in case of disagreement between them, with respect to the time of adjournment, he may adjourn them to such time as he shall think proper ; he shall receive ambassadors and other public ministers ; he shall take care that the laws be faithfully executed, and shall commission all the officers of the United States.

Sect. 4. The president, vice-president and all civil officers of the United States, shall be removed from office on impeachment for, and conviction of, treason, bribery, or other high crimes and misdemeanors.

III.

Sect. 1. The judicial power of the United States, shall be vested in one supreme court, and in such inferior courts as the Congress may from time to time ordain and establish. The judges, both of the supreme and inferior courts, shall hold their offices during good behaviour, and shall, at stated times, receive for their services, a compensation, which shall not be diminished during their continuance in office.

Sect. 2. The judicial power shall extend to all cases, in law and equity, arising under this constitution, the laws of the United States, and treaties made, or which shall be made, under their authority ; to all cases affecting ambassadors, other public ministers and consuls ; to all cases of admiralty and maritime jurisdiction ; to controversies to which the United States shall be a party ; to controversies between two or more States, between a state and citizens of another state, between citizens of different States, between citizens of the same state claiming lands under grants of different States, and between a state, or the citizens thereof, and foreign States, citizens or subjects.

In all cases affecting ambassadors, other public ministers and consuls, and those in which a state shall be party, the supreme court shall have original jurisdiction. In all the other cases before mentioned, the supreme court shall have appellate jurisdiction, both as to law and fact, with such exceptions, and under such regulations as the Congress shall make.

The trial of all crimes, except in cases of impeachment, shall be by jury ; and such trial shall be held in the state where the said crimes shall have been committed ; but when not committed within any state, the trial shall be at such place or places as the Congress may by law have directed.

Sect. 3. Treason against the United States, shall consist only in levying war against them, or in adhering to their enemies, giving them aid and comfort. No person shall be convicted of treason unless on the testimony of two witnesses to the same overt act, or on confession in open court.

The Congress shall have power to declare the punishment of treason, but no attainder of treason shall work corruption of blood, or forfeiture except during the life of the person attainted.

IV.

Sect. 1. Full faith and credit shall be given in each state to the public acts, records, and judicial proceedings of every other state. And the Congress may by general laws prescribe the manner in which such acts, records and proceedings shall be proved, and the effect thereof.

Sect. 2. The citizens of each state shall be entitled to all privileges and immunities of citizens in the several states.

A person charged in any state with treason, felony, or other crime, who shall flee from justice, and be found in another state, shall, on demand of the executive authority of the state from which he fled, be delivered up, to be removed to the state having jurisdiction of the crime.

No person held to service or labour in one state, under the laws thereof, escaping into another, shall, in consequence of any law or regulation therein, be discharged from such service or labour, but shall be delivered up on claim of the party to whom such service or labour may be due.

Sect. 3. New states may be admitted by the Congress into this union ; but no new state shall be formed or erected within the jurisdiction of any other state ; nor any state be formed by the junction of two or more states, or parts of states, without the consent of the legislatures of the states concerned as well as of the Congress.

The Congress shall have power to dispose of and make all needful rules and regulations respecting the territory or other property belonging to the United States ; and nothing in this Constitution shall be so construed as to prejudice any claims of the United States, or of any particular state.

Sect. 4. The United States shall guarantee to every state in this union a Republican form of government, and shall protect each of them against invasion ; and on application of the legislature, or of the executive (when the legislature cannot be convened) against domestic violence.

V.

The Congress, whenever two-thirds of both houses shall deem it necessary, shall propose amendments to this constitution, or, on the application of the legislatures of two-thirds of the several states, shall call a convention for proposing amendments, which, in either case, shall be valid to all intents and purposes, as part of this constitution, when ratified by the legislatures of three-fourths of the several states, or by conventions in three-fourths thereof, as the one or the other mode of ratification may be proposed by the Congress ; Provided, that no amendment which may be made prior to the year one thousand seven hundred and eight shall in any manner affect the first and fourth clauses in the ninth section of the first article ; and that no state, without its consent, shall be deprived of its equal suffrage in the senate.

VI.

All debts contracted and engagements entered into, before the adoption of this Constitution, shall be as valid against the United States under this Constitution, as under the confederation.

This constitution, and the laws of the United States which shall be made in pursuance thereof ; and all treaties made, or which shall be made, under the authority of the United States, shall be the supreme law of the land ; and the judges in every state shall be bound thereby, any thing in the constitution or laws of any state to the contrary notwithstanding.

The

The senators and representatives beforementioned, and the members of the several state legislatures, and all executive and judicial officers, both of the United States and of the several States, shall be bound by oath or affirmation, to support this constitution; but no religious test shall ever be required as a qualification to any office or public trust under the United States.

VII.

The ratification of the conventions of nine States, shall be sufficient for the establishment of this constitution between the States so ratifying the same.

Done in Convention, by the unanimous consent of the

States present, the seventeenth day of September, in the year of our Lord one thousand seven hundred and eighty-seven, and of the Independence of the United States of America the twelfth. In witness whereof we have hereunto subscribed our Names.

GEORGE WASHINGTON, President,
And Deputy from VIRGINIA.

NEW-HAMPSHIRE.	*John Langdon,* *Nicholas Gilman.*	
MASSACHUSETTS.	*Nathaniel Gorham,* *Rufus King.*	DELAWARE.
CONNECTICUT.	*William Samuel Johnson,* *Roger Sherman.*	
NEW-YORK.	*Alexander Hamilton.*	MARYLAND.
NEW-JERSEY.	*William Livingston,* *David Brearly,* *William Paterson,* *Jonathan Dayton.*	VIRGINIA.
PENNSYLVANIA.	*Benjamin Franklin,* *Thomas Mifflin,* *Robert Morris,* *George Clymer,* *Thomas Fitzsimons,* *Jared Ingersoll,* *James Wilson,* *Gouverneur Morris.*	NORTH-CAROLINA SOUTH-CAROLINA. GEORGIA.

DELAWARE. *George Read,* *Gunning Bedford, Junior,* *John Dickinson,* *Richard Bassett,* *Jacob Broom.*

MARYLAND. *James M'Henry,* *Daniel of St. Tho. Jenifer,* *Daniel Carrol.*

VIRGINIA. *John Blair,* *James Madison, Junior.*

NORTH-CAROLINA *William Blount,* *Richard Dobbs Spaight,* *Hugh Williamson.*

SOUTH-CAROLINA. *John Rutledge,* *Charles Cotesworth Pinckney* *Charles Pinckney,* *Pierce Butler.*

GEORGIA. *William Few,* *Abraham Baldwin.*

Attest, *William Jackson,* SECRETARY.

In CONVENTION, Monday September 17th, 1787.
PRESENT

The States of New-Hampshire, Massachusetts, Connecticut, Mr. *Hamilton* from New-York, New-Jersey, Pennsylvania, Delaware, Maryland, Virginia, North-Carolina, South-Carolina and Georgia:

RESOLVED,

THAT the preceding Constitution be laid before the United States in Congress assembled, and that it is the opinion of this Convention, that it should afterwards be submitted to a Convention of Delegates, chosen in each State by the People thereof, under the recommendation of its Legislature, for their assent and ratification; and that each Convention assenting to, and ratifying the same, should give Notice thereof to the United States in Congress assembled.

Resolved, That it is the opinion of this Convention, that as soon as the Conventions of nine States shall have ratified this Constitution, the United States in Congress assembled should fix a day on which Electors should be appointed by the States which shall have ratified the same, and a day on which the Electors should assemble to vote for the President, and the time and place for commencing proceedings under this Constitution. That after such publication the Electors should be appointed, and the Senators and Representatives elected: That the Electors should meet on the day fixed for the Election of the President, and should transmit their votes certified, signed, sealed and directed, as the Constitution requires, to the Secretary of the United States in Congress assembled, that the Senators and Representatives should convene at the time and place assigned; that the Senators should appoint a President of the Senate, for the sole purpose of receiving, opening and counting the votes for President; and, that after he shall be chosen, the Congress, together with the President, should, without delay, proceed to execute this Constitution.

By the unanimous Order of the Convention,
GEORGE WASHINGTON, President.

William Jackson, Secretary.

In Convention, September 17, 1787.

SIR,

WE have now the honor to submit to the confideration of the United States in Congress affembled, that Conftitution which has appeared to us the moft advifeable.

The friends of our country have long feen and defired, that the power of making war, peace and treaties, that of levying money and regulating commerce, and the correfpondent executive and judicial authorities fhould be fully and effectually vefted in the general government of the Union: but the impropriety of delegating fuch extenfive truft to one body of men is evident—Hence refults the neceffity of a different organization.

It is obvioufly impracticable in the fœderal government of thefe States, to fecure all rights of independent fovereignty to each, and yet provide for the intereft and fafety of all—Individuals entering into fociety, muft give up a fhare of liberty to preferve the reft. The magnitude of the facrifice muft depend as well on fituation and circumftance, as on the object to be obtained. It is at all times difficult to draw with precifion the line between thofe rights which muft be furrendered, and thofe which may be referved ; and on the prefent occafion this difficulty was encreafed by a difference among the feveral States as to their fituation, extent, habits, and particular interefts.

In all our deliberations on this fubject we kept fteadily in our view, that which appears to us the greateft intereft of every true American, the confolidation of our Union, in which is involved our profperity, felicity, fafety, perhaps our national exiftence. This important confideration, ferioufly and deeply impreffed on our minds, led each State in the Convention to be lefs rigid on points of inferior magnitude, than might have been otherwife expected; and thus the Conftitution, which we now prefent, is the refult of a fpirit of amity, and of that mutual deference and conceffion which the peculiarity of our political fituation rendered indifpenfible.

That it will meet the full and entire approbation of every State is not perhaps to be expected ; but each will doubtlefs confider, that had her interefts been alone confulted, the confequences might have been particularly difagreeable or injurious to others ; that it is liable to as few exceptions as could reafonably have been expected, we hope and believe; that it may promote the lafting welfare of that country fo dear to us all, and fecure her freedom and happinefs, is our moft ardent wifh.

With great refpect,

We have the honor to

SIR,

Your EXCELLENCY's moft

Obedient and humble Servants,

George Wafhington, Prefident.

By unanimous Order of the CONVENTION.

HIS EXCELLENCY
The Prefident of Congrefs.

PRINTED BY DUNLAP & CLAYPOOLE.

The Perils of "Consolidation"

But how, precisely, would the people express their will? The delegates in Philadelphia gave the question much thought. As both a practical matter and for reasons of principle, the Constitution's fate should not be left in the hands of either Congress or the state legislatures. If adopted, the Constitution would abolish the Confederation Congress. That body might therefore have an interest in killing the proposal. Likewise, state legislatures would see their own powers modified and, in some cases, significantly restricted if the Constitution went into effect. They, too, might be inclined to reject the Constitution. To avoid these potential conflicts of interest, as well as to establish the nation's fundamental law more firmly on a basis of popular sovereignty, ratification should be decided more directly by the people themselves. A simple referendum, in which individual citizens voted on whether to ratify the Constitution, seemed impractical at the time. The best method, delegates concluded, would be to hold special conventions in each of the states at which the people could meet, discuss, and (the vast majority of delegates hoped) agree to ratify the Constitution. Each convention's final vote would be interpreted as the will of one part of the American people. Since the people would be exercising their sovereign power to create an entirely new form of government, the delegates reasoned, they were not bound by the Articles of Confederation's requirement that amendments achieve the unanimous approval of all thirteen states. Once nine state conventions voted to ratify, the Constitution would go into effect—at least for those nine states.

Ratification inspired a vibrant, nationwide debate. Americans discussed questions of government and rights with remarkable sophistication and candor. To be sure, the discussion would have been much richer and more comprehensive had women, African Americans, and Native Americans—who, we should remember, collectively composed a majority of United States inhabitants—been permitted formally to participate and express their views on a constitution that would profoundly affect their lives and the lives of their children. This important caveat notwithstanding, the ratification process produced a scene that would have been unimaginable just fifteen years earlier. The Revolution had prompted Americans from a wide variety of backgrounds to come together and create new governments for themselves. The question now before Americans was whether the constitution written by the Philadelphia convention represented the logical and necessary continuation of that unfolding process of self-government, or a step backward—a threat to the gains Americans had won at great cost during the War of Independence. Those who supported ratifying the United States Constitution became known as "Federalists," while those who harbored reservations about ratifying became known—rather simplistically, given the variety of views encompassed under the label—as "Antifederalists."

The nature of the debate and the respective positions began to take shape in Pennsylvania in late 1787. The day after the constitutional convention left its room in the State House, the state legislature moved back in and arranged for a ratifying convention to meet—in the same room—on November 21. Ultimately, sixty-nine delegates won election in their respective districts and attended. A clear majority of the convention supported ratification, but a vocal minority insisted on a thorough examination and debate. Although the convention's final verdict in favor of ratification was never in doubt—the vote occurred on December 12 with a tally of 46 to 23—in the course of the proceedings both sides developed many of the main arguments and counterarguments that would define the ratification contest generally.

Shortly after the Pennsylvania convention voted to ratify the Constitution, twenty-one of the delegates who had opposed ratification put their names to a lengthy document, "The Address and Reasons of Dissent of the Minority," that rehearsed many of the key Antifederalist objections to the Constitution. These Antifederalists expressed grave concerns that the Constitution would turn the United States into a "consolidated" nation. "The preamble begins with the words,

OPPOSITE: Cat. 11. Constitution of the United States of America, 1787

The Address and Reasons of Dissent of the Minority of the Convention of the State of Pennsylvania, to their Constituents.

IT was not until after the termination of the late glorious contest, which made the people of the United States an independent nation, that any defect was discovered in the present confederation. It was formed by some of the ablest patriots in America. It carried us successfully through the war; and the virtue and patriotism of the people, with their disposition to promote the common cause, supplied the want of power in Congress.

The requisition of Congress for the five *per cent.* impost was made before the peace, so early as the first of February, 1781, but was prevented taking effect by the refusal of one state; yet it is probable every state in the union would have agreed to this measure at that period, had it not been for the extravagant terms in which it was demanded. The requisition was new moulded in the year 1783, and accompanied with an additional demand of certain supplementary funds for 25 years. Peace had now taken place, and the United States found themselves labouring under a considerable foreign and domestic debt, incurred during the war. The requisition of 1783, was commensure with the interest of the debt as it was then calculated; but it has been more accurately ascertained since that time. The domestick debt has been found to fall several millions of dollars short of the calculation; and it has lately been considerably diminished by large sales of the western lands. The states have been called on by Congress annually for supplies until the general system of finance proposed in 1783 should take place.

It was at this time that the want of an efficient federal government was first complained of, and that the powers vested in Congress were found to be inadequate to the procuring of the benefits that should result from the union. The impost was granted by most of the states, but many refused the supplementary funds; the annual requisitions were set at nought by some of the states, while others complied with them by legislative acts, but were tardy in their payments, and Congress found themselves incapable of complying with their engagements, and supporting the federal government. It was found that our national character was sinking in the opinion of foreign nations. The Congress could make treaties of commerce, but could not enforce the observance of them. We were suffering from the restrictions of foreign nations, who have shackled our commerce, while

we

'We the people of the United States,'" they noted with alarm, "which is the style of a compact between individuals entering into a state of society, and not that of a confederation of states." The delegates to the constitutional convention had been tasked only with "revising and amending" the Articles of Confederation. But, fully intending to exceed their mandate, the delegates had adopted a rule of secrecy more befitting a papal conclave than a gathering of honorable republican statesmen. They had crafted a national government designed "to annihilate the state governments, and swallow them up in the grand vortex of general empire."

"Consolidation," the addressers argued, would come about through the extensive but vaguely defined powers the Constitution granted to Congress. Perhaps most important, Congress would abuse its power to levy and collect direct taxes. "Land-taxes, poll-taxes, excises, duties on all written instruments, and duties on every other article that [Congress] may judge proper"—according to the Pennsylvania Antifederalists, this federal tax regime would prove so comprehensive and demanding that states would be left unable to raise any money for their own purposes. Congress would "monopolise every source of revenue, and thus indirectly demolish the state governments." Congress would also have the power to create a standing army and to regulate state militias, both of which would be used to "enforce the collection" of taxes and guarantee the people's compliance with countless other laws passed under the flimsy pretext of the Constitution's "general welfare" and "necessary and proper" clauses.

But why would Congress pursue such a despotic course? Surely the men whom the people selected to represent them in the national legislature would look after the rights and interests of their fellow citizens. "How inadequate and unsafe a representation!" the addressers exclaimed when they turned to this topic. Under the Constitution both houses of Congress would be woefully small, and "the sense and views of 3 or 4 millions of people diffused over so extensive a territory, comprising such various climates, products, habits, interests, and opinions, can not be collected in so small a body." Inevitably, "men of the most elevated rank in life, will alone be chosen" to serve in the House and Senate, and "the other orders in the society, such as farmers, traders, and mechanics, who all ought to have a competent number of their best informed men in the legislature, will be totally unrepresented." The elites who comprised the federal government could never be trusted to protect their constituents' interests. They would be too removed from the common people and, even worse, the Constitution would grant them exclusive authority over a number of important matters that currently fell under the remit of the state governments, which were far more open to popular influence and control. And since the Constitution also granted Congress the authority to regulate federal elections, congressmen and senators would find ways to remain in power indefinitely—all the better to implement their tyrannical agenda.

Elaborating on the most common and effective Antifederalist critique, the Pennsylvania addressers noted that the Constitution lacked a bill of rights that guaranteed individual liberties and the integrity of the states. Most state constitutions contained a bill of rights, and the baffling absence of one in the United States Constitution left many Americans concerned that they would have no protection against a federal government whose powers came with few clear limitations and whose very structure, Antifederalists believed, would place unreliable men in positions of authority. State constitutions and bills of rights would be made worthless: the Constitution (Article VI, Section 2) stated that the federal Constitution, federal laws, and federal treaties "shall be the supreme law of the land."

In short, Antifederalists such as the Pennsylvania addressers argued that the Constitution represented a far greater danger than whatever temporary problems currently beset the Confederation. In their view, Federalists were proposing to create a system every bit as oppressive and just as certain to undermine true government by the people (by eliminating the states as important political units) as the British Empire had been. While Antifederalists did not deny that the United States faced significant hardships at the moment, they claimed that these would quickly pass, or could be resolved through minor amendments to the Articles of Confederation.

OPPOSITE: Cat. 12. An Antifederalist Critique of the Constitution: Pennsylvania, 1787

The Union Is Essential

By the time the Pennsylvania convention adjourned, Delaware had beaten its larger neighbor and become the first state to ratify the United States Constitution. The Delaware convention needed only four days of deliberations before it voted, 30 to 0, on December 7, 1787. Three other states joined Delaware and Pennsylvania in rapid succession: New Jersey on December 18 by a vote of 38 to 0; Georgia on January 2 by a vote of 26 to 0; and Connecticut on January 9 by a vote of 128 to 40. Antifederalists in Pennsylvania and elsewhere had raised important questions about the Constitution. "The Address and Reasons of Dissent of the Minority" joined a multitude of other newspaper essays, pamphlets, and broadsides that circulated widely and explained Antifederalist views. And yet the quick and apparently easy decisions for ratification in several states suggested a strong base of support for the Constitution. When advocating ratification, Federalists focused on their opponents' greatest fears—a despotic, consolidated national government and the destruction of the states—and persuasively argued that the Constitution represented not a threat but in fact an essential means to prevent these troubling possibilities from coming to fruition. The Constitution, Federalists maintained, would foster liberty and prosperity by bringing the states together in a sustainable framework, a federal union grounded on the sovereignty of the people and sound republican principles.

The closely contested Massachusetts convention forced Federalists to expound their views and make their case even more cogently. The convention began in January 1788, after citizens in towns throughout the state met to debate the Constitution and elect delegates whose opinions appeared in sync with their own. So many delegates attended—364 in all—and so many spectators wished to view the proceedings that the convention shuttled back and forth between a few different buildings in Boston before finally finding a permanent home in a spacious church. Reflecting the state's large and diverse population, the convention was attended by many delegates who viewed the Constitution with skepticism. Geographically separated from the rest of the state, many delegates from Maine wondered if the Constitution would serve their interests and, especially, if it would make Maine statehood more difficult to achieve. Meanwhile, delegates from several interior counties remained very suspicious of more powerful government generally. In 1786 and 1787, inhabitants in these parts of the state, stretched to the breaking point by what they considered unjust and unduly burdensome state tax policies, had risen up in protest. Known as Shays's Rebellion after its ostensible leader, the movement had been dispersed with military force (and some loss of life) by the state government. Animosities lingered and inclined many to oppose a new system that at first blush seemed to place power and decision-making in the hands of authorities even more removed from the people. If Federalists were to carry the day in the Massachusetts convention, then, they would need to put forth an argument so convincing that even the Constitution's staunchest opponents would have to acknowledge its merits.

Federalists declared that the Constitution would create not a tyrannical government, but a thoroughly republican one resembling those already established in Massachusetts and other states. Representation in the proposed legislature would be robust, they insisted, in size virtually equivalent to the Confederation Congress under the Articles. These representatives would, in fact, remain in touch with their constituents. Congressmen would have to earn reelection every two years, and their numbers would increase in proportion to the country's population. Congress's power to regulate congressional elections and pay representatives' salaries, Federalists explained, would guarantee that all the states sent their full complements and enabled Congress to achieve a quorum for doing business. Each state received two senators, regardless of population, in order to protect its interests. The state legislatures would select these senators, just as they had selected delegates to Congress under the Articles—yet another way in which states would continue to be important.

OPPOSITE AND FOLLOWING PAGES: Cat. 13. A Federalist Defense of the Constitution: Massachusetts, 1788

DEBATES,

RESOLUTIONS AND OTHER PROCEEDINGS,

OF THE

CONVENTION

OF THE

COMMONWEALTH OF MASSACHUSETTS,

Convened at Boston, on the 9th of *January*, 1788,
and continued until the 7th of *February* follow-
ing, for the purpose of assenting to and ratify-
ing the CONSTITUTION recommended by the
Grand FEDERAL CONVENTION.

TOGETHER WITH

The YEAS AND NAYS ON THE

DECISION OF THE GRAND QUESTION,

TO WHICH

The FEDERAL CONSTITUTION

IS PREFIXED.

BOSTON:

Printed and sold by ADAMS and NOURSE, in Court-Street; and
BENJAMIN RUSSELL, and EDMUND FREEMAN, in State-Street.

M,DCC,LXXXVIII.

ture, unanimity may be expected. But in discussing a
whole Constitution, in which the very amendments, that
it is said will not be agreed to by the States, are to be in-
serted, unanimity will be almost a miracle. Either the
amendments will be agreed to by the union, or they will
not—If it is admitted that they will be agreed to, then
there is an end of the objection to your Excellency's pro-
positions, and we ought to be unanimous for the Constitu-
tion. If it is said that they will not be agreed to, then it
must be because they are not approved by the United States,
or at least nine of them. Why shall we reject the Consti-
tution, then, for the sole purpose of obtaining that unani-
mous vote of thirteen States, which it is confidently said,
it is impossible we ever shall obtain from nine only ?—An
object which is impossible is out of the question. The
arguments that the amendments will not prevail, is not
only without force, but directly against those who use it,
unless they admit that we have no need of a government,
or assert that by ripping up the foundations of compact
upon which we now stand, and setting the whole Consti-
tution afloat, and introducing an infinity of new subjects of
controversy, we pursue the best method to secure the entire
unanimity of thirteen States.

But shall we put every thing that we hold precious to
the hazard by rejecting this Constitution ? We have great
advantages by it in respect of navigation—and it is the
general interest of the States that we should have them.
But if we reject it, what security have we that we shall ob-
tain them a second time against the local interests and pre-
judices of the other States—Who is there that really loves
liberty that will not tremble for its safety, if the federal go-
vernment should be dissolved—Can liberty be safe without
government ?

The period of our political dissolution is approaching—
Anarchy and uncertainty attend our future State—But this
we know that liberty, which is the *soul* of our existence,
once fled, can return no more.

The union is essential to our being as a nation. The pil-
lars that prop it are crumbling to powder. The union is
the vital sap that nourishes the tree—If we reject the Con-
stitution

stitution, to use the language of the country, we girdle
the tree, its leaves will wither, its branches drop off, and
the mouldering trunk will be torn down by the tempest.
What security has this single state against foreign enemies?
Could we defend the mast country, which the Britons so
much desire? Can we protect our fisheries, or secure by
treaties a sale for the produce of our lands in foreign mark-
ets? Is there no loss, no danger by delay? In spite of our
negligence and perverseness, are we to enjoy *at all times* the
privilege of forming a Constitution, which no other nation
has ever enjoyed at all? We approve our own form of
state government, and seem to think ourselves in safety un-
der its protection. We talk as if there was no danger in
deciding wrong. But when the inundation comes, shall
we stand on dry land? The state government is a beauti-
ful structure. It is situated however upon the naked beach.
The union is the dyke to fence out the flood—That dyke is
broken and decayed, and if we do not repair it, when the
next spring tide comes we shall be buried in one common
destruction.

Mr. BARRELL. [*of York*] Awed in the presence of
his august assembly—conscious of my inability to express
my mind fully on this important occasion—and sensible
how little I must appear in the eyes of those giants in rhe-
torick, who have exhibited such a pompous display of de-
clamation:—Without any of those talents calculated to
draw attention—without the pleasing eloquence of Cicero,
or the blaze of Demosthenian oratory, I rise, Sir, to dis-
charge my duty to my constituents, who I know expect
something more from me than meerly a silent vote. With
no pretensions to talents above the simple language adapt-
ed to the line of my calling, the plain husbandman, I hope
the gentlemen who compose this hon. body, will fully un-
derstand me when I attempt to speak my mind of the Fe-
deral Constitution as it now stands.—I wish, Sir, to give
my voice for its amendment before it can be salutary for
our acceptance—because, Sir, notwithstanding the Wilso-
nian oratory and all the learned arguments I have seen
written—notwithstanding the many laboured speeches I
have heard in its defence, and after the best investigation
I am able to give this subject, I fear it is pregnant with

B b baneful

The Congress thus elected would not abuse its powers, Federalists claimed. For the nightmare scenarios that Antifederalists imagined to come to pass, an absurdly large number of individuals from all parts of the union would need to conspire to deprive the people of their liberties. This was simply not credible. If Americans believed such conspiracies likely on a continental scale, then all republican governments everywhere, including those established by their state constitutions, were also destined to collapse into despotism. The people could be trusted to elect responsible men to serve in the national legislature. And, as further reassurance that these elections could not be manipulated by the federal government, the Constitution left it to the states to determine who could vote in them. Anyone qualified to vote for the "most numerous Branch" of the state legislature would be qualified to vote for members of the United States House of Representatives. As a result, the extent of the suffrage would vary from state to state. States would be free to establish whatever rules—including ones respecting race, sex, age, and economic status—they saw fit. Americans would revisit this key provision of the federal Constitution several times over the next two centuries, resorting to the amendment process to extend voting rights to more citizens.

A union endowed with more "energy," Federalists argued, would reduce the burdens on individual citizens and enable the states to flourish. The states were being asked to give up only those powers that they were currently using to harm one another. What good did it do anyone for states to retain control over levying and collecting continental taxes, for instance, when many states repeatedly failed to contribute their fair shares and thus imperiled the entire nation's credit? The Constitution would allow Congress to pay off its debts and set the country on a stable financial foundation, which in turn would pave the way for economic prosperity and collective security. The federal government would raise the bulk of its revenue through the impost, taxes levied on goods imported into the country and paid by merchants and shipowners at the water's edge. Although these costs would ultimately be paid by Americans (in the form of higher prices on goods), most citizens agreed that this represented the least invasive and objectionable mode of taxation.

State governments would no longer have to burden their constituents with heavy direct taxes requested by Congress, and they would retain plenty of sources of revenue to pay for their own affairs. The Constitution did grant Congress the power to levy direct taxes of its own, but such a power was necessary in case the country had to fight a war and needed alternative sources of money.

Here lay the heart of the Federalists' case for the Constitution: the states would never be able to survive in a world full of hostile powers as thirteen weak, separate republics. Only as part of a robust union could the states expect to endure and thrive. If the states remained in their current loose confederation, tensions between them would fester and they would exist in a constant state of mutual animosity—which might become so acrimonious that the United States would break apart into multiple, regional confederacies. If that came to pass, the states could easily be bullied or even conquered by foreign countries eager to increase their own wealth and power at the expense of the squabbling Americans. Such a scenario was hardly conducive to enjoying life, liberty, and the pursuit of happiness. Indeed, continuing in a state of loose confederation was the surest route to the despotism and destruction of the states that Antifederalists feared so intensely. Love of liberty and of one's own state, then, should foster not opposition to the Constitution, but support of it. Would Americans risk all they had achieved in a misguided attempt to protect their own selfish interests and powers? Or would they once again demonstrate the enlightened perspective that had enabled them to write constitutions for their individual states, making minor concessions and compromises in order to secure far more important rights and opportunities in the long term?

The Federalists in the Massachusetts convention included many of the state's best-educated and most articulate men, including the twenty-nine-year-old Harvard graduate and lawyer Fisher Ames. Toward the end of the convention, on February 5, 1788, Ames rose and gave a speech in which he encapsulated the Federalists' central point about the relationship between the individual states and the United States as a whole. In short, they depended on one another. "The union is essential to our being as a nation," Ames declared.

"What security has this single state against foreign enemies?" he asked. Surely Massachusetts alone could not protect such a "vast country" against determined aggressors or negotiate favorable commercial relationships with the world's great powers. To persuade his listeners, Ames appealed to their strong desire to preserve their state constitution, which they had managed to craft after years of effort and which many of their sons, brothers, and fathers had sacrificed their lives in the War of Independence to secure. Using an analogy he hoped would illustrate his point to his practical-minded fellow delegates, he explained, "The state government is a beautiful structure. It is situated however upon the naked beach. The union is the dyke to fence out the flood— That dyke is broken and decayed, and if we do not repair it, when the next spring tide comes we shall be buried in one common destruction." It was an image and idea that could be appreciated by Americans not just in Massachusetts, but in every state. Americans had won their independence only by working together, and going forward, they would enjoy liberty and self-government only if they remained united.

The day after Ames's speech, the Massachusetts convention voted to ratify the Constitution by the narrow margin of 187 to 168. Americans by this time accorded so much respect to the results of a convention of the people that the many delegates who had voted against ratification quickly vowed to accept the decision and to address their remaining concerns through the mechanisms established by the new frame of government. Despite their passionate criticisms of the Constitution, Antifederalists were not, in the end, intractably opposed to reforming a failing confederation. By participating in the ratification process, moreover, Antifederalists conveyed their willingness to accept its final outcome. They ultimately served a constructive role, forcing the Constitution's supporters to explain and justify the new government and guaranteeing that Americans did not take such a far-reaching step lightly. At the end of the debate, Americans everywhere were far more informed, and the experience itself clearly encouraged active participation in civic life in the years to come.

Maryland, South Carolina, and New Hampshire soon followed Massachusetts in ratifying the Constitution. Although ratification by nine states marked the

threshold for establishing the new federal government, it was important for two of the biggest states, Virginia and New York, to endorse the Constitution as well. Both states saw closely fought conventions. In Virginia, Patrick Henry, who had written the celebrated Virginia Resolves during the Stamp Act crisis of 1765, and George Mason, the author of the influential Virginia Declaration of Rights of 1776, both opposed ratification. James Madison, the chronicler of the Philadelphia convention, led the effort in support of the Constitution. On June 26, by a vote of 89 to 79, Virginia voted to ratify. In New York, where Antifederalist sentiment remained strong, Alexander Hamilton, John Jay, and Madison (though a Virginian) published a series of newspaper essays under the classical pseudonym Publius to aid the Constitution's cause. Though its impact in New York at the time was rather small, *The Federalist*, as these eighty-five sophisticated essays became collectively known, would go on to inform how generations of Americans understood the Constitution and what its framers and supporters were trying to achieve in 1787–88. New York ratified the Constitution on July 26 by a vote of 30 to 27. With eleven states now officially signed on, Americans were finally ready to establish a federal government under the Constitution.

Adding a Bill of Rights

CAT. 14. BILL OF RIGHTS AS PROPOSED BY THE HOUSE OF REPRESENTATIVES (17 AMENDMENTS), 1789

CAT. 15. BILL OF RIGHTS AS APPROVED BY CONGRESS (12 AMENDMENTS), 1789

When the first Congress, along with President George Washington, gathered in New York City in 1789, Americans did not assume that the process of constitution-making was now—or ever would be— complete. Many expected the document to be amended almost immediately. Several state conventions had ratified the Constitution with the expectation that their suggestions for its improvement would be taken up and adopted. Most of the proposed amendments grew out of one of the main critiques that Antifederalists such as the Pennsylvania addressers had leveled against the

Constitution: that it lacked a bill of rights resembling those attached to most state constitutions. Americans strongly desired guarantees that the federal government would not use its considerable powers to infringe key individual rights.

In the summer of 1787, the Philadelphia convention had briefly discussed adding such a list of rights. Focused intently on crafting the basic frame of government, however, delegates had brushed aside the idea rather quickly. During the ratification debates a short time later, Federalists such as James Wilson and James Madison argued that the convention's failure to include a list of rights was not an accident or shortcoming, but a well-reasoned decision designed to protect the rights of Americans. Writing down a necessarily limited number of rights might (incorrectly and dangerously) imply that those were the only rights Americans possessed, they said. Besides, the Constitution granted the government specific powers, and these did not include the power to violate the people's rights. Americans therefore had nothing to worry about. Although a clever argument, it was not a persuasive one. Most Americans who read the Constitution recognized that the federal government's authority would be very extensive and often ambiguous. There was no reason why the document could not explicitly spell out a number of important rights while also clearly noting that the people retained many others. By adding protections for the people's rights, the federal Constitution would appear even more similar to the state constitutions that Americans had previously written for themselves. Doing so would also offer important reassurances to those who remained skeptical about the new government.

The Philadelphia convention may not have given much thought to a bill of rights, but it had provided a method by which Americans could add one. Article V of the Constitution outlined the procedure for amending the nation's fundamental law. On the one hand, the framers knew that Americans would want to make changes to the Constitution whenever necessary. Doing so should not be prohibitively difficult—as it was under the Articles of Confederation. On the other hand, changing the Constitution should not be as easy as passing normal legislation. Given that the Constitution

represented the work of the people, the people should be more directly involved in the process, and any amendments adopted should reflect a significant consensus. Article V seemed to satisfy both of these objectives. Both houses of Congress could begin the process by passing an initial proposal for an amendment by a two-thirds vote (rather than the simple majority needed for regular laws). Alternatively, two-thirds of the states could inform Congress that they desired to amend the Constitution, and Congress would be obligated to call a convention for that purpose. Either way, any proposed amendments would then need to be ratified by three-fourths of the states. Congress would decide whether ratification would take place in the state legislatures or in special state conventions.

Article V served as one of the Constitution's major selling points for Antifederalists—and ultimately for all Americans—since it laid out a path for obtaining whatever changes people felt the Constitution needed. When the federal government convened in New York, Madison and other supporters of the Constitution wanted to show that they had been sincere in welcoming requests for amendments. But which amendments should be added was no easy question. State declarations of rights differed, and state ratifying conventions had made a bewildering variety of suggestions: New Hampshire had proposed twelve amendments; Massachusetts, nine; South Carolina, four; Virginia, forty; and New York, an astounding fifty-seven. As a member of the House, Madison proposed an initial list, and by August 24, 1789, that body had agreed on drafts of seventeen amendments. Taking the House's list, the Senate combined a few amendments, altered the wording of some, and dropped some others. After reconciling a few differences, the two houses, on September 24 and 26, 1789, finally approved a list of twelve proposed amendments to the Constitution.

The first proposed amendment responded to concerns that the members of the House of Representatives would fall increasingly out of touch with their constituents. It stated that there would initially be one representative for every 30,000 Americans, until the House included 100 members, after which the ratio could change to one for every 40,000. When the House

OPPOSITE AND FOLLOWING PAGES: Cat. 14. Bill of Rights as Proposed by the House of Representatives (17 Amendments), 1789

CONGRESS OF THE UNITED STATES.

In the HOUSE of REPRESENTATIVES,

Monday, 24th August, 1789,

RESOLVED, BY THE SENATE AND HOUSE OF REPRESENTATIVES OF THE UNITED STATES OF AMERICA IN CONGRESS ASSEMBLED, two thirds of both Houses deeming it necessary, That the following Articles be proposed to the Legislatures of the several States, as Amendments to the Constitution of the United States, all or any of which Articles, when ratified by three fourths of the said Legislatures, to be valid to all intents and purposes as part of the said Constitution—Viz.

ARTICLES in addition to, and amendment of, the Constitution of the United States of America, proposed by Congress, and ratified by the Legislatures of the several States, pursuant to the fifth Article of the original Constitution.

ARTICLE THE FIRST.

After the first enumeration, required by the first Article of the Constitution, there shall be one Representative for every thirty thousand, until the number shall amount to one hundred, after which the proportion shall be so regulated by Congress, that there shall be not less than one hundred Representatives, nor less than one Representative for every forty thousand persons, until the number of Representatives shall amount to two hundred, after which the proportion shall be so regulated by Congress, that there shall not be less than two hundred Representatives, nor less than one Representative for every fifty thousand persons.

ARTICLE THE SECOND.

No law varying the compensation to the members of Congress, shall take effect, until an election of Representatives shall have intervened.

ARTICLE THE THIRD.

Congress shall make no law establishing religion or prohibiting the free exercise thereof, nor shall the rights of Conscience be infringed.

ARTICLE THE FOURTH.

The Freedom of Speech, and of the Press, and the right of the People peaceably to assemble, and consult for their common good, and to apply to the Government for a redress of grievances, shall not be infringed.

ARTICLE the FIFTH.

A well regulated militia, composed of the body of the People, being the best security of a free State, the right of the People to keep and bear arms, shall not be infringed, but no one religiously scrupulous of bearing arms, shall be compelled to render military service in person.

ARTICLE the SIXTH.

No soldier shall, in time of peace, be quartered in any house without the consent of the owner, nor in time of war, but in a manner to be prescribed by law.

ARTICLE the SEVENTH.

The right of the People to be secure in their persons, houses, papers and effects, against unreasonable searches and seizures, shall not be violated, and no warrants shall issue, but upon probable cause supported by oath or affirmation, and particularly describing the place to be searched, and the persons or things to be seized.

ARTICLE the EIGHTH.

No person shall be subject, except in case of impeachment, to more than one trial, or one punishment for the same offence, nor shall be compelled in any criminal case, to be a witness against himself, nor be deprived of life, liberty or property, without due process of law; nor shall private property be taken for public use without just compensation.

ARTICLE the NINTH.

In all criminal prosecutions, the accused shall enjoy the right to a speedy and public trial, to be informed of the nature and cause of the accusation, to be confronted with the witnesses against him, to have compulsory process for obtaining witnesses in his favor, and to have the assistance of counsel for his defence.

ARTICLE the TENTH.

The trial of all crimes (except in cases of impeachment, and in cases arising in the land or naval forces, or in the militia when in actual service in time of War or public danger) shall be by an Impartial Jury of the Vicinage, with the requisite of unanimity for conviction, the right of challenge, and other accostomed requisites; and no person shall be held to answer for a capital, or otherways infamous crime, unless on a presentment or indictment by a Grand Jury; but if a crime be committed in a place in the possession of an enemy, or in which an insurrection may prevail, the indictment and trial may by law be authorised in some other place within the same State.

ARTICLE the ELEVENTH.

No appeal to the Supreme Court of the United States, shall be allowed, where the value in controversy shall not amount to one thousand dollars, nor shall any fact, triable by a Jury according to the course of the common law, be otherwise re-examinable, than according to the rules of common law.

ARTICLE the TWELFTH.

In suits at common law, the right of trial by Jury shall be preserved.

ARTICLE the THIRTEENTH.

Excessive bail shall not be required, nor excessive fines imposed, nor cruel and unusual punishments inflicted.

ARTICLE the FOURTEENTH.

No State shall infringe the right of trial by Jury in criminal cases, nor the rights of conscience, nor the freedom of speech, or of the press.

ARTICLE the FIFTEENTH.

The enumeration in the Constitution of certain rights, shall not be construed to deny or disparage others retained by the people.

ARTICLE the SIXTEENTH.

The powers delegated by the Constitution to the government of the United States, shall be exercised as therein appropriated, so that the Legislative shall never exercise the powers vested in the Executive or Judicial; nor the Executive the powers vested in the Legislative or Judicial; nor the Judicial the powers vested in the Legislative or Executive.

ARTICLE the SEVENTEENTH.

The powers not delegated by the Constitution, nor prohibited by it, to the States, are reserved to the States respectively.

Teste,

JOHN BECKLEY, Clerk.

In Senate, *August* 25, 1789.

Read and ordered to be printed for the consideration of the Senate.

Attest, **SAMUEL A. OTIS, Secretary.**

New-York, Printed by T. Greenleaf, near the Coffee-House.

contained 200 members based on this formula, the ratio would be further adjusted to a maximum of one representative for every 50,000 Americans. The size of the House might then expand indefinitely according to this ratio. The first federal census, conducted the following year, would report a total of about 3.9 million people (including just under 700,000 slaves). The proposed amendment thus appeared very reasonable at the time. For the foreseeable future, the United States House of Representatives, by these rules, would contain perhaps a few hundred members—not many more than some state legislatures. But if the population increased dramatically, as many assumed it would, then the House might become very large indeed. Were there one representative for every 50,000 Americans today, when the U.S. population exceeds 300 million, the House would contain more than 6,000 representatives. The amendment was not ultimately ratified, however, and Congress eventually capped the size of the House at 435 members.

The second amendment that Congress proposed in 1789 mandated that any pay raises for Congress take effect only after an intervening election. This would prevent legislators from increasing their own salaries immediately. Americans apparently did not consider this issue very important at the time, and the states failed to ratify the amendment. Incredibly, in 1992, after sitting on the books for over two centuries, the proposal finally achieved ratification by more than three-fourths of the (now fifty) states, and it became part of the Constitution as the Twenty-Seventh Amendment.

The last ten amendments proposed in 1789 did achieve ratification, and they comprise some of the most celebrated and important statements in all of American constitutionalism. The first of these declared that "Congress shall make no law respecting an establishment of religion, or prohibiting the free exercise thereof." The United States would not have an official religion (though states could continue to support specific denominations). The First Amendment (the original "Article the Third" in the list approved by Congress) also denied Congress the power of "abridging the freedom of speech, or of the press; or the right of the people peaceably to assemble, and to petition the

Government for a redress of grievances." By expressing their views in speech, assembly, or writing, the people could hold their government accountable for its actions and ensure that it remained firmly under their control. Echoing similar declarations found in state constitutions, the Second Amendment affirmed that "A well regulated militia, being necessary to the security of a free State, the right of the people to keep and bear arms, shall not be infringed." Harking back to issues precipitating the American Revolution (and ultimately to the English Bill of Rights of 1689), the Third Amendment guaranteed that "no soldier shall, in time of peace be quartered in any house, without the consent of the owner, nor in time of war, but in a manner prescribed by law."

The next five amendments helped outline a legal system worthy of a free republic. The Fourth Amendment assured citizens that they would be "secure in their persons, houses, papers, and effects, against unreasonable searches and seizures," and that "no warrants shall issue, but upon probable cause, supported by oath or affirmation, and particularly describing the place to be searched, and the persons or things to be seized." The Fifth Amendment guaranteed the right to "due process of law" while declaring also that no one could be tried in federal court "for the same offense twice" or "be compelled in any criminal case to be a witness against himself." The Sixth Amendment guaranteed citizens "the right to a speedy and public trial, by an impartial Jury" when facing criminal charges, and the Seventh Amendment guaranteed trial by jury in civil cases as well. The Eighth Amendment prohibited "excessive bail," "excessive fines," and "cruel and unusual punishments." Together these guarantees added substance to the idea of the equality of all citizens. Everyone was subject to the same set of rules, and all enjoyed the same protections. This is what John Adams and other revolutionaries had meant when they spoke of "a government of laws, and not of men."

The final two amendments presented important but rather general statements. More philosophical than specific, they attempted to sum up the spirit of the form of government Americans had created through their constitution. The Ninth Amendment avowed that "the

OPPOSITE AND FOLLOWING PAGES: Cat. 15. Bill of Rights as Approved by Congress (12 Amendments), 1789

JOURNAL

OF THE FIRST SESSION OF THE

SENATE

OF THE

UnitedStatesofAmerica,

BEGUN AND HELD

AT THE

CITY OF NEW-YORK,

MARCH 4th, 1789,

AND

IN THE THIRTEENTH YEAR OF THE

INDEPENDENCE OF THE SAID STATES.

NEW-YORK, PRINTED BY THOMAS GREENLEAF,
——M,DCC,LXXX,IX.——

The Conventions of a Number of the States having, at the Time of their adopting the Constitution, expressed a Desire, in order to prevent misconstruction or abuse of its Powers, that further declaratory and restrictive Clauses should be added : And as extending the Ground of public Confidence in the Government, will best insure the beneficent Ends of its Institution—

RESOLVED, by the Senate and House of Representatives of the United States of America in Congress assembled, two thirds of both Houses concurring, That the following Articles be proposed to the Legislatures of the several States, as Amendments to the Constitution of the United States, all or any of which Articles, when ratified by three fourths of the said Legislatures, to be valid to all intents and purposes, as part of the said Constitution—Viz.

Articles in addition to, and amendment of, the Constitution of the United States of America, proposed by Congress, and ratified by the Legislatures of the several States, pursuant to the fifth Article of the original Constitution.

ARTICLE the FIRST.

After the first enumeration, required by the first Article of the Constitution, there shall be one Representative for every thirty thousand, until the number shall amount to one hundred ; after which the proportion shall be so regulated by Congress, that there shall be not less than one hundred Representatives, nor less than one Representative for every forty thousand persons, until the number of Representatives shall amount to two hundred ; after which the proportion shall be so regulated by Congress, that there shall not be less than two hundred Representatives, nor more than one Representative for every fifty thousand persons.

ARTICLE the SECOND.

No law, varying the compensation for the services of the Senators and Representatives, shall take effect, until an election of Representatives shall have intervened.

ARTICLE the THIRD.

Congress shall make no law respecting an establishment of religion, or prohibiting the free exercise thereof, or abridging the freedom of speech, or of the press, or the right of the people peaceably to assemble, and to petition the Government for a redress of grievances.

ARTICLE the FOURTH.

A well regulated militia, being necessary to the security of a free State, the right of the people to keep and bear arms, shall not be infringed.

ARTICLE the FIFTH.

No soldier shall, in time of peace, be quartered in any house, without the consent of the owner, nor in time of war, but in a manner to be prescribed by law.

ARTICLE THE SIXTH.

The right of the people to be fecure in their perfons, houfes, papers, and effects, againft unreafonable fearches and feizures, fhall not be violated, and no warrants fhall iffue, but upon probable caufe, fupported by oath or affirmation, and particularly defcribing the place to be fearched, and the perfons or things to be feized.

ARTICLE THE SEVENTH.

No perfon fhall be held to anfwer for a capital, or otherwife infamous crime, unlefs on a prefentment or indictment of a Grand Jury, except in cafes arifing in the land or naval forces, or in the militia, when in actual fervice in time of war or public danger : nor fhall any perfon be fubject for the fame offence to be twice put in jeopardy of life or limb ; nor fhall be compelled in any criminal cafe, to be a witnefs againft himfelf, nor be deprived of life, liberty or property, without due procefs of law ; nor fhall private property be taken for public ufe without juft compenfation.

ARTICLE THE EIGHTH.

In all criminal profecutions the accufed fhall enjoy the right to a fpeedy and public trial by an impartial Jury of the State and Diftrict wherein the crime fhall have been committed, which Diftrict fhall have been previoufly afcertained by law ; and to be informed of the nature and caufe of the accufation, to be confronted with the witneffes againft him, to have compulfory procefs for obtaining witneffes in his favor, and to have the affiftance of counfel for his defence.

ARTICLE THE NINTH.

In fuits at common law, where the value in controverfy fhall exceed twenty dollars, the right of trial by Jury fhall be preferved, and no fact, tried by a Jury, fhall be otherwife re-examined in any court of the United States, than according to the rules of the common law.

ARTICLE THE TENTH.

Exceffive bail fhall not be required, nor exceffive fines impofed, nor cruel and unufual punifhments inflicted.

ARTICLE THE ELEVENTH.

The enumeration in the Conftitution, of certain rights, fhall not be conftrued to deny or difparage others retained by the people.

ARTICLE THE TWELFTH.

The powers not delegated to the United States by the Conftitution, nor prohibited by it to the States, are referved to the States refpectively, or to the people.

FREDERICK AUGUSTUS MUHLENBERG,
SPEAKER OF THE HOUSE OF REPRESENTATIVES.

JOHN ADAMS, VICE-PRESIDENT OF THE UNITED STATES, AND PRESIDENT OF THE SENATE.

Atteft.
JOHN BECKLEY, *Clerk of the Houfe of Reprefentatives.*
SAMUEL A. OTIS, *Secretary of the Senate.*

enumeration in the Constitution, of certain rights, shall not be construed to deny or disparage others retained by the people." The Tenth Amendment declared that "the powers not delegated to the United States by the Constitution, nor prohibited by it to the States, are reserved to the States respectively, or to the people." In short, sovereignty continued to lie with the people. The people had, so far, put down on paper only a few of their many rights. The people themselves ultimately decided which rights they possessed, and they were not obligated to write them all down at any one time. In addition, through their constitutions, the people had assigned certain powers to the state and federal governments. If the United States Constitution did not appear to grant the federal government a given power, the exercise of that power was assumed to be left to the state governments, or to no government authority at all. Governments could do only those things that the people had authorized them to do.

These final two amendments, it is fair to say, were especially vague in their implications. In fact, all of the amendments—along with the Constitution as a whole—contained countless ambiguities that would crop up in the course of experience. As precise as Americans tried to be when they wrote constitutions, it was simply impossible to account for how every clause would apply in every situation. A vibrant constitutional democracy ultimately required a robust and legitimate judicial branch that served Americans by wrestling with the immensely complicated and inevitable points of uncertainty that arose in their constitutions and laws. The fact that all amendments to the United States Constitution would simply be appended to the end of the document, rather than inserted into the body of the text next to the provisions they were intended to explain or modify (as Madison at first suggested), meant that those statements would demand particularly careful attention from the nation's judges. The interpretive challenges they present notwithstanding, few Americans then or since disputed the value of these amendments, which eventually came to be called the Bill of Rights. Indeed, Americans continued to debate the meaning of these concise phrases, seeing in them a key to establishing the political system and society in which they hoped to live.

Fixing Presidential Elections

CAT. 16. CERTIFIED MANUSCRIPT COPY OF THE TWELFTH AMENDMENT AS APPROVED BY CONGRESS, 1803

As the eighteenth century came to a close, many Americans looked back on the developments of the preceding decades with awe and admiration. They had no intention ever of dishonoring the founding generation by failing to preserve—or by flippantly undoing—its constitutional handiwork. At the same time, reverence for the constitutional achievements of the past readily fostered a desire to build on the good work already done. After all, a fundamental assumption at the core of the American Revolution, and of the experiment in constitutional democracy, was that it always lay in the people's power to adapt their political systems to the conditions and imperatives of the age. If, after serious reflection, Americans decided that their governments required alterations, they need not hesitate to act. No longer would thousands or millions of people be held captive to the whims of inherited rulers, whose self-interest drove them to resist promising changes. (That this continued to describe the situation of approximately three-quarters of a million enslaved African Americans reminds us that, at this time, white Americans deliberately excluded vast numbers of their fellow countrymen from the benefits of equal citizenship.)

The Constitution had hardly gone into effect before Americans realized that the Philadelphia convention had failed to anticipate every contingency related to the new federal system. Even the wisest and most thorough group of individuals could overlook both small details and potentially major issues. In the 1790s, Americans quickly ratified an amendment to the Constitution guaranteeing states "sovereign immunity": citizens of one state could not sue other states in federal court. The somewhat technical nature of the Eleventh Amendment notwithstanding, the swift approval of another change to the Constitution reinforced the idea that adjustments could be made whenever appropriate.

The Philadelphia convention could not have foreseen the development of national political parties just a few years into President George Washington's

administration. Rival groups headed by Thomas Jefferson on the one hand and men such as John Adams and Alexander Hamilton on the other strongly disagreed about a range of issues that included foreign policy, the future of economic development, and even the basic tone and style that the new national government should adopt. The widespread dissemination of information and opinions in newspapers—itself a logical consequence of the First Amendment's guarantee of freedom of speech—created a far more national political culture in which Americans across the country came to align themselves with one side or another: with Jefferson's "Democratic-Republicans," or with the opposing "Federalists" (who were not exactly the same as the Federalists who had supported ratification of the Constitution). Presidential elections became more organized as the respective parties tried to secure the nation's highest office by backing a single candidate. At the Philadelphia convention, delegates had assumed that there would usually be numerous candidates for president, each with mainly regional, not national, support.

The new national party system, when combined with the Constitution's original method of electing the president, produced results that appeared to many Americans at first curious, and then potentially dangerous. The Constitution mandated that the candidate who received the most electoral votes would become the president (assuming his tally also comprised a majority of electors), and the candidate with the second-most votes the vice-president. The first contested election in 1796 resulted in the elevation of John Adams to the presidency and of his principal political opponent, Thomas Jefferson, to the vice-presidency. Although sharing the executive branch was certainly awkward for the two rivals, the powers of the respective offices—Adams once described the vice-presidency as "the most insignificant Office that ever the Invention of Man contrived or his Imagination conceived"[21]—allowed Adams and Jefferson to coexist without much tension (or interaction).

The election of 1800 called attention to a more troubling issue, one that seemed likely to recur in the future. That year, Democratic-Republicans hoped to elect Jefferson as president and Jefferson's political ally, Aaron Burr, as vice-president. Achieving this outcome appeared easy enough. The Constitution stipulated that each presidential elector cast ballots for two candidates (one of which had to hail from a different state). Since Americans favored Jefferson over the incumbent Adams that cycle, more Democratic-Republican electors were chosen throughout the country. These electors were expected to cast ballots for Jefferson and Burr, but it was assumed that at least one elector would intentionally not vote for Burr, thus guaranteeing Jefferson the presidency and Burr the vice-presidency. Unfortunately, the electors proved so disciplined that Jefferson and Burr each received exactly seventy-three electoral votes. The Constitution dictated that in case of such a tie, the House of Representatives would choose the president. (Each state's contingent of representatives collectively possessed one vote.) To Jefferson's mortification, the ambitious Burr did not gracefully step aside but instead tried to become president himself. Only Burr's reputation as outrageously untrustworthy and unfit for the nation's highest office convinced Federalists to support Jefferson, who was finally elected after thirty-six ballots.

Many Americans worried that subsequent elections would witness similar deadlocks and that the selection of the president would frequently be attended by intrigues and conspiracies. Congress debated how presidential elections might be improved through a constitutional amendment. By late 1803, the House and Senate had agreed on a plan. From now on, presidential electors would cast specific ballots for president and vice-president. As inevitable as this solution appears in retrospect, Americans at the time knew the change carried significant implications for future presidential elections, the nature of the executive, and party-political organization generally. No longer would the second-place candidate, potentially representing the country's minority party, hold an office in the executive branch—as Vice-President Jefferson had done during the administration of President Adams. In addition, by making the election a winner-take-all affair, the new system further encouraged partisan organization.

FOLLOWING PAGES: Cat. 16. Certified Manuscript Copy of the Twelfth Amendment as Approved by Congress, 1803

as Vice President; and they shall make distinct lists of all persons voted for as President, and of all persons voted for as Vice President, and of the number of votes for each, which lists they shall sign and certify, and transmit sealed to the seat of the Government of the United States, directed to the President of the Senate; the President of the Senate shall, in the presence of the Senate and House of Representatives, open all the certificates and the votes shall then be counted;— The person having the greatest number of votes for President, shall be the President, if such number be a majority of the whole number of Electors appointed; and if no person have such majority, then from the persons having the highest numbers not exceeding three on the list of those voted for as President, the House of Representatives shall choose immediately, by ballot, the President. But in choosing the President, the votes shall be taken + by States, the representation from each State having one vote; a quorum for this purpose shall consist of a member or members from two thirds of the States, and a majority of all the States shall be necessary to a choice. And if the House of Representatives shall not choose a President whenever the right of choice shall devolve upon them,

before

before the fourth day of March next following, then the Vice President shall act as President, as, in the case of the death or other constitutional disability of the President.

The person having the greatest number of votes as Vice President, shall be the Vice President, if such number be a majority of the whole number of Electors appointed, and if no person have a majority, then from the two highest numbers on the list, the Senate shall choose the Vice President; a quorum for the purpose shall consist of two thirds of the whole number of Senators, and a majority of the whole number shall be necessary to a choice.

But no person constitutionally ineligible to the Office of President shall be eligible to that of Vice President of the United States.

Nath. Macon, Speaker of the House of Representatives

A. Burr, Vice President of the United States and President of the Senate

Attest

An earlier proposal, defeated by just one vote in the Senate, would also have altered the constitutional provision that left the selection of presidential electors to the discretion of the states by stipulating their selection by smaller districts. Instead of a state casting its entire complement of electoral votes in a single bloc—which maximizes the state's impact on the national election but minimizes the voice of the state's political minority, however sizable—selection of electors by district would have resulted in a more complicated electoral map, albeit one that perhaps more closely reflected the views of the American citizenry as a whole. (Today, the vast majority of states continue to award all their electoral votes to the candidate with the most popular votes statewide—which suggests just how impactful the proposed district method would have been.)

As it was, the House and Senate approved, by the required two-thirds vote, only the separation of presidential and vice-presidential electoral ballots. Ironically, Vice-President Burr, in his capacity as president of the Senate, signed the congressional resolution. It took just over half a year for three-fourths of the states to ratify the Twelfth Amendment and make it part of the Constitution in time for the next presidential election.

Clearly, the governments Americans had created in the founding era would require their constant attention as the nation moved into the new century. Constitutional republics on both the state and federal levels did not run themselves. Compared to the colonial regimes under which Americans had lived previously, or to forms of government that existed in other parts of the world, they placed far greater demands on average citizens. Not only did the people have to create their own governments in the first place, they then had to vote in elections, run for office, engage in constructive civic dialogue, scrutinize the actions of government officials, and consider alterations to the basic constitutional structure of the political system. For all the inconveniences these responsibilities entailed, however, few Americans who bore the burdens of citizenship were willing to part with them. Many more Americans—those still denied the chance to participate solely because of their race or gender, for example—would gladly have made great sacrifices to experience the minor annoyances and unprecedented opportunities full citizenship in a constitutional republic bestowed. Once "the people" controlled their own governments, they could use that awesome power to pursue "happiness" in countless ways. The developments of the nineteenth century, made possible by the system of constitutional government forged during the Revolution, would extend greater liberty and prosperity to many Americans, continued oppression to many others, and a transformed world to all.

1. Thomas Paine, *Common Sense and Related Writings*, ed. Thomas P. Slaughter (Boston: Bedford, 2001), 83, 85.

2. John Adams to James Warren, May 15, 1776, in Paul H. Smith et al., eds., *Letters of Delegates to Congress, 1774–1789* (Washington, D.C.: Library of Congress, 1976–2000), 3: 676.

3. John Adams to Abigail Adams, May 17, 1776, ibid., 4: 18.

4. Gordon S. Wood, *The Creation of the American Republic, 1776–1787* (Chapel Hill: University of North Carolina Press, 1998 [orig. 1969]), 271.

5. Richard Alan Ryerson, *The Revolution Is Now Begun: The Radical Committees of Philadelphia, 1765–1776* (Baltimore: Johns Hopkins University Press, 1978), 234.

6. Oscar Handlin and Mary Handlin, eds., *The Popular Sources of Political Authority: Documents on the Massachusetts Constitution of 1780* (Cambridge, Mass.: Harvard University Press, 1966), 99.

7. Ibid., 122.

8. Ibid., 174–75.

9. Ibid., 297.

10. Ibid., 302.

11. Ibid., 434, 435.

12. R. R. Palmer, *The Age of the Democratic Revolution: A Political History of Europe and America*, vol. 1, *The Challenge* (Princeton: Princeton University Press, 1959), 214.

13. Merrill D. Peterson, ed., *Thomas Jefferson: Writings* (New York: Library of America, 1984), 479.

14. Paine, *Common Sense*, 97, 98.

15. Report of the Annapolis Convention, quoted in Richard Beeman, *Plain, Honest Men: The Making of the American Constitution* (New York: Random House, 2009), 19.

16. Beeman, *Plain, Honest Men*, 154.

17. Ibid., 333.

18. Quoted in ibid., 271.

19. Quoted in ibid., 368.

20. Quoted in ibid., 412.

21. Quoted in Richard Alan Ryerson, *John Adams's Republic: The One, the Few, and the Many* (Baltimore: Johns Hopkins University Press, 2016), 344.

LETTER

FROM

THOMAS WORTHINGTON,

INCLOSING AN

ORDINANCE

PASSED BY THE

Convention of the State of Ohio,

TOGETHER WITH THE

CONSTITUTION,

Formed and agreed to by the Convention for the said State,

AND SUNDRY PROPOSITIONS

Submitted to the Congress of the United States.

23d *December*, 1802.

Referred to Mr. *Randolph*,
　　　　　Mr. *Elmendorf*,
　　　　　Mr. *Goddard*,
　　　　　Mr. *Henderson*, and
　　　　　Mr. *Archer*.

An Expanding Union

Admitting New States to the Union

CAT. 17. OHIO CONSTITUTION OF 1802

Lying along the banks of the Scioto River, about forty miles due north of that tributary's junction with the Ohio, the town of Chillicothe waited only six years after its founding in 1796 to host a gathering most of the world's great cities had yet to witness: a constitutional convention. On November 1, 1802, thirty-five delegates, all elected by the male inhabitants of the region per Congress's instructions, began the task of writing a constitution for the new state of Ohio. The delegates traced their roots from near and far. Edward Tiffin, the Ohio convention's president, had been ten years old in 1776—and still living in his native England. Tiffin emigrated to the United States just after the end of the Revolutionary War, settling first in western Virginia and then, like many other Virginians, moving on to southwestern Ohio. Other settlers, mostly New Englanders, established communities just to the east. By 1800, the territory's white inhabitants numbered over 42,000.

The preamble that the delegates in Chillicothe wrote for their frame of government contains crucial insights about the American constitutional order shaping the future of Ohio and of the continent writ large. The preamble declared that "the people of the eastern division of the territory of the United States northwest of the river Ohio" enjoyed "the right of admission into the General Government as a member of the Union." The United States Constitution, the Northwest Ordinance of 1787, and a recent act of Congress combined to make possible Ohio's admission "on an equal footing with the original States."

Ohio was the first state to be created out of the federal Northwest Territory, a vast tract of land not within the jurisdiction of any other state. The Northwest Ordinance had outlined a plan whereby three to five new states would be carved out of this region. By announcing their intention to expand the national domain in this distinctive way, Americans rejected the example set by other empires, which usually kept their newly acquired or settled lands politically subordinate to the home authority. The thirteen colonies had endured the pernicious effects of such an unequal relationship with Britain and its Parliament, and Americans vowed never to recreate this situation after achieving their independence. From the start, Americans expected to add more republics—not

OPPOSITE: Cat. 17. Ohio Constitution of 1802

CONSTITUTION, &c.

WE the people of the eastern division of the territory of the United States north-west of the river Ohio, having the right of admission into the general government, as a member of the union, consistent with the constitution of the United States, the ordinance of Congress of one thousand seven hundred and eighty-seven, and the law of Congress, entitled, " An act to enable the people of the eastern division of the territory of the United States north-west of the river Ohio, to form a constitution and state government, and for the admission of such state into the union, on an equal footing with the original states, and for other purposes ;" in order to establish justice, promote the welfare and secure the blessings of liberty to ourselves and our posterity, do ordain and establish the following constitution or form of government, and do mutually agree with each other to form ourselves into a free and independent state, by the name of the State of OHIO.

ARCTICLE I.

SEC. I. The legislative authority of this state shall be vested in a general assembly, which shall consist of a senate and house of representatives, both to be elected by the people.

SEC. 2. Within one year after the first meeting of the general assembly and within every subseqent term of four years, an enumeration of all the white male inhabitants above twenty-one years of age, shall be made in such manner as shall be di-

Cat. 17. Ohio Constitution of 1802

colonies—to their federal union. As the Ohio preamble indicated, the United States Constitution (Article IV, Section 3) provided for the incorporation of new states.

Indeed, the Ohio convention delegates would not have been meeting in Chillicothe in 1802 if not for the powerful federal government established by the United States Constitution. On the most basic level, the federal government delivered protection to the territory's settlers. Occupying the Ohio Valley and parts adjacent were many Indian nations, including the Delawares, Wyandots, Shawnees, Miamis, Kickapoos, Ottawas, Potawatomis, and Chippewas. All of these groups had their own distinct identities and perspectives, as well as legitimate claims to the lands upon which white settlers now encroached. After a series of costly and often bloody campaigns, the federal government compelled Native peoples to concede more and more territory. As the area open to settlement expanded in size and became safer, increasing numbers of Americans arrived to exploit Ohio's natural riches.

Americans also flocked to places such as Ohio because the federal government laid out a clear process by which settlers could soon expect to exercise all the prerogatives of constitutional self-government that they had enjoyed in their states of origin. Contrary to some persistent myths about the American "frontier," few settlers longed to reside in a lawless society bereft of the rights and opportunities of citizens. They needed assurances that their property and persons would be secure and that they would have a voice in making the laws under which they lived. The more ambitious among them hoped to hold public office and direct the region's development. (The delegates in Chillicothe surely fell into this category.) While the prospect of enjoying these rights and opportunities drew settlers to new territories, the guarantee that new states would become full members of the federal union ensured that settlers would remain permanently attached to the United States. Americans worried that, without such incentives, their fellow citizens to the west might declare independence and even ally with one of the rival empires that still maintained a presence in North America.

For many of the convention delegates in Chillicothe, the central drama of the American Revolution—the struggle for self-government—seemed not a distant memory but a present and palpable concern. Before

Ohio became a state, authority rested in a federal territorial government that (as many observed at the time) bore striking similarities to the colonial governments established by the British Empire in centuries past. Territorial status allowed inhabitants some opportunities for self-government: an elected legislature, for example. But it also imposed significant restrictions on the people: most obviously a governor, appointed by Congress, who exercised extensive powers. Fortunately, settlers did not need to resort to violent rebellion to vindicate their rights, as an earlier generation had done. Instead, thanks to Congress's foresight, these latter-day colonists looked forward to a time in the near future when they could channel their energies into a peaceful and orderly process of constitution-making.

It took Ohioans less than a month to write and adopt a state constitution in 1802. Predictably, given the convention delegates' intense antipathy for territorial governor Arthur St. Clair and the quasi-colonial regime he represented, the defining feature of Ohio's new frame of government lay in its provisions for a very weak executive. When Edward Tiffin took office as the state's first governor on March 1, 1803, his powers of appointment were severely limited and his ability to veto acts of the legislature was nonexistent. In this respect, Ohio's constitution resembled those that had been written in the early days of the American Revolution, when many states had revolted at the thought of creating any executive officer too akin to the powerful royal governors they had just deposed. In another remarkable Revolutionary parallel, Ohio's convention chose not to submit the constitution for popular ratification. The delegates in Chillicothe remained so confident the people would prefer the republican frame of government they had written to the continued tyranny of federal rule that (in their view) holding a vote on the question seemed a waste of time. Several states had similarly enacted new constitutions without popular ratification in the period immediately surrounding the Declaration of Independence, the assumption then being that the people would rather live under any republican government than continue to recognize British authority.

Perhaps more than anything, then, Ohio's experience confirmed that new generations of Americans—even those residing in places far removed from the

long-settled Atlantic seaboard—could relive and thus continually reinvigorate the spirit of the Revolution in the course of writing new constitutions for new states. Circumstances in other future states differed from those that prevailed in Ohio, and each state would write a constitution suited to its local conditions and its inhabitants' specific preferences. Yet most states followed the same basic path. By the time Ohio officially entered the union in 1803, three stars had already been added to the nation's flag: for Vermont (1791), Kentucky (1792), and Tennessee (1796). Many more were soon to follow. "But who can limit the extent to which the federative principle may operate effectively?"[1] President Thomas Jefferson asked in 1805 as he contemplated the vast tract of land west of the Mississippi River—the Louisiana Purchase—just added to the national domain. Jefferson and many other Americans already envisaged the creation of state republics across the continent. Blithely ignoring Native American rights to these lands, they embraced a distinct form of American expansion made possible by the allure and potential of democratic constitution-making. "Congregate a hundred Americans any where beyond the settlements," one observer wrote in 1859 while visiting Denver, in the future state of Colorado (1876), "and they immediately lay out a city, frame a State Constitution, and apply for admission to the union, while twenty-five of them become candidates for the United States Senate."[2]

Rewriting and Amending Constitutions

CAT. 18. ILLINOIS CONSTITUTION OF 1818

The addition of new states to the union guaranteed that many Americans would be writing constitutions throughout the nineteenth century and into the twentieth. In 1803, Ohio became the seventeenth state; by 1861, with Kansas's admission, the number of states had doubled to thirty-four (though the crisis of secession and Civil War would severely test how many of those states would remain together). By 1912, there were forty-eight states, and in 1959, Alaska and Hawaii's achievement of statehood would bring the total number to fifty.

Yet constitution-writing was even more frequent and widespread in this period than a simple tally of new states might suggest. Americans wrote constitutions not only when their states joined the union, but whenever citizens concluded that their frames of government needed revisions, large or small. Most states have crafted more than one constitution, and many have held numerous conventions. To cite only a few notable examples: New Hampshire has held no fewer than seventeen conventions, while Louisiana and Georgia have both held twelve. Not all of these conventions have resulted in new constitutions, and conventions are not always necessary to make constitutional amendments. Americans have, in fact, devised a variety of procedures to revise or rewrite their fundamental laws.

In the early years of the Republic, Thomas Jefferson and James Madison laid out a set of principles that have greatly influenced how Americans think about constitutional revision. Friends and political allies, Jefferson and Madison shared a commitment to popular sovereignty but emphasized different considerations when it came to the people's power to alter their forms of government. For Jefferson, the most important fact remained the people's absolute right to determine the constitutions under which they lived. Because "the earth belongs always to the living generation," frames of government written by "the dead" could not, as a matter of principle, be considered unshakably binding.[3] The members of the living generation retained a right to repeal the work of their forebears and establish governments more suited to contemporary conditions and attitudes. "Laws and institutions must go hand in hand with the progress of the human mind," Jefferson proclaimed.[4] For his part, Madison urged his fellow citizens to exercise their constitution-making powers with great caution. Good constitutions are hard to write, Madison noted, and the people should be careful not to discard the many valuable contributions bequeathed by earlier generations. Historically, Americans have honored both of these perspectives by making constitutional change possible but not easy.

Early state constitutions experimented with provisions for future revisions. A few—including Virginia's, to Jefferson's chagrin—remained silent on the question, but others revealed Americans groping toward a proper procedure. Pennsylvania's 1776 constitution provided

for a "council of censors" to meet every seven years to consider "whether the constitution has been preserved inviolate in every part." If two-thirds of the censors determined there to be "an absolute necessity of amending any article of the constitution which may be defective," they could call a constitutional convention to address the issue. In 1780, the Massachusetts constitution stipulated that the state hold a referendum every fifteen years in which the people could vote on whether to call a convention.

The notion of regularly gauging the people's interest in reconsidering their state constitution gained widespread approval. Indeed, as of the early twenty-first century, fourteen states still require convention referendums at set intervals.[5] But what if the people did not want to wait until the next mandated opportunity to call a convention? After all, many Americans reasoned, problems with the structure or powers of government could crop up at any time. This view led a number of states to adopt more flexible mechanisms.

In 1818, the new state of Illinois favored this more flexible approach. Following in the tradition of shamelessly borrowing good ideas from other states, Illinois constitution-makers copied Article X, Section 3 of the Tennessee constitution of 1796 word for word. The resulting Article VII of the Illinois constitution stated that two-thirds of the legislature could "recommend" to citizens that the state hold a convention. If a majority of voters agreed, the legislature would arrange for a convention to take place within three months.

This system enabled Illinois inhabitants to alter their form of government whenever and to whatever extent they desired. To be sure, getting two-thirds of both houses of the state legislature to approve a convention could represent a high hurdle in some instances. The record of states that had similar provisions, however, reveals that proponents of constitutional reform could often put together the necessary coalitions. To many Americans, the issues attending their rapidly growing and developing states frequently appeared obvious, and the need for constitutional remedies uncontroversial. Holding full-scale conventions every time the state constitution required some amending

was undoubtedly a rather cumbersome and costly process. Over time, states would look for ways to tinker with their constitutions at less expense. Article V of the United States Constitution offered one example of an amendment procedure that did not require special conventions but was nonetheless viewed as a legitimate expression of popular sovereignty. Still, Americans continued to embrace conventions on the state level. Entirely rewriting a state constitution has always appeared both less daunting and, often, due to drastic transformations in a state's population or circumstances, more necessary than rewriting the immensely complex federal compact. Moreover, the symbolism of holding a constitutional convention could foster a powerful sense of attachment to the Revolutionary generation and its legacy of self-government.

The first attempt to hold a convention in Illinois came only five years after the state's original constitution went into operation. The goal of those who wanted a convention, and who successfully shepherded a referendum bill through the assembly by the requisite two-thirds vote, serves as a reminder that merely implementing a democratic constitutional system does not guarantee the steady progress of liberty and justice for all. In this instance, convention advocates—most of whom were emigrants from southern states—aimed to rewrite the state constitution to legalize slavery in Illinois. Although constitution-makers in 1818 had endorsed the Northwest Ordinance's antislavery language, even slavery's opponents acknowledged the people's sovereign right to repeal their constitution's prohibition on the institution if they so wished. Illinoisans debated the question for the eighteen months leading up to the scheduled referendum. Finally, in August 1824, voters rejected the proposal to hold a convention 6,540 to 4,972. Few citizens were more relieved by the outcome than Illinois governor Edward Coles, a protégé of both Jefferson and Madison. The controversy illustrated the tensions inherent in the constitutional perspectives that those two men had expressed—and that all Americans now revered. The people held awesome power to craft their governments and societies, but when and how should they use that power?

FOLLOWING PAGES: CAT. 18. Illinois Constitution of 1818

Sect. 6. The supreme court, or a majority of the justices there-of, the circuit courts or the justices thereof, shall respectively appoint their own clerks.

Sect. 7. All process, writs, and other proceeding, shall run in the name of "*the people of the state of Illinois*." All prosecutions shall be carried on "*in the name and by the authority of the people of the state of Illinois*," and conclude "*against the peace and dignity of the same*."

Sect. 8. A competent number of justices of the peace shall be appointed in each county in such manner as the general assembly may direct, whose time of service, power, and duties, shall be regulated and defined by law. And justices of the peace when so appointed shall be commissioned by the governor.

ARTICLE V.

Sect. 1. The militia of the state of Illinois shall consist of all free male able bodied persons, negroes, mulattoes and Indians excepted, resident in the state, between the ages of eighteen and forty-five years, except such persons as now are or hereafter may be exempted by the laws of the United States, or of this state, and shall be armed, equipped and trained as the general assembly may provide by law.

Sect. 2. No person or persons conscientiously scrupulous of bearing arms shall be compelled to do militia duty in time of peace, provided such person or persons shall pay an equivalent for such exemption.

Sect. 3. Company, battalion and regimental officers, staff officers excepted, shall be elected by the persons composing their several companies, battalions and regiments.

Sect. 4. Brigadier and major generals shall be elected by the officers of their brigades and divisions respectively.

Sect. 5. All militia officers shall be commissioned by the governor, and may hold their commissions during good behaviour, or until they arrive at the age of sixty years.

Sect. 6. The militia shall in all cases except treason, felony or breach of the peace, be privileged from arrest during their attendance at musters and elections of officers, and in going to and returning from the same.

ARTICLE. VI.

Sect. 1. Neither slavery nor involuntary servitude shall hereafter be introduced into this state, otherwise than for the punishment of crimes, whereof the party shall have been duly convicted; nor shall any male person arrived at the age of twenty-one years, nor female person arrived at the age of eighteen years, be held to serve any person as a servant, under any indenture hereafter made, unless such person shall enter into such indenture while in a state of per-

fect freedom, and on condition of a bona fide consideration received, or to be received for their service. Nor shall any indenture of any negro or mulatto hereafter made and executed out of this state, or if made in this state, where the term of service exceeds one year, be of the least validity, except those given in cases of apprenticeship.

Sect. 2. No person bound to labor in any other state, shall be hired to labor in this state, except within the tract reserved for the salt works near Shawneetown; nor even at that place for a longer period than one year at any one time; nor shall it be allowed there after the year one thousand eight hundred and twenty-five: any violation of this article shall effect the emancipation of such person from his obligation to service.

Sect. 3. Each and every person who has been bound to service by contract or indenture in virtue of the laws of the Illinois Territory, heretofore existing, and in conformity to the provisions of the same, without fraud or collusion, shall be held to a specific performance of their contracts or indentures; and such negroes and mulattoes as have been registered in conformity with the aforesaid laws, shall serve out the time appointed by said laws: Provided however, that the children hereafter born of such persons, negroes or mulattoes, shall become free, the males at the age of twenty-one years, the females at the age of eighteen years. Each and every child born of indentured parents, shall be entered with the clerk of the county in which they reside, by their owners, within six months after the birth of said child.

ARTICLE VII.

Sect. 1. Whenever two-thirds of the general assembly shall think it necessary to alter or amend this constitution, they shall recommend to the electors at the next election of members to the general assembly to vote for or against a convention; and if it shall appear that a majority of all the citizens of the state voting for representatives have voted for a convention, the general assembly shall, at their next session, call a convention, to consist of as many members as there may be in the general assembly; to be chosen in the same manner, at the same place, and by the same electors that choose the general assembly, and which convention shall meet within three months after the said election, for the purpose of revising, altering, or amending this constitution.

ARTICLE VIII.

That the general, great, and essential principles of liberty and free government may be recognised and unalterably established, WE DECLARE,

Democratizing the Judiciary

CAT. 19. MISSISSIPPI CONSTITUTION OF 1832

When Mississippi citizens rewrote their constitution in 1832, they, too, chose not to alter slavery's status in their state. Slavery had been legal in Mississippi from the beginning, as Congress had always permitted it in the federal territory lying between Georgia and the Mississippi River. Settlers flocked to this "southwest" region in the 1810s as a burgeoning market for cotton impelled many planters to seek new lands for the crop's cultivation. With an economy based on plantation agriculture, the men who wrote Mississippi's first state constitution in 1817 (and those who wrote neighboring Alabama's in 1819) gave no thought to restricting slavery. Mississippians' attitudes and assumptions about the institution hardly changed in the subsequent fifteen years; if anything, they became only more entrenched and hard-line. But the state's citizens did change their minds about several key features of their frame of government, and they did not hesitate to adopt dramatic and influential alterations.

Although the irony largely escaped them, Mississippi slaveholders pioneered notable democratic reforms. By 1832, parts of the first state constitution struck many citizens as already out of step with the spirit of the age, which emphasized more strongly than ever before the equality and political capacities of all white men. Mississippians therefore abolished property-owning qualifications to hold elected office, theoretically enabling men of more modest means to pursue political careers. They retained minimum age requirements to hold office (twenty-one for representatives, thirty for senators and the governor), but these were uncontroversial provisions corresponding to similar requirements found in the United States Constitution.

Mississippi constitution-makers (and Americans generally) saw no need to use the federal Constitution as their model in all cases, however. One area that seemed ripe for experimentation was the judicial branch. In 1817, Mississippians had adopted a set of typical provisions: a state supreme court consisting of between four and eight judges "appointed" by joint ballot of the state's House and Senate. Other American constitutions, including the U.S. Constitution,

stipulated that judges be nominated by the executive and confirmed by another body—the Senate, in the federal case. Mississippi had again followed common practice in 1817 by making its judges eligible to serve during "good behavior." Once appointed, they would sit on the bench for life (unless two-thirds of each house of the assembly supported their removal). Increasingly, however, many Americans wondered why the people, who elected the other two branches of government, did not also have a direct and regular voice in choosing the judicial branch. After all, by interpreting the law and resolving disputes, judges served the public as much as any governor or representative. Would it not make sense for these officials to be more responsive to the popular will, and subject to the voters' frequent evaluation of their performance?

Article IV of the Mississippi constitution of 1832 accordingly provided for the popular election of all state judges. A "high court of errors and appeals" (the name given to the state supreme court) would consist of three judges, one for each district established by the legislature, to be elected by the voters to six-year terms. Below the high court, a number of circuit courts would be the first to hear most civil and criminal cases. Voters would elect their circuit court judges every four years. Each county also had a probate court that handled such important matters as wills, "administration of orphans' business," cases involving a wife's dowry rights to a share of her husband's property, and guardianship issues related to people deemed mentally unfit. County probate judges were to be elected every two years, as were a variable number of justices of the peace, who settled minor criminal and civil disputes. Finally, every six years the voters of the state at large were to elect a chancellor who presided over a "superior court of chancery," which heard equity cases.

Mississippians thus significantly increased the number of public officials that ordinary voters elected. In every instance, the constitution required judges to reside in the districts they served. These men would know the voters to whom they owed their offices and would presumably feel some pressure to satisfy their fellow citizens. Did this arrangement represent a positive advancement, though? Some commentators harbored strong doubts. Should those who interpreted the law really be liable to popular influence of this kind?

ARTICLE IV.

JUDICIAL DEPARTMENT.

Sec. 1. The judicial power of this State shall be vested in one High Court of Errors and Appeals, and such other Courts of law and equity as are hereafter provided for in this Constitution.

Sec. 2. The High Court of Errors and Appeals shall consist of three Judges, any two of whom shall form a quorum. The Legislature shall divide the State into three districts, and the qualified electors of each district shall elect one of said Judges for the term of six years.

Sec. 3. The office of one of said Judges shall be vacated in two years, and of one in four years, and of one in six years, so that at the expiration of every two years, one of said Judges shall be elected as aforesaid.

Sec. 4. The High Court of Errors and Appeals shall have no jurisdiction, but such as properly belongs to a Court of Errors and Appeals.

Sec. 5. All vacancies that may occur in said Court, from death, resignation or removal, shall be filled by election as aforesaid. *Provided however*, That if the unexpired term do not exceed one year, the vacancy shall be filled by executive appointment.

Sec. 6. No person shall be eligible to the office of Judge of the High Court of Errors and Appeals, who shall not have attained, at the time of his election, the age of thirty years.

Sec. 7. The High Court of Errors and Appeals shall be held twice in each year, at such place as the Legislature shall direct, until the year eighteen hundred and thirty-six, and afterwards at the seat of Government of the State.

Sec. 8. The Secretary of State, on receiving all the official returns of the first election, shall proceed, forthwith, in the presence and with the assistance of two Justices of the Peace, to determine by lot among the three candidates having the highest number of votes, which of said Judges

Cat. 19. Mississippi Constitution of 1832

Was it right and prudent for judges to run for office as members of specific political parties?

After considering these and other questions that the election of judges raised, Americans elsewhere ultimately followed Mississippi's lead. When Michigan wrote its first constitution in 1835, for instance, it provided for the regular election of all state judges except for those on its supreme court. In 1846, New York rewrote its constitution and made all judgeships elected offices. Over subsequent decades, the majority of other states scrambled to bring their frames of government in line with what appeared to be a new American consensus on the proper mode of constituting a judiciary. Despite the frenetic activity in the states, however, the federal Constitution remained unchanged. The president continued to nominate, and the Senate continued to confirm, all federal judges to life tenure.

Native Americans and American Constitutionalism

CAT. 20. CHOCTAW NATION CONSTITUTION OF 1838

Toward the end of Mississippi's 1832 constitution, amid the hodgepodge of Article VII's "general provisions," came a striking and distinctive clause. "The legislature," Section 18 stated, "shall have power to admit to all the rights and privileges of free white citizens of this State all such persons of the Choctaw and Chickasaw tribes of Indians as shall choose to remain in this State, upon such terms as the legislature may from time to time deem proper." Although this language may have appeared innocuous on its face, Mississippi constitution-makers here referred to the forced removal, initiated just two years before, of most of the state's Native American inhabitants to territory in present-day southern Oklahoma.

Both the federal government and the state of Mississippi played a role in bringing about what Alexis de Tocqueville, the great French chronicler of American democracy, called a "solemn spectacle [that] will stay with me forever." Tocqueville witnessed a group of Choctaws crossing the Mississippi River in the "bitter" cold of late 1831, part of a deadly trek made necessary by the forcible seizure of the Nation's lands.[6] The

United States government's dealings with the Choctaws had begun decades earlier. The Constitution (and the Articles of Confederation before that) made Indian affairs the responsibility of the national government. As it did with many other Native groups, the federal government concluded a series of treaties with the Choctaws beginning in the 1780s that were aimed at reducing their power as well as the extent of territory they controlled. Many white Americans simply wanted the land; others, with varying degrees of sincere conviction, also maintained that Native Americans actually benefited from possessing less territory and being more dependent on whites—since they would be sooner forced to adopt the hallmarks of "civilization" and thereby escape total extinction as a people.

For the Choctaws, treaties and land cessions formed part of a calculated strategy for preserving autonomy and security during a time of profound uncertainty. Every Indian group responded to pressure from white Americans differently. The Choctaws, in fact, at one point allied with the United States and assisted American troops in their wars against other Native Americans (in 1814) and the British (at New Orleans in 1815).

Unfortunately, the federal government and its primary liaison, General Andrew Jackson (alongside whom the Choctaws fought), did not negotiate in good faith. In 1829, Jackson assumed the presidency and continued his lifelong campaign to eliminate the Native presence east of the Mississippi. After Jackson announced (in violation of treaty obligations) that the federal government would no longer prevent state governments from exercising jurisdiction over Native American communities, Mississippi passed laws designed to dismantle Choctaw sovereignty. Jackson also (narrowly) secured funding from Congress to deport tens of thousands of Indians to federal lands west of both the Mississippi River and the Arkansas Territory, which white settlers wanted to keep for themselves. Meanwhile, Secretary of War John Eaton secured a dubious treaty that required most Choctaws to leave Mississippi. About four thousand Choctaws who remained behind endured an oppressive form of second-class status imposed by the state government, as the 1832 constitution had left it to the legislature to extend equal "rights and privileges" only as that body "deem[ed] proper."

THE

CONSTITUTION

AND

LAWS

OF THE

CHOCTAW NATION.

PARK HILL, CHEROKEE NATION.

JOHN CANDY, PRINTER.

—

1840.

Cat. 20. Choctaw Nation Constitution of 1838

CONSTITUTION.

WE the people of the Choctaw Nation, having a right to establish our own form of Government, not inconsistent with the Constitution, Treaties and laws of the United States—by our representatives, assembled in convention at Nunihwaya on Wednesday the third day of October eighteen hundred and thirty eight—

In order to establish justice, insure tranquility, promote the general welfare, and secure to ourselves and our posterity the right of life, liberty and property—We mutually agree with each other to form for ourselves a free and independent Government. And we do hereby recognize the boundaries assigned the Choctaw Nation by the second article of the treaty made and concluded with the United States of America at Dancing Rabbit Creek on the twenty seventh day of September eighteen hundred and thirty; viz:

Beginning near Fort Smith where the Arkansas boundary crosses the Arkansas River; running thence to the source of the Canadian Fork, if in the limits of the United States, or to those limits; thence due south to Red River; thence down Red River to the western boundary of the State of Arkansas; thence north along that line to the beginning—the boundary of the same to be agreeable to the treaty made and concluded at Washington City in the year 1825.

District Boundaries.

For the convenience and good government of the people of the Choctaw Nation—We make, ordain and establish four districts in this Nation, to be known by the following names and boundaries, viz. Moshulatubbee district, Puckshanubbee district, Pushmatahaw district, and Chickasaw district.

Cat. 20. Choctaw Nation Constitution of 1838

"Removed" westward with much suffering and loss of life through a naked exercise of power by American constitutional governments, the Choctaws took steps to ensure their survival. Adopting a written constitution of their own became part of their new strategy. Initially drafted in the wake of the federal government's threat to impose its authority on the Choctaws if they did not make their own formal arrangements, the Choctaw constitution preserved many traditional structures and practices but also incorporated key features of American constitutionalism—a design the Nation thought likely to stave off further federal encroachments on its autonomy. The Choctaws knew that many white Americans remained violently hostile to the notion of Native American constitutions. When the Cherokees had written a constitution for themselves in the late 1820s, the state of Georgia had redoubled its efforts to expel the Nation from its borders.

The 1838 Choctaw constitution's preamble began with "We the people" and announced the Choctaws' intentions "to establish justice, insure tranquility, promote the general welfare, and secure to ourselves and our posterity the right of life, liberty and property." The frame of government accommodated the Choctaw Nation's longstanding organization as a confederacy composed of three separate districts. A fourth district had been added in 1837 after the Chickasaws agreed to join the Choctaw polity. Indeed, Article VII, Section 2 guaranteed citizens of each district the same "privileges and immunities" as citizens of other districts—a provision likely modeled on Article IV, Section 2 of the United States Constitution. The Choctaw constitution ended the traditional practice of hereditary rule and mandated the election of district chiefs every four years by all male citizens over sixteen years old. A "general council" of forty annually elected representatives, apportioned among the respective districts, was to meet every year "to pass such laws and measures as they shall deem expedient for the general good of the Nation." The four district chiefs could veto legislation, but their veto could be overridden by a two-thirds vote of the general council. Each district had a supreme district court and other inferior courts, with the district chiefs appointing judges to serve during good behavior.

A declaration of rights offered freedom of conscience and banned double jeopardy, titles of nobility,

and the establishment of any religion by law. Each Choctaw citizen also enjoyed the right of trial by jury and "a right to bear arms in defence of himself and his country." Unfortunately, the Choctaw constitution's resemblance to other American constitutions and laws extended to the status of African Americans. The constitution prohibited individuals who were "any part negro" from holding office, becoming citizens, or even settling within Choctaw territory. The ban on settlement applied only to free blacks, for the Choctaws permitted slavery. The Choctaws' longstanding embrace of that institution had, in fact, influenced the federal government's decision on where to relocate the Nation. During the debates on removal, northern congressmen had insisted that slaveholding Indians such as the Choctaws and the Cherokees (the latter originally settled in Georgia and Tennessee) remain south of the line of latitude dividing slave and free territory in the United States.

Adopting a constitution did not, in the end, insulate the Choctaws against internal political strife or prevent future injustices by the federal government. In 1857, a small group of Choctaws who stood to benefit if the Nation's land was incorporated within a U.S. federal territory wrote a new constitution that, they believed, would help make this goal a reality. Rightly fearing the rejection of their constitution in a popular ratification referendum, the members of this faction simply declared the new document to be in effect. The U.S. government intervened on their side, and by 1859 the Choctaws had a new constitution that provided for a stronger unitary executive in the form of an overall principal chief. The Civil War quickly redirected the Choctaws' attention, however. Despite some dissenting voices, they allied with the Confederacy—a decision that made the triumphant U.S. government even less sympathetic to the Nation's plight in the decades that followed. Finally abandoning its policy of negotiating with Indian groups as "domestic dependent nations," the federal government implemented new land policies that stripped most tribes in the United States of their communal territory. The Choctaws joined with neighboring Native Americans in a last-ditch effort to stave off a complete end to their governmental autonomy. They wrote a constitution for a proposed "State of Sequoyah," which they ratified in a popular referendum

and sent to Congress at the turn of the twentieth century. But this proved fruitless. In 1907, Congress instead approved the new (white-dominated) state of Oklahoma, and the Choctaw constitution fell by the wayside.

The Choctaws were just one of many Native American groups that persevered throughout an era of enormous transformations and, despite what many white Americans predicted or even hoped, remained a vital presence in the United States. Each group faced unique challenges and circumstances; each responded in different ways. The Choctaws and many other Native American groups adopted their own written constitutions, and all indigenous peoples interacted with other American constitutional governments in one form or another. Not only did this American constitutional regime facilitate the Indians' initial dispossession, but the exclusionary assumptions woven into Americans' foundational documents—about who was capable of becoming an equal citizen—also continued to prevent the true incorporation of Native peoples into the American body politic.

Expanding the Right to Vote (to Some People)

CAT. 21. RHODE ISLAND CONSTITUTION OF 1842

Throughout the nineteenth century, Americans never ceased to debate whom to include and exclude from full participation in political life. One key indicator of any group's status, of course, was whether or not it had the right to vote. The United States Constitution left it up to each state to determine its own qualifications for "suffrage." In 1787, no national consensus had existed regarding precisely which individuals could (and could not) be trusted to exercise the franchise. The result was a profusion of different qualifications, but also some clear trends. Unsurprisingly, very few Native Americans could vote. Many state constitutions restricted suffrage to white men, a requirement frequently assumed to exclude even "civilized" and "assimilated" Indians. Such racial restrictions obviously prevented black men from voting. As the historian Alexander Keyssar notes, by the 1850s only five

states had not formally barred African Americans from the polls—and all of these lay in the northeast and contained only 4 percent of the nation's free black population.[7] No state—aside from New Jersey for a brief period—allowed women to vote.

Not even all white men could count on the right to vote. Many early state constitutions required voters to own a certain amount of property, which ideally took the form of real estate or land. Some states allowed men to meet the requirement by owning other kinds of personal property worth a certain amount. The number of men disqualified from voting because of property qualifications varied from state to state, but this group of otherwise eligible citizens always comprised a significant proportion of the populace.

The justifications for a property requirement drew from two main arguments. The first held that voters needed to demonstrate a sufficient "stake in society." If a man owned his own farm, for example, and paid taxes assessed on its value, he would pay at least some attention to public matters, the thinking went, if only because he knew that the government's policies would eventually affect his own affairs. Such an individual could be trusted to vote for responsible representatives and, it went without saying, to oppose anyone who proposed to infringe property rights. The second argument for property qualifications emphasized the need for voters to maintain their "independence" from external influences. Eighteenth-century Americans generally assumed that a man who worked for someone else—laboring on his farm or in his factory, for instance—remained dangerously dependent on his employer and might vote at his direction. Or, an unscrupulous candidate—one seeking office for personal gain rather than out of any desire to advance the public good—might pander to the vulnerable, impoverished masses by making outlandish promises he had no intention to fulfill. Men who owned enough property to enjoy relative social and economic security, however, could vote objectively and wisely.

Americans never stopped pining for voters who possessed a genuine "stake in society" and exercised "independent" judgment when participating in elections. They just became less and less convinced that ownership of a certain amount of property served as a useful way to measure or promote such virtues. Indeed,

property qualifications seemed increasingly at odds with a belief in the equality of all (white male) citizens. Political parties often found it advantageous to advocate the elimination of restrictions on suffrage, not least because they hoped to augment the ranks of their supporters with the newly enfranchised. For many reasons, then, state after state changed its laws or amended its constitution to remove property qualifications.

The struggle to remove these qualifications sparked a constitutional controversy in Rhode Island and led to one of the stranger episodes in all of American history. Rhode Island had long been synonymous with radicalism and democracy, a reputation grounded in its colonial charter of 1663. The charter had guaranteed religious liberty and had made Rhode Island virtually a self-governing republic inside the British Empire. With no crown governor to expel at the outbreak of the American Revolution, the state simply kept its charter. Over time, though, a frame of government that had seemed radical and democratic in the 1660s appeared increasingly hidebound, elitist, and unsuited to contemporary conditions and values. By 1840, the state's population stood at about 109,000 and was primed to grow rapidly in the decades ahead. Yet representation in the state's assembly continued to be assigned to towns according to the outdated provisions of the 1663 charter, thus allowing a minority of the populace to wield vastly disproportionate power. One initiative this governing minority opposed—correctly assuming it would threaten its dominance—was the elimination of the requirement that voters own $134 worth of real property.

The Rhode Island charter contained no provisions for amendment or replacement, but a coalition finally convinced the legislature to call a constitutional convention. A new frame of government, many hoped, would apportion representation more equitably and eliminate property qualifications for suffrage. Unfortunately, the assembly stipulated that only those who could meet the property requirement could vote for convention delegates—a decision that appeared to guarantee that the new constitution would perpetuate the same flaws and injustices that marred the current political system. Led by a lawyer named Thomas Dorr, those who sup-

ported broadening the franchise organized elections for a competing convention to meet in October 1841, a month before the assembly-sanctioned convention. Dorr and others wrote a "People's Constitution" that did not require voters to own property to vote for state officials. In a popular referendum held that December, nearly 14,000 white men voted to ratify the People's Constitution; only 52 rejected it. The rather incredible tally reflected the fact that the opponents of the constitution boycotted the referendum in an attempt to delegitimize it. Meanwhile, the government-sanctioned convention wrote a document dubbed the "Landholder's Constitution" because it retained property requirements. This constitution, too, was put to a popular referendum but was narrowly rejected by voters.

Rhode Island now witnessed the spectacle of two groups of citizens each claiming to represent the legitimate government of the state. In elections held under the People's Constitution in April 1842, Dorr was elected governor, and he fully intended to see himself inaugurated. The sitting charter-based government refused to acknowledge Dorr's new constitution, however, and it passed remarkably harsh laws to dissuade anyone from supporting it. Finding themselves locked out of the Providence statehouse on the day they had designated for the People's Constitution to go into effect, Dorr and his supporters met elsewhere and started passing their own program of legislation. After unsuccessfully lobbying President John Tyler to recognize his government, Dorr returned to Rhode Island and led his supporters in an ill-conceived attempt to take possession of a state arsenal. No one was hurt, but the debacle forced Dorr to flee and the "government" under the People's Constitution to disband.

At this point, Rhode Island still needed to draft a new constitution and to heal the rift that the attempt to write one had caused. The state government called yet another convention to meet in Newport in September 1842. This constitution, easily ratified in November, granted Dorr and his supporters essentially what they had wanted all along. Under the 1842 constitution, "male native citizen[s] of the United States" no longer needed any set amount of property to vote for state officials.

FOLLOWING PAGES: Cat. 21. Rhode Island Constitution of 1842

of that liberty; and in all trials for libel, both civil and criminal, the truth, unless published from malicious motives, shall be sufficient defence to the person charged.

Sec. 21. The citizens have a right in a peaceable manner to assemble for their common good, and to apply to those invested with the powers of Government, for redress of grievances, or for other purposes, by petition, address, or remonstrance.

Sec. 22. The right of the people to keep and bear arms, shall not be infringed.

Sec. 23. The enumeration of the foregoing rights shall not be construed to impair or deny others retained by the people.

ARTICLE SECOND.
OF THE QUALIFICATION OF ELECTORS.

Section 1. Every male citizen of the United States, of the age of twenty-one years, who has had his residence and home in this State for one year, and in the town or city in which he may claim a right to vote, six months next preceding the time of voting, and who is really and truly possessed in his own right of real estate in such town or city of the value of one hundred and thirty-four dollars over and above all incumbrances, or which shall rent for seven dollars per annum over and above any rent reserved or the interest of any incumbrances thereon, being an estate in fee simple, fee tail, for the life of any person, or an estate in reversion or remainder, which qualifies no other person to vote, the conveyance of which estate, if by deed, shall have been recorded at least ninety days, shall thereafter have a right to vote in the election of all civil officers and on all questions in all legal town or ward meetings so long as he continues so qualified. And if any person hereinbefore described shall own any such estate within this State out of the town or city in which he resides, he shall have a right to vote in the election of all general officers and members of the General Assembly in the town or city in which he shall have had his residence and home for the term of six months next preceding the election, upon producing a certificate from the clerk of the town or city in which his estate lies, bearing date within ten days of the time of his voting, setting forth that such person has a sufficient estate therein to qualify him as a voter; and that the deed, if any, has been recorded ninety days.

Sec. 2. Every [] male native citizen of the United States, of the age of twenty-one years, who has

had his residence and home in this State two years and in the town or city in which he may offer to vote, six months next preceding the time of voting, whose name is registered pursuant to the act calling the convention to frame this constitution, or shall be registered in the office of the clerk of such town or city at least seven days before the time he shall offer to vote. and before the last day of December in the present year; and who has paid or shall pay a tax or taxes assessed upon his estate within this State and within a year of the time of voting to the amount of one dollar, or who shall voluntarily pay at least seven days before the time he shall offer to vote, and before said last day of December, to the clerk or treasurer of the town or city where he resides, the sum of one dollar, or such sum as with his other taxes, shall amount to one dollar, for the support of public schools therein, and shall make proof of the same, by the certificate of the clerk, treasurer or collector of any town or city where such payment is made : or, who being so registered, has been enrolled in any military company in this State, and done military service or duty therein, within the present year, pursuant to law, and shall, (until other proof is required by law,) prove by the certificate of the officer legally commanding the regiment, or chartered, or legally authorized volunteer company in which he may have served or done duty, that he has been equipped and done duty according to law, or by the certificate of the commissioners upon military claims, that he has performed military service, shall have a right to vote in the election of all civil officers, and on all questions in all legally organized town or ward meetings, until the end of the first year after the adoption of this constitution, or until the end of the year eighteen hundred and forty-three.

From and after that time, every such citizen who has had the residence herein required, and whose name shall be registered in the town where he resides, on or before the last day of December, in the year next preceding the time of his voting, and who shall show by legal proof, that he has for and within the year next preceding the time he shall offer to vote, paid a tax or taxes assessed against him in any town or city in this State, to the amount of one dollar, or that he has been enrolled in a military company in this State, been equipped and done duty therein, according to law, and at least, for one day during such year, shall have a right to vote in the election of all civil officers, and on all questions in all legally orga-

The reference to "native" citizens, though, points to one of the ironic and illuminating aspects of Rhode Island's struggle over suffrage. In this period, many who supported broader suffrage for American-born men also frequently desired to make it more difficult for immigrants to vote. Thus the Rhode Island constitution stated that men of foreign birth, though naturalized U.S. citizens, would still have to meet the old $134 property requirement. Such provisions reflected deep-seated suspicions of immigrants' political, religious, cultural, and economic motivations at a time when large numbers of newcomers were arriving in American ports and transforming the areas in which they settled. Other states adopted literacy tests that required would-be voters to read English in order to cast their ballots. Still other states, many of which already contained large numbers of foreign-born inhabitants, adopted the completely opposite policy of granting suffrage to immigrants who simply declared their intent to become U.S. citizens. Arkansas, for example, allowed noncitizens to vote until 1926. Clearly, the debate over immigrants' place in the body politic never ceased. Rhode Island finally amended its constitution to remove the property qualification for naturalized citizens in 1888.

Because Rhode Island's 1842 constitution did not specify that voters had to be white, African American men gained suffrage. Despite Dorr's democratic goal of broadening the franchise, his People's Constitution actually would have excluded blacks. Unsurprisingly, few African Americans had joined Dorr's movement. To reward them for their stance throughout the tumult, the supporters of the state government in the Newport convention ensured that the new constitution's voter-qualification provisions made no mention of race. The role of politics (and simple vindictiveness) in the crafting of Article II speaks to the fragile nature of the rights even free African Americans enjoyed in the United States during this period.

It should be noted, finally, that the "stake in society" ideal lived on in Rhode Island and elsewhere. In Providence, the state's largest city, men still needed $134 worth of property to vote in municipal elections. Likewise, the property requirement still applied for those voting in any of the popular referendums that the 1842 constitution mandated for tax-related propositions.

Payment of an annual $1 "registry tax" remained a requirement for all voters, nonpayment of which in either of the two preceding years would prevent an individual from casting a ballot. Such tax-payment requirements enjoyed fluctuating degrees of support throughout the United States, reappearing in various places at telling moments—most notoriously in the states of the former Confederacy during Reconstruction. More common were provisions that restricted "paupers" from voting. Anyone who received any kind of state support could not be trusted to exercise independent judgment at the polls, many Americans argued, because they would simply vote for those who promised to keep the handouts coming regardless of the consequences for the public at large. Rhode Island's "Dorr War" may have settled one suffrage-related issue in the union's smallest state, but Americans everywhere still faced many profound questions about the right to vote that lay at the heart of their constitutional republics.

A Look Inside a Convention

CAT. 22. DEBATES OF THE LOUISIANA STATE CONSTITUTIONAL CONVENTION OF 1845

Rhode Island's constitutional controversies spilled into the streets in 1841 and 1842. Large numbers of average citizens could not help but notice the commotion and learn something about the issues at stake. In most states, of course, the major constitutional debates occurred in the more distant and (somewhat) more peaceful confines of convention halls. The example of 1787 looms large whenever we think about the relationship between delegates inside a constitutional convention and the rest of the people outside. In Philadelphia, delegates had famously adopted a rule of secrecy, agreeing not to discuss the convention's business in public. Only decades later did a small handful of participants, most importantly James Madison, publish the notes they had scribbled down that summer and finally give Americans a rough, incomplete summary of the convention's deliberations. Yet on this score, as on many others, Americans on the state level did not take the federal convention as their model. State constitutional conventions were far more open affairs, featuring

PROCEEDINGS

AND

DEBATES

OF THE

CONVENTION OF LOUISIANA.

WHICH ASSEMBLED

AT THE CITY OF NEW ORLEANS

JANUARY 14, 1844.

ROBERT J. KER, REPORTER.

NEW ORLEANS:
BESANCON, FERGUSON & Co.,
Printers to the Convention.

1845.

tarte, would have fewer difficulties. He saw no reason why the Convention should not fix the seat of government. It could be more effectually done by the Convention than by the legislature. In the legislature there were various concurrences to be obtained before the measure could be consummated, and it might be defeated against the wishes of the people. It might be lost in the senate, after it had passed the house of representatives, or it might pass both houses and be vetoed by the governor. It was exposed to many casualties if left to the legislature, and the better plan was for us to decide that question as the immediate organs of the people.

Mr. CONRAD of New Orleans, was somewhat surprised at what fell from the gentleman from East Feliciana, (Mr. Dunn) on the subject of the removal of the seat of government being offered as a compromise on the part of the city. He (Mr. Conrad) disclaimed the remotest knowledge of any such compromise. He considered the two questions as entirely distinct—the removal of the seat of government, and the apportionment of representation. He thought the question of the removal of the seat of government, was best committed to the legislature. It was a question for the decision of the legislature, and not for the decision of the Convention. The experiment had been made to take the seat of government from New Orleans, and it had proved abortive. The year succeeding, the legislature returned back to the city, and it was frequently here asserted, that this country legislation was not very remarkable for its sagacity. The question after all was nothing more than this, which village or town shall have the honor and profit of feeding the members of the legislature for a given time.

Mr. BENJAMIN said that he had understood that certain members of the Legislature had expressed the opinion that if the seat of government were taken out of the city, they would be disposed to act with less rigor towards the city in reference to her representation. He had no objection that the question of the seat of government should first be decided, and if its decision were to exercise a favorable influence upon the question of apportionment, he would be glad to have the benefit of that influence

for his proposition. But he would certainly vote against the removal.

Mr. VOORHIES submitted the following substitute, viz :

At the first session of the legislature under this constitution, a law shall be passed to fix a suitable location for the seat of government of this State, which shall take effect in the year 1850; and shall not be subject to any change before the year 1870, and every twenty years thereafter, if deemed proper and expedient.

Mr. WADSWORTH thought it an erroneous idea to suppose that the city of New Orleans exercised any control over the legislature, because it was the seat of government. The question at any rate, properly belonged to the legislature. There was certainly less apprehension of any influence directed towards the legislature being pernicious in the city than in the country. The city was the focus of all the interests of the State, and the legislature were sure to be in possession of both sides of every question. Say what you will, New Orleans was the centre of all information. The idea that was put forth by some persons, that the members of the legislature were seduced from their line of duty in the city, was a most humiliating reproach. Will any member of this body admit that any attempt has been made to seduce him with a plate of gombo, or a stuffed turkey. Yet this was the silly slang that was heard whenever it was proposed to take the seat of government from New Orleans. The Legislature had tried the experiment once, and it had signally failed. They have had the power for thirty-two years, to remove the seat of government, and have done so but once; and immediately afterwards, they repented and brought it back—a sufficient proof that it is best located where it is.

Mr. BEATTY moved for the previous question.

The PRESIDENT then put the question, "shall the main question be now put ?" which motion prevailed.

Mr. VOORHIES then moved to lay indefinitely on the table the said section, and the yeas and nays being called for,

Messrs. Benjamin, Boudousquie, Carriere Cenas, Claiborne, Conrad of New Orleans, Conrad of Jefferson, Derbes, Eustis, Garcia, Ledoux, Legendre, Marigny,

Mazureau, Porche, Preston, Roman, Roselius, St Amand, Soule, Voorhies, Wadsworth and Winchester—23 yeas; and

Messrs. Aubert, Beatty, Bourg, Brazeale, Brent, Briant, Brumfield, Burton Chambliss, Chinn, Covillion, Downs, Dunn, Garrett Humble Hynson, Kenner, Leonard, McCallop, McRae, Mayo, O'Bryan, Peets, Porter, Prescott, of St. Landry, Prudhomme, Pugh, Ratliff, Read, Saunders, Scott of Baton Rouge, Scott of Feliciana, Scott of Madison, Sellers, Stephens, Taylor of Assumption, Waddill, Wederstrandt, Wikoff and Winder—40 nays. The motion was therefore lost.

Mr. BEATTY moved to fill the blank with "1849," and the yeas and nays being called,

Messrs. Aubert, Beatty, Benjamin, Bourg, Brumfield, Burton, Carriere, Covillion, Garett, Hynson, Kenner, Labauve, Leonard, McRae, Mayo, Prescott of St. Landry, Preston, Pugh Read, Scott of Baton Rouge, Scott of Feliciana, Soule, Stephens, Waddill, and Wikoff voted in the affirmative—25 yeas; and

Messrs. Boudousquie, Brazcal,e Brent, Briant Cenas, Chambliss, Chinn, Claiborne, Conrad of New Orleans, Conrad of Jefferson, Derbes, Downs, Dunn, Eustis, Garcia, Humble, Ledoux, Legendre, McCallop, Marigny, Mazureau, O'Bryan, Peets, Porche, Porter, Prudhomm, Ratliff, Roman, Roselius, St. Amand, Scott of Madison, Sellers, Voorhies, Wadsworth, Wederstrandt, Winchester and Winder voted in the negative—37 nays; consequently the motion was lost.

Mr. WEDERSTRANDT then moved to fill the blank with "1848;" the yeas and nays being called for,

Messrs. Beatty, Bourg, Brazeale, Brent, Brumfield, Burton, Chambliss, Chinn, Covillion, Downs, Dunn, Garrett, Humble Hynson, Kenner, Labauve, Leonard, McCallop, McRae, Mayo, O'Bryan Peets, Porter, Prescott of St Landry, Preston, Pugh, Ratliff, Read, Saunders, Scott of Baton Rouge, Scott of Feliciana, Scott of Madison, Sellers, Stephens, Taylor of Assumption, Waddill Wederstrandt, Wikoff and Winder voted in the affirmative—39 yeas; and

Messrs. Aubert Benjamin, Boudousquie, Briant, Carriere, Cenas, Claiborne, Conrad of New Orleans, Conrad of Jefferson, Derbes, Eustis, Garcia, Ledoux, Legendre,

Marigny, Mazureau, Porche, Prudhomme, Roman, Roselius, St. Amand, Soule, Voorhies, Wadsworth and Winchester voted in the negative—25 nays; said motion was carried.

Mr MARIGNY moved that the Convention adjourn till to-morrow at 11 o'clock, a. m., and the yeas and nays being called,

Messrs. Benjamin, Boudousquie, Briant, Brumfield, Cenas, Chambliss, Claiborne, Conrad of New Orleans, Conrad of Jefferson, Derbes, Dunn, Eustis, Garcia, Kenner, Ledoux, Legendre, Leonard, McCallop, McRae, Marigny, Mazureau, O'Bryan, Porche, Porter, Prescott of St. Landry, Preston, Ratliff, Roman, Roselius, St. Amand, Scott of Madison, Soule, Stephens, Wadsworth, Wikoff and Winchester voted for the adjournment—36 yeas; and

Messrs. Aubert, Beatty, Bourg, Brazeale, Brent, Burton, Carriere, Chinn, Covillion, Downs, Garrett, Humble, Hynson, Labauve, Mayo, Peets, Pugh, Read, Saunders, Scott of Baton Rouge, Scott of Feliciana, Sellers, Taylor of Assumption, Voorhies, Waddill, Wederstrandt and Winder voted against the adjournment—27 nays; consequently the motion was carried.

FRIDAY, March 7, 1845.

The Convention met pursuant to adjournment.

The Rev. Mr. NICHOLSON opened the proceedings by prayer.

The journal was read and approved.

Mr. RATLIFF offered the following resolution:

Resolved, That the sum of one hundred and forty-seven dollars be allowed D. O. Nadaud, as a remuneration for that amount paid by him to an assistant, to enable him to keep his records up with the proceedings of the Convention, and that the committee on contingent expenses be authorized to pay the same.

Mr. RATLIFF explained that it was the opinion of himself and another member of the committee on contingent expenses, that the allowance asked for in this resolution, was nothing more than just and proper; and on the score of economy alone, it ought to be allowed. The duties which were imposed upon Mr. Nadaud were very heavy, and in transcribing the journal he has already had to employ a young man to

ongoing interactions between delegates inside the halls and fellow citizens outside.

Many state conventions kept remarkably thorough records of their debates. As the historian Silvana R. Siddali notes in her study of this period, conventions received extensive coverage in newspapers nearby; these reports "were in turn copied in local county papers," where they could be read by hundreds more interested citizens. Those following the conventions at home did not hesitate to write letters expressing their views. Indeed, as Siddali writes, such public opinion "functioned as the single most relentless driving force behind the delegate votes."[8] Well-informed citizens fully intended to hold those they sent to conventions accountable for their decisions, and delegates preferred to incorporate instant feedback into the constitutions they would soon be sending out for the people's endorsement.

In addition to allowing newspapers to cover conventions as they were happening, many states published volumes containing the full records of debates after the fact. The political scientist John Dinan finds that just under half of all state constitutional conventions have arranged for such publications, though usually not before giving the question careful thought.[9] Opponents worried that delegates, knowing that their words would be immortalized, would grandstand and make the conventions longer than necessary. A certain amount of bloviating is inevitable in any democratic gathering, however, and proponents cited the value that recorded debates could offer future generations of citizens looking for insights into how and why their constitutions came to take the forms they did. Pennsylvania's 1837–38 convention generated the most extensive published record, an incredible fourteen volumes. Even the more modest tomes, though, allow us to explore many state conventions in vivid detail.

Nearly verbatim transcripts in the *Proceedings and Debates* of Louisiana's 1844–45 convention, which runs to nearly 1,000 pages, allow readers to track the development of almost every constitutional provision. Just one among the numerous issues discussed in Louisiana concerned the location of the state capital. Americans everywhere recognized that this was no trivial matter. For one thing, the capital's location carried practical and symbolic consequences for a state's political system.

In an age when geographic distance still significantly affected the ease of travel and communication, a well-located capital could offer a larger proportion of a state's citizenry ready access to the institutions and officers of government. Placing one segment of the populace at an obvious geographic disadvantage in this regard could only diminish the government's legitimacy and effectiveness.

In addition, the site of the capital inevitably influenced the state's pattern of growth and development. Many states entered the union as mostly empty frames, their populations clustered in a few small areas of initial settlement. Placing the capital at a particular site could promote the spread of settlement and guarantee that the state's infrastructure—its roads, canals, railroads, and other institutions—would extend throughout the state, to everyone's benefit. For these reasons, towns near the geographic center of a state often won the right to serve as the government's meeting place, even when they at first appeared woefully small or remote. Sometimes the capital cities were literally nonexistent, and state constitutions provided for a commission or some other method to choose a completely undeveloped site. Although many of these capitals never turned into metropolises, all played important roles in the development of their states.

In 1845, the debate in Louisiana pitted those who wanted to keep the capital in New Orleans against those who wanted to relocate it to the north. These positions reflected fundamental cleavages in the state, the product of Louisiana's distinctive history. Originally a French colony founded in the late seventeenth century as an offshoot of Canada, Louisiana became part of the United States in 1803 as a result of the Louisiana Purchase and was admitted to the union in 1812. Its cultural heritage endured thanks to a significant population of French-descended "Creoles" in the area around New Orleans. By 1840, the Crescent City contained about 100,000 of the state's 350,000 inhabitants and was by far the largest city, not only in Louisiana, but in the southern half of the United States. Predictably, citizens in the northern, more rural half of the state wanted the state government to meet elsewhere.

The capital issue came up on March 6, 1845. Delegates had been debating the apportionment of representation throughout the state, and a compromise

was on the table that would grant New Orleans a respectable, if still disproportionately low, number of representatives—if only the city's delegates would agree to give up the state capital. "Large cities were not the appropriate places for the functions of popular governments," one delegate declared. Indeed, "the conflict of interests, and the most weighty considerations of public policy had induced most of the States of the Union to transfer their seats of government into the interior." New Orleans, some delegates asserted, exerted an influence that was "pernicious to sound legislation" while also encouraging "extravagant expenditures" and corrupting everyone who spent time there.

Other delegates defended the city's fitness to serve as the state capital. One reminded the convention that the state government had already experimented with meeting elsewhere. So dissatisfied had the legislature been with extremely rural Donaldsville in 1829 that it had voted to return to New Orleans the following year. Nor had Donaldsville's allegedly more virtuous "country" location improved that session's legislation, which "was not very remarkable for its sagacity." Another delegate argued that New Orleans exerted, if anything, a positive influence on legislators. Because the bustling city was "the centre of all information," the legislators who met there "were sure to be in possession of both sides of every question." The ridiculous notion that "members of the legislature were seduced from their line of duty in the city" through bribes or other vices was entirely without foundation. "Will any member of this body admit that any attempt has been made to seduce him with a plate of gombo, or a stuffed turkey?" the delegate asked. "Yet this was the silly slang that was heard whenever it was proposed to take the seat of government from New Orleans."

In the end, proponents of moving the state capital won out. The Louisiana constitution of 1845 mandated that the legislature select a new "seat of government at some place not less than sixty miles from the city of New Orleans." Once the legislature picked Baton Rouge, the constitution guaranteed that the capital would likely remain there, since four-fifths of both houses needed to agree to move it again. The capital's relocation thus became one of the 1845 constitution's

permanent legacies. Any citizen who obtained a copy of the mammoth *Debates and Proceedings*, published by the state at significant cost, could read for themselves how their delegates had discussed this and countless other issues. The debates were not over, however. Only seven years elapsed before Louisianans called yet another convention and wrote still another constitution.

Dealing with Debt

CAT. 23. NEW YORK CONSTITUTION OF 1846

In New York, delegates to the state's 1846 convention did not need to debate their capital's location. The government had moved to Albany decades before. While New York City had grown into the nation's largest metropolis—and its unofficial economic and financial capital—state officials and citizens found the smaller town up the Hudson River a more suitable meeting place. In 1825, the completion of the Erie Canal, one of the great engineering feats of the age, connected the Hudson River to Lake Erie and made Albany an even more "central" hub. Settlements along the canal's route—such as Buffalo, Rochester, and Syracuse—grew rapidly, distributing the state's population more evenly between the great city to the south and the upstate region. Despite the transformative effects of the canal and subsequent "internal improvement" projects, however, many New Yorkers worried that such undertakings imposed excessive costs on the state's citizens—and on future generations. The state's 1846 constitutional convention, appropriately held in Albany, near the canal's eastern terminus, therefore addressed classic questions that Americans have never definitively settled. What is the proper role of government? How should governments balance the twin goals of actively improving the material conditions of life on the one hand and exercising fiscal restraint on the other?

Internal improvements and their costs became such pressing issues on the state level in this period partly because the federal government declined to take on such tasks. The federal government proved energetic and effective in many ways: it dispossessed Native

FOLLOWING PAGES: Cat. 23. New York Constitution of 1846

appropriated by this article, shall not be sufficient to
fray the necessary expenses of the government, without
tinuing or laying a direct tax, the Legislature may, at its
cretion, supply the deficiency, in whole or in part, from the
plus revenues of the canals, after complying with the p
sions of the first two sections of this article, for paying
interest and extinguishing the principal of the Canal and
neral Fund debt ; but the sum thus appropriated from the su
revenues of the canals shall not exceed annually three hundred
fifty thousand dollars, including the sum of two hundred thou
dollars, provided for by this section for the expenses of the go
ment, until the General Fund debt shall be extinguished, or
the Erie Canal enlargement and Genessee Valley and Black
Canals shall be completed, and after that debt shall be paid, o
said canals shall be completed, then the sum of six hundred
seventy-two thousand five hundred dollars, or so much th
as shall be necessary, may be annually appropriated to defray
expenses of the government.

Section 4. The claims of the State against any incorporated
pany to pay the interest and redeem the principal of the sto
the State loaned or advanced to such company, shall be f
enforced, and not released or compromised ; and the mo
arising from such claims shall be set apart and applied as
of the sinking fund provided in the second section of this
cle. But the time limited for the fulfilment of any conditio
any release or compromise heretofore made or provided for,
be extended by law.

Section 5. If the sinking funds, or either of them, provided in
article, shall prove insufficient to enable the State, on the c
of such fund, to procure the means to satisfy the claims of
creditors of the State as they become payable, the Legisla
shall, by equitable taxes, so increase the revenues of the said f
as to make them, respectively, sufficient perfectly to preserve
public faith. Every contribution or advance to the canals
their debt, from any source, other than their direct revenues, s
with quarterly interest, at the rates then current, be repaid
the Treasury, for the use of the State, out of the canal reve
as soon as it can be done consistently with the just rights of
creditors holding the said canal debt.

Section 6. The Legislature shall not sell, lease, or otherwise
pose of any of the canals of the State; but they shall remain
property of the State and under its management, forever.

Section 7. The Legislature shall never sell or dispose of the salt springs, belonging to this State. The lands contiguous thereto and which may be necessary and convenient for the use of the salt springs, may be sold by authority of law and under the direction of the commissioners of the land office, for the purpose of investing the moneys arising therefrom in other lands alike convenient; but by such sale and purchase the aggregate quantity of these lands shall not be diminished.

Section 8. No moneys shall ever be paid out of the Treasury of this State, or any of its funds, or any of the funds under its management, except in pursuance of an appropriation by law; nor unless such payment be made within two years next after the passage of such appropriation act; and every such law, making a new appropriation, or continuing or reviving an appropriation, shall distinctly specify the sum appropriated, and the object to which it is to be applied ; and it shall not be sufficient for such law to refer to any other law to fix such sum.

Section 9. The credit of the State shall not, in any manner, be given or loaned to, or in aid of any individual association or corporation.

Section 10. The State may, to meet casual deficits or failures in revenues, or for expenses not provided for, contract debts, but such debts, direct and contingent, singly or in the aggregate, shall not at any time, exceed one million of dollars ; and the moneys arising from the loans creating such debts, shall be applied to the purpose for which they were obtained, or to repay the debt so contracted, and to no other purpose whatever.

Section 11. In addition to the above limited power to contract debts, the State may contract debts to repel invasion, suppress insurrection, or defend the State in war; but the money arising from the contracting of such debts shall be applied to the purpose for which it was raised, or to repay such debts, and to no other purpose whatever.

Section 12. Except the debts specified in the tenth and eleventh sections of this article, no debt shall be hereafter contracted by or on behalf of this State, unless such debt shall be authorized by a law, for some single work or object, to be distinctly specified therein; and such law shall impose and provide for the collection of a direct annual tax to pay, and sufficient to pay the interest on such debt as it falls due, and also to pay and discharge the principal of such debt within eighteen years from the time of the contracting thereof.

No such law shall take effect until it shall, at a general elec
have been submitted to the people, and have received a maj
of all the votes cast for and against it, at such election.

On the final passage of such bill in either house of the
gislature, the question shall be taken by ayes and noes, to be
entered on the journals thereof, and shall be: " Shall this bill
and ought the same to receive the sanction of the people?"

The Legislature may at any time, after the approval of
law by the people, if no debt shall have been contracted
pursuance thereof, repeal the same; and may at any time,
law, forbid the contracting of any further debt or liability
der such law; but the tax imposed by such act, in propor
to the debt and liability which may have been contracted
pursuance of such law, shall remain in force and be irrepeala
and be annually collected, until the proceeds thereof shall h
made the provision herein before specified to pay and discha
the interest and principal of such debt and liability.

The money arising from any loan or stock creating such d
or liability, shall be applied to the work or object specified in
act authorising such debt or liability, or for the repayment of s
debt or liability, and for no other purpose whatever.

No such law shall be submitted to be voted on, within th
months after its passage, or at any general election, when a
other law, or any bill, or any amendment to the Constituti
shall be submitted to be voted for or against.

Section 13. Every law which imposes continues or revives a t
shall distinctly state the tax and the object to which it is to
applied; and it shall not be sufficient to refer to any other law
fix such tax or object.

Section 14. On the final passage, in either house of the Legislatu
of every act which imposes, continues, or revives a tax, or creat
a debt or charge, or makes, continues or revives any appropriati
of public or trust money or property, or releases, discharges,
commutes any claim or demand of the State, the question shall
taken by ayes and noes, which shall be duly entered on the jou
nals, and three-fifths of all the members elected to either hous
shall, in all such cases, be necessary to constitute a quoru
therein.

ARTICLE VIII.

SECTION 1. Corporations may be formed under general laws; but shall not be created by special act, except for municipal purposes, and in cases where in the judgment of the Legislature, the objects of the corporation cannot be attained under general laws. All general laws and special acts passed pursuant to this section, may be altered from time to time or repealed.

Section 2. Dues from corporations shall be secured by such individual liability of the corporators and other means as may be prescribed by law.

Section 3. The term corporations as used in this article, shall be construed to include all associations and joint-stock companies having any of the powers or privileges of corporations not possessed by individuals or partnerships. And all corporations shall have the right to sue and shall be subject to be sued in all courts in like cases as natural persons.

Section 4. The Legislature, shall have no power to pass any act granting any special charter for banking purposes; but corporations or associations may be formed for such purposes under general laws.

Section 5. The Legislature shall have no power to pass any law sanctioning in any manner, directly or indirectly, the suspension of specie payments, by any person, association or corporation issuing bank notes of any description.

Section 6. The Legislature shall provide by law for the registry of all bills or notes, issued or put in circulation as money, and shall require ample security for the redemption of the same in specie.

Section 7. The stockholders in every corporation and joint-stock association for banking purposes, issuing bank notes or any kind of paper credits to circulate as money, after the first day of January, one thousand eight hundred and fifty, shall be individually responsible to the amount of their respective share or shares of stock in any such corporation or association, for all its debts and liabilities of every kind, contracted after the said first day of January, one thousand eight hundred and fifty.

Section 8. In case of the insolvency of any bank or banking association, the bill-holders thereof shall be entitled to preference in payment, over all other creditors of such bank or association.

Section 9. It shall be the duty of the Legislature to provide for the organization of cities and incorporated villages, and to restrict their power of taxation, assessment, borrowing money, con-

peoples, facilitated the creation of new states, and even purchased vast tracts of new territory. In 1846 the United States also declared war on Mexico, invading its southern neighbor and forcing it to sell large parts of what would become the American Southwest. But the same constitution that enabled the federal government to exert great power in some areas prevented it from acting in others. Some legal thinkers claimed that the Constitution granted Congress no explicit authority to do such things as construct roads and canals, an argument that Southern slaveholders found especially appealing. If Americans determined that the Constitution allowed Congress to propose and finance massive infrastructure projects, slaveholders reasoned, perhaps in the future they would declare that the Constitution also authorized Congress to abolish slavery.

Even for the majority of Americans who accepted the constitutionality of federal support for internal improvements, the political difficulties of winning enough support for particular projects frequently proved insurmountable. Building a road or digging a canal (or, later, determining the route of a transcontinental rail line) in one part of the country invariably upset Americans who lived elsewhere and would not immediately benefit from the expenditure. Congress struggled to appropriate money and resources in ways all Americans would find equitable. Although the federal government did sponsor some projects in this period, Congress more often found it easier to leave most of the responsibility and expense to the individual states.

After New York's state government subsidized the Erie Canal, other states poured money into similar projects in the hope of reaping comparable benefits. Yet even New York struggled to pay off its canal debt. Many states, whose ventures usually proved far less successful than the Erie Canal, faced bankruptcy. Citizens griped about high taxes for decades. The final straw in New York came in the early 1840s, when members of the pro–internal improvement Whig Party proposed to allocate still more money to expand the state's system of canals. Whatever the proposal's actual merits, it reinforced a belief among many New Yorkers that the state government could not be trusted to manage the people's money responsibly.

Delegates to the 1846 convention made sure that the new constitution significantly restricted the state legislature's ability to authorize expensive projects. Article VII stipulated that the legislature could never contract debts totaling over $1 million to cover ordinary shortfalls in revenue. This meant that the costs of government must be met primarily through taxation rather than borrowing. In Section 12, the constitution declared that the state could go into debt for a specific project only if the law authorizing the undertaking provided for the complete repayment of the debt within eighteen years. If New York taxpayers would not be able to pay off both the principal and the interest in that span, the venture was deemed too expensive and the legislature was prohibited from enacting it. Even pieces of legislation that met the eighteen-year repayment requirement still needed to be "submitted to the people" for their approval at the next general election.

In November 1846, New Yorkers ratified their new constitution by a wide margin of 221,528 to 92,436. The provisions designed to guarantee fiscal restraint on the part of the people's representatives evidently enjoyed broad support, and other states adopted similar measures. Rhode Island's 1842 constitution, for example, required a referendum anytime the legislature wanted to incur a debt over $50,000. A large number of states also changed their constitutions to make legislative sessions biennial. If a legislature met only every two years, it would have fewer opportunities to approve disastrous boondoggles, and taxpayers would also be spared the expense of compensating their representatives for attending superfluous sessions.

Although some of these measures probably reflected a simple aversion to paying taxes, many Americans genuinely believed they had a sacred obligation not to burden future generations of citizens with crushing debts. The New York constitution's eighteen-year repayment requirement closely echoed an idea expressed decades before by Thomas Jefferson. Precisely because each generation had a natural right to craft its own constitution and govern itself, asserted Jefferson in 1789, it followed that the present generation could not "validly extend a debt" beyond the term of nineteen years (Jefferson's preferred definition of a single generation).[10] Overloading members of the succeeding generation with inherited debts restricted their sovereignty, their capacity to choose their own course. Citizens stuck paying for unwise initiatives to which they had not

consented experienced the very antithesis of republican government, and Americans living in the eight states and one federal territory that declared bankruptcy in the 1840s could certainly testify that the consequences of one generation's decisions could linger for decades. Ultimately, Jefferson knew that his philosophical proposition about debt could never be implemented in every instance; the real world was too complex. Clearly, though, as Article VII of the New York constitution attests, the underlying principle continued to resonate with many Americans.

Regulating Banks

CAT. 24. WISCONSIN CONSTITUTION OF 1846

As voters in New York went to the polls to ratify their new constitution, convention delegates in Madison, Wisconsin, continued to write a constitution for their new state. None of the 124 delegates had been born in Wisconsin, which had formally become a federal territory only ten years before. The population of this last section of the old Northwest Territory had increased to a level worthy of statehood still more recently, from 30,000 in 1840 to over 155,000 by 1846. Wisconsin's relative youth notwithstanding, its inhabitants remained attuned to the same economic and financial pressures facing older states. Not only did many Wisconsinites shudder at the thought of future legislatures plunging the state into the debts that bedeviled so many of their neighbors, they also distrusted their legislature's ability to regulate a responsible banking system.

Widespread animus toward banks grew out of sobering recent experiences. Prior to the Civil War, the United States did not have a national circulating medium. Instead, state legislatures permitted hundreds of private and state-chartered banks to issue their own paper notes, which people needed to conduct daily transactions. Unfortunately, many banks engaged in wildly irresponsible practices. When people attempted to exchange their banknotes for the legal tender of metal coins, especially during such economic downturns as the Panic of 1837, banks frequently lacked adequate

reserves and were forced to suspend specie payments, "thereby demolishing the value of paper money everywhere," writes Silvana Siddali. "By the 1840s, every bank in Illinois, Michigan, and Wisconsin had failed."[11]

Writing a state constitution offered citizens the opportunity to rectify past errors and ensure a more responsible future. Many Wisconsin convention delegates aimed to restrict their legislature's authority when it came to the banking system. But how? The leading voice on the issue came from Edward G. Ryan, an Irish-born lawyer who chaired the convention's banking committee. Ryan's extreme solution was simply to prohibit the legislature from authorizing any banks in the entire state. Under Ryan's plan, no corporation would be able to issue notes or receive deposits. In the near future, only large denominations of out-of-state banknotes would be allowed to circulate within Wisconsin. Ryan's proposals gained the convention's approval and became Article X of the 1846 constitution. Some citizens expressed misgivings, however. Cracking down on irresponsible practices and lax regulation was one thing; essentially banning banks completely was quite another. Wisconsinites needed banks to facilitate economic growth. In April 1847, by a vote of 20,231 to 14,116, Wisconsinites refused to ratify the constitution, in no small part because of their displeasure over Article X.

A new convention in late 1847 and early 1848 found a compromise that allowed Wisconsinites to enjoy the advantages of a sophisticated banking system while still retaining tight control over that system's policies. Article XI, Section 5 of the 1848 constitution laid out the process by which banking laws could be enacted. First, the legislature could "submit to the voters, at any general election, the question of 'BANK' or 'NO BANK.'" If a majority voted for the bank option, "then the Legislature shall have power to grant Bank charters, or to pass a general banking law." But this did not mark the end of the people's oversight. Anytime the legislature wanted to pass a banking law, it needed to submit the text to the voters for approval in a mandatory referendum.

Wisconsin's debate over banking speaks to Americans' ambivalent relationship with the financial

FOLLOWING PAGES: Cat. 24. Wisconsin Constitution of 1846

Sec. 2. There shall be a State fund for the support of common schools throughout the State, the capital of which shall be preserved inviolate. All monies that may be granted by the United States to this State, and the clear proceeds of all property real or personal, that has been, or may be granted as aforesaid, for educational purposes (except the lands heretofore granted for the purposes of a University,) or for the use of the State where the purposes of the grant are not specified ; and all monies, and the clear proceeds of all property which may accrue to the State by forfeiture or escheat, shall be appropriated to and made a part of the capital of said fund. The interest on said fund, together with the rents on all such property until sold, shall be inviolably appropriated to the support of said schools annually. Provision shall be made by law for an equal and equitable distribution of the income of the State school fund amongst the several towns, cities and districts, for the support of schools therein respectively, in some just ratio to the number of children who shall reside in the same between the ages of five and sixteen years inclusive.

Sec. 3. Provision shall be made by law requiring the several towns and cities to raise a tax on the taxable property therein, annually, for the support of common schools in said towns and cities respectively.

Sec. 4. The legislature shall provide for a system of common schools, which shall be as nearly uniform as may be throughout the State, and the common schools shall be equally free to all children, and no sectarian instruction be used or permitted in any common school in this State.

Sec. 5. The Legislature shall provide for the establishment of libraries, one at least in each town and city; and the money which shall be paid as an equivalent for exemption from military duty, and the clear proceeds of all fines asses-

sed in the several counties for any breach of the penal laws, shall be exclusively applied to the support of said libraries.

ARTICLE X.

ON BANKS AND BANKING.

Section 1. There shall be no Bank of issue within this State.

Sec. 2. The Legislature shall not have power to authorize or incorporate, by any general or special law, any bank or other institution having any banking power or privilege, or to confer upon any corporation, institution, person or persons any banking power or privilege.

Sec. 3. It shall not be lawful for any corporation, institution, person or persons, within this State, under any pretence or authority, to make or issue any paper money, note, bill, certificate, or other evidence of debt whatever, intended to circulate as money.

Sec. 4. It shall not be lawful for any corporation within this State, under any pretence or authority, to exercise the business of receiving deposits of money, making discounts or buying or selling bills of exchange, or to do any other banking business whatever.

Sec. 5. No branch or agency of any bank or banking institution of the United States, or of any State or Territory within or without the United States, shall be established or maintained within this State.

Sec. 6. It shall not be lawful to circulate within this State after the year one thousand eight hundred and forty-seven, any paper money, note, bill, certificate or other evidence of debt whatever, intended to circulate as money, issued without this State, of any denomination less than ten dollars, or after the year one thousand eight hundred and forty-nine, of any denomination less than twenty dollars.

institutions that have enabled remarkable prosperity but have also left many citizens vulnerable to economic hardship. Harnessing capitalism's potential while taming its excesses has proven to be an ongoing process, one that each generation of citizens has been compelled to address. The specific solution Wisconsinites offered in the 1840s is perhaps less important than their willingness to confront the issue with all the constitutional means at their disposal.

Multicultural Democracy and Its Limits

CAT. 25. DEBATES OF THE CALIFORNIA STATE
CONSTITUTIONAL CONVENTION OF 1849

In contrast to paper banknotes, whose worth depended on the probity of the banks that issued them, gold possessed an intrinsic value largely unaffected by the vagaries of human institutions. Only gold's scarcity prevented it from serving as a primary circulating medium. The Wisconsinites who went to the polls in March 1848 could not have known that a discovery made some 1,500 miles to the west, only a month and a half before, was about to infuse the nation with gold coins worth hundreds of millions of dollars and thereby alleviate many of the monetary issues that had inspired the banking provisions of their new constitution.

The famous gold strike occurred just northeast of modern-day Sacramento, California, on property owned by the Swiss emigrant John Sutter. In a remarkable coincidence, only days later, an American negotiator finalized with his Mexican counterparts the Treaty of Guadalupe Hidalgo, which ended the war between the two nations and officially made California part of the United States. News of the gold rush spread rapidly, spurring tens of thousands of (mostly male) emigrants to risk the arduous trek across the continent. By 1849, California's population had exploded to around 90,000. With more than enough inhabitants to qualify for statehood, a constitutional convention gathered in Monterey on September 1, 1849.

Although most of the forty-eight delegates hailed from one of the eastern states, seven had been born in

California. Others came originally from Spain, France, Scotland, and (since Sutter was elected) Switzerland. The seven *californios*, as they were known, spoke for the sizable number of Mexican citizens who, thanks to the Treaty of Guadalupe Hidalgo, had been granted American citizenship and would now live under the new state constitution as well. Throughout September and the first half of October, delegates debated constitutional provisions that would determine the extent to which this group of American citizens would enjoy the rights and privileges of self-government.

By no means was it a foregone conclusion that the constitution would permit *californios* to vote. As one delegate reminded his colleagues, "in forming a new State, it is clear that we have a right to determine the qualifications of our voters." That right extended to denying suffrage to "those who were previously citizens of Mexico." At first, the convention contemplated enfranchising only "every white male citizen of the United States." When delegates voted on a proposal to add the phrase "and every white male citizen of Mexico, who shall have elected to become a citizen of the United States," they initially deadlocked, 20 to 20, before the chairman of the convention cast the deciding vote in favor of the amendment.

The right to vote was obviously crucial, but former Mexican citizens still faced a significant barrier when it came to participating in public life: language. During an evening session about a month into the convention, a *californio* delegate addressed this concern. Pablo de la Guerra y Noriega had been born in Santa Barbara in 1819. His father, born in Spain, had first arrived in Monterey in 1801, when California was still part of the Spanish Empire. With Mexico achieving its independence in 1821, the younger de la Guerra (as he would be known to history) grew up a citizen of that nation. Serving as a judge after the United States takeover, de la Guerra became particularly aware of the challenges the Spanish-speaking populace encountered as it prepared to navigate an unfamiliar legal and political system. Already a minority, *californios* would be left politically impotent and open to manipulation if English remained the government's sole language. As if to illustrate the point, even the official who

OPPOSITE: Cat. 25. Debates of the California State Constitutional Convention of 1849

Sec. 16. Laws shall be made to exclude from office, serving on juries, and from the right of suffrage, those who shall hereafter be convicted of bribery, forgery, perjury, or other high crimes. The privilege of free suffrage shall be supported by laws regulating elections, and prohibiting, under adequate penalties, all undue influence thereon from power, bribery, tumult, or other improper practice.

Sec. 17. Absence on the business of this State, or of the United States, shall not forfeit a residence once obtained, so as to deprive any one of the right of suffrage, or of being elected or appointed to any office under this Constitution.

Sec. 18. A plurality of the votes given at an election, shall constitute a choice, where not otherwise directed in this Constitution.

Mr. Noriego offered the following:

All laws, decrees, regulations, and provisions emanating from any of the three supreme powers of this State, which from their nature require publication, shall be published in English and Spanish.

Mr. Norton. I believe a section has already been adopted, providing that all laws, &c., shall be published in Spanish as well as in English.

Mr. Botts. We must take care what we are doing here. If I understand the resolution, as I heard it read, it is to engraft in the Constitution that all laws shall be published in Spanish and English. That is a necessity so clear that the Legislature must at once perceive and provide for it; but we cannot but foresee here, that the day will soon arrive when every man in the State will understand the English language. If you engraft this upon the Constitution, you impose an immense and permanent expense upon the people—an expense for which there will be no necessity in a few years. The Legislature will provide for the translation and publication of these laws in Spanish as long as it is necessary. It is one of those things that are vacillating, and should not be put in the permanent fundamental law of the land.

Mr. Noriego. The reason why I make this proposition is, that since this country has been under the American Government, in general all decrees have been published in English. In Santa Barbara, there has been no interpreter at all, and I myself, though my knowledge of the English language is imperfect, have been compelled to translate several public documents. I desire to put it in the Constitution for this reason: that however natural and obvious it may appear that the Legislature should take care of it, the experience of three years has proved that such things may be neglected. The proposition may seem of trival consequence to some; but to me, and those whom I represent, is one of very great importance. The present inhabitants of California will not learn the English language in three or four years; their children may do it; but at present, all laws ought to be published in a language which the people understand, so that every native Californian shall not be at the expense of procuring his own interpreter; and moreover, you will bear in mind that the laws which will hereafter be published, will be very different from those which they obeyed formerly. They cannot obey laws unless they understand them. I do not believe that in six years the adult Spanish population will be able to speak English; but in twenty years they may; and by that time it is very probable that the present Constitution will be altered.

Mr. Tefft moved to amend, by providing that these laws and decrees shall be published in Spanish for a certain number of years.

Mr. Gwin. In support of the section offered by the gentleman from Santa Barbara, I would state that it has been nearly fifty years since Louisiana came into the Union, and they have published laws there in English, French, and Spanish, ever since.

Mr. Lippitt, I am in favor of inserting this provision as drawn up by the gentleman from Santa Barbara. I have no doubt the Legislature will do it; but in order to satisfy the California population, I think it well to insert this provision in the Constitution. No inconvenience will grow out of it. In the course of ten or twenty years, everybody will speak English, and it will then be a very easy matter to have the Constitution altered in that respect. There is this especially in favor of it—that it will satisfy the minds of the whole California population.

recorded the convention's debates for later publication misspelled de le Guerra's name as "Noriego."

De la Guerra proposed to insert into the constitution a section mandating that "all laws, decrees, regulations, and provisions emanating from any of the three supreme powers of this State, which from their nature require publication, shall be published in English and Spanish." In the brief discussion that ensued, Charles T. Botts, a Virginian who had been in California for about sixteen months, questioned whether the constitution needed to include such a binding directive. Botts predicted that "the day will soon arrive when every man in the State will understand the English language," after which the government would be stuck with an unnecessary expense. But de la Guerra's experiences had impressed upon him the importance and urgency of his measure. Capable translators were few and far between. Although his own English was "imperfect," in recent years he had been "compelled to translate several public documents" for the people of Santa Barbara. Perhaps the next generation would become fluent in English, he explained, but it was unrealistic to expect adult *californios* to learn the language in the short span of a few years. "They cannot obey laws unless they understand them," he declared. Other delegates agreed. Louisiana, one reminded his colleagues, still published its laws in English, French, and Spanish. Translating important government documents into Spanish would cause "no inconvenience," another concurred, and it would "satisfy the minds of the whole California population." "The proposition is so reasonable that I trust it will be unanimously adopted," a third stated. And so it was.

Delegates continued to take measures to accommodate Spanish speakers both among themselves and throughout California. One day in the convention, when "the official interpreter was absent on account of illness," Charles Botts forcefully insisted that it would be "unjust" to ask *californios* to vote on measures they did not understand. Delegates also arranged for both English and Spanish copies of the constitution to be distributed prior to the November 13 ratification vote. The constitution passed by a margin of 12,061 to 811. De la Guerra embarked on a successful career in politics, serving as a state senator, lieutenant governor, and district judge before his death in 1874.

The convention and constitution of 1849 suggested that California might embrace the elements of its diverse population within a single body politic, making all inhabitants part of one "people." But if the majority of Californians ever truly contemplated such a future, they quickly repudiated it. Although the constitution banned slavery, it also (with de la Guerra's approval) prohibited black men from voting. The denial of suffrage represented perhaps the slightest injury inflicted upon the Native American population, which suffered appalling violence and privation at the hands of Californians in these years. Moreover, as *californio* delegates such as de la Guerra feared, many Spanish-speaking citizens experienced great difficulties defending their property rights in the American legal system. Indeed, when Californians rewrote their state constitution in 1878–79, they insisted that all government proceedings "be conducted, preserved, and published in no other than the English language." The revised state constitution also infamously declared that "no native of China" could "ever" vote, a provision that remained in force until 1926. Asian immigrants, whom the state constitution baselessly blamed for various "burdens and evils," had been attracted to California by the same opportunities that had drawn thousands of Americans and Europeans to the Pacific coast. The federal government contributed to the discrimination, passing laws restricting Chinese immigration and (until 1943) even denying these immigrants the opportunity to become naturalized citizens. Future generations would have to reverse these and other obstacles to inclusive democracy.

Constituting Religious Freedom

CAT. 26. DESERET CONSTITUTION OF 1872

Among those who first discovered gold at John Sutter's mill in 1848 were several Mormons. These adherents of the Church of Jesus Christ of Latter-day Saints intended to cross the Sierra Nevada mountains and join the settlements that their coreligionists had recently founded along the shores of the Great Salt Lake. Just as California's history reminds us of the United States' cultural and ethnic diversity, the Mormons and the state of Utah highlight the nation's remarkable

CONSTITUTION

OF THE

State of Deseret,

WITH ACCOMPANYING

MEMORIAL

TO

CONGRESS.

ADOPTED MARCH 2, 1872.

Salt Lake City:

PRINTED AT THE DESERET NEWS BOOK AND JOB ESTABLISHMENT.

Cat. 26. Deseret Constitution of 1872

CONSTITUTION

OF THE

STATE OF DESERET.

ORDINANCE.

We, the people of the Territory of Utah, do ordain as follows, and this ordinance shall be irrevocable without the consent of the United States and the people of the State of Deseret.

FIRST.—That we adopt the Constitution of the United States.

SECOND.—That there shall be in this State neither slavery nor involuntary servitude otherwise than in the punishment of crimes whereof the party shall have been duly convicted.

THIRD.—That perfect toleration of religion shall be secured, and no inhabitant of said State shall ever be molested in person or property on account of his or her mode of religious worship.

FOURTH.—That the people inhabiting said Territory do agree and declare, that they forever disclaim all right and title to the unappropriated public lands lying within said Territory, and that the same shall be and remain at the sole and entire disposition of the United States; and that lands belonging to citizens of the United States residing without the said State shall never be taxed higher than the land belonging to residents thereof, and that no taxes shall be imposed by said State on lands or property therein, belonging to, or which may hereafter be purchased by, the United States.

FIFTH.—That such terms, if any, as may be prescribed by Congress as a condition of the admission of the said State into the Union, shall, if ratified by a majority vote of the people thereof, at such time and under such regulations as may be prescribed by this Constitution—thereupon be embraced within, and constitute a part of, this ordinance.

PREAMBLE.

We, the People of the State of Deseret, grateful to Almighty God for our freedom, in order to secure its blessings, insure domestic tranquility, and form a more perfect Government, do establish this

CONSTITUTION.

ARTICLE I.—DECLARATION OF RIGHTS.

SEC. 1.—In Republican Governments all men should possess their natural rights, among which are those of enjoying and defending their lives and liberty, acquiring, possessing and protecting property, and of seeking and obtaining their safety and happiness.

SEC. 2.—All political power is inherent in the people, and all free governments are founded in their authority, and instituted for their benefit; therefore they have an inalienable right to institute government, and to alter, reform, or change the same, when their safety, happiness, and

Cat. 26. Deseret Constitution of 1872

religious mosaic—and the role constitutions have always played in establishing religious freedom.

Americans embraced religious freedom partly as a pragmatic response to the actual presence of many different religious groups in their midst, and partly because of an ideological commitment to the principle that the state possessed no right to dictate private beliefs. Before the Revolution, the colonies already hosted a variety of different faiths. That these were mostly different forms of Protestant Christianity by no means assured civil harmony or government toleration. In Massachusetts, Puritans who had fled religious persecution in England did not hesitate to persecute those who dissented from their own church. Puritans drove a number of colonists to resettle in Rhode Island, whose 1663 charter explicitly guaranteed "full libertie in religious concernements."

After independence, Americans endorsed toleration and the free exercise of religion, but some of their state constitutions still sanctioned official support—in the form of tax money—for particular churches. Connecticut and Massachusetts did not finally abolish their church "establishments" until 1818 and 1833, respectively. Elsewhere, several state constitutions required officeholders to profess certain beliefs. North Carolina's 1776 constitution, to take just one example, excluded anyone "who shall deny the being of God or the truth of the Protestant religion." When North Carolinians amended their constitution in 1835, they still required officeholders to acknowledge "the truth of the Christian religion." The state's 1868 and 1876 constitutions persisted in disqualifying anyone who "den[ied] the being of Almighty God," which removed formal barriers against such groups as Jews and Muslims but retained one for atheists.

By declaring that "Congress shall make no law respecting an establishment of religion, or prohibiting the free exercise thereof," the First Amendment to the United States Constitution guaranteed that there would be no official national religion. Under no circumstances could Americans in 1789 have agreed on any one religion to establish. Just as important, however, the legacy of the Revolution fostered support for a greater separation of "church and state." As such Revolutionaries as Thomas Jefferson and James Madison argued, government endorsement of a particular set of beliefs, or its support for a specific set of clerics, undermined fundamental premises of republican government. Constitutional democracy depended on citizens offering their free consent to the arrangements and laws under which they lived. By exerting an undue influence over individual conscience, government intervention in matters of religion tainted not only a man's most sacred convictions but also his capacity to serve as a true citizen. Indeed, the separation of church and state would lead not to the elimination of religion from the American landscape, proponents insisted, but to religion's full flourishing. Government's absence from the scene would allow all religious sects to vie equally for the people's affections.

The nineteenth century witnessed an explosion in the number of churches and religious ministers. Growth occurred in all denominations, but especially among the Methodists and the Baptists. The number of Roman Catholics increased dramatically beginning in the century's middle decades as waves of immigrants arrived from Ireland and other European countries. Later streams of immigration brought adherents of other Christian churches as well as large numbers of Jews. Although remarkably peaceful and open by any comparative standard, the American religious landscape still produced ugly instances of violence and lingering mutual suspicion. Widespread anti-Catholic sentiment, for instance, spawned riots and fueled nativist, anti-immigrant political movements.

The Mormons emerged in this dynamic context and soon discovered the limits of Americans' religious tolerance. Joseph Smith was living in western New York (near the Erie Canal) when he experienced the visions that led him to publish the Book of Mormon in 1830. Smith and his early followers moved first to northern Ohio and then to Missouri, where suspicious locals harassed and attacked them until even the state's governor issued an order calling for them to be "exterminated" or at least "driven from the State if necessary for the public peace."[12] Mormons found neighboring Illinois no more welcoming. After Smith's murder in 1844, Brigham Young determined to relocate the group far beyond the reach of hostile mobs and government authorities. In the summer of 1847, Young and an initial band of migrants arrived at the Great Salt Lake, where they were technically outside United States jurisdiction.

But not for long: the same Treaty of Guadalupe Hidalgo that made California an American possession also resulted in the transfer to the United States of present-day Utah.

The Mormons turned to constitution-making to escape what they considered an overbearing and unsympathetic federal territorial government. As early as 1849, they petitioned for the creation of the State of Deseret. Taken from the Book of Mormon, which reported its meaning as "honeybee," the name Deseret signified the Mormons' industriousness in transforming an arid land into a thriving oasis. Observers who visited did indeed come away impressed with how much the group had accomplished in a short span. Nevertheless, Congress rejected statehood petitions in 1849 and 1862.

Another constitution of Deseret, written in 1872, outlined a conventional frame of government, complete with a bicameral legislature, a governor with qualified veto power, and an elected judiciary. Convention delegates in Salt Lake City sought to make their proposal even more unobjectionable by inserting into the text several guarantees of religious freedom. A "perfect toleration of religion shall be secured, and no inhabitant of [Deseret] shall be molested in person or property on account of his or her mode of religious worship," the constitution's first page declared. "Free exercise and enjoyment of religious profession and worship, shall, without discrimination or preference, forever be allowed in this State," another provision affirmed. "No religious test shall be ever required as a qualification for holding any office of honor, trust, or profit under this State," still another announced. The letter to Congress that the convention appended to the constitution made no mention of autonomy in religious matters as a motivation for seeking statehood. Instead, it emphasized the "oppressive and anti-republican" territorial government, the need to regulate and exploit business and mining opportunities, and the people's desire to "move forward in the grand march of national progress, as loyal, true, free, and liberal a commonwealth as any among the glorious sisterhood" of the American union.

But Congress feared statehood would further entrench the Mormon practice of polygamy, by which a man kept multiple wives, and it refused to grant the territory's application until the LDS Church officially disavowed the doctrine. Mormons unsuccessfully protested that polygamy, arising as it did out of sincere religious convictions, was protected under the First Amendment's "free exercise" clause. After Congress passed legislation that cracked down on polygamists and dissolved the LDS Church, Mormon leaders relented and renounced the practice in 1890. By 1894, Congress was prepared to accept Utah as a state, provided its citizens "forever prohibited" polygamous marriage. A new constitution written in 1895 did just that while also guaranteeing, for good measure, that public schools would "be free from sectarian control" and that "there shall be no union of church and state." President Grover Cleveland's January 1896 proclamation announcing Utah's admission to the union described the state constitution as fully compatible with "the Constitution of the United States and the Declaration of Independence." The symbolism of "Deseret" lived on in the beehive depicted on the state's seal and flag.

The Mormons had revealed a tension at the core of Americans' commitment to religious diversity. Americans have consistently found it easy—in their constitutions and elsewhere—to praise tolerance and free exercise in the abstract. Yet they often struggle to accept the implications of that commitment when they encounter actual groups of people whose presence they deem threatening and whose views they consider incompatible with America's democratic principles and institutions. Since such dilemmas are inescapable in a free, diverse society like the United States, citizens' only option is to return to those very principles and institutions for guidance in blazing a path forward.

1. "Second Inaugural Address," March 4, 1805, in Merrill D. Peterson, ed., *Thomas Jefferson: Writings* (New York: Library of America, 1984), 519.

2. Albert D. Richardson quoted in D. W. Meinig, *The Shaping of America: A Geographical Perspective on 500 Years of History*, vol. 3, *Transcontinental America, 1850–1915* (New Haven: Yale University Press, 1998), 138.

3. Thomas Jefferson to James Madison, September 6, 1789, in Peterson, ed., *Thomas Jefferson, Writings*, 963.

4. Thomas Jefferson to Samuel Kercheval, July 12, 1816, in ibid., 1401.

5. As of 2009, per John J. Dinan, *The American State Constitutional Tradition* (Lawrence: University Press of Kansas, 2009), 11.

6. Alexis de Tocqueville, *Democracy in America*, trans. Arthur Goldhammer (New York: Library of America, 2004), vol. 1, 374.

7. Alexander Keyssar, *The Right to Vote: The Contested History of Democracy in the United States,* rev. ed. (New York: Basic Books, 2009), 44.

8. Silvana R. Siddali, *Frontier Democracy: Constitutional Conventions in the Old Northwest* (New York: Cambridge University Press, 2016), 59.

9. Dinan, *The American State Constitutional Tradition*, 18.

10. Thomas Jefferson to James Madison, September 6, 1789, in Peterson, ed., *Thomas Jefferson: Writings*, 961.

11. Siddali, *Frontier Democracy*, 354.

12. Governor Lilburn Boggs quoted in Daniel Walker Howe, *What Hath God Wrought: The Transformation of America, 1815–1848* (New York: Oxford University Press, 2007), 319.

THE
CONSTITUTION

OF THE
PENNSYLVANIA SOCIETY,

FOR PROMOTING THE
ABOLITION OF SLAVERY,

AND THE RELIEF OF
FREE NEGROES,

UNLAWFULLY HELD IN
BONDAGE.

BEGUN IN THE YEAR 1774, AND ENLARGED ON THE
TWENTY-THIRD OF APRIL, 1787.

TO WHICH ARE ADDED,

THE ACTS OF
The General Affembly of Pennfylvania,

FOR THE GRADUAL
ABOLITION OF SLAVERY.

" *All Things whatfoever ye would that Men fhould do to you,
do ye even fo to them; for this is the Law and the Pro-
phets.*" Matth. vii. 12.

III

Slavery and Freedom

The Antislavery Movement

CAT. 27. CONSTITUTION OF THE PENNSYLVANIA
ABOLITION SOCIETY, 1787

A new constitution appeared in Philadelphia in
1787—a month before delegates from twelve states
first gathered in the Pennsylvania State House. The
document outlined not the government of a stronger
federal union but the organization and rules for the
Pennsylvania Society for Promoting the Abolition
of Slavery and the Relief of Free Negroes Unlawfully
Held in Bondage. This Pennsylvania Abolition Society
(PAS), as its name is usually shortened, had been
founded in 1775 but now sought to expand its member-
ship and activities.

A constitution offered a convenient way to publi-
cize the organization's goals while also spelling out its
practical mode of operation. God made no distinctions
among "members of the same family," the constitution
asserted, "however diversified they may be, by colour,
situation, religion, or different states of society." It was
the "duty" of all Christians "to use such means as are
in their power, to extend the blessings of freedom to
every part of the human race." Especially in need were
those "fellow-creatures . . . entitled to freedom by
the laws and constitutions of any of the United States,
and who, notwithstanding, are detained in bondage,
by fraud or violence." A president, two vice-presidents,
two secretaries, a treasurer, four counselors (i.e.,
lawyers), and two other committees—all elected
annually—would coordinate PAS efforts on behalf of
free and enslaved African Americans at four meetings
per year. Membership required acceptance of the
society's constitution, payment of annual dues, and
assurance that one did not own slaves. (The society's
president, Benjamin Franklin, had owned at least five
in the past.) Like other constitutions of the era, the
PAS constitution contained a procedure for its own
amendment: members could vote on a change only if
it had been proposed at the previous meeting.

The PAS recognized that American constitutions—
both state and federal—established the key political
contexts for its antislavery activism. Effective advocacy
demanded strategies directed at plausible objectives.
The society expected its lawyers to be experts in "the
laws and constitutions of the states, which relate to the
emancipation of slaves," so they could do such things
as "urge [slaves'] claims to freedom, when legal, before
such persons or courts as are authorized to decide upon

OPPOSITE: Cat. 27. Constitution of the Pennsylvania Abolition Society, 1787

[3]

THE
CONSTITUTION

OF THE

PENNSYLVANIA SOCIETY,

FOR PROMOTING THE

ABOLITION OF SLAVERY,

AND THE RELIEF OF

FREE NEGROES,

UNLAWFULLY HELD IN

BONDAGE;

ENLARGED AT PHILADELPHIA, APRIL 23d, 1787.

IT having pleafed the Creator of the world, to make *Introduction.*
of one flefh all the children of men—it becomes
them to confult and promote each other's happinefs, as
members of the fame family, however diverfified they
may be, by colour, fituation, religion, or different ftates
of fociety. It is more efpecially the duty of thofe per-
fons, who profefs to maintain for themfelves the rights
of human nature, and who acknowledge the obligations
of Chriftianity, to ufe fuch means as are in their power,
to extend the bleffings of freedom to every part of the
human race; and in a more particular manner, to fuch
of their fellow-creatures, as are entitled to freedom by
the laws and conftitutions of any of the United States,

and

them." By the time the PAS gathered for its October 1787 meeting, members also had available to them copies of the new United States Constitution.

The federal Constitution presented slavery's opponents with precious few opportunities for action on the national level. It authorized Congress to regulate the African slave trade beginning in 1808. (Only South Carolina would still permit the importation of African slaves as that year approached, and Congress easily legislated a federal ban.) The Constitution's Article IV, Section 3 also gave Congress the power to "make all needful rules and regulations respecting the territory or other property belonging to the United States," which Congress duly did when it reaffirmed the Ordinance of 1787, with its provision prohibiting slavery in the Northwest Territory. After securing these two measures, however, slavery's opponents encountered mostly obstacles. New England Federalists railed against the inflated strength their political adversaries derived, in Congress and the electoral college, from the Constitution's three-fifths clause, by which three-fifths of the number of enslaved African Americans was added to the population total used to apportion United States representatives. But the requirements to propose and ratify federal amendments (two-thirds majorities in both houses of Congress, then approval by three-fourths of the states) made it virtually impossible to repeal the Constitution's existing protections for slavery. Attacking the institution via this method seemed like a waste of time.

Lobbying state legislatures and constitutional conventions, on the other hand, often yielded significant results. The New England states all abolished slavery during the Revolutionary era. In 1780, Pennsylvania passed its Act for the Gradual Abolition of Slavery. This law declared that all children born into slavery in Pennsylvania after 1780 would gain their freedom at age twenty-eight. New York and New Jersey passed similar "gradual emancipation" measures in 1799 and 1804. Although they permitted slavery to linger well into the nineteenth century, gradual emancipation acts at least established a firm end date for the institution. The members of the PAS considered such "moderate," gradual measures, adopted on the state level, as their best hope to secure their long-term goals.

South of Pennsylvania, slaves comprised a far greater proportion of the total population and slavery was far more integral to the economy. Slavery's opponents in these states believed that their fellow citizens could be persuaded to eliminate the institution if, and only if, they knew they would not have to live alongside former slaves. It had become an article of faith among whites of all ranks, North and South, that the two races could never peacefully coexist in the same society. Some citizens proposed "colonizing" freed slaves on the west coast of Africa, where British philanthropists had already founded Sierra Leone. The idea won the support of numerous state legislatures and several religious denominations, and the American Colonization Society even received appropriations from the federal government. Thomas Jefferson, James Madison (who served for a time as president of the ACS), James Monroe (for whom Liberia's capital was named), Edward Coles (the antislavery governor of Illinois), Henry Clay (the great Kentucky congressman and senator), and even Abraham Lincoln would all ultimately voice support for colonization. After founding Liberia in 1822, the ACS assisted a few thousand African Americans in migrating across the Atlantic. In 1847, the inhabitants declared their independence, wrote a constitution, and established a self-governing republic—all feats, of course, that white Americans had assumed lay beyond their capacities.

Many African American observers in these years pointed out what should have been obvious to all: that the notion of colonizing hundreds of thousands—ultimately millions—of people who considered the United States their home was both completely impractical and deeply offensive. Black abolitionists powerfully invoked the nation's Revolutionary ideals and constitutional heritage to argue that Americans could, in fact, change their course and end the shocking injustices of human bondage and racial oppression. The Declaration of Independence proclaimed Americans' commitment to fundamental equality and rights. How then, the black abolitionist David Walker asked in 1829, could white citizens read the Declaration's plain language and not feel ashamed about their continued support of slavery, which violated every principle they claimed to champion? Moreover, whereas most white Americans—including many abolitionists—read the United States Constitution and saw only robust protections for slavery, many African Americans read the nation's

fundamental law and discerned no insurmountable obstacles to enlarging the sphere of freedom. Indeed, the great black abolitionist Frederick Douglass believed that the Constitution resounded with antislavery principles and also offered a blueprint for achieving meaningful and sweeping reforms in the political arena.

By contrast, that a large contingent of leading white statesmen, all with impeccable democratic credentials, went on record in support of such an absurd plan as colonization speaks to the severity of the nation's dilemma. For it revealed a deep-seated and widespread suspicion that the constitutional governments Americans celebrated as examples to the world would, in the end, prove incapable of resolving the greatest internal threat to the Republic's survival. If enlightened, self-governing citizens could not address the questions of slavery and race through democratic, constitutional means, Americans could only pray for a providential deliverance— the fantasy of colonization—that would remove the issue altogether. The other possibility, about which most Americans feared to speak, was settlement of the question through armed conflict. Yet this, too, would indicate the failure of American constitutionalism and lend credence to those who still doubted that any collection of ordinary people could successfully govern themselves for long.

The Spread of Slavery

CAT. 28. MISSOURI CONSTITUTION OF 1820

Just as some white Americans began to advocate colonizing African Americans on another continent, citizens confronted the more immediate question of whether slavery should be allowed to expand indefinitely on their own soil. Could the people, acting through their federal government, legitimately restrict the institution's spread? A controversy over the proposed state of Missouri presented Americans with an opportunity to prove that their form of constitutional democracy could calm a rancorous debate and prevent an ominous crisis.

As the first decades after the Constitution's ratification witnessed the creation of new states in the lands

lying east of the Mississippi River, the question of whether slavery would ultimately be allowed or prohibited in these additions to the union provoked little controversy. Ohio, Indiana, and Illinois were clearly going to become "free" states, while Kentucky, Tennessee, Alabama, Mississippi, and Louisiana (where the institution had long existed under Spanish and French rule) were just as clearly destined to become "slave" states. The rough geographical symmetry of this pattern of admissions gave rise to rudimentary theories about slavery's suitability to various climates and latitudes. Missouri Territory, however, refused to fall obviously into one section or another. Americans in both the North and South assumed that the new state would, and should, come into the union as part of their particular bloc. Southerners pointed to the presence in Missouri by 1819 of over 10,000 slaves, who had been brought there by white settlers. At the same time, the fact that Missouri shared most of its eastern border with Illinois, a free state, suggested its potential affinity with that section.

The crisis began in February 1819, when James Tallmadge of New York proposed in the House of Representatives that Congress prohibit the introduction of any more slaves into Missouri. In addition, he suggested that Missouri adopt a gradual emancipation policy, similar to those in operation in New York and Pennsylvania, stipulating that all children born into slavery after Missouri's admission to the union would gain their freedom when they turned twenty-five years old. Adoption of gradual emancipation would be made a condition of Congress's acceptance of Missouri's petition for statehood.

Tallmadge's proposal appealed to Northerners for two reasons. First, making Missouri a (relatively) free state would add two senators who could be counted on to advance free-state interests. Even with the benefit of the three-fifths clause, slave states already appeared destined to hold a minority of seats in the House of Representatives. Free-state majorities in both houses of Congress would only reflect the American people's majority views, Northerners reasoned. Second, many Northerners hoped to reserve new states for settlement by white Americans only. Unfortunately, when it came

OPPOSITE: Cat. 28. Missouri Constitution of 1820

[2]

CONSTITUTION

OF

THE STATE OF MISSOURI.

NOVEMBER 16, 1820.

Read, and referred to a select committee.

WASHINGTON:

PRINTED BY GALES & SEATON.

1820.

SEC. 23. Senators and representatives shall, in all cases, except of treason, felony, or breach of the peace, be privileged from arrest during the session of the general assembly, and for fifteen days next before the commencement and after the termination of each session; and for any speech or debate in either house they shall not be questioned in any other place.

SEC. 24. The members of the general assembly shall severally receive from the public treasury a compensation for their services, which may, from time to time, be increased or diminished by law; but no alteration increasing or tending to increase the compensation of members, shall take effect during the session at which such alterations shall be made.

SEC. 25. The general assembly shall direct, by law, in what manner, and in what courts, suits may be brought against the state.

SEC. 26. The general assembly shall have no power to pass laws; First, For the emancipation of slaves without the consent of their owners, or without paying them, before such emancipation, a full equivalent for such slaves so emancipated; and, Second, To prevent bona fide emigrants to this state, or actual settlers therein, from bringing from any of the United States, or from any of their territories, such persons as may there be deemed to be slaves, so long as any persons of the same description are allowed to be held as slaves by the laws of this state.

They shall have power to pass laws; First, To prohibit the introduction into this state of any slave who may have committed any high crime in any other state or territory; Second, To prohibit the introduction of any slave for the purpose of speculation, or as an article of trade or merchandise; Third, To prohibit the introduction of any slave, or the offspring of any slave, who heretofore may have been, or who hereafter may be, imported from any foreign country into the United States, or any territory thereof, in contravention of any existing statute of the United States; and, Fourth, To permit the owners of slaves to emancipate them, saving the rights of creditors, where the person so emancipating will give security that the slave so emancipated shall not become a public charge.

It shall be their duty, as soon as may be, to pass such laws as may be necessary,

First, To prevent free negroes and mulattoes from coming to, and settling in, this state, under any pretext whatsoever; and,

Second, To oblige the owners of slaves to treat them with humanity, and to abstain from all injuries to them extending to life or limb.

SEC. 27. In prosecutions for crimes, slaves shall not be deprived of an impartial trial by jury; and a slave convicted of a capital offence shall suffer the same degree of punishment, and no other, that would be inflicted on a free white person for a like offence; and courts of justice before whom slaves shall be tried, shall assign them counsel for their defence.

SEC. 28. Any person who shall maliciously deprive of life or dis-

Cat. 28. Missouri Constitution of 1820

to the driving motivations for restricting the expansion of slavery in the United States, white Americans' racist aversion to living alongside—and competing for economic opportunities with—allegedly inferior slaves and free blacks often outpaced qualms about the morality of human bondage.

Remarkably, some Southerners cited their desire for slavery's eventual destruction as their reason for opposing any restriction on slavery's permanent spread into Missouri. They theorized that "diffusing" the total number of existing slaves in the United States over a larger geographical area would decrease the concentration of African Americans in any one region, leaving slave owners less likely to fear the consequences of freeing their slaves. At the very least, owners would take steps to "ameliorate" their slaves' condition. According to this view, African Americans represented a serious threat to whites as long as they remained in states where they comprised a large proportion of the populace. Slaveholders had no choice in these circumstances, some argued, but to impose harsh discipline; the alternative was slave revolt and race war. This tortured logic led some Southerners to conclude that Missouri "restrictionists" wanted nothing less than to foment a bloody insurrection throughout the slaveholding states of the union.

Southerners expressed constitutional concerns as well. Congress had never before demanded that the citizens of a new state republic accept as a condition of their admission to the union a policy—gradual emancipation—so determinative of their state's future character. If a heavy-handed Congress prevented American citizens in Missouri from writing the constitution they wanted to write, then Congress would be denying their rights to self-government and deeming some citizens more "equal" than others. Moreover, forcing Missouri to prohibit slavery would suggest that the federal government considered freedom, not slavery, to be the union's official goal—the ideal toward which states should strive. But Southerners objected that the United States Constitution supported no such invidious distinction between slave and free states. How, they asked, could a slaveholding state such as Virginia, the birthplace of countless Revolutionary heroes and of four out of the first five presidents, ever be considered less "republican" than its northern

counterparts? For such slaveholding founders as Jefferson and Madison, accepting this policy would pave the way for the dissolution of the union, and thus for the destruction of their life's work.

The stakes, then, could not have been higher after Tallmadge's proposal passed in the House but suffered defeat in the Senate. Leaders in Congress remained at an impasse for months before finally discovering a solution acceptable to enough legislators from both sections. By the terms of the famous Missouri Compromise, Congress agreed to prohibit slavery in all federal territory acquired in the Louisiana Purchase lying north of 36°30' latitude (Missouri's southern border). Congress would not, however, demand that Missouri's constitution outlaw slavery.

With Congress's conditions for statehood finally clear, Missourians elected delegates to a constitutional convention that met in St. Louis between June 12 and July 19, 1820. The key provisions relating to slavery came in Article III, Section 26. First, the constitution listed steps the state legislature could not take. Most important, the legislature could not pass any laws "for the emancipation of slaves without the consent of their owners." In other words, the legislature could not abolish slavery, immediately or gradually. Every individual slave owner in the state would have to agree, of their own volition, to free their slaves. Nor could the state legislature "prevent bona fide emigrants to this state, or actual settlers therein," from bringing more slaves into Missouri—a direct repudiation of Tallmadge's original proposal. The constitution permitted the legislature to pass laws, similar to those found in other slave states, prohibiting the introduction of the wrong kinds of slaves: criminals; those transported into the state by slave traders merely "for the purpose of speculation"; and those illegally imported into the United States in violation of the federal ban on the African slave trade. Finally, the constitution positively enjoined the legislature "to prevent free negroes and mulattoes [of mixed racial background] from coming to, and settling in, this state, under any pretext whatsoever." Missouri thus followed the example of several other states, slave and free, North and South, which prohibited free African Americans from settling within their borders. Article III, Section 26 concluded with a vague order to the state legislature to "oblige the owners of

slaves to treat them with humanity, and to abstain from all injuries to them extending to life or limb." The people of Missouri had spoken: theirs would be a slave state.

For Americans in 1820, the Missouri Compromise suggested that the constitutional governments they had created over the previous generation could, in fact, cope with the tensions inherent in a large, dynamic, and internally diverse federal republic. Both sections of the country had been mollified and a conflict had been averted. Yet the very fact that there now clearly were two distinct sections of the country, as votes in Congress had revealed, indicated the strong likelihood of future friction.

Balancing the Union Between Slave and Free States

CAT. 29. LIST OF DELEGATES TO THE MAINE STATE CONSTITUTIONAL CONVENTION OF 1819

Another aspect of the Missouri Compromise cast doubt on the notion that the sectional conflict had been contained. In 1820, Americans agreed to continue their practice of adding new states to the union in a way that preserved a balance in the number of slave and free states. As long as slave states maintained equal representation in one chamber of Congress, the Senate, then slaveholders could stave off legislative threats to their "peculiar institution." Americans hoped that the pairing of new states, combined with the Missouri Compromise's other provisions, would minimize the occasions for debating slavery. But prescient observers could have predicted that this policy, in the words of historian D. W. Meinig, "had simply extended the reach and enlarged the arena of confrontation."[1]

When Congress decided to allow Missouri into the union as a slave state, it appeared to face an immediate problem. Missouri's addition would increase the number of slave states to twelve, one more than the number of free states. Congress therefore needed to find another free state, but where? While Michigan Territory, for example, looked promising in the long term, its population barely topped 7,000.

The District of Maine, in contrast, boasted a population of nearly 300,000. Many of these citizens had long favored separation from Massachusetts, which had exercised jurisdiction "Downeast" since colonial days. Given that New Hampshire awkwardly divided Maine from Massachusetts proper, proponents of Maine statehood argued that geography alone destined them to establish their own government. Indeed, geographical separation lay at the root of many complaints about the connection to Massachusetts. Mainers protested that state authorities in Boston paid too little attention to their region's distinctive issues. Even under ideal conditions, the state's political system made it difficult for Maine representatives to set the agenda. The disparity in population between the two parts of the state ensured that the majority of members of both houses of the General Court represented Massachusetts towns. These members naturally looked first and foremost after their own constituents' interests. To make matters worse, the difficulty of traveling to Boston sometimes prevented Maine representatives from attending legislative sessions, while the Massachusetts constitution's requirement that towns pay their own representatives discouraged many hardscrabble communities from electing one at all. Internal tensions over land policies and other issues also led increasing numbers of Maine voters to support the Democratic-Republican Party of Jefferson, which further differentiated the district from generally Federalist Massachusetts.

Maine's statehood movement came to a head just as Congress needed a free state to pair with Missouri. Early petitions for statehood had been rebuffed by the General Court in the 1780s. Some Maine delegates to Massachusetts's 1788 ratifying convention had even opposed the federal Constitution because they believed it would make it harder to achieve a break with the Bay State. In fact, the Constitution laid out a path for Maine statehood. The guarantee in Article IV, Section 3 that "no new state shall be formed or erected within the jurisdiction of any other state" would be waived as soon as Mainers obtained the "consent" of the Massachusetts General Court and Congress. The General Court finally relented in June 1819, and a referendum confirmed (17,091 to 7,132) that the people of Maine

OPPOSITE AND FOLLOWING PAGES: Cat. 29. List of Delegates to the Maine State Constitutional Convention of 1819

[3]

PETITION

OF A

CONVENTION OF THE PEOPLE

OF

THE DISTRICT OF MAINE,

PRAYING TO BE ADMITTED INTO

THE UNION

AS A

SEPARATE AND INDEPENDENT STATE,

ACCOMPANIED WITH

A CONSTITUTION FOR SAID STATE.

———◆———

DECEMBER 8, 1819.

Read, and referred to a Select Committee.

———◆———

WASHINGTON:

PRINTED BY GALES & SEATON.

1819.

Readfield,	John Hubbard,
	Samuel Currier.
Monmouth,	John Chandler,
	Simon Dearborne, junior.
Mount-Vernon,	David McGaffey.
Sidney,	Ambrose Howard,
	Reuel Howard.
Farmington,	Nathan Cutler,
	Jabez Gay.
New-Sharon,	Christopher Dyer.
Clinton,	Herbert Moore.
Fayette,	Charles Smith.
Belgrade,	Elias Taylor.
Harlem,	William Pullen.
AUGUSTA,	Daniel Cony,
	Joshua Gage,
	James Bridge.
Wayne,	Joseph Lamson.
Leeds,	Thomas Francis.
Chesterville,	Ward Locke.
Vienna,	Nathaniel Whittier.
Waterville,	Abijah Smith,
	Ebenezer Bacon.
Gardiner,	Jacob Davis,
	Sanford Kingsbery.
Temple,	Benjamin Abbot.
Wilton,	Ebenezer Eaton.
Rome,	John S. Colboth.
Fairfax,	Joel Wellington.
Unity,	Rufus Burnham.
Malta,	William Hilton.
Freedom,	Mathew Randall.
Joy,	James Parker.
China,	Daniel Stevens.

HANCOCK.

Belfast,	Alfred Johnson, junior.
Islesboro',	Josiah Farrow.
Deer-Isle,	Ignatius Haskell,
	Asa Green.
Bluehill,	Andrew Witham.
Trenton,	Peter Haynes.
Sullivan,	George Henman.
Gouldsborough,	Samuel Davis.
Vinalhaven,	Benjamin Beverage.
Frankfort,	Alexander Milliken,
	Joshua Hall.

Bucksport,	Samuel Little.
Prospect,	Abel W. Atherton.
CASTINE,	William Abbot.
Northport,	David Alden.
Eden,	Nicholas Thomas, junior.
Orland,	Horatio Mason.
Ellsworth,	Mark Shepard,
Lincolnville,	Samuel A. Whitney.
Belmont,	James Weymouth.
Brooks,	Samuel Whitney.
Jackson,	Bordman Johnson.
Searsmont,	Ansel Lathrop.
Swansville,	Eleazer Nickerson.
Thorndike,	Joseph Blethen.
Monroe,	Joseph Neally.
Knox,	James Weed.

WASHINGTON.

MACHIAS,	John Dickinson.
Steuben,	Alexander Nichols.
Harrington,	James Campbell.
Eastport,	John Burgin.
Jonesborough,	Ephraim Whitney.
Calais,	William Vance.
Lubec,	Lemuel Trescott.
Robbinston,	Thomas Vose.
Cherryfield,	Joseph Adams.
Perry,	Peter Golding.

OXFORD.

Fryeburg,	Judah Dana,
Turner,	John Turner,
	Philip Bradford.
Hebron,	Alexander Greenwood.
Buckfield,	Enoch Hall.
PARIS,	James Hooper,
	Benjamin Chandler.
Jay,	Cornelius Holland.
Livermore,	Benjamin Bradford,
	Thomas Chase, junior.
Bethel,	John Grover.
Waterford,	Josiah Shaw.
Narway,	Aaron Wilkins.
Hartfort,	Joseph Tobin.
Sumner,	Calvin Bisbee.
Rumford,	Peter C. Virgin.
Lovell,	Josiah Heald, 2d.

5

wanted statehood. A convention met in Portland in October and wrote a constitution that voters easily ratified.

Printed in Washington, D.C., for the members of Congress whose consent remained the last major hurdle to Maine statehood, a pamphlet version of the constitution listed the 270 or so delegates who participated in the Portland convention. Maine's relatively large population compared to those of other prospective states helps to explain the convention's unusual size. The convention deviated not at all from standard American practice, however, in memorializing the men who had written the state's foundational text. Future generations could look over these names and, depending on what they thought of the state constitution, lavish praise or heap blame. Keepsakes produced by other states later in the century even featured photographs of convention delegates.

Participation in a constitutional convention could not guarantee future political success. Nor did nonattendance necessarily doom men to political obscurity. Neither John Adams nor Thomas Jefferson, after all, attended the Philadelphia convention of 1787. But convention participation certainly did not hurt one's prospects. The names of six of the first eight Maine governors appeared on the list in the 1819 printing. In addition, at least five future United States senators and three United States representatives were present. Many more delegates would go on to hold various state and local offices under the government they helped frame. The knowledge that such opportunities might be available surely raised the stakes in debates and heightened delegates' interest in particular constitutional provisions. Every part of the constitution, delegates knew, would affect the lives of their fellow citizens; certain key features, meanwhile, might go a long way in determining the course of their individual careers.

Although statehood proponents had been motivated by internal political issues, once Congress approved Maine's admission to the union, the state's citizens found themselves enlisted as participants in the larger sectional debate. Maine's two senators joined their colleagues in Washington and contributed to the balance between free states and slave states in the nation's upper house. Early returns suggested that the Missouri Compromise had served its purpose. Tensions between the sections remained, but Americans adhered to the policy of paired admissions the next time two states appeared ready to enter the union. Congress approved Arkansas and Michigan statehood in 1836 and 1837. Questions loomed on the horizon, however. Would new developments force Americans to revisit their tenuous solution to the fundamental disagreement straining their constitutional republic?

Slavery's Expansion Renewed

CAT. 30. CONSTITUTION OF THE
REPUBLIC OF TEXAS, 1836

Shortly after Maine and Missouri entered the union, increasing numbers of Americans began to move into Texas. In so doing they set in motion a series of events destined to inflame the conflict over slavery. Long a remote outpost of New Spain, Texas became part of a newly independent Mexico in 1821. At first, Mexican authorities welcomed Americans to this sparsely settled corner of their jurisdiction, accommodating the newcomers' differences in religion and attitudes toward slavery. Indeed, permitting slaveholding in Texas, even though the institution had already been abolished in Mexico, represented part of the Mexican government's attempt to populate and pacify a contested frontier region in which Native American groups such as the Comanche Nation remained dominant powers. American-born settlers, in turn, relished the autonomy they enjoyed and expressed admiration for the Mexican Constitution of 1824, which established a federal system of government quite similar to that of the United States. By the 1830s, Texas's large, cheap tracts of land had lured over 30,000 "Anglo" settlers. But when Mexico's elected president, the war hero Antonio López de Santa Anna, assumed dictatorial powers, Texans resisted the new regime "in defence of the republican principles of the Federal Constitution of Mexico, of 1824."[2] Determined to crush the revolt, in March 1836 Santa Anna defeated and massacred Texans in San Antonio (at the Alamo) and Goliad. Meanwhile, to the east, a convention at Washington-on-the-Brazos issued a declaration of independence and immediately proceeded to write a constitution for the Republic of Texas.

Completed and unanimously adopted by the convention (without any attempt at popular ratification) on March 17, 1836, the Texas constitution strongly resembled the United States Constitution and other typical American state constitutions. The new government's status became far more secure just over a month later, when Texas forces under Sam Houston defeated Santa Anna at the battle of San Jacinto, extracting from the Mexican leader a pledge to remove his armies beyond Texas's borders. Hostilities continued off and on for years as Mexican authorities attempted to reassert control, but the Lone Star Republic stood firm.

Citizens of Texas did not wish to remain independent for long, however. In 1837, they urged their government to seek annexation to the United States. Yet negotiations stalled because of slavery. Texas's constitution declared that "all persons of color who were slaves for life previous to their emigration to Texas, and who are now held in bondage, shall remain in the like state of servitude." The Texas Congress was prohibited from emancipating any slaves and from restricting the importation of more slaves. The constitution even prohibited individual owners from manumitting (freeing) their slaves without the Texas Congress's consent, after which the owner had to "send his or her slave or slaves without the limits of the Republic." Clearly, annexing Texas meant adding another slave state to the union. This prospect proved too contentious. As Texas's population increased rapidly, though, a variety of international and domestic factors convinced the administration of President John Tyler to reconsider annexation. In 1844, Tyler tried to accomplish annexation through a treaty with the Lone Star Republic. After the Senate failed to approve this treaty by the two-thirds margin the Constitution requires, Tyler claimed that under the provision in Article IV, Section 3 for adding new states, Congress could annex Texas and make it a state all in one motion. A resolution to this effect passed both houses by simple majorities, over the objections of many Americans who questioned the measure's constitutionality.

Since Texans now needed a new constitution—one that was suited to a state instead of an independent republic—they called a convention, which met in Austin from July 4 to August 27, 1845. Article VIII

dealt with slaves and essentially retained the provisions found in the 1836 constitution. Voters ratified the document in October 1845, and Texas became the fifteenth slave state. Florida had become the fourteenth earlier in the year. Iowa's admission in 1846 and Wisconsin's in 1848 (after the delay caused by its citizenry's rejection of its proposed 1846 constitution) restored a tenuous equilibrium between the sections.

The new president, the slaveholding Tennessean James K. Polk, ensured that Texas still had a role to play in the debate over slavery's expansion. When Mexican officials refused Polk's offer to buy northern California and New Mexico, the president opted to acquire the desired territory by war. Texas's disputed southern border proved the most convenient place to provoke hostilities. As soon as word arrived in May 1846 that Mexican forces had attacked the American troops Polk had ordered into contested territory, the president asked Congress to exercise its constitutional authority to declare war. Many of the administration's opponents objected strongly to the president's actions, but American public opinion endorsed Polk's policy. Thousands volunteered to fight Mexico. Ultimately, 12,512 Americans and at least 25,000 Mexicans died in the course of a conflict that concluded with United States forces occupying Mexico City in 1848—a show of force that compelled Mexican authorities to accept the terms of the Treaty of Guadalupe Hidalgo.

Even amid the initial popular enthusiasm for war, leaders in Congress considered the conflict's long-term consequences for the stability of the union. In August 1846, Representative David Wilmot of Pennsylvania proposed that Congress make clear from the start that it would prohibit slavery in any territory acquired from Mexico. Wilmot's measure would have been mostly symbolic, as few slaves lived in New Mexico or California, and white Americans in those places showed little desire to introduce large numbers of slaves anytime soon. (Like Wilmot, white settlers wanted to preserve these regions for whites only.) To representatives from slaveholding states, however, the symbolism of Congress officially banning slavery in new territories represented a psychological blow that, they feared, might one day lead to efforts to dismantle the

FOLLOWING PAGES: Cat. 30. Constitution of the Republic of Texas, 1836

CONSTITUTION

OF

THE REPUBLIC OF TEXAS.

We, the People of Texas, in order to form a Government, establish justice, ensure domestic tranquillity, provide for the common defence and general welfare, and to secure the blessings of liberty to ourselves and our posterity, do ordain and establish this Constitution.

ARTICLE I.

SECTION 1. The powers of this Government shall be divided into three departments, viz: Legislative, Executive, and Judicial, which shall remain forever separate and distinct.

SEC. 2. The Legislative power shall be vested in a Senate and House of Representatives, to be styled The Congress of the Republic of Texas.

SEC. 3. The members of the House of Representatives shall be chosen annually on the first Monday of September each year, until Congress shall otherwise provide by law, and shall hold their offices one year from the date of their election.

SEC. 4. No person shall be eligible to a seat in the House of Representatives until he shall have attained the age of twenty-five years, shall be a citizen of the Republic, and shall have resided in the county or district six months next preceding his election.

SEC. 5. The House of Representatives shall not consist of less than twenty-four, nor more than forty members, until the population shall amount to one hundred thousand souls, after which time the whole number of Representatives shall not be less than forty nor more than one hundred : provided, however, that each county shall be entitled to at least one Representative.

Sec. 6. The House of Representatives shall choose their speaker and other officers, and shall have the sole power of impeachment.

Sec. 7. The Senators shall be chosen by districts, as nearly equal in free population (free negroes and Indians excepted) as practicable, and the number of Senators shall never be less than one-third nor more than one-half the number of Representatives, and each district shall be entitled to one member and no more.

Sec. 8. The Senators shall be chosen for the term of three years, on the first Monday in September, shall be citizens of the Republic, reside in the district for which they are respectively chosen at least one year before the election, and shall have attained the age of thirty years.

Sec. 9. At the first session of the Congress after the adoption of this Constitution, the Senators shall be divided by lot into three classes, as nearly equal as practicable ; the seats of the Senators of the first class shall be vacated at the end of the first year, of the second class at the end of the second year, the third class at the end of the the third year, in such manner that one-third shall be chosen each year thereafter.

Sec. 10. The Vice President of the Republic shall be President of the Senate, but shall not vote on any question, unless the Senate be equally divided.

Sec. 11. The Senate shall choose all other officers of their body, and a President pro tempore, in the absence of the Vice President, or whenever he shall exercise the office of President; shall have the sole power to try impeachments, and when sitting as a court of impeachment, shall be under oath ; but no conviction shall take place without the concurrence of two-thirds of all the members present.

Sec. 12. Judgment in cases of impeachment shall only extend to removal from office, and disqualification to hold any office of honor, trust, or profit under this Government; but the party shall nevertheless be liable to indictment, trial, judgment, and punishment, according to law.

Sec. 13. Each House shall be the judge of the elections, qualifications, and returns of its own members. Two-thirds of each House shall constitute a quorum to do business, but a smaller number may adjourn from day to day, and may compel the attendance of absent members.

Sec. 14. Each House may determine the rules of its own proceedings, punish its members for disorderly behaviour, and, with the concurrence of two-thirds, may expel a member, but not a second time for the same offence.

2

institution of slavery elsewhere. The Senate killed Wilmot's "proviso," but the issue lingered throughout the war and into its aftermath.

In 1850, Congress passed a series of measures that granted some concessions to Americans in both sections. Northerners took solace in the admission of California as a free state, the organization of the territories gained from Mexico on a basis that would lead to slavery's prohibition within their borders, and the end of the slave trade (though not of slavery itself) in the District of Columbia. Southerners, meanwhile, gained a much stronger fugitive slave law. Slaveholders also counted as a victory the fact that Congress had rejected Wilmot's formula for prohibiting slavery directly in the territories acquired from Mexico, a precedent on which they hoped to build in the tumultuous decade to come.

"No Rights Which the White Man Was Bound to Respect"

CAT. 31. OPINION OF CHIEF JUSTICE ROGER TANEY IN THE CASE OF DRED SCOTT, 1857

To this point, the first two branches of the federal government had taken the most prominent roles in the sectional dispute over slavery. Although Congress and a number of presidents had succeeded in reducing tensions from time to time, they had clearly failed to resolve the underlying issues to anyone's permanent satisfaction. Perhaps the third branch of government, the judiciary, could offer a solution that neither the legislature nor the executive had the authority to enact. According to American constitutional theory, judges were just as much the servants of the people as any representative, senator, or president. Americans had even begun to alter their state constitutions to provide for direct election of their state judges. Members of the federal judiciary, including the justices of the United States Supreme Court, continued to be nominated by the president and confirmed by the Senate, but this in no way diminished their legitimacy or obviated their responsibility to serve their fellow citizens by untangling the knottiest problems the American constitutional system presented.

The nation's highest court saw its opportunity to make a contribution at the very moment when the debate showed signs of spilling over into outright violence. The case's origins lay two decades in the past and intersected with several key developments in the constitutional struggle over slavery. In the early 1830s, an African American slave named Dred Scott had been taken into the state of Missouri by his owners, who soon sold Scott to an army surgeon named John Emerson. In 1834, Emerson took Scott to Illinois, where, thanks to that state's constitution—and the failure of the proslavery convention referendum of the 1820s—slavery remained prohibited. After two years, Emerson took Scott with him to Fort Snelling in what was then Wisconsin Territory (near present-day Minneapolis and St. Paul, Minnesota). There Scott met and married his wife, Harriet, with whom he had two daughters. After several years, Emerson took the Scott family back with him to Missouri. When Emerson died in 1843, his wife inherited his slaves.

In 1846, Dred Scott sued Irene Emerson for his freedom in Missouri state court, claiming that his residence in Illinois and Wisconsin Territory, where slavery did not legally exist, had made him free. In 1850, a jury found in Scott's favor, but the Missouri supreme court overturned this ruling and returned Scott to slavery. Scott sensed a new opportunity when Emerson, now remarried, left him in the care of her brother, John Sanford. Because Sanford lived in another state, New York, Scott decided in 1853 to sue for his freedom in federal court under the diverse citizenship clause of the United States Constitution. A federal circuit court ruled against Scott on the merits of his case but, crucially, accepted his right to bring it. Scott then appealed to the United States Supreme Court.

The nine Supreme Court justices who heard Scott's case in February 1856 understood its potential implications. Depending on how they ruled, they might provide much-needed clarity and a path forward in the sectional controversy. President-elect James Buchanan, perhaps dreading that he, like his predecessors, would make no headway in resolving the national dilemma, even conveyed his desire that the court issue a broad decision. Given the Supreme Court's composition,

OPPOSITE: Cat. 31. Opinion of Chief Justice Roger Taney in the Case of Dred Scott, 1857

which he did not before possess, and placed him in every other State upon a perfect equality with its own citizens as to rights of person and rights of property; it made him a citizen of the United States.

It becomes necessary, therefore, to determine who were citizens of the several States when the Constitution was adopted. And in order to do this, we must recur to the Governments and institutions of the thirteen colonies, when they separated from Great Britain and formed new sovereignties, and took their places in the family of independent nations. We must inquire who, at that time, were recognised as the people or citizens of a State, whose rights and liberties had been outraged by the English Government; and who declared their independence, and assumed the powers of Government to defend their rights by force of arms.

In the opinion of the court, the legislation and histories of the times, and the language used in the Declaration of Independence, show, that neither the class of persons who had been imported as slaves, nor their descendants, whether they had become free or not, were then acknowledged as a part of the people, nor intended to be included in the general words used in that memorable instrument.

It is difficult at this day to realize the state of public opinion in relation to that unfortunate race, which prevailed in the civilized and enlightened portions of the world at the time of the Declaration of Independence, and when the Constitution of the United States was framed and adopted. But the public history of every European nation displays it in a manner too plain to be mistaken.

They had for more than a century before been regarded as beings of an inferior order, and altogether unfit to associate with the white race, either in social or political relations; and so far inferior, that they had no rights which the white man was bound to respect; and that the negro might justly and lawfully be reduced to slavery for his benefit. He was bought and sold, and treated as an ordinary article of merchandise and traffic, whenever a profit could be made by it. This opinion was at that time fixed and universal in the civilized portion of the white race. It was regarded as an axiom in morals as well as in politics, which no one thought of disputing, or supposed to be open to dispute; and men in every grade and position in society daily and habitually acted upon it in their private pursuits, as well as in matters of public concern, without doubting for a moment the correctness of this opinion.

And in no nation was this opinion more firmly fixed or more

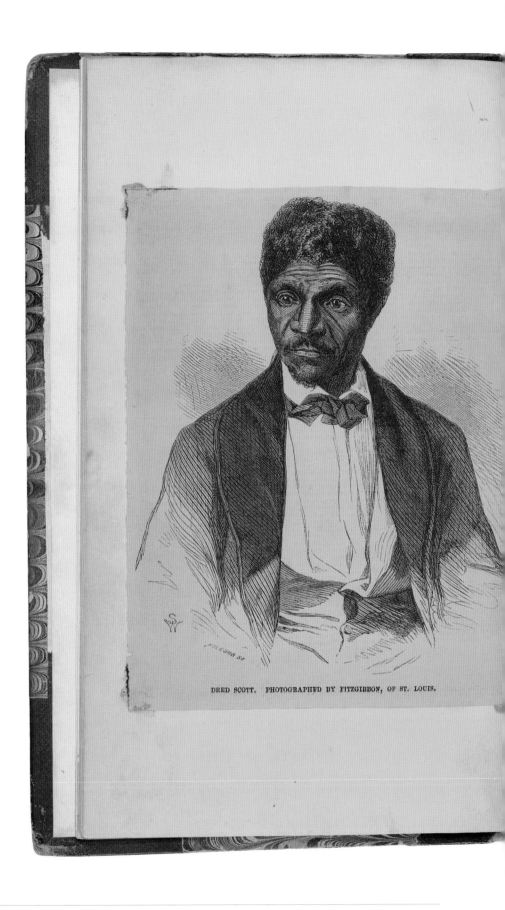

DRED SCOTT. PHOTOGRAPHED BY FITZGIBBON, OF ST. LOUIS.

Portraits of Dred and Harriet Scott, published in *Frank Leslie's Illustrated Newspaper*, June 27, 1857, and pasted into cat. 31

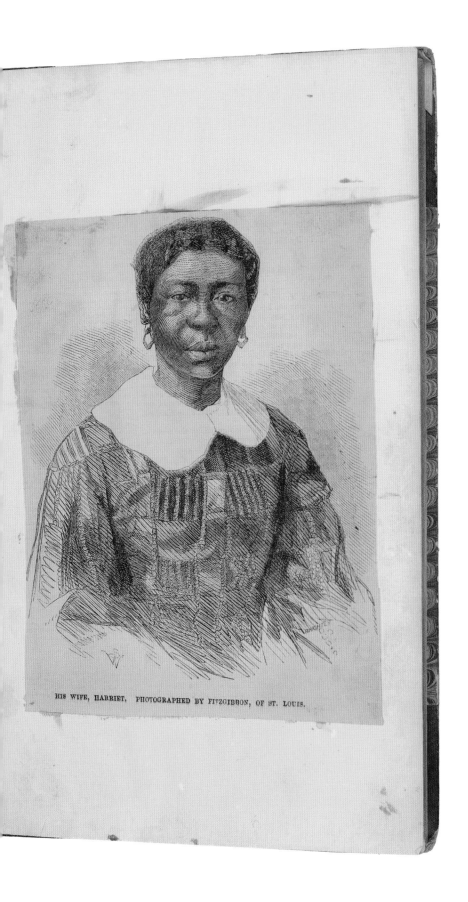

HIS WIFE, HARRIET, PHOTOGRAPHED BY FITZGIBBON, OF ST. LOUIS.

urging it to decide the issue once and for all was not necessarily a neutral stance. Because justices still possessed circuit responsibilities that required them to travel throughout a designated geographical region, and because the practice in preceding years had been to appoint men with some connection to the circuits they were to ride, a majority (five of the nine justices) came from slave states. These states' combined area exceeded that of the free states despite containing less than half the white population.

On March 6, 1857, Chief Justice Roger B. Taney delivered the most important opinion explaining the court's ruling against Scott. (The court's misspelling of the defendant's name, Sanford, resulted in the case's official title, *Scott v. Sandford*.) Taney came to two main conclusions. First, he addressed whether Scott was a citizen and could sue another citizen in federal court. As Taney put it, "can a negro whose ancestors were imported into this country and sold as slaves become a member of the political community formed and brought into existence by the Constitution of the United States"? Answering this question, Taney insisted, required assessing the views held by those who wrote the Declaration of Independence and the Constitution. Based on his selective and dubious reading of the sources, Taney offered his sweeping conclusion: "neither... slaves nor their descendants, whether they had become free or not, were then acknowledged as a part of the people, nor intended to be included in the general words used in that memorable instrument," the Declaration of Independence. Such phrases as "all men are created equal" definitely excluded blacks, Taney claimed, because Americans at the time all agreed that blacks were racially inferior. Describing the attitudes about Africans that American colonists had inherited from their European forebearers, Taney penned his most infamous passage:

> They had for more than a century before been regarded as beings of an inferior order, and altogether unfit to associate with the white race, either in social or political relations; and so far inferior, that they had no rights which the white man was bound to respect; and that the negro might justly and lawfully be reduced to slavery for his benefit.

In sum, Taney proclaimed that no one of African descent could ever be a citizen of the United States. Dred Scott, as a black man, was not a citizen and therefore could not sue in federal court.

Taney's insistence that founding-era Americans never considered blacks as potential fellow citizens but simply as "article[s] of property" laid the foundation for his second main conclusion, one that he apparently thought would save Americans the trouble of debating slavery's extension every time the federal government organized a new territory. After explaining why no black person could ever become a United States citizen under any circumstances, Taney considered the question of whether Scott's residence in Illinois or Wisconsin Territory had at least changed his status from enslaved to free. (The federal circuit court, Taney explained, had erroneously allowed Scott to sue in part because it had resolved this question incorrectly, and therefore he and the court had a responsibility to clear up the misunderstanding.) Taney brushed aside the Illinois issue and concentrated on the status of slavery in the federal territory where Scott had lived for several years. As everyone knew, the Act of 1820, part of the Missouri Compromise, had banned slavery in the Louisiana Purchase north of 36°30' latitude. Incredibly, Taney now asserted that Congress never had the constitutional authority to pass this law in the first place. Congress could not infringe any citizen's constitutional rights, he reasoned, and these included the Fifth Amendment's guarantee that no citizen would "be deprived of life, liberty, or property, without due process of law." Taney argued further that Congress could not make any distinctions between various forms of property, allowing citizens to take some forms into the territory acquired in the Louisiana Purchase while prohibiting them from taking others. And since Taney had allegedly established, earlier in his opinion, that Americans classified slaves merely as property, then it followed that Congress could not prohibit slavery in any federal territory.

The ruling Taney hoped would defuse the nation's constitutional crisis only exacerbated it further. The chief justice's bold assertions rested on a slew of very questionable interpretations, and his elaborate argument suggested not the strength of his position, but its vulnerability to attack on multiple fronts. Instead of enhancing

the majority of the American people's faith that the judicial branch of their government could help resolve the sectional conflict, the court's intervention severely damaged its own legitimacy in the eyes of many citizens and left Americans still searching for answers.

Kansas and Its Constitutions

CAT. 32. KANSAS CONSTITUTION OF 1859

African Americans, of course, deplored the court's decision in *Dred Scott*. For years, they had quoted the Declaration of Independence's universal language to prove that slavery violated the nation's most cherished principles. That Taney could pervert so clear a statement of human equality into a justification for racial exclusion provoked anger and frustration among those who hoped one day to enjoy full citizenship within the American body politic. White abolitionist allies agreed. Such a ruling by the nation's foremost interpreters of the United States Constitution seemed only to confirm the radical William Lloyd Garrison's longstanding view of that document as "a covenant with death" and "an agreement with hell."[3] Dred Scott and his family gained their freedom, but only because a new owner emancipated them. Scott died in 1858, a year after the famous decision that bears his name.

Supporters of the new Republican Party also expressed outrage over *Dred Scott*. They took issue with Taney's claim that Congress had no constitutional authority to prohibit slavery in the federal territories. Previously, only the most extreme of slavery's defenders had advanced such a view. In Article IV, Section 3 of the Constitution, Republicans insisted, the sovereign American people clearly granted their Congress the "power to dispose of and make all needful rules and regulations respecting the territory or other property belonging to the United States." If citizens could not exercise the powers they themselves had written into their fundamental law—in this case to restrict the further spread of slavery—then the very idea of constitutional government was a sham.

By the time the Supreme Court issued its ruling, the focus of the sectional controversy had shifted to Kansas. Congress had organized the territory, along with Nebraska Territory to the north, in 1854. After much debate, Congress had repealed the Missouri Compromise prohibition on slavery north of 36°30' latitude and instead decreed that the inhabitants of the territories, through their territorial legislatures, would determine whether to allow or prohibit slavery. Known as "popular sovereignty," this policy appeared democratic on its face. Yet as its detractors pointed out, the policy actually substituted the whims of a tiny fraction of the American people—those who happened to be in Kansas or Nebraska Territory during the territorial election—for the will of the entire body of the nation's citizens, as expressed through Congress. The *Dred Scott* ruling ultimately called into question the constitutionality of "popular sovereignty," too, since any territorial legislature that prohibited slavery would be relying on Congress's delegated authority to do so.

As events unfolded, however, the Kansas territorial legislature did not prohibit slavery. In 1855, voters—including a large number of proslavery Missourians who crossed the border on election day to ensure the desired outcome—returned a proslavery majority to the legislature, which promptly expelled the antislavery minority. Violence erupted between the respective factions. Antislavery Kansans—who comprised a clear majority of the territory's actual settlers—elected their own legislature, held a convention, and even claimed to have ratified a constitution. Meanwhile, the official, proslavery legislature called its own constitutional convention. Settlers who wanted to make Kansas a free state refused to participate in the elections for delegates, claiming that they were rigged. When the convention met in Lecompton, the delegates grasped at their chance to make Kansas a slave state. "The right of property is before and higher than any constitutional sanction," the convention wrote in Article VII, "and the right of the owner of a slave to such slave and its increase is the same, and as inviolable as the right of the owner of any property whatever."

FOLLOWING PAGES: Cat. 32. Kansas Constitution of 1859

CONSTITUTION

OF THE

STATE OF KANSAS;

Kansas. [1859.] Slightly imp:- pp. 7,

Adopted at Wyandot, July 29, '59.

1860, Sept. 17. By mail.

ORDINANCE.

Whereas, the Government of the United States is the proprietor of a large portion of the Lands included in the limits of the State of Kansas as defined by this Constitution; and whereas the State of Kansas will possess the right to tax said lands for purposes of government, and for other purposes; Now, therefore, be it ordained by the people of Kansas, that the right of the State of Kansas to tax such lands, is relinquished forever, and the State of Kansas will not interfere with the title of the United States to such lands, nor with any regulation of Congress in relation thereto, nor tax non-residents higher than residents; PROVIDED always, that the following conditions be agreed to by Congress:

SECTION 1. Sections numbered sixteen and thirty-six in each township in the State, including Indian reservations and Trust lands, shall be granted to the State for the exclusive use of Common Schools; and when either of said sections, or any part thereof, has been disposed of, other lands of equal value, as nearly contiguous thereto as possible, shall be substituted therefor.

SEC. 2. That seventy-two sections of land shall be granted to the State for the erection and maintenance of a State University.

SEC. 3. That thirty-six sections shall be granted to the State for the erection of public buildings.

SEC. 4. That seventy-two sections shall be granted to the State for the erection and maintenance of charitable and benevolent institutions.

SEC. 5. That all salt springs, not exceeding twelve in number, with six sections of land adjacent to each, together with all mines, with the lands necessary for their full use, shall be granted to the State for works of public improvement.

SEC. 6. That five per centum of the proceeds of the public lands in Kansas, disposed of after the admission of the State into the Union, shall be paid to the State for a fund, the income of which shall be used for the support of Common Schools.

SEC. 7. That the Five Hundred Thousand acres of land to which the State is entitled under the Act of Congress entitled "An Act to appropriate the proceeds of the sales of public lands and grant pre-emption rights," approved September 4th, 1841, shall be granted to the State for the support of Common Schools.

SEC. 8. That the lands hereinbefore mentioned shall be selected in such manner as may be prescribed by law; such selections to be subject to the approval of the Commissioner of the General Land Office of the United States.

PREAMBLE.

We, the people of Kansas, grateful to Almighty God for our civil and religious privileges, in order to insure the full enjoyment of our rights as American citizens, do ordain and establish this constitution of the State of Kansas, with the following boundaries, to-wit: Beginning at a point on the western boundary of the State of Missouri, where the thirty-seventh parallel of north latitude crosses the same; thence running west on said parallel to the twenty-fifth meridian of longitude west from Washington; thence north on said meridian to the fortieth parallel of north latitude; thence east on said parallel to the western boundary of the State of Missouri; thence south with the western boundary of said State to the place of beginning.

BILL OF RIGHTS.

Section 1. All men are possessed of equal and inalienable natural rights, among which are life, liberty, and the pursuit of happiness.

Sec. 2. All political power is inherent in the people, and all free governments are founded on their authority, and are instituted for their equal protection and benefit. No special privileges or immunities shall ever be granted by the Legislature, which may not be altered, revoked or repealed by the same body; and this power shall be exercised by no other tribunal or agency.

Sec. 3. The people have the right to assemble, in a peaceable manner, to consult for their common good, to instruct their representatives, and to petition the government, or any department thereof, for the redress of grievances.

Sec. 4. The people have the right to bear arms for their defence and security; but standing armies, in time of peace, are dangerous to liberty, and shall not be tolerated, and the military shall be in strict subordination to the civil power.

Sec. 5. The right of trial by jury shall be inviolate.

Sec. 6. There shall be no slavery in this State; and no involuntary servitude, except for the punishment of crime, whereof the party shall have been duly convicted.

Sec. 7. The right to worship God according to the dictates of conscience shall never be infringed; nor shall any person be compelled to attend or support any form of worship; nor shall any control of, or interference with the rights of conscience be permitted, nor any preference be given by law to any religious establishment or mode of worship. No religious test or property qualification shall be required for any office of public trust, nor for any vote at any election, nor shall any person be incompetent to testify on account of religious belief.

Sec. 8. The right to the writ of *habeas corpus* shall not be suspended, unless the public safety requires it in case of invasion or rebellion.

Sec. 9. All persons shall be bailable by sufficient sureties except for capital offences, where proof is evident or the presumption great. Excessive bail shall not be required, nor excessive fines imposed, nor cruel or unusual punishment inflicted.

Sec. 10. In all prosecutions, the accused shall be allowed to appear and defend in person, or by counsel; to demand the nature and cause of the accusation against him; to meet the witness face to face, and to have compulsory process to compel the attendance of witnesses in his behalf, and a speedy public trial by an impartial jury of the county or district in which the offence is alleged to have been committed. No person shall be a witness against himself, or be twice put in jeopardy for the same offence.

Sec. 11. The liberty of the press shall be inviolate: and all persons may freely speak, write or publish their sentiments on all subjects, being responsible for the abuse of such right; and in all civil or criminal actions for libel, the truth may be given in evidence to the jury, and if it shall appear that the alleged libelous matter was published for justifiable ends, the accused party shall be acquitted.

Sec. 12. No person shall be transported from the State for any offence committed within the same, and no conviction in the State shall work a corruption of blood or forfeiture of estate.

Sec. 13. Treason shall consist only in levying war against the State, adhering to its enemies, or giving them aid and comfort. No person shall be convicted of treason unless on the evidence of two witnesses to the overt act, or confession in open court.

Sec. 14. No soldier shall, in time of peace, be quartered in any house without the consent of the occupant, nor in time of war, except as prescribed by law.

Sec. 15. The right of the people to be secure in their persons and property against unreasonable searches and seiz-

Drafting the proslavery constitution proved the easy part. The Lecompton convention now had to devise some way to endow it with the legitimacy of popular ratification without actually risking that Kansas voters would reject it, as they surely would if given a fair opportunity. The delegates' cynical solution was to offer their fellow citizens a choice of voting for either the "Constitution with slavery" or the "Constitution with no slavery." The people could not reject the constitution entirely, and even if they approved the "no slavery" option, the institution would endure in the state in the form of the two hundred or so slaves (plus their children) currently kept in the territory by their owners. On December 21, 1857, free-state men abstained from the Lecompton convention's ratification vote, which predictably yielded an overwhelming victory for the "Constitution with slavery." But the territorial legislature, now controlled by free-state supporters, arranged for another referendum two weeks later—this time on the entire constitution. Slave-state men now boycotted this vote, which proved even more decisive against the constitution. Congress received the Lecompton constitution and its supporters' assurance of its ratification, but news of the second vote raised too many questions about the legitimacy of the proceedings in Kansas for them to approve statehood. Congress then found an excuse to order the entire Lecompton constitution resubmitted to voters. In this third referendum in August 1858, the people finally killed the proslavery constitution by a margin of 11,300 to 1,788.

The majority of Kansans had prevailed against a determined minority, but the ordeal demonstrated the potential volatility of the constitution-making process and its susceptibility to manipulation. Citizens started afresh by holding a new convention in Wyandotte (near present-day Kansas City, Kansas). Completed on July 29, 1859, the new constitution contained none of the proslavery provisions that had defined the Lecompton document. In place of a ringing endorsement of the right to hold property in human beings, the Wyandotte constitution simply declared in Section 6 of its bill of rights that "there shall be no slavery in this State; and no involuntary servitude, except for the punishment of crime, whereof the party shall have been duly

convicted." By closely echoing the phrasing Congress had used in 1787 (and again in 1789) to ban slavery in the Northwest Territory, Kansans aligned themselves with several generations of Americans who had taken steps—for a variety of motives, to be sure—to restrict the extension of slavery. The Supreme Court had purported to eliminate one avenue—congressional prohibition—by which that goal could be accomplished. While Americans sorted out that contentious claim, citizens in Kansas, at least, could use the means at their disposal to check the growth of slavery in their own political community. On October 4, 1859, they went to the polls yet again and ratified their state constitution.

Disunion

CAT. 33. ALABAMA ORDINANCE OF SECESSION OF 1861

John Brown had left Kansas for the final time about ten months earlier. The white abolitionist had been in the territory off and on since 1855, waging war against slavery and its supporters. Most notably, in May 1856, Brown, four of his sons, and a few others had used swords to murder five proslavery settlers at Pottawatomie Creek. Although Brown clearly preferred more direct and violent methods, not even he could resist the constitutional impulse of the age when planning his most spectacular assault. In 1858, he wrote a "provisional constitution" for a government he intended to implement with the help of his small band of followers and the multitudes of slaves who would, he believed, respond to his call to revolt. Contradicting Chief Justice Taney's claim in *Dred Scott*, the preamble to Brown's constitution asserted that slavery violated "those eternal and self-evident truths set forth in our Declaration of Independence." In place of the familiar phrase "we the people," Brown's preamble referred, with obvious sarcasm, to "we, citizens of the United States, and the Oppressed People, who, by a recent decision of the Supreme Court, are declared to have no rights which the White Man is bound to respect."[4]

On the night of October 16, 1859, just twelve days after the Kansas ratification vote, Brown and his band

OPPOSITE: Cat. 33. Alabama Ordinance of Secession of 1861

ORDINANCES.

The State of Alabama.

At a Convention of the People of the State of Alabama, begun and holden at Montgomery, on the seventh day of January, in the year of our Lord, one thousand eight hundred and sixty-one, and continued to the twelfth day of February in the same year.

AN ORDINANCE

To dissolve the Union between the State of Alabama and other States united under the compact styled "The Constitution of the United States of America."

Whereas, the election of Abraham Lincoln and Hannibal Hamlin to the offices of President and Vice President of the United States of America, by a sectional party, avowedly hostile to the domestic institutions and to the peace and security of the people of the State of Alabama, preceded by many and dangerous infractions of the Constitution of the United States by many of the States and people of the northern section, is a political wrong of so insulting and menacing a character as to justify the people of the State of Alabama in the adoption of prompt and decided measures for their future peace and security; therefore,

Be it declared and ordained by the people of the State of Alabama in Convention assembled, That the State of Alabama now withdraws, and is hereby withdrawn from the Union known as "the United States of America," and

descended upon the town of Harpers Ferry, Virginia (present-day West Virginia), and seized the federal armory there. Brown's plan, as his constitution hinted, called for taking control of a large tract of territory and creating a haven for slaves fleeing their bondage. This would, somehow, hasten the "Amendment and Repeal" of the United States Constitution in an antislavery direction.[5] State militia and federal troops quickly put an end to Brown's efforts, however. Brown's trial and subsequent execution on December 2, 1859, brought the sectional conflict to a fever pitch of mutual suspicion and anxiety just as the nation prepared for the most important presidential election in its young history.

The election of 1860 offered citizens the opportunity to determine nothing less than the future of slavery in the United States. The candidates presented starkly different options. The Democratic Party having split over the slavery question, Stephen A. Douglas of Illinois represented the Northern wing and John C. Breckinridge of Kentucky carried the banner for the Southern. Douglas advocated "popular sovereignty" for determining the status of slavery in federal territories, while Breckinridge agreed with the Supreme Court in *Dred Scott* that slavery could not be prohibited. The Tennessee slaveholder John Bell headed the ticket for the Constitutional Union Party, whose inscrutable platform spoke of preserving the Constitution and the union but did not explain exactly what that meant. Republican candidate Abraham Lincoln of Illinois, meanwhile, proposed to restrict the spread of slavery.

According to the Constitution, the candidate with a majority of electoral votes wins the presidency. Only Lincoln had a good chance of outright victory by this method, but his opponents hoped to deny him the required number of electoral votes and throw the election to the House of Representatives, where one of them might be able to secure the support of a majority of state delegations. In the end, after not even appearing on the ballot in nine slave states, Lincoln received only 39 percent of the national popular vote. With 71 percent of eligible voters having gone to the polls, about 1.8 million Americans voted for him and over 2.8 million voted for someone else. But Lincoln won majorities or pluralities in seventeen states (in addition to a share of New Jersey's electors) and easily compiled more than enough electoral votes.

Southerners could not dispute that Lincoln had won the presidency fair and square. Instead, they immediately declared that the Republican's election would lead to an intolerable assault on both slavery and, by extension, Southern society itself. Ignoring Lincoln's assurances that the Constitution prevented the president and Congress from interfering with slavery in the states, they focused on Lincoln's avowed desire to see the institution set on a path to "ultimate extinction."[6] The mere fact that the occupant of the nation's highest office would hold such views constituted a grave threat, they insisted. Once given hope by a sympathetic Republican administration, over four million African Americans held in bondage would sense their opportunity to resist their oppressors—in small ways at first, perhaps, but violently in the end.

Many Southerners concluded that they could not run the risk. Rather than wait for Lincoln to violate the Constitution and take steps to free their slaves (or worse), they would sever the federal compact now and place themselves beyond the Republicans' reach. For decades proslavery ideologues had been developing a constitutional theory that Southerners could invoke to justify secession. The Constitution, this theory held, had been ratified by the people of each individual state. Since the sovereign people always retained the right to determine the political system under which they lived, the people of a state could decide to withdraw their consent from the federal Constitution and take their state out of the union. What conventions of the people could make, they could also unmake; the people could call a secession convention just as they had once called a ratification convention. On November 10, 1860, just four days after Lincoln's election, the South Carolina legislature passed a bill arranging for a convention, which met on December 17 and voted unanimously to secede three days later.

Lower South states such as Alabama followed close behind. Alabama's legislature had set the wheels in motion even before election day, empowering the state's governor to announce a convention as soon as Lincoln won. In elections on December 24, citizens chose whether to support hard-line candidates who demanded secession immediately or candidates who probably still supported secession but wanted to proceed more

cautiously and in "cooperation" with fellow slave states. About 55 percent of the votes went to more radical secessionist candidates. The convention met in Montgomery on January 7, and four days later that body rendered its verdict: Alabama would secede from the union.

The Alabama convention clearly identified the threat to slavery as the main reason for secession, even if its ordinance did not use the word. (Some other states, such as South Carolina and Georgia, referred directly to "slavery," dispelling any doubts about secessionists' motivations.) "The election of Abraham Lincoln . . . by a sectional party, avowedly hostile to the domestic institutions and to the peace and security of the people of the State of Alabama," appeared foremost on the list of alleged outrages. In addition, the ordinance complained of "many and dangerous infractions of the Constitution of the United States by many of the States and people of the northern section." This passage referred to laws passed by some Northern states, and to a handful of popular acts of defiance, intended to undermine the federal Fugitive Slave Act of 1850. The fact that the federal courts were consistently enforcing the law and upholding its constitutionality directly contradicted the Alabama convention's claim that the Constitution no longer protected Southern rights. Nevertheless, the convention discerned in these things "a political wrong of so insulting and menacing a character as to justify the people of the State of Alabama in the adoption of prompt and decided measures for their future peace and security." By a 61 to 39 vote, the convention declared Alabama "hereby withdrawn from the Union known as 'the United States of America.'"

As Lincoln prepared to take office on March 4, 1861, conventions in seven Lower South states voted to secede: South Carolina, Mississippi, Florida, Alabama, Georgia, Louisiana, and Texas. Only in Texas were voters given the chance to approve their convention's secession ordinance (and Texas's convention agreed to such a measure only because of doubts about its own legality and legitimacy). Clearly, though, secession enjoyed significant popular support in these states. The slave states of the Upper South—North Carolina, Virginia, Tennessee, and Arkansas—remained tenuously attached to the union, but even they agreed that any attempt by the federal government to "coerce" the seceded states would lead to their secession as well.

Lincoln refused to recognize the legitimacy of secession, seeing in it the destruction of the very idea of constitutional government. The Constitution's opening line, "We the People of the United States," indicated the existence of a perpetual union created in the Revolution, he argued. Citizens had voluntarily consented to live under a frame of government that, in addition to guaranteeing the fundamental rights of all, spelled out how the majority would rule. If a minority could simply declare itself out of the union anytime a majority attempted to govern—in perfect accord with the constitutional rules previously established—then no constitutional government was possible. "Anarchy or despotism in some form is all that is left," Lincoln explained, and secession was "the essence of anarchy."[7] Allow the precedent of state secession to stand, and the door would be open to an infinite series of future secessions; it would give license to small minorities to tyrannize over the majority in ways that made a mockery of the notion of the sovereignty of the people. If Americans wished to alter their political system, Lincoln noted, the Constitution outlined a method by which this could be accomplished. The burden lay with members of the minority to persuade their fellow citizens of the justice and propriety of any particular amendment. Indeed, Lincoln did not object to a proposed amendment, passed by the Senate on the morning of his inauguration, that would have prohibited any future amendments empowering Congress to meddle with slavery in the states. Secession, in contrast, was mere lawlessness, and Lincoln would not be cowed.

A Slaveholding Nation

CAT. 34. CONSTITUTION OF THE CONFEDERATE STATES OF AMERICA, 1861

One week after President Lincoln used his inaugural address to denounce secession and declare his intention to preserve the union, a provisional congress made up of representatives from the seceded states, sitting as a constitutional convention in Montgomery, Alabama, unanimously approved a permanent constitution for the Confederate States of America (or Confederacy, for short). The provisional congress offered voters no

CONSTITUTION

OF THE

CONFEDERATE STATES OF AMERICA.

Adopted unanimously by the Congress of the Confederate States of America,
March 11, 1861.

MONTGOMERY, ALA.:
SHORTER & REID, PRINTERS, ADVERTISER OFFICE.
1861.

ABOVE AND OPPOSITE: Cat. 34. Constitution of the Confederate States of America, 1861

16. To provide for organizing, arming, and disciplining the militia, and for governing such part of them as may be employed in the service of the Confederate States; reserving to the States, respectively, the appointment of the officers, and the authority of training the militia according to the discipline prescribed by Congress:

17. To exercise exclusive legislation, in all cases whatsoever, over such district (not exceeding ten miles square) as may, by cession of one or more States and the acceptance of Congress, become the seat of the Government of the Confederate States; and to exercise like authority over all places purchased by the consent of the legislature of the State in which the same shall be, for the erection of forts, magazines, arsenals, dockyards, and other needful buildings: and

18. To make all laws which shall be necessary and proper for carrying into execution the foregoing powers, and all other powers vested by this Constitution in the government of the Confederate States, or in any department or officer thereof.

Section 9.

1. The importation of negroes of the African race, from any foreign country, other than the slaveholding States or Territories of the United States of America, is hereby forbidden; and Congress is required to pass such laws as shall effectually prevent the same.

2. Congress shall also have power to prohibit the introduction of slaves from any State not a member of, or Territory not belonging to, this Confederacy.

3. The privilege of the writ of habeas corpus shall not be suspended, unless when in cases of rebellion or invasion the public safety may require it.

4. No bill of attainder, *ex post facto* law, or law denying or imparing the right of property in negro slaves shall be passed.

5. No capitation or other direct tax shall be laid, unless

opportunity to voice their opinions on the document, choosing instead to send it to the previously elected state conventions for ratification. All the talk of state sovereignty and the name "Confederacy" might have led observers to expect that this new frame of government would resemble the old Articles of Confederation more than the federal Constitution. Quite the contrary. For recently seceded Southerners, the problem lay not with the founding document itself so much as with the majority of the people who fell under its jurisdiction and dared to use the means it provided to enact laws and pursue policies that reflected the popular will. But with these Americans safely excised from the body politic, Confederates saw no reason to dispense with the bulk of a text that had otherwise proven so effective and admirable. They wanted a government capable of winning a war for independence, and the Revolution had demonstrated the shortcomings of too loose an association of state republics.

Improvements could always be made, of course, and the Confederate constitution incorporated several provisions its authors deemed advances on the old federal charter. To minimize the disruptions and rancor that frequent presidential campaigns appeared to foster, the constitution made the Confederate president eligible to serve only a single, six-year term. It also granted him a "line-item" veto, empowering him to strike out specific items in a list of appropriations passed by the legislature, thus saving him the trouble of rejecting the entire bill. (Ironically, this turned out to be one of the Confederate constitution's lasting legacies. After Georgia became the first state to adopt a line-item veto for its executive in 1865, the vast majority of other states eventually followed suit.) Other modifications made it more difficult for Congress to pass spending bills and restricted its power to finance most internal improvement projects. River and harbor improvements, which helped facilitate the international commerce essential to the slave-based plantation economy, enjoyed an exemption.

Indeed, the Confederate constitution diverged most markedly in its explicit protections for the institution of slavery. Article I, Section 9 continued the ban on participation in the international slave trade (the convention had needed to debate this), but the key clause prohibited the Confederate Congress from passing any "law denying or impairing the right of property in negro slaves." Elsewhere, the constitution sanctioned the acquisition of new territory—some Confederates had designs on Cuba or parts of Central America—and guaranteed that "the institution of negro slavery, as it now exists in the Confederate States, shall be recognized and protected" there. As if to dispel any doubts, the text assured Confederate citizens they would also have the right to take their slaves into any such territories. In addition, the constitution affirmed the right of owners to recapture fugitive slaves and promised that a slave owner's sojourn in any other state with his slaves would never alter their status. All these provisions responded to various points of controversy that had roiled the United States over the previous half century.

Among those pleased with the new constitution was the Confederacy's vice-president, Alexander Hamilton Stephens. On March 21, ten days after the constitution's approval, Stephens gave a speech in his native Georgia lauding its virtues. "The new constitution has put at rest, *forever*," Stephens declared, "all the agitating questions relating to our peculiar institution—African slavery as it exists amongst us— the proper *status* of the negro in our form of civilization. This was the immediate cause of the late rupture and present revolution." Apparently, Chief Justice Taney had gotten some facts wrong in his *Dred Scott* opinion. Jefferson and his contemporaries, Stephens contended, had in fact clung to the idea that "the enslavement of the African was in violation of the laws of nature; that it was wrong in *principle*, socially, morally, and politically." Even though the founding generation had entertained plenty of racist assumptions, Americans back then had still believed in the fundamental "equality of the races," Stephens explained, hardly containing his contempt. "Our new government is founded upon exactly the opposite idea," he thundered. "Its foundations are laid, its corner-stone rests upon the great truth, that the negro is not equal to the white man; that slavery— subordination to the superior race—is his natural and normal condition." Finally, thanks to the Confederate constitution, Americans had a government "based upon this great physical, philosophical, and moral truth."[8]

The Confederacy soon added new states, bringing its total to eleven. On April 12, 1861, Confederate

forces fired on Fort Sumter, the federal installation in Charleston harbor. President Lincoln's subsequent call for troops to put down the rebellion violated the central condition that many in North Carolina, Virginia, Tennessee, and Arkansas had articulated for remaining in the Union: namely, that Lincoln would not take any real action to preserve it. The four "border states" of Delaware, Maryland, Kentucky, and Missouri remained in the Union, their attachment to slavery far more attenuated than in the states farther to the south. Many border-state inhabitants still volunteered their services to the Confederacy.

In the four years of war that followed, American constitutional governments demonstrated their remarkable power. It is common to note the North's superior population and industrial might, but these advantages would have been meaningless without the citizenry's abiding support for the goal of preserving the Union, whatever the enormous cost. The Constitution Lincoln swore an oath to preserve, protect, and defend placed at his disposal a variety of tools he needed to accomplish that goal. Through free elections, citizens consented to the administration's policies and ensured the war would be fought to complete victory. Meanwhile, in the course of its struggle for independence, the Confederacy mobilized an incredible 75 to 85 percent of its white, military-age manpower. Whatever their defects and shortcomings, Southern governments, both state and national, retained their legitimacy in the eyes of a large proportion of the populace. For white Americans at least, the Confederacy operated not as despotism but as a democracy. Citizens wrote constitutions and participated in elections. The press remained free to criticize the government—which it did in acerbic abundance. Although a select group of individuals, usually large slaveholders, had been the most outspoken advocates of secession and wielded disproportionate influence, the governments of the Confederacy ultimately drew their authority from the consent of the entire body of the white citizenry. These, too, were governments of, by, and for the people, and the people of the Confederate States were, in the end, responsible for the course their governments pursued. At least 600,000 Americans died in the war; nearly half a million more suffered wounds.

Constituting Freedom

CAT. 35. ALABAMA CONSTITUTION OF 1867

The Civil War killed slavery as well. As the war progressed, many Northerners who, at the start, had seen no reason to abolish the institution became convinced that only slavery's destruction could guarantee the permanent preservation of the Union. Slavery had turned out to be the single issue capable of threatening the Constitution and the possibility of self-government that it represented. Many Americans, of course, saw emancipation and justice for African Americans as worthy ends in themselves. African Americans took countless actions that kept freedom front and center in the public consciousness. They fled slavery by the hundreds of thousands during the war, forcing federal authorities and white citizens alike to confront the fundamental moral issue underlying the nation's defining crisis. Such African American activism helped lay the groundwork for President Lincoln's Emancipation Proclamation of January 1, 1863, which struck at slavery in large parts of the Confederacy where the presence of United States forces—which included approximately 200,000 black soldiers and sailors—terminated rebel authority. Permanent abolition everywhere came with the Thirteenth Amendment, which passed Congress by the requisite two-thirds vote of both houses on January 31, 1865, and became part of the Constitution upon its ratification by three-fourths of the states that December.

But what did the end of slavery mean for the future of African Americans? Would they become full participants in political life, truly part of "we the people"? Or would they endure a form of second-class status and see themselves denied the rights and opportunities that other Americans enjoyed? As the guns fell silent, no one knew for sure.

Initially, the future did not look promising. Andrew Johnson, the Tennessean who ascended to the presidency upon Lincoln's assassination, pursued his main goal of putting the union back together. This entailed "reconstructing" the state governments of the former Confederacy. In Johnson's view, the sooner this could be done, the better. Thanks to Lincoln's efforts, a few Southern states were already operating under Unionist governments. Now, at Johnson's direction in the late

summer and fall of 1865, the other former Confederate states held conventions to write new constitutions, repudiate secession, and abolish slavery. Unfortunately, these conventions and the governments they created were full of former Confederates. The new state constitutions denied African Americans the right to vote, and state legislatures quickly enacted so-called black codes that placed demeaning restrictions on former slaves. Congress considered these states' actions so flagrant and unacceptable that it refused to seat any of their representatives or senators. Throughout 1866, as they read reports of appalling violence against African Americans, Northerners grew only more outraged at the intransigence displayed by Southern whites.

The Republican majority in Congress inaugurated a new phase of reconstruction and prepared the way for a milestone in the history of American constitutionalism. In 1867, Congress passed a series of acts over President Johnson's vetoes. The former Confederate states were in for another round of constitution-making. Congress divided the South into five military districts and put a general in charge of each. These district commanders arranged elections for constitutional conventions, making sure in the process that many former Confederates were barred and that African Americans could vote and serve as delegates.

It was a remarkable moment, then, when eighteen black delegates took their seats in the Alabama convention in Montgomery in November 1867. Just six years earlier, the city had seen a convention write a constitution for the Confederate States of America—a frame of government grounded on the alleged "truth" of black inferiority. Predictably, Southern whites decried the black delegates' presence. Even worse, the president of the United States himself disparaged their abilities, claiming that "in the progress of nations negroes have shown less capacity for government than any other race of people."9

The president's claims were, of course, completely unfounded. The Alabama constitution more than measured up to any constitution Americans had yet written. The first section of the document's Declaration of Rights announced, "That all men are created equal; that they are endowed by their Creator with certain inalienable rights; that among these are life, liberty, and the pursuit of happiness." Given the recent debate over the meaning of this famous sentence, the convention's decision to quote it in full on the first page made a powerful statement and prepared fellow citizens for the provisions to come.

The next section declared that "all persons" who resided in Alabama and who were born in the United States were "citizens of the State of Alabama, possessing equal civil and political rights and public privileges." This section echoed the Fourteenth Amendment, passed by Congress in June 1866 and rejected by most of the former Confederate states, including Alabama, shortly thereafter. By declaring that "All persons born or naturalized in the United States, and subject to the jurisdiction thereof, are citizens of the United States and of the state wherein they reside," the Fourteenth Amendment aimed once and for all to overturn the Supreme Court's notorious ruling in *Dred Scott*. The amendment also prohibited state governments from denying anyone "the equal protection of the laws." By paraphrasing and incorporating its text, the Alabama constitution signaled that the new state government would not only ratify the Fourteenth Amendment, but also embody the principles it appeared to espouse.

In addition, the constitution granted suffrage to "every male person." This ensured that African American men would have the right to vote in Alabama—a noteworthy development in a nation still bitterly divided on the question. Although nearly all white Northerners supported abolishing slavery, some expressed misgivings about the degree of equality for African Americans implied by the Fourteenth Amendment. Many remained downright opposed to black voting. Less than a month before Alabama's convention met, voters in Ohio rejected a referendum proposal that would have extended suffrage to the state's African Americans. Other states—including Connecticut, Kansas, Michigan, Minnesota, Missouri, and Wisconsin—also saw black suffrage proposals defeated in these years. Only with the ratification of the Fifteenth Amendment in 1870 did African American men gain the right to vote nationwide. Until then, the United States witnessed the strange paradox

OPPOSITE: Cat. 35. Alabama Constitution of 1867

CONSTITUTION.

PREAMBLE.

WE, The People of the State of Alabama, by our Representatives in Convention assembled, in order to establish justice, insure domestic tranquillity, provide for the common defence, promote the general welfare, and secure to ourselves and to our posterity the rights of life, liberty, and property, invoking the favor and guidance of Almighty God, do ordain and establish the following Constitution and form of government for the State of Alabama:

ARTICLE I.

DECLARATION OF RIGHTS.

That the great, general and essential principles of liberty and free government may be recognized and established, WE DECLARE:

§1. That all men are created equal; that they are endowed by their Creator with certain inalienable rights; that among these are life, liberty, and the pursuit of happiness.

§2. That all persons resident in this state, born in the United States, or naturalized, or who shall have legally declared their intention to become citizens of the United States, are hereby declared citizens of the State of Alabama, possessing equal civil and political rights and public privileges.

§3. That all political power is inherent in the people, and all free governments are founded on their authority, and instituted for their benefit; and that, therefore, they have, at all times, an inherent right to change their form of government, in such manner as they may deem expedient.

§4. That no person shall be deprived of the right to worship God according to the dictates of his own conscience.

§ 5. That no religion shall be established by law.

§ 6. That any citizen may speak, write, and publish his sentiments on all subjects, being responsible for the abuse of that liberty.

§ 7. That the people shall be secure in their persons, houses, papers and possessions, from unreasonable seizures or searches, and that no warrant shall issue to search any place, or to seize any person or thing without probable cause, supported by oath or affirmation.

§ 8. That in all criminal prosecutions, the accused has a right to be heard by himself and counsel, or either; to demand the nature and cause of the accusation; to have a copy thereof; to be confronted by the witnesses against him; to have compulsory process for obtaining witnesses in his favor; and in all prosecutions by indict-

of black voting and constitution-making in states of the former Confederacy and continued disfranchisement of blacks in many states where slavery had never existed.

An Educated Citizenry

CAT. 36. LOUISIANA CONSTITUTION OF 1868

Although they held fewer than one-fifth of the seats in the Alabama convention, African American delegates clearly exerted a powerful influence on the state's new constitution. In the Louisiana convention, just getting under way in New Orleans as the Alabama convention prepared to adjourn, black delegates comprised at least half of the total number. (South Carolina's convention boasted the highest proportion of black delegates with 61 percent.) Like their counterparts in other conventions, Louisianans quoted the Declaration of Independence, guaranteed equal rights, and granted suffrage to all men regardless of race. They also considered other measures their state might pursue to ensure that the freedom and equality African Americans now enjoyed in law would lead to the tangible improvement of their prospects in life.

Delegates focused their attention on education. Since antebellum Southern governments had made it a crime to teach slaves how to read or write, the vast majority of African Americans remained illiterate. Illiteracy did not necessarily prevent freed people from being good citizens. Throughout the country's history, plenty of white Americans, especially in the South, could neither read nor write, and they had always been considered competent enough to exercise their political rights responsibly. Still, illiteracy placed obvious limitations on what citizens of any background could contribute and achieve. Recognizing the crucial connection between education and a thriving republic, Thomas Jefferson had proposed a system of free public schooling for all children in Virginia as early as 1779. Southern state governments showed little interest in such expensive ideas, however, and prior to the Civil War, educational options, even for white children, remained limited. Finally in a position to rectify the region's longstanding neglect of basic education, African American constitution-makers set out to design systems of public schooling.

The Louisiana convention proposed a revolutionary plan. The new constitution ordered the legislature to "establish at least one free public school in every parish throughout the State." These schools would be supported from taxation and other sources of revenue. The constitution did not merely "encourage" the legislature to do this; it positively mandated it. A large number of the state's rising generation would benefit. All children aged six to twenty-one, the constitution stated, "shall be admitted to the public schools . . . without distinction of race, color, or previous condition." The constitution did not require children to attend school—very few states in this period mandated compulsory education—but many parents, both white and black, appreciated this opportunity to offer their children something they themselves had never received, however rudimentary the lessons turned out to be. Literacy among black children in the Deep South increased significantly as a result of the new schools. Whereas virtually none could read in 1865, perhaps one-quarter could fifteen years later.

Especially in light of future developments, the most striking aspect of the constitution's plan for public education surely came in its declaration that "there shall be no separate schools or institutions of learning established exclusively for any race by the State of Louisiana." Racially integrated schools were rare anywhere in the United States. For white Americans who had long taken for granted black social and intellectual inferiority, the notion of sending their children to share a classroom with former slaves was shocking. Unsurprisingly, only the constitutions of South Carolina and Louisiana—the states whose conventions featured the highest proportion of black delegates—explicitly called for integrated schools. Louisiana's convention approved the provision by a vote of 71 to 6. For African Americans, the prohibition on separate schools symbolized black equality. It also guaranteed that some future legislature would never be able to provide different levels of funding to black and white schools, thus depriving African American students

OPPOSITE: Cat. 36. Louisiana Constitution of 1868

ART. 123. The general assembly shall provide for the protection of the rights of married women to their dotal and paraphernal property, and for the registration of the same; but no mortgage or privilege shall hereafter affect third parties, unless recorded in the parish where the property to be affected is situated. The tacit mortgages and privileges now existing in this State shall cease to have effect against third persons after the 1st day of January, 1870, unless duly recorded. The general assembly shall provide by law for the registration of all mortgages and privileges.

ART. 124. The general assembly, at its first session under this constitution, shall provide an annual pension for the veterans of 1814 and 1815, residing in the State.

ART. 125. The military shall be in subordination to the civil power.

ART. 126. It shall be the duty of the general assembly to make it obligatory upon each parish to support all paupers residing within its limits.

ART. 127. All agreements, the consideration of which was confederate money, notes or bonds, are null and void, and shall not be enforced by the courts of this State.

ART. 128. Contracts for the sale of persons are null and void, and shall not be enforced by the courts of this State.

ART. 129. The State of Louisiana shall never assume nor pay any debt or obligation contracted or incurred in aid of the rebellion; nor shall this State ever, in any manner, claim from the United States, or make any allowance or compensation for slaves emancipated or liberated in any way whatever.

ART. 130. All contracts made and entered into under the pretended authority of any government heretofore existing in this State, by which children were bound out without the knowledge or consent of their parents, are hereby declared null and void; nor shall any child be bound out to any one for any term of years, while either one of its parents live, without the consent of such parent, except in cases of children legally sent to the house of correction.

ART. 131. The seat of government shall be established at the city of New Orleans, and shall not be removed without the consent of two-thirds of the members of both houses of the general assembly.

ART. 132. All lands sold in pursuance of decrees of courts shall be divided into tracts of from ten to fifty acres.

ART. 133. No judicial powers shall be exercised by clerks of courts.

ART. 134. No soldier, sailor, or marine in the military or naval service of the United States shall hereafter acquire a residence in this State by reason of being stationed or doing duty in the same.

TITLE VII.—*Public education.*

ART. 135. The general assembly shall establish at least one free public school in every parish throughout the State, and shall provide for its support by taxation or otherwise. All children of this State between the years of six (6) and twenty-one (21) shall be admitted to the public schools or other institutions of learning sustained or established by the State in common without distinction of race, color, or previous condition. There shall be no separate schools or institutions of learning established exclusively for any race by the State of Louisiana.

ART. 136. No municipal corporation shall make any rules or regulations contrary to the spirit and intention of article one hundred and thirty-five, (135.)

ART. 137. There shall be elected by the qualified voters of this State a superintendent of public education, who shall hold his office for four years. His duties shall be prescribed by law, and he shall have the supervision and the general control of all public schools throughout the State. He shall receive a salary of five thousand dollars per annum, payable quarterly on his own warrant.

of much-needed resources. Meanwhile, some white delegates may have acquiesced to integrated schools because they assumed that the Fourteenth Amendment would not allow states to set up segregated ones.

White Southerners need not have worried. Throughout the period of Reconstruction, the United States Supreme Court issued rulings that suggested that the Fourteenth Amendment placed far fewer restrictions on state actions than many Americans had initially believed. Responsibility for interpreting and protecting African Americans' civil rights rested largely with the state governments—a deeply troubling proposition once racist Democrats gained power in Louisiana in 1877. When white Louisianans rewrote the state constitution in 1879, they altered the wording of the section on public schooling. Louisiana would still offer "free public schools" open to "all children . . . between six and eighteen," but would no longer uphold the prohibition on "separate schools." The legislature could now establish parallel education systems along racial lines. This policy would ultimately find its most important affirmation in the 1896 case *Plessy v. Ferguson*, in which the Supreme Court ruled that as long as states provided allegedly "separate but equal" facilities, state governments could mandate segregation without violating the Fourteenth Amendment. Not until 1954, in *Brown v. Board of Education*, did the court reverse itself and declare that segregated schools "are inherently unequal" and therefore unconstitutional.

Oppression Restored

CAT. 37. FLORIDA CONSTITUTION OF 1885

The period following the Civil War witnessed a flurry of constitutional activity on both the state and federal levels. Time and again, for good and for ill, Americans used their sovereign authority to transform the governments under which they lived. African Americans figured prominently in all these developments. They pushed for the abolition of slavery, the extension of full citizenship, and the right to vote. After helping to write new constitutions for their states, many black men held

public office for the first time in the nation's history. Sixteen served in either the United States House of Representatives or the Senate between 1869 and 1880. Given the size of the African American population, the number of black officeholders lagged far behind their just proportion. Still, the advances were significant.

African Americans' rights remained vulnerable, however. The ability of blacks to exercise the prerogatives of citizenship depended on white Americans' commitment to the goal of racial equality. For their part, Southern whites wasted no time in attempting to destroy African Americans' political power and civil rights. They denounced the constitutions of 1867–68 as well as the governments they created. They depicted "Black Republican" rule as a time of corruption and profligacy. And, nominally in "self-defense," they launched a systematic campaign of intimidation and violence against African Americans and their white allies. In Louisiana alone between April and November 1868—the months immediately following the completion of the state's new constitution—whites killed 1,081 African Americans. In all, over 3,000 African Americans and white Republicans were killed throughout the South between 1867 and 1877.

Americans in the North recognized the severity of the situation and yet ultimately chose not to demand adequate federal intervention. Contrary to myth, few federal troops remained in the South during Reconstruction. Through its legislation, Congress had ensured that the states of the former Confederacy created new governments open to African American participation. With the Fifteenth Amendment, Americans had guaranteed (or so they thought) that black citizens could wield political power through voting. In short, Northerners believed African Americans possessed the tools they needed to fend for themselves. Northern whites' collective will to help African Americans truly thrive in a new era of freedom, never that strong or consistent to begin with, evaporated almost entirely.

Without meaningful federal oversight to stop them, Southern whites' various terror tactics soon suppressed enough of the black vote for white so-called Redeemers to regain control of state governments. From there, Southern whites swiftly proceeded to entrench

OPPOSITE: Cat. 37. Florida Constitution of 1885

be obtained at the time of said election, he shall be allowed to make affidavit before a proper officer, setting forth the reason why he is unable to furnish such certificate, and if said affidavit prove satisfactory to the inspectors they shall allow said elector to cast his vote; and any naturalized citizen offering to vote shall, if so required by any elector, produce his certificate of naturalization or a duly certified copy thereof, and in the event that said elector cannot produce the same, he shall be allowed to make affidavit before a proper officer, stating in full the reason why it cannot be furnished, and if satisfactory to the inspectors of said election, such elector shall be allowed to vote.

SEC. 8. The Legislature shall have power to make the payment of the capitation tax a prerequisite for voting, and all such taxes received shall go into the school fund. *Legislature may make poll tax a prerequisite.*

SEC. 9. The Legislature shall enact such laws as will preserve the purity of the ballot given under this Constitution. *Purity of ballot to be preserved.*

ARTICLE VII.

CENSUS AND APPORTIONMENT.

SECTION 1. The Senators representing the odd numbered districts, as said districts are now designated, whose terms have not expired, and those Senators representing even numbered districts, to be elected A. D. 1886, under the Constitution of 1868, shall be the first Senate under this Constitution; and the members of the Assembly to be elected A. D. 1886 shall be the first House of Representatives under this Constitution, and the Senate and House of Representatives thus constituted shall be the first Legislature under this Constitution, and the terms of office of each of the said Senators and members of the House of Representatives shall expire at the election for Senators and members of the House of Representatives A. D. 1888, and in that year a new Senate and House of Representatives shall be elected. *What Senators and Representatives to compose first Legislature under this Constitution.*

SEC. 2. The Legislatures that convene in the year 1889 and thereafter, shall consist of not more than thirty-two members of the Senate, and of not more than sixty-eight members of the House of Representatives. The members of the House of Representatives shall be elected for terms of two years, and the members of the Senate shall be elected for terms of four years, except as hereafter provided, the elections for members of the Senate and House of Representatives to be held at the same time and places. The terms of Senators elected in 1888 from districts designated by even numbers, shall expire at the end of two years from that date, and thereafter all Senators *Number of Senators and Representatives.* *Terms of Senators and Representatives.*

themselves in power. They could always use violence against African Americans when necessary, but the more formal mechanisms of the law and constitutional revision made the repression of their fellow citizens both easier and more comprehensive.

Southern states found ways to prevent most African Americans from voting. Although the Fifteenth Amendment prohibited states from denying any man the right to vote "on account of race, color, or previous condition of servitude," other, supposedly colorblind methods of disfranchisement existed. Before the Civil War, the constitutions of both Connecticut and Massachusetts had made passing a "literacy test" a qualification for suffrage. Would-be voters had to be able to read a passage from the constitution in order to cast their ballots. Proponents insisted that such provisions merely guaranteed good citizenship and a responsible electorate, but the real goal in these New England states was to keep immigrants from voting. Southern states now adopted literacy tests to disfranchise black men, a large segment of whom could not read. (Simultaneous attempts to curtail state school systems dovetailed with these efforts.) To ensure that the tests would not disfranchise too many illiterate white men, some states offered exemptions through preposterous "grandfather clauses." These declared that anyone who had been eligible to vote prior to a certain date—one usually coinciding with the extension of voting rights to African Americans—did not have to pass the test, nor did his descendants.

States also prevented African Americans from voting by requiring that they pay a poll tax. By the late nineteenth and early twentieth century, a poll tax referred more exclusively to an amount one paid to participate in an election. Poll taxes obviously proved an obstacle for the poor, with African Americans disproportionately affected. Nevertheless, several states permitted them. Florida did so in 1885, the year it discarded its Reconstruction-era constitution. Article VI, Section 8 of the new state constitution declared, "The Legislature shall have power to make the payment of the capitation tax a prerequisite for voting, and all such taxes received shall go into the school fund." ("Capitation" tax recalled the older meaning of the term "poll" as a taxable individual. A poll tax therefore had denoted a single flat rate assigned per capita, to all heads, in a community.) Four years later, Florida's legislature set the tax at $1.

Poll taxes, literacy tests, other forms of manipulation, and the constant threat of violence all worked to suppress the number of African American voters for the better part of a century. Studies have offered sobering statistics. The number of registered black voters plummeted in many states: for instance, to 4 percent of those eligible in Georgia in 1910. Previously, 60 to 85 percent of black men had participated in elections throughout the South; by the early decades of the twentieth century, black turnout hovered under 10 percent. Responsibility for this situation, of course, lay most directly with the whites of the South. Upon regaining power through underhanded means, they exploited the mechanisms of constitutional democracy to cement their rule and lend it a thin veneer of legitimacy. But white Americans everywhere also bore responsibility. Large numbers of Americans in states outside the former Confederacy either actively supported Southern whites or remained apathetic to the plight of African Americans. They failed to act when it lay in their power to do so. Only with the civil rights movement did the situation begin to change significantly. In 1964, the Twenty-fourth Amendment to the United States Constitution finally banned poll taxes, which only a handful of states still enforced. Except for Tennessee, no other former Confederate state ratified the amendment. With 1965's seminal Voting Rights Act, the American people, acting through their federal government, finally took steps to ensure that black citizens could participate in elections and once again help constitute and run their governments. Slavery's legacy endures, however, challenging each generation of Americans to foster "more perfect unions" between all citizens.

1. D. W. Meinig, *The Shaping of America: A Geographical Perspective on 500 Years of History*, vol. 2, *Continental America, 1800–1867* (New Haven: Yale University Press, 1993), 459.

2. Declaration of the People of Texas (1835), *Texas Constitutions 1824–1876*, Jamail Center for Legal Research at the University of Texas at Austin, https://tarltonapps.law.utexas.edu /constitutions/dpt1835 (accessed April 12, 2019).

3. Quoted in Timothy S. Huebner, *Liberty and Union: The Civil War Era and American Constitutionalism* (Lawrence: University Press of Kansas, 2016), 84.

4. Quoted in Robert L. Tsai, "John Brown's Constitution," *Boston College Law Review* 51, no. 1 (2010): 187.

5. Ibid., 199.

6. Lincoln quoted in Huebner, *Liberty and Union*, 103.

7. Lincoln Inaugural Address, March 4, 1861, http://avalon.law .yale.edu/19th_century/lincoln1.asp (accessed January 25, 2019).

8. Henry Cleveland, ed., *Alexander Stephens, in Public and Private: With Letters and Speeches, Before, During, and Since the War* (Philadelphia: National Publishing Company, 1866), 721.

9. Johnson quoted in Huebner, *Liberty and Union*, 374.

ARTICLE XIII.

STATE INSTITUTIONS.

Section 1. Educational, reformatory and penal institutions; those for the benefit of blind, deaf, dumb or otherwise defective youth; for the insane or idiotic; and such other institutions as the public good may require, shall be fostered and supported by the state, subject to such regulations as may be provided by law. The regents, trustees, or commissioners of all such institutions existing at the time of the adoption of this constitution, and of such as shall thereafter be established by law, shall be appointed by the governor, by and with the advice and consent of the senate; and upon all nominations made by the governor, the question shall be taken by the ayes and noes, and entered upon the journal.

Support of.

Regents, etc., appointed by whom.

ARTICLE XIV.

SEAT OF GOVERNMENT.

Section 1. The legislature shall have no power to change, or to locate the seat of government of this state; but the question of the permanent location of the seat of government of the state shall be submitted to the qualified electors of the territory, at the election to be held for the adoption of this constitution. A majority of all the votes cast at said election, upon said question, shall be necessary to determine the permanent location of the seat of government for the state; and no place shall ever be the seat of government which shall not receive a majority of the votes cast on that matter. In case there shall be no choice of location at said first election, the legislature shall, at its first regular session after the adoption of this constitution, provide for submitting to the qualified electors of the state, at the next succeeding general election thereafter, the question of choice of location between the three places for which the highest number of votes shall have been cast at the said first election. Said legislature shall provide, further, that in case there shall be no choice of location at said second election, the question of choice between the two places for which the highest number of votes shall have been cast, shall be submitted in like manner to the qualified electors of the state at the next ensuing general election: *Provided*, That until the seat of government shall have been permanently located as herein provided, the temporary location shall remain at the city of Olympia.

Location of.

Method of choosing.

Temporary location.

Sec. 2. When the seat of government shall have been located as herein provided, the location thereof shall not thereafter be changed except by a vote of two-thirds of all the qualified electors of the state voting on that question, at a general election, at which the question of location of the seat of government shall have been submitted by the legislature.

Two-thirds vote necessary to change.

IV

Reform and Renewal

Promoting the General Welfare

CAT. 38. WASHINGTON CONSTITUTION OF 1889

In the decades following the Civil War, Americans began to reconsider what their governments should do to promote the welfare of the most vulnerable and disadvantaged of their fellow citizens. The war had demonstrated once again the remarkable power Americans could wield when they focused on a common goal. Saving the union and abolishing slavery certainly represented worthy causes in the eyes of most Americans, but the costs lingered long after the conflict ended. The federal government began to spend a large portion of its annual budget on soldiers' pensions. Thousands of men also required continuing medical care as a result of their wounds. Providing for these citizens alone—and, in many cases, for their widows and children—led state and federal governments to take much more active roles. It is perhaps not surprising, then, that around the same time, state constitutions became more likely to mandate support for public institutions specializing in the care of people with disabilities.

In 1889, citizens in the state of Washington made sure their first constitution included such provisions.

When Washington became a federal territory in 1853, it served as a satellite to more substantial settlements in Oregon to the south. (Oregon achieved statehood in 1859.) The advent of railroads to the region led to rapid development a few decades later. Between 1880 and 1890, the population increased from about 75,000 to over 350,000. Many migrants settled near the coast, around Puget Sound, but many others settled inland, in the vicinity of Spokane. Industries such as lumbering, fishing, and mining fueled economic growth. Proximity to Alaska, recently acquired by the United States from Russia, promised additional opportunities.

The constitutional convention met in Olympia, the territorial capital, from July 4 to August 22, 1889. Article XIII dealt with "state institutions." Among those that "shall be fostered and supported by the state," the constitution listed "educational, reformatory and penal institutions," as well as "those for the benefit of blind, deaf, dumb or otherwise defective youth." The constitution also announced a desire to help "the insane or idiotic" while leaving it up to citizens to decide about "such other institutions as the public good may require." That October, citizens ratified the frame of government by a vote of 40,152 to 11,879.

OPPOSITE: Cat. 38. Washington Constitution of 1889

It was probably not a coincidence that Washington and several other new Western states proved more amenable to inserting provisions of this kind in their constitutions. Many states in the nation's Northeast and Midwest had undertaken large-scale "internal improvement" projects earlier in the century and had come out of the experience committed to fiscal restraint for decades thereafter. These states' constitutions, written or rewritten with the perils of excessive spending and debt firmly in mind, did not, in general, encourage legislatures to appropriate money for what could be deemed nonessential services. The Americans who wrote constitutions for new Western states later in the century still took measures to curb spending, but their explicit support for social welfare institutions suggests that popular attitudes about government's fundamental obligations were beginning to change. Generous federal land grants and the absence of large preexisting debts in these states surely helped matters as well.

The constitutions of Kansas (1859), Nevada (1864), and Colorado (1876) all mentioned "public institutions" in some form. In 1889, the constitutions of Washington, Idaho, Wyoming, South Dakota, and North Dakota followed suit; in 1895, so did the constitution of Utah. It is important to note, as well, that many Reconstruction-era constitutions—those written in the late 1860s with the participation of African Americans—had helped pave the way for such provisions. The 1868 constitutions of Florida, Louisiana, Mississippi, North Carolina, and South Carolina all mentioned the state's responsibility to assist people with physical or intellectual disabilities. When Southern whites rewrote these states' constitutions in the 1870s and 1880s, they in some cases eliminated the social welfare provisions (in Louisiana and Mississippi, for instance), but in others they retained them in close to the same form (in Florida, North Carolina, and South Carolina, for example). Arkansas (1874), Texas (1876), Alabama (1901), and Virginia (1902) added language on these topics.

States whose constitutions did not expressly encourage "public institutions" were by no means restrained from creating and maintaining them. Conversely, states with constitutional mandates of this type did not

necessarily follow through to the extent constitution-makers may have hoped. And, as suggested by the very terms the constitutions used to describe those who would benefit, the care and services turn-of-the-century state institutions did provide inevitably reflected the era's all-too-limited knowledge. Yet the increasing presence of such provisions in state constitutions surely represented a significant development. Perhaps more than ever before, Americans assumed that their governments ought to take an active role in looking after the welfare of certain groups of citizens. Any constitutional statement that suggested government's responsibility in this respect gave citizens a firm basis on which to hold their elected officials to account whenever they failed to carry out the people's wishes.

Prohibition

CAT. 39. KANSAS STATE PROHIBITION AMENDMENT OF 1880

The proper role of government in molding the behavior and morals of citizens is a topic never far from the center of American politics. Americans have never reached—and probably will never reach—a consensus on how to balance respect for individual rights and freedom, on the one hand, with the promotion of the common good, on the other. Members of the Revolutionary generation believed that simply participating in the political life of a republic edified and enhanced a citizen's character, and that may well have been the case. Yet in the eyes of successive generations of reformers, Americans still remained susceptible to an alarming variety of vices. These temptations harmed both individuals and the community at large. What steps should citizens take to suppress such dangerous influences and encourage more constructive conduct?

Within a few decades of the nation's founding, alcohol became the focus of much attention and activism. The issue confronted citizens on a daily basis. Scholars estimate that the average American in the 1820s drank seven gallons of alcohol annually—at least three and a half times the intake of the typical

OPPOSITE: Cat. 39. Kansas State Prohibition Amendment of 1880

time, receives from the time of the purchase a homestead exemption from seizure upon execution or attachment. (Monroe v. May, 9 K. 466.)

Under the constitution, a parol agreement for sale of homestead without the consent of wife cannot be enforced. (Lister v. Batson, 6 K. 426.)

A mortgage of the homestead executed by the husband alone, is void. (Morris v. Ward, 5 K. 239.)

J. S. owned one hundred and two and three-fourths acres of land; seventeen and one-fourth acres of the tract lies within the corporate limits of the city of Wyandotte, the residue adjoining the city. He lives on that part of the land outside the city limits. The land in the city was sold on execution. *Held*, That the homestead of J. S. was on that part of the land outside the city, and that the land inside the city was subject to forced sale under execution. (Sarahas v. Fenlon, 5 K. 592.)

A mortgage of the homestead, executed by the wife alone, is void, notwithstanding the legal title to the same may be in her, and not in her husband. (Dollman v. Harris, 5 K. 597.)

Held, That the homestead-exemption clause in the constitution of Kansas (§ 9, art. 15) is not in contravention of the constitution of the United States as impairing the obligation of contracts. (Art. 1, § 10.) Judgment below reversed — demurrer ordered to be overruled. (Cusic v. Douglass, 3 K. 123.)

(236) Prohibition. § 10. The manufacture and sale of intoxicating liquors shall be forever prohibited in this state, except for medical, scientific and mechanical purposes.

[The foregoing amendment was submitted by the legislature at the session of 1879, and was adopted by the people at the general election, held November 2, 1880.]

A physician having no permit cannot furnish a patient liquor for pay. (State v. Fleming, 32 K. 588.)

A state law prohibiting the sale and manufacture of intoxicating liquors, is not repugnant to the federal constitution. (U. S. Sup. Ct.) (Foster v. State, 32 K. 765.)

The constitution provides that propositions for its amendment may be submitted to the people by the concurrence of two-thirds of the members of each house, that such propositions, together with the yeas and nays, shall be entered on the journal, and that if a majority of the electors voting on such proposed amendment adopt them, they shall become a part of the constitution. It also provides for a "general election" to be held annually on the Tuesday succeeding the first Monday in November. From early Kansas history, there has been in force a general-election law. It provides all the machinery for elections, names judges, canvassing boards, prescribes forms and procedure for the election of all officers — state, district, county and township. In terms, it names only individuals and officers, and does not refer to constitutional amendments or other questions. In 1879, the legislature, by the requisite vote, submitted a proposition to amend the constitution. This proposition was not entered at length upon the journal, but was described by its title, its scope and object. Otherwise, the submission was legal and regular. The joint resolution making the submission simply provides that the proposition shall be submitted to the electors at the general election in 1880, and prescribes the form of ballots. It does not in terms declare that the machinery of the general-election law shall control, or that any particular officers or boards shall receive, count or canvass the votes cast. As a matter of fact, the full machinery of the general-election law was appropriated, votes were received, counted, canvassed, and the result declared, just as fully as though it had been in terms ordered. Further, the records of legislative action disclose that while, from 1861 to 1868, propositions for constitutional amendments were submitted, in which the machinery of the general-election law was specifically appropriated, and from 1868 to 1873 no propositions for constitutional amendments were submitted, yet that, from 1873 to the present time, four legislatures have submitted constitutional amendments, and that during these years the same form of submission has been observed as was used in this submission; that many of the propositions so submitted have been adopted, and, without question, recognized and acted upon as parts of the constitution; that among these changes are such vital ones as the numerical organization of the legislature, length of official terms, scope of revenue laws, and biennial sessions. Frequently, also, the full text of the proposed amendment did not appear upon the journal of either house, but, like the one in question, it was referred to only by the title and object. Beyond this, it is a matter of public history, that between the submission and the vote, a period of over twenty months, this proposition for amendment was the subject of a warm and heated canvass throughout the entire state, and no suggestion, even, was publicly made that the proposition was not fully and legally presented to the people for decision. At the election, seven out of every eight voters recorded, by ballot, their views upon the question, and a majority of these ballots was in favor of the adoption of the amendment. *Held*, That, conceding the irregularity in the proceedings of the legislature, and the doubtful scope of the provisions for the election, yet, in view of the uncertainty as to those provisions, the past legislative history of similar propositions, the universal prior acquiescence in the same forms of procedure, and the popular and unchallenged acceptance of the legal pendency before the people of the question of this amendment for decision, and also in view of the duty cast upon this court of taking judicial knowledge of everything affecting the existence and validity of any law or portion of the constitution, it must be, and it is adjudged, that such proposed amendment has become, and is, a part of the constitution. (Const. Prohib. Amend. Cases, 24 K. 700.)

The constitutional amendment does not repeal the dramshop act *in toto*, but only so far as that act authorized licenses for the sale of intoxicating liquors as a beverage. (Prohib. Amend. Cases, 24 K. 700.)

twenty-first-century American. Reformers blamed the pernicious influence of liquor for all manner of societal ills, including unemployment, family abandonment, and crime. Temperance advocates encouraged Americans to take a personal pledge to refrain from drinking, but upholding this promise proved difficult given alcohol's easy availability. Governments must compensate for the inevitable failings of the human will, reformers concluded, by reducing Americans' opportunities to imbibe.

Citizens considered how best to restrict the legal availability of alcohol. Early reformers directed their efforts at persuading local government officials to grant fewer liquor licenses. Where such officials held office by election, organized groups of voters could make clear that their support depended on a candidate's pledge not to license establishments that served intoxicating beverages. These efforts achieved success in some regions and culminated in Michigan (1850) and Ohio (1851) eliminating their licensing systems through constitutional provision.

Seeking to build on these gains, reformers adopted another tactic designed to appeal to Americans' democratic sensibilities. Why not, they asked, leave it directly to the citizens of each town or county to decide whether to permit the sale of alcohol? This "local option" plan disarmed critics who claimed that politicians supported temperance measures only because highly disciplined but unrepresentative groups of voters threatened them with electoral defeat if they did not submit to their minority positions. The people themselves could not be pressured, however. Surely, reformers insisted, no one could be afraid to let responsible citizens determine how their own communities would address an issue of such importance. This logic proved powerful indeed, with no fewer than thirty-seven states allowing some form of the local option by the turn of the twentieth century. In 1876, Texas became the first state to mandate the local option in its constitution.

Yet for many Americans the ultimate goal remained total prohibition. If voters could ban alcohol in their locality, they could also choose to allow it. In many instances, the existence of non-dry towns or counties in a state meant that determined individuals could obtain alcohol simply by entering a neighboring

jurisdiction. When the political circumstances appeared favorable, then, reformers advocated state-wide bans. In 1851, Maine became the first state to pass a statewide prohibition statute. In the next few years, twelve other states or territories also adopted statewide laws. The Civil War temporarily redirected Americans' attention, but the movement revived thereafter.

For reformers, prohibition statutes were good, but prohibition provisions in state constitutions were even better. The same simple majorities in state legislatures that could enact prohibition laws could also repeal them. And, just as abstaining individuals were prone to relapse if the obstacles to obtaining alcohol appeared too easily overcome, whole state governments were liable to give in to the temptation to re-legalize alcohol at the first sign of popular agitation. Enshrining prohibition in a constitution reduced that risk. Adopting an amendment required a greater effort at first, but once prohibition became part of a state's constitution, its opponents would face an equally daunting challenge if they tried to remove it. Kansas, the first state to incorporate prohibition in its constitution, serves as an example. The state constitution (written in 1859) required that two-thirds of both houses of the legislature approve a proposal for a constitutional amendment. A majority of the state's voters then had to approve the same proposal. In 1879, the state legislature approved the text of a prohibition amendment; on November 2, 1880, voters ratified it. "The manufacture and sale of intoxicating liquors shall be forever prohibited in this state," the constitution now declared, "except for medical, scientific and mechanical purposes."

In the next four decades, eighteen other states eventually added prohibition to their constitutions and another fourteen ultimately adopted prohibition statutes. At this point, the same nagging issue that left reformers unsatisfied with local-option laws on the state level presented itself on a national scale. Support grew for a federal amendment that would eliminate the patchwork of dry and non-dry states by making prohibition the law everywhere. Two-thirds of both houses of Congress approved such a proposal in 1917, at which point it needed to be ratified by thirty-six states. The Eighteenth Amendment met this threshold in 1919 and became part of the Constitution. In the end, only three states failed to ratify the amendment.

Nationwide prohibition lasted only fourteen years before Americans, in an unprecedented decision, ratified another amendment to repeal the provisions they had just approved. However misguided the whole experiment seemed to many Americans in hindsight, no one could dispute that citizens had the authority to revise their fundamental laws after reaching the requisite degree of consensus about a desirable change. A federal amendment came about only after citizens in many states had used the democratic and constitutional means at their disposal to implement local anti-alcohol measures. Ultimately, the people affirmed their power both when they adopted prohibition and when they repealed it.

Women's Suffrage

CAT. 40. WYOMING CONSTITUTION OF 1889

From the beginning, women played prominent roles in the temperance and prohibition movements. Female activists justified their public stance by persuasively arguing that alcohol-related issues affected the "domestic sphere," those matters related to home and family life that American society had designated as the proper focus of women's concerns. Women made similar arguments to defend their involvement in the antislavery movement. It was during the course of these campaigns that many female activists grew frustrated with the constant need to justify their presence in the public arena. They bristled at the notion that their political participation should take only certain forms and remain confined to certain subjects. Increasingly, many women called for the right to vote.

Nothing in the United States Constitution prevented states from allowing women to vote. Women could, in fact, vote in New Jersey from 1790 to 1807, provided they met a property requirement. But this stood as the exception rather than the rule. Men (and some women, too) offered several reasons for denying women's suffrage. Women lacked a sufficient "stake in society," they claimed. Because of their reliance on their fathers or husbands, women could not exercise truly independent judgment. Even if women had achieved the level of education necessary to

comprehend complex public affairs, exposure to the world of rough-and-tumble politics would quickly degrade female virtues that should be preserved inviolate. At bottom, most men probably feared that women's suffrage would upset supposedly natural gender relations and family dynamics.

For their part, women countered with two somewhat divergent lines of argument. Sometimes they contended that women should have the right to vote because they were just like men in terms of their rights, capacities, and interests. Since government rested on "the consent of the governed," and since women were perfectly capable of rendering their informed consent, no valid justification existed for denying them the ballot. At other times, activists emphasized that women could offer valuable perspectives and contributions precisely because they differed from men in key ways. Perhaps women were peculiarly qualified to address issues that men often ignored. Activists deployed these and other arguments to suit their audiences and their own views.

For decades, the movement suffered far more defeats than victories. When Congress drafted the Fifteenth Amendment in the late 1860s, activists failed to persuade lawmakers to include sex among the list of traits that states were prohibited from using to deny suffrage. Some activists continued to focus on the federal level, while others concentrated on making gains in individual states.

At first glance, Wyoming seemed an unlikely place for the women's suffrage movement to achieve a toehold. When it became a federal territory in 1868, Wyoming contained only about 9,000 nonindigenous inhabitants, most of them clustered in the territory's southeastern corner. Railroads, ranching, and mining comprised the main industries. But in December 1869, the territorial legislature passed a law granting women's suffrage. A few factors may have played a role in the decision. Wyoming's six-to-one male-to-female ratio may have led legislators to seek ways to attract more women to the territory. Perhaps more important, men from the territory's permanently settled families wanted to counterbalance the votes of transient laborers, single men not much interested in Wyoming's long-term development or beholden to local elites. A measure that permitted their female relatives to vote

CONSTITUTION

OF THE PROPOSED

STATE OF WYOMING

ADOPTED IN CONVENTION

AT CHEYENNE, WYOMING.

SEPTEMBER 30, 1889.

CHEYENNE, WYO.
THE CHEYENNE LEADER PRINTING CO.
1889.

ABOVE AND OPPOSITE: Cat. 40. Wyoming Constitution of 1889

be eligible thereto during the term for which he was elected or appointed such judge.

SEC. 28. Appeals from decisions of compulsory boards of arbitration shall be allowed to the supreme court of the State, and the manner of taking such appeals shall be prescribed by law.

ARTICLE No. VI.

SUFFRAGE.

SECTION 1. The rights of citizens of the State of Wyoming to vote and hold office shall not be denied or abridged on account of sex. Both male and female citizens of this State shall equally enjoy all civil, political and religious rights and privileges.

SEC. 2. Every citizen of the United States of the age of twenty-one years and upwards, who has resided in the State or Territory one year and in the county wherein such residence is located sixty days next preceding any election, shall be entitled to vote at such election, except as herein otherwise provided.

SEC. 3. Electors shall in all cases except treason, felony or breach of the peace, be privileged from arrest on the days of election during their attendance at elections, and going to and returning therefrom.

SEC. 4. No elector shall be obliged to perform militia duty on the day of election, except in time of war or public danger.

SEC. 5. No person shall be deemed a qualified elector of this State, unless such person be a citizen of the United States.

SEC. 6. All idiots, insane persons, and persons convicted of infamous crimes, unless restored to civil rights, are excluded from the elective franchise.

SEC. 7. No elector shall be deemed to have lost his residence in the State, by reason of his absence on business of the United States, or of this State, or in the military or naval service of the United States.

SEC. 8. No soldier, seaman, or marine in the army or navy of the United States shall be deemed a resident of this State in consequence of his being stationed therein.

SEC. 9. No person shall have the right to vote who shall not be able to read the constitution of this State. The provisions of this section shall not apply to any person pre-

(and perhaps tip a close election their way) may have held significant appeal for territorial lawmakers. Whatever the true motivation, Wyoming became the first territory to grant women's suffrage, beating Utah Territory by a month. Ironically, the Wyoming legislature tried to repeal the law at its next session, but the territorial governor vetoed the bill. There the matter rested for two decades as the territory's population increased to around 60,000 and citizens prepared to apply for statehood.

The constitutional convention that met in Cheyenne from September 2 to 30, 1889, featured a brief but revealing debate over women's suffrage. (There were no female delegates, but the convention's stenographer, "Miss Louise S. Smith," recorded its debates.)[1] On the morning of September 17, delegates considered a proposal to refer the question of women's suffrage to a separate referendum. State constitutional conventions often set aside controversial issues to be voted on by the people themselves at ratification elections. In these instances, convention delegates worried that their making a decision one way or another—and incorporating that decision in the text of the constitution—might cause voters to reject an otherwise fine frame of government. The implication of the proposal made that day in Cheyenne, then, was that women's suffrage indeed comprised a controversial topic in Wyoming. One delegate who supported a separate referendum suggested that the territorial legislature had originally allowed women to vote "more as a joke than anything else" and that the people "have never had the chance to vote upon this proposition."[2]

In response, several delegates offered strong defenses of women's suffrage and praised Wyoming's progressive stance. One believed that holding a separate referendum or even debating whether to allow women to vote "would be a mere waste of time." The people were "nearly unanimous" in their support for the policy. If the convention was going to ask voters whether they wanted to deny suffrage to women, another delegate quipped, perhaps it should ask them "whether a male citizen of the territory shall be entitled to vote," too. Yet another delegate summed up a common view. "No man has ever dared to say in the territory of Wyoming that woman suffrage is a failure," he stated. "There has been no disturbance of the domestic relations, there has been no diminution of the dignity which characterizes the exercise of the elective franchise; there has been on the contrary an improvement of the social order, better laws, better officials, a higher and better civilization. We stand today proud, proud of this great experiment." The delegates defeated the proposal for a separate referendum by a vote of 20 to 8.[3]

The Wyoming constitution's section on suffrage declared that "the rights of citizens . . . to vote and hold office shall not be denied or abridged on account of sex. Both male and female citizens of this State shall equally enjoy all civil, political and religious rights and privileges." In its "Address to the People of Wyoming," the convention called its handiwork "the first constitution adopted by man which gives to each citizen the same rights guaranteed to every other citizen."[4] Voters ratified the constitution just over a month later, and Wyoming officially entered the union the following year.

The cause of women's suffrage had hardly triumphed, however. In 1890, just 62,555 of roughly 63 million Americans lived in Wyoming. In the 1890s, only Utah, Idaho, and Colorado granted women the right to vote. Between 1910 and 1914, Washington, California, Arizona, Kansas, Oregon, Illinois (on a partial basis), Montana, and Nevada did as well. State referendum defeats still outnumbered victories, and in many states the question never even made it to voters. No states in the South, Northeast, or Midwest enfranchised women as the nation prepared to enter the First World War.

The war breathed new life into the possibility of a federal amendment just as suffrage activists feared diminishing returns in their state-by-state campaigns. Women's contributions, sacrifices, and patriotism—never absent from American life, of course—became impossible even for most politicians to ignore during the national emergency. After President Woodrow Wilson publicly endorsed a suffrage amendment in January 1918, Congress set to work on approving a text that activists had been proposing for years. The House passed it quickly; the Senate took longer. By mid-1919, the amendment went to the states for ratification. In August 1920, Tennessee's final approval made the Nineteenth Amendment part of the Constitution, and women gained the right to vote nationwide.

Throughout the three decades after its constitution guaranteed women's suffrage, Wyoming often served

as an example for activists looking to reassure skeptical Americans that they had no reason to dread female participation in the political process. Their efforts paled in comparison to those of countless women throughout the United States, but both the delegates to the Cheyenne convention and the Wyoming voters who ratified their state constitution in 1889 made a significant contribution to a momentous development. Going forward, constitutional conventions would not automatically exclude one half of the American citizenry.

Citizen Initiative

CAT. 41. ARIZONA CONSTITUTION OF 1910

As Americans campaigned for prohibition, women's suffrage, and a host of other reforms in the decades surrounding the turn of the twentieth century, many asked whether citizens ought to play an even more direct role in making laws and revising their constitutions. Americans traditionally chose representatives to sit in legislatures and write laws on their behalf. There were plenty of ways for citizens to communicate their views, and regular elections provided them the opportunity to express their preferences at the ballot box. In many cases, however, citizens found that their elected officials were unresponsive and refused to enact the will of the people. Perhaps more troubling still, citizens could not exercise their sovereign authority to revise their constitutions without the help of their legislatures, which needed either to approve amendments or initiate the process of calling a convention. Many Americans blamed special interests—in the form of powerful corporations, usually—for corrupting the political process and blocking necessary reforms. Whether the source of the problem lay with special interests or simply in the conservative inertia that often characterizes democratic institutions, increasing numbers of citizens wanted a way to bypass their representatives and initiate laws and constitutional amendments themselves.

By the time delegates gathered in Phoenix to write Arizona's first constitution in October 1910, several other states had already begun to experiment with new ways for citizens to effect democratic change. Arizonans wanted a frame of government in step with their growing, dynamic society. The territory had originally been acquired by the United States following the war with Mexico. After rising slowly for several decades, Arizona's population increased fivefold between 1890 and 1910, surpassing 200,000. The long wait for statehood allowed Arizona's first constitution-makers to profit from the experiences and models provided by Americans elsewhere.

Borrowing from several recent state constitutions, Article IV of the Arizona constitution outlined procedures for the "initiative" and the "referendum." The initiative gave citizens the right to propose their own laws and constitutional amendments. First, citizens had to persuade qualified voters to sign a petition with "the title and text of the measure" being proposed. If citizens wanted to propose a law, they needed a number of signatures equivalent to 10 percent of the votes cast for all candidates for governor at the last election. If they wanted to propose a constitutional amendment, the number of required signatures rose to 15 percent of the same total. Though not trivial by any means, these requirements lay well within the capacities of motivated citizens, provided their cause enjoyed a baseline degree of support. Once a proposal earned enough signatures within the specified timeframe, the secretary of state arranged for it to be put on the ballot at the next election. If a majority of voters approved the measure, it became law or part of the constitution. Neither the legislature nor the governor had the power to block the process at any point.

In contrast, the referendum gave citizens the chance to block acts of the legislature. If 5 percent of qualified voters (calculated using the same method as in the initiative) objected to "any measure, or item, section, or part of any measure, enacted by the Legislature," they could file a petition within ninety days of the legislature's adjournment to put the question to a majority vote of the people at the next election. The constitution even stipulated that, in order to give citizens time to compose and file their referendum petitions, nonemergency acts of the legislature would

FOLLOWING PAGES: Cat. 41. Arizona Constitution of 1910

porations to organize, maintain, or employ an armed body of men.

SEC. 27. No standing army shall be kept up by this State in time of peace, and no soldier shall in time of peace be quartered in any house without the consent of its owner, nor in time of war except in the manner prescribed by law.

SEC. 28. Treason against the State shall consist only in levying war against the State, or adhering to its enemies, or in giving them aid and comfort. No person shall be convicted of treason unless on the testimony of two witnesses to the same overt act, or confession in open court.

SEC. 29. No hereditary emoluments, privileges, or powers shall be granted or conferred, and no law shall be enacted permitting any perpetuity or entailment in this State.

SEC. 30. No person shall be prosecuted criminally in any court of record for felony or misdemeanor, otherwise than by information or indictment; no person shall be prosecuted for felony by information without having had a preliminary examination before a magistrate or having waived such preliminary examination.

SEC. 31. No law shall be enacted in this State limiting the amount of damages to be recovered for causing the death or injury of any person.

SEC. 32. The provisions of this Constitution are mandatory, unless by express words they are declared to be otherwise.

SEC. 33. The enumeration in this Constitution of certain rights shall not be construed to deny others retained by the people.

ARTICLE III.

DISTRIBUTION OF POWERS.

The powers of the government of the State of Arizona shall be divided into three separate departments, the Legislative, the Executive, and the Judicial; and, except as provided in this Constitution, such departments shall be separate and distinct, and no one of such departments shall exercise the powers properly belonging to either of the others.

ARTICLE IV.

LEGISLATIVE DEPARTMENT.

1. INITIATIVE AND REFERENDUM.

SEC. 1. (1) The legislative authority of the State shall be vested in a Legislature, consisting of a Senate and a House of Representatives, but the people reserve the power to propose laws and amendments to the Constitution and to enact or reject such laws and amendments at the polls, independently of the Legislature; and they also reserve, for use at their own option, the power to approve or reject at the polls any Act, or item, section, or part of any Act, of the Legislature.

(2) The first of these reserved powers is the Initiative. Under this power ten per centum of the qualified electors shall have the

4

right to propose any measure, and fifteen per centum shall have the right to propose any amendment to the Constitution.

(3) The second of these reserved powers is the Referendum. Under this power the Legislature, or five per centum of the qualified electors, may order the submission to the people at the polls of any measure, or item, section, or part of any measure, enacted by the Legislature, except laws immediately necessary for the preservation of the public peace, health, or safety, or for the support and maintenance of the departments of the State Government and State institutions; but to allow opportunity for Referendum Petitions, no Act passed by the Legislature shall be operative for ninety days after the close of the session of the Legislature enacting such measure, except such as require earlier operation to preserve the public peace, health, or safety, or to provide appropriations for the support and maintenance of the Departments of State and of State institutions; Provided, that no such emergency measure shall be considered passed by the Legislature unless it shall state in a separate section why it is necessary that it shall become immediately operative, and shall be approved by the affirmative votes of two-thirds of the members elected to each House of the Legislature, taken by roll call of ayes and nays, and also approved by the Governor; and should such measure be vetoed by the Governor, it shall not become a law unless it shall be approved by the votes of three-fourths of the members elected to each House of the Legislature, taken by roll call of ayes and nays.

(4) All petitions submitted under the power of the Initiative shall be known as Initiative Petitions, and shall be filed with the Secretary of State not less than four months preceding the date of the election at which the measures so proposed are to be voted upon. All petitions submitted under the power of the Referendum shall be known as Referendum Petitions, and shall be filed with the Secretary of State not more than ninety days after the final adjournment of the session of the Legislature which shall have passed the measure to which the Referendum is applied. The filing of a Referendum Petition against any item, section, or part of any measure shall not prevent the remainder of such measure from becoming operative.

(5) Any measure or amendment to the Constitution proposed under the Initiative, and any measure to which the Referendum is applied, shall be referred to a vote of the qualified electors, and shall become law when approved by a majority of the votes cast thereon and upon proclamation of the Governor, and not otherwise.

(6) The veto power of the Governor shall not extend to Initiative or Referendum measures approved by a majority of the qualified electors.

(7) The whole number of votes cast for all candidates for Governor at the general election last preceding the filing of any Initiative or Referendum petition on a State or county measure shall be the basis on which the number of qualified electors required to sign such petition shall be computed.

(8) The powers of the Initiative and the Referendum are hereby further reserved to the qualified electors of every incorporated city, town, and county as to all local, city, town, or county matters on which such incorporated cities, towns, and counties are or shall be empowered by general laws to legislate. Such incor-

5

become "operative" only after the ninety-day window expired. The constitution provided for initiative and referendum procedures at the local level as well.

Arizonans wasted little time putting the initiative to use. They ratified their constitution twice in 1911: first in February and then again, in a revised version, that December after President William Howard Taft objected to the constitution's provisions allowing citizens to "recall" elected officials upon the petition of 25 percent of eligible voters. Arizonans removed the offending section long enough for Congress and the president to grant them statehood on February 14, 1912. Then the legislature and the voters simply reinserted the recall provisions via an amendment ratified that November. The November 1912 election also featured the state's first amendment proposed through citizen initiative: women's suffrage. The amendment passed by a vote of 13,442 to 6,202. Two years later, a citizen initiative placed another amendment on the ballot: statewide prohibition. This proposition elicited a much larger turnout, with voters approving prohibition 25,887 to 22,743.

The new mode of direct democracy inspired its share of criticism. Some commentators voiced concerns that the constitutional initiative process could be used to infringe the rights of various minorities—members of particular racial, ethnic, or religious groups, for instance—or wealthy property-holders. Others worried that the initiative and referendum would lead to poorly crafted laws and constitutions. While these were and still are valid questions, it is fair to note that the traditional methods of legislating and constitution-making have hardly prevented infringements on the rights of many minorities throughout the nation's history. Nor have they guaranteed well-written laws. All of these methods present both potential shortcomings and potential advantages.

Ultimately, many but not all states adopted some form of the initiative and referendum. Oregon became the first to allow constitutional amendments by initiative in 1902. According to the scholar John Dinan, by the year 2000, eighteen states allowed initiatives for constitutional amendments while twenty-four permitted some type of initiative or referendum for ordinary statutes.[5]

Workers' Rights

CAT. 42. BILINGUAL NEW MEXICO CONSTITUTION OF 1910

Although New Mexico's convention coincided with Arizona's, the constitutions produced by the neighboring states differed on several points. The delegates who gathered in Santa Fe in late 1910 adopted a referendum provision but declined to approve the citizen initiative for proposing laws and amendments. In fact, the constitution New Mexico voters ratified in January 1911 made amendment too difficult in the eyes of Congress, which asked the state to lower the legislative majority needed to refer constitutional revisions to voters. Citizens complied, and New Mexico entered the union in January 1912. Even though they rejected some of the Progressive era's constitutional innovations, New Mexico's citizens embraced several others, notably in the area of workers' rights.

New Mexico's path to joining the union stretched back to 1850, when Congress rejected an early statehood petition for fear of exacerbating the sectional crisis over slavery. In the half century that followed, the number of New Mexico's inhabitants was never the issue; the territory more than met the conventional population threshold for statehood. The obstacle lay in the citizenry's composition. The majority of New Mexicans were of Hispanic heritage, and many white Americans hesitated to incorporate a population of this ethnic, religious, and linguistic background. Elements of the Hispano majority, in turn, worried that statehood might mean greater political and cultural suppression. In 1906, a plan to combine New Mexico and Arizona into one state failed when Arizonans rejected the idea (despite New Mexico's endorsement). By 1910, all parties agreed on separate statehood, and constitution-making commenced. Hispanos held about one-third of the one hundred seats in the Santa Fe convention, enough to guarantee that all laws—including the constitution—would be published in both English and Spanish for at least twenty years. Spanish-speaking citizens would enjoy other protections as well.

Several provisions of the New Mexico constitution aimed to soften the adverse consequences of a modern

economy. The emergence of the United States as a global industrial powerhouse in the period following the Civil War had altered the working conditions experienced by many Americans. Western states such as New Mexico were home to several especially hazardous industries. To their credit, delegates wanted to provide basic safeguards for some of the state's most vulnerable working-class citizens. Because an unfortunate number of young children numbered among this group, the constitution urged the legislature to enact "suitable laws for the regulation of" their employment. A more specific provision concerned employer liability. All railroad corporations, the constitution declared, would have to pay damages to any employee who suffered injury or death as a result of the company's "negligence," and the corporations were also prohibited from making their workers sign contracts "waiving or limiting [their] right to recover such damages." Other provisions forbade the state from leasing out the labor of its convicts, and mandated an eight-hour workday for all individuals employed by the state, county, or municipality.

In adopting these and other measures, Americans yet again exercised their power to determine the character of the governments under which they lived.

Without question, the protections that late nineteenth- and early twentieth-century state constitutions offered to workers can appear paltry and insufficient to modern eyes. North Dakota's 1889 constitution, for instance, declared that "the labor of children under twelve years of age shall be prohibited in mines, factories and workshops in this state." These provisions did, nevertheless, point toward the society that many citizens aspired to create. They also inspired future generations as they, too, responded to the rapid changes that have been a constant feature of American life. The minimum wage provision that Ohioans added to their constitution in 1912 may have seemed a novelty at first, but it eventually gained admirers and emulators around the country. Soon, Americans extended the debate over workers' rights to include collective bargaining and the right to organize.

1. *Journal and Debates of the Constitutional Convention of the State of Wyoming* (Cheyenne: The Daily Sun, Book and Job Printing, 1893), 31.
2. Ibid., 346.
3. Ibid., 351, 353, 354.
4. Ibid., 119.
5. John J. Dinan, *The American State Constitutional Tradition* (Lawrence: University Press of Kansas, 2009), 62, 94.

FOLLOWING PAGES: Cat. 42. Bilingual New Mexico Constitution of 1910

persona que infrinja las prescripciones de ésta al ser condenado en una corte de jurisdicción competente sufrirá el castigo que previenen las secciones treinta y siete y cuarenta del Artículo relativo al departamento legislativo de esta constitución.

Sec. 15. La penitenciaría es una escuela de reforma é industrial, y todas las personas detenidas en ella en cuanto sea consistente con la disciplina é interés público serán empleados en alguna industria beneficiosa; y en los casos en que un convicto tenga familia dependiente de él, sus ganancias netas serán pagadas á su dicha familia en caso que fuere necesario para su mantención.

Sec. 16. Toda persona, recibidor ó corporación que tenga ú opere un ferrocarril dentro de los límites de este estado estará sujeto á daños y perjuicios por daño ó muerte de cualquiera persona que esté en su empleo, siendo el resultado de la negligencia, total ó en parte, del dicho dueño ú operario ó de cualesquiera de los oficiales, agentes ó empleados del mismo, ó por motivo de algun defecto ó insuficiencia debida á su negligencia, total ó en parte, en sus carros, máquinas, artefactos, maquinaria, via, obras ú otro equipo. La acción por causar negligentemente la muerte de un empleado, como queda dicho, será defendida por el albacea ó administrador para beneficio de la viuda, esposo ó niños sobrevivientes del empleado; ó si no los hubiere, entonces para sus padres, ó si no los hubiere, entonces para los parientes más cercanos dependientes del dicho finado. La cantidad recobrada podrá ser distribuida de acuerdo con la ley. Todo contrato ó convenio celebrado de antemano antes de ocurrido tal perjuicio con cualquier empleado por medio del cual éste renuncie ó limite el derecho á recobrar daños y perjuicios será nulo.

Esta disposición no será interpretada á manera de afectar las prescripciones de la sección dos del artículo veintidos de esta constitución, á saber, el Artículo sobre Cédula.

Sec. 17. Habrá un sistema uniforme de libros de texto para las escuelas públicas los cuales no serán cambiados más de una vez en seis años.

Sec.18. Se prohibe el arrendamiento del trabajo de los convictos, por el estado.

Sec. 19. Ocho horas comprenderá un dia de trabajo en todos casos de empleo por parte del estado ó de cualquier condado ó municipalidad del mismo.

Sec. 20. Toda persona detenida por un magistrado de primera instancia para aguardar la acción del gran jurado bajo acusación de felonía ó de otro delito infamante podrá, en corte abierta, con el con-

tion in a court of competent jurisdiction, be punished as provided sections thirty-seven and forty of the article on legislative departnt in this constitution.

Sec. 15. The penitentiary is a reformatory and an industrial school d all persons confined therein shall, so far as consistent with disline and the public interest, be employed in some beneficial indus; and where a convict has a dependent family, his net earnings ll be paid to said family if necessary for their support.

Sec. 16. Every person, receiver or corporation owning or operating railroad within this state shall be liable in damages for injury to, the death of, any person in its employ, resulting from the neglince, in whole or in part, of said owner or operator or of any of e officers, agents or employes thereof, or by reason of any defect insufficiency, due to its negligence, in whole or in part, in its cars, gines, appliances, machinery, track, roadbed, works or other equipnt.

An action for negligently causing the death of an employe as above ovided shall be maintained by the executor or administrator for benefit of the employe's surviving widow or husband and child; or if none, then his parents; or if none, then the next of kin pendent upon said deceased. The amount recovered may be disbuted as provided by law. Any contract or agreement made in vance of such injury with any employe waiving or limiting any ht to recover such damages shall be void.

This provision shall not be construed to affect the provisions of tion two of article twenty-two of this constitution, being the article on Schedule.

Sec. 17. There shall be a uniform system of textbooks for the blic schools which shall not be changed more than once in six ars.

Sec. 18. The leasing of convict labor by the state is hereby probited.

Sec. 19. Eight hours shall constitute a day's work in all cases of ployment by and on behalf of the state or any county or municility thereof.

Sec. 20. Any person held by a committing magistrate to await e action of the grand jury on a charge of felony or other infamous ime, may in open court with the consent of the court and the

Eighth Congress of the United State

at the first Session.

Begun and held at the City of Washin

erritory of Columbia, on Monday the Sevente

October, one thousand eight hundred and three

Resolved, by the Senate and House of Rep

f the United States of America, in Congress af

hirds of both Houses concurring, that in lieu o

aragraph of the first Section of the Second article

titution of the United States, the following be pr

mendments to the Constitution of the United S

hen ratified by three fourths of the Legislatur

al states, shall be valid to all intents and purp

the said Constitution, to wit:

The Electors shall meet in their respective

Epilogue

The American experiment in self-government continued throughout the twentieth century and remains vital in the twenty-first. Born colonists and subjects of a king, eighteenth-century Americans took great pride in their collective achievement: proclaiming the principles and developing the essential practices of constitutional democracy. They derived even more satisfaction from their confident expectation that future generations would be able to carry on the experiment unabated. Citizens cherished the legacy bequeathed to them by holding conventions, crafting frames of government, adding amendments, and, in general, debating the meaning and implications of every aspect of the fundamental laws that governed their dynamic communities—all freedoms for which most of the world's people still yearned.

While exercising popular sovereignty, citizens venerated the fundamental ideas on which their political system rested. American constitutions written between the founding period and the turn of the twentieth century—including the representative examples highlighted in *Colonists, Citizens, Constitutions*—offer windows into worlds different than but intimately connected to our own. The United States as we know it is the result of countless decisions made by generations of Americans wrestling simultaneously with the pressing concerns of particular eras and the timeless issues that confront democratic societies everywhere. Returning to the documents themselves, and to the contexts of their creation, allows us to appreciate how and why past Americans devised the constitutional solutions they did. In a remarkable number of cases, the provisions and rights put on paper by constitution-makers over two centuries ago continue to merit admiration and appear destined to serve as essential bulwarks of freedom in all ages to come.

Those constitutional experiments that proved less enduring—that now appear as false starts or dead ends—are important as well. They remind us that democracy is an ongoing process, one that requires constant engagement with the questions of civic life. Some possibilities that citizens advanced in the past, though rejected at the time or eventually allowed to lapse, may contain a good deal of wisdom and be worth reconsideration. Other constitutional alternatives that citizens once embraced, meanwhile, demand our attention because they suggest the possibility that our current fundamental laws may still be improved. A survey of the constitutions Americans have written throughout their history reveals puzzling oversights, stunning omissions, and glaring injustices. Flaws that Americans now agree inhibited the full realization of their highest principles were allowed to remain in their constitutions for far longer than they may care to admit. For good reason, then, the preamble to the United States Constitution announces we the people's intention to make the political system "more perfect"—a phrase that encourages humility about past shortcomings while also inspiring faith in the possibility of progress.

OPPOSITE: Cat. 16. Certified Manuscript Copy of the Twelfth Amendment as Approved by Congress, 1803

Works in the Catalogue

The titles listed below retain the documents' original spelling and punctuation. However, titles that were originally printed in all uppercase letters have been converted here to upper- and lowercase. Abbreviations of lengthy titles are indicated with bracketed ellipses. Extraneous information related to a document's publisher or place of publication has been omitted. Roman numerals (such as those for dates of publication) have been changed to Arabic numerals. Any other alterations are noted.

The short caption following each catalogue number identifies the year in which a constitution or other document was first drafted. This date sometimes differs from that on which a constitution achieved ratification, officially went into effect, or was published.

Cat. 1. Georgia Charter of 1732
A List of Copies of Charters, from the Commissioners for Trade and Plantations [. . .]
London: 1741

Cat. 2. Stamp Act of 1765
An Act for granting and applying certain Stamp Duties, and other Duties, in the British Colonies and Plantations in America [. . .]
London: Mark Baskett and the Assigns of Robert Baskett, 1765

Cat. 3. Massachusetts Government Act of 1774
An Act for the better regulating the Government of the Province of the Massachuset's Bay, in New England
London: Charles Eyre and William Strahan, 1774

Cat. 4. Charles Thomson Description of the Great Seal of the United States, 1782
Manuscript daybook of Charles Thomson, including a description of the design for the Great Seal of the United States and the text of the preliminary Peace of Paris, 1776–83

Cat. 5. Virginia Declaration of Rights of 1776
The Proceedings of the Convention of Delegates, Held at the Capitol, in the City of Williamsburg, in the Colony of Virginia [. . .]
Williamsburg: Alexander Purdie, [1776]

Cat. 6. Pennsylvania Constitution of 1776
The Constitution of the Common-Wealth of Pennsylvania [. . .]
Philadelphia: John Dunlap, 1776

Cat. 7. New York Constitution of 1777
The Constitution of the State of New-York
Fish-Kill: Samuel Loudon, 1777

Cat. 8. Resolve of the Massachusetts General Court of May 5, 1777
State of Massachusetts-Bay. In the House of Representatives, May 5, 1777. That the happiness of mankind depends very much on the Form and Constitution of Government they live under, and that the only object and design of Government should be the good of the People [. . .]
[Boston: Benjamin Edes, 1777]

Cat. 9. Massachusetts Constitution of 1780
The Constitution or Frame of Government for the Commonwealth of Massachusetts
Boston: Benjamin Edes and Sons, 1[7]81

Cat. 10. Articles of Confederation and Perpetual Union, 1777
Articles of Confederation and Perpetual Union Between the States of New-Hampshire, Massachusetts-Bay, Rhode-Island and Providence Plantations, Connecticut, New-York, New-Jersey, Pennsylvania, Delaware, Maryland, Virginia, North-Carolina, South-Carolina and Georgia
Lancaster, (Pennsylvania): Printed; Boston: Re-printed, John Gill, 1777

Cat. 11. Constitution of the United States of America, 1787
We, the People of the United States, in order to form a more perfect union, establish justice, insure domestic tranquility, provide for the common defence, promote the general welfare, and secure the blessings of liberty to ourselves and our posterity, do ordain and establish this Constitution for the United States of America
[Philadelphia:] Dunlap & Claypoole, [September 17, 1787]

Cat. 12. An Antifederalist Critique of the Constitution: Pennsylvania, 1787
The Address and Reasons of Dissent of the Minority of the Convention of the State of Pennsylvania, to their Constituents
[Philadelphia: 1787]

Cat. 13. A Federalist Defense of the Constitution: Massachusetts, 1788
Debates, Resolutions and Other Proceedings, of the Convention of the Commonwealth of Massachusetts [. . .]
Boston: Adams and Nourse, Benjamin Russell, and Edmund Freeman, 1788

Cat. 14. Bill of Rights as Proposed by the House of Representatives (17 Amendments), 1789
Congress of the United States. In the House of Representatives, Monday, 24th August, 1789, Resolved, by the Senate and House of Representatives of the United States of America [. . .], That the following Articles be proposed to the Legislatures of several States, as Amendments to the Constitution of the United States [. . .]
New-York: T[homas] Greenleaf, [1789]

Cat. 15. Bill of Rights as Approved by Congress (12 Amendments), 1789
Journal of the First Session of the Senate of the United States of America, Begun and Held at the City of New-York, March 4th, 1789 [. . .]
New-York: Thomas Greenleaf, 1789

Cat. 16. Certified Manuscript Copy of the Twelfth Amendment as Approved by Congress, 1803
Manuscript from the first session of the Eighth Congress of the United States, held in Washington, D.C., 1803

Cat. 17. Ohio Constitution of 1802
Letter from Thomas Worthington, Inclosing an Ordinance Passed by the Convention of the State of Ohio, Together with the Constitution, Formed and agreed to by the Convention for the said State [. . .]
[Washington, D.C.: 1802]

Cat. 18. Illinois Constitution of 1818
Constitution of the State of Illinois
Washington City [D.C.]: E. de Krafft, 1818

Cat. 19. Mississippi Constitution of 1832
The Constitution of the State of Mississippi
Jackson: Peter Isler, 1832

Cat. 20. Choctaw Nation Constitution of 1838
The Constitution and Laws of the Choctaw Nation
Park Hill, Cherokee Nation: John Candy, 1840

Cat. 21. Rhode Island Constitution of 1842
The Constitution of the State of Rhode-Island and Providence Plantations [. . .]
Providence: Knowles and Vose, 1842

Cat. 22. Debates of the Louisiana State Constitutional Convention of 1845
Proceedings and Debates of the Convention of Louisiana [. . .]
New Orleans: Besancon, Ferguson & Co., 1845

Cat. 23. New York Constitution of 1846
The Constitution of the State of New-York
[Albany(?): 1846]

Cat. 24. Wisconsin Constitution of 1846
Constitution of the State of Wisconsin [. . .]
Madison, W[isconsin] T[erritory]: Beriah Brown, 1846

Cat. 25. Debates of the California State Constitutional Convention of 1849
Report of the Debates in the Convention of California, on the Formation of the State Constitution [. . .]
Washington [D.C.]: John T. Towers, 1850

Cat. 26. Deseret Constitution of 1872
Constitution of the State of Deseret [. . .]
Salt Lake City: Deseret News Book and Job Establishment, [1872]

Cat. 27. Constitution of the Pennsylvania Abolition Society, 1787
The Constitution of the Pennsylvania Society, for Promoting the Abolition of Slavery, and the Relief of Free Negroes, Unlawfully Held in Bondage. Begun in the Year 1774, and Enlarged on the Twenty-Third of April, 1787 [. . .]
Philadelphia: Francis Bailey, 1788

Cat. 28. Missouri Constitution of 1820
Constitution of the State of Missouri
Washington [D.C.]: Gales & Seaton, 1820

Cat. 29. List of Delegates to the Maine State Constitutional Convention of 1819
Petition of a Convention of the People of the District of Maine, Praying to be Admitted into the Union as a Separate and Independent State, Accompanied with a Constitution for Said State
Washington [D.C.]: Gales & Seaton, 1819

Cat. 30. Constitution of the Republic of Texas, 1836
Constitution of the Republic of Texas
Washington [D.C.]: Gales and Seaton, 1836

Cat. 31. Opinion of Chief Justice Roger Taney in the Case of Dred Scott, 1857
A Report of the Decisions of the Supreme Court of the United States, and the Opinions of the Judges Thereof, in the Case of Dred Scott, versus John F. A. Sandford
New York: D. Appleton and Company, 1857

Cat. 32. Kansas Constitution of 1859
Constitution of the State of Kansas; Adopted at Wyandot, July 29, '59
[Wyandotte: 1859]

Cat. 33. Alabama Ordinance of Secession of 1861
Ordinances and Constitution of the State of Alabama, with the Constitution of the Provisional Government and of the Confederate States of America
Montgomery: Barrett, Wimbish, & Co.; Montgomery Advertiser Book and Job Printing Office, 1861

Cat. 34. Constitution of the Confederate States of America, 1861
Constitution of the Confederate States of America
Montgomery, Ala.: Shorter & Reid, 1861

Cat. 35. Alabama Constitution of 1867
Constitution of the State of Alabama [. . .]
Montgomery, Ala.: Barrett & Brown, 1867

Cat. 36. Louisiana Constitution of 1868
*40th Congress, 2d Session. House of
Representatives. Ex. Doc. No. 281.
North Carolina and Louisiana. Message
from the President of the United States,
Transmitting Documents and papers
relating to the proceedings in North
Carolina and Louisiana to which they
refer, viz: constitutions of those States.
May 11, 1868.—Referred to the Committee
on Reconstruction* [. . .]
[Washington, D.C.: Printed for the
House of Representatives, 1868]

Cat. 37. Florida Constitution of 1885
*Constitution Adopted by the Convention
of 1885*
Tallahassee, Fla.: N. M. Bowen,
Floridian Steam Printing House, 1889

Cat. 38. Washington Constitution of 1889
Constitution of the State of Washington [. . .]
Seattle, Washington: 1889

Cat. 39. Kansas State Prohibition
Amendment of 1880
[. . .] *Constitution of the State of Kansas,
with Notes of Cases Arising under the
Provisions of the State Constitution*
Topeka, Kansas: Geo. W. Crane & Co.,
1890

Cat. 40. Wyoming Constitution of 1889
*Constitution of the Proposed State of
Wyoming* [. . .]
Cheyenne, Wyo.: The Cheyenne
Leader Printing Co., 1889

Cat. 41. Arizona Constitution of 1910
*The Proposed Constitution for the State
of Arizona*
[Phoenix: 1910]

Cat. 42. Bilingual New Mexico
Constitution of 1910
*Constitution of the State of New Mexico.
Constitucion del Estado de Nuevo Mexico*
Santa Fe, N.M.: La Voz del Pueblo, 1912

Selected Bibliography

Primary Sources

Cleveland, Henry, ed. *Alexander Stephens, in Public and Private: With Letters and Speeches, Before, During, and Since the War*. Philadelphia: National Publishing Company, 1866.

Everett, Edward. *Address of Hon. Edward Everett, at the Consecration of the National Cemetery at Gettysburg, 19th November, 1863. . . .* Boston: Little, Brown and Company, 1864.

Forstall, Richard L., comp. and ed. *Population of States and Counties of the United States: 1790–1990*. Washington, D.C.: U.S. Bureau of the Census, 1996.

Handlin, Oscar, and Mary Handlin, eds. *The Popular Sources of Political Authority: Documents on the Massachusetts Constitution of 1780*. Cambridge, Mass.: Harvard University Press, 1966.

Journal and Debates of the Constitutional Convention of the State of Wyoming. Cheyenne: The Daily Sun, Book and Job Printing, 1893.

Paine, Thomas. *Common Sense and Related Writings*. Edited by Thomas P. Slaughter. Boston: Bedford, 2001.

Peterson, Merrill D., ed. *Thomas Jefferson: Writings*. New York: Library of America, 1984.

Schechter, Stephen L., ed. *Roots of the Republic: American Founding Documents Interpreted*. Madison: Madison House Publishers, 1990.

Smith, Paul Hubert, et al., eds. *Letters of Delegates to Congress, 1774–1789*. 26 vols. Washington, D.C.: Library of Congress, 1976–2000.

Thorpe, Francis Newton, ed. *The Federal and State Constitutions, Colonial Charters, and Other Organic Laws of the States, Territories, and Colonies Now or Heretofore Forming the United States of America*. 7 vols. Washington, D.C.: Government Printing Office, 1909.

Tocqueville, Alexis de. *Democracy in America*. Translated by Arthur Goldhammer. New York: Library of America, 2004.

Scholarship

Adams, Willi Paul. *The First American Constitutions: Republican Ideology and the Making of the State Constitutions in the Revolutionary Era*. Translated by Rita and Robert Kimber. Chapel Hill: University of North Carolina Press, 1980.

Akers, Donna L. *Living in the Land of Death: The Choctaw Nation, 1830–1860*. East Lansing: Michigan State University Press, 2004.

Ammerman, David. *In the Common Cause: American Response to the Coercive Acts of 1774*. New York: Norton, 1975 (orig. 1974).

Angel, Myron. *History of San Luis Obispo County, California. . . .* Oakland: Thompson and West, 1883.

Beeman, Richard R. *Plain, Honest Men: The Making of the American Constitution*. New York: Random House, 2009.

———. *The Varieties of Political Experience in Eighteenth-Century America*. Philadelphia: University of Pennsylvania Press, 2004.

Bilder, Mary Sarah. *Madison's Hand: Revising the Constitutional Convention*. Cambridge, Mass.: Harvard University Press, 2015.

Brophy, Alfred L. "'These Great and Beautiful Republics of the Dead': Constitutionalism and the Antebellum Cemetery." (August 12, 2013) UNC Legal Studies Research Paper 2304305. https://ssrn.com/abstract=2304305.

Cayton, Andrew R. *The Frontier Republic: Ideology and Politics in the Ohio Country, 1780–1825*. Kent, Ohio: Kent State University Press, 1986.

Center for the Study of the American Constitution at the University of Wisconsin-Madison. "The First Printing of the Constitution Sponsored by the Constitutional Convention." Accessed April 12, 2019. https://csac.history.wisc.edu/document-collections/foundationaldocuments-of-american-constitutionalism/first-printing/.

Conner, George E., and Christopher W. Hammond, eds. *The Constitutionalism of American States*. Columbia: University of Missouri Press, 2008.

Countryman, Edward. *A People in Revolution: The American Revolution and Political Society in New York, 1760–1790*. Baltimore: Johns Hopkins University Press, 1981.

Dinan, John J. *The American State Constitutional Tradition*. Lawrence: University Press of Kansas, 2009.

Edelson, S. Max. *Plantation Enterprise in Colonial South Carolina*. Cambridge, Mass.: Harvard University Press, 2006.

Edling, Max M. *A Hercules in the Cradle: War, Money, and the American State, 1783–1867.* Chicago: University of Chicago Press, 2014.

———. *A Revolution in Favor of Government: Origins of the U.S. Constitution and the Making of the American State.* New York: Oxford University Press, 2003.

Elliott, J. H. *Empires of the Atlantic World: Britain and Spain in America, 1492–1830.* New Haven: Yale University Press, 2006.

Everill, Bronwen. "Experiments in Colonial Citizenship in Sierra Leone and Liberia." In *New Directions in the Study of African American Recolonization,* edited by Beverly C. Tomek and Matthew J. Hetrick, 184–205. Gainesville: University Press of Florida, 2017.

Franklin, John Hope. *Reconstruction After the Civil War.* 3rd ed. Chicago: University of Chicago Press, 2013.

Fritz, Christian G. *American Sovereigns: The People and America's Constitutional Tradition Before the Civil War.* New York: Cambridge University Press, 2008.

Gallagher, Gary W. *The Confederate War.* Cambridge, Mass.: Harvard University Press, 1997.

———. *The Union War.* Cambridge, Mass.: Harvard University Press, 2011.

Greenberg, Amy S. *A Wicked War: Polk, Clay, Lincoln, and the 1846 U.S. Invasion of Mexico.* New York: Knopf, 2012.

Greene, Jack P., and J. R. Pole, eds. *A Companion to the American Revolution.* Malden, Mass.: Blackwell, 2004.

Hendrickson, David C. *Peace Pact: The Lost World of the American Founding.* Lawrence: University Press of Kansas, 2003.

Holt, Michael F. *The Rise and Fall of the American Whig Party: Jacksonian Politics and the Onset of the Civil War.* New York: Oxford University Press, 1999.

Howe, Daniel Walker. *What Hath God Wrought: The Transformation of America, 1815–1848.* New York: Oxford University Press, 2007.

Huebner, Timothy S. *Liberty and Union: The Civil War Era and American Constitutionalism.* Lawrence: University Press of Kansas, 2016.

Hulsebosch, Daniel. *Constituting Empire: New York and the Transformation of Constitutionalism in the Atlantic World, 1664–1830.* Chapel Hill: University of North Carolina Press, 2005.

Keyssar, Alexander. *The Right to Vote: The Contested History of Democracy in the United States.* Rev. ed. New York: Basic Books, 2009.

Kruman, Marc W. *Between Authority and Liberty: State Constitution Making in Revolutionary America.* Chapel Hill: University of North Carolina Press, 1997.

Kyvig, David E. *Explicit and Authentic Acts: Amending the U.S. Constitution, 1776–2015.* Lawrence: University Press of Kansas, 2016.

Leamon, James S. *Revolution Downeast: The War for American Independence in Maine.* Amherst: University of Massachusetts Press, 1993.

Levinson, Sanford. *Framed: America's Fifty-One Constitutions and the Crisis of Governance.* New York: Oxford University Press, 2012.

Maier, Pauline. *American Scripture: Making the Declaration of Independence.* New York: Knopf, 1997.

———. *From Resistance to Revolution: Colonial Radicals and the Development of American Opposition to Britain, 1765–1776.* New York: Norton, 1972.

———. *Ratification: The People Debate the Constitution, 1787–1788.* New York: Simon and Schuster, 2010.

Matson, Cathy D., and Peter S. Onuf. *A Union of Interests: Political and Economic Thought in Revolutionary America.* Lawrence: University Press of Kansas, 1990.

McCoy, Drew R. *The Last of the Fathers: James Madison and the Republican Legacy.* New York: Cambridge University Press, 1989.

McDonnell, Michael A. *The Politics of War: Race, Class, and Conflict in Revolutionary Virginia.* Chapel Hill: University of North Carolina Press for the Omohundro Institute of Early American History and Culture, 2007.

Meinig, D. W. *The Shaping of America: A Geographical Perspective on 500 Years of History.* Vol. 1, *Atlantic America, 1492–1800.* New Haven: Yale University Press, 1986.

———. *The Shaping of America: A Geographical Perspective on 500 Years of History.* Vol. 2, *Continental America, 1800–1867.* New Haven: Yale University Press, 1993.

———. *The Shaping of America: A Geographical Perspective on 500 Years of History.* Vol. 3, *Transcontinental America, 1850–1915.* New Haven: Yale University Press, 1998.

Middleton, Richard, and Anne Lombard. *Colonial America: A History to 1763.* 4th ed. Chichester: Wiley-Blackwell, 2011.

Morgan, Edmund S., and Helen M. Morgan. *The Stamp Act Crisis: Prologue to Revolution.* Rev. ed. New York: Collier Books, 1963.

Newman, Richard S. "The PAS and American Abolitionism: A Century of Activism from the American Revolutionary Era to the Civil War." *Historical Society of Pennsylvania.* https://hsp.org/sites/default/files/legacy_files/migrated/newmanpasessay.pdf.

Noll, Mark A. *America's God: From Jonathan Edwards to Abraham Lincoln.* New York: Oxford University Press, 2002.

Novak, William J. *The People's Welfare: Law and Regulation in Nineteenth-Century America.* Chapel Hill: University of North Carolina Press, 1996.

Onuf, Peter S. "Reflections on the Founding: Constitutional Historiography in Bicentennial Perspective." *William and Mary Quarterly* 46, no. 2 (1989): 341–75.

———. *Statehood and Union: A History of the Northwest Ordinance*. Bloomington: Indiana University Press, 1987.

O'Shaughnessy, Andrew Jackson. *The Men Who Lost America: British Leadership, the American Revolution, and the Fate of the Empire*. New Haven: Yale University Press, 2013.

Palmer, R. R. *The Age of the Democratic Revolution: A Political History of Europe and America*. Vol. 1, *The Challenge*. Princeton: Princeton University Press, 1959.

Perdue, Theda, and Michael D. Green. *The Cherokee Nation and the Trail of Tears*. New York: Penguin, 2007.

Pole, J. R. *Political Representation in England and the Origins of the American Republic*. New York: Macmillan, 1966.

Potter, David M. *The Impending Crisis: 1848–1861*. Edited by Don E. Fehrenbacher. New York: Harper Torchbooks, 1976.

Rable, George C. *The Confederate Republic: A Revolution Against Politics*. Chapel Hill: University of North Carolina Press, 1994.

Rakove, Jack N. *The Beginnings of National Politics: An Interpretive History of the Continental Congress*. Baltimore: Johns Hopkins University Press, 1979.

Reid, John Phillip. *Constitutional History of the American Revolution*. Abridged ed. Madison: University of Wisconsin Press, 1995.

Ryerson, Richard Alan. *John Adams's Republic: The One, the Few, and the Many*. Baltimore: Johns Hopkins University Press, 2016.

———. *The Revolution Is Now Begun: The Radical Committees of Philadelphia, 1765–1776*. Philadelphia: University of Pennsylvania Press, 1978.

Saler, Bethel. *The Settlers' Empire: Colonialism and State Formation in America's Old Northwest*. Philadelphia: University of Pennsylvania Press, 2014.

Siddali, Silvana R. *Frontier Democracy: Constitutional Conventions in the Old Northwest*. New York: Cambridge University Press, 2016.

Smith, Rogers M. *Civic Ideals: Conflicting Visions of Citizenship in U.S. History*. New Haven: Yale University Press, 1997.

Storke, Yda Addis. *A Memorial and Biographical History of the Counties of Santa Barbara, San Luis Obispo and Ventura, California*. Chicago: Lewis Publishing, 1891.

Tsai, Robert L. "John Brown's Constitution." *Boston College Law Review* 51, no. 1 (2010): 151–207.

Tuck, Richard. *The Sleeping Sovereign: The Invention of Modern Democracy*. Cambridge: Cambridge University Press, 2016.

University Archives and Records Center, University of Pennsylvania. "Charles Thomson." https://archives.upenn.edu/exhibits/penn-people/biography/charles-thomson.

U.S. Department of State. *The Great Seal of the United States*. Washington, D.C.: Bureau of Public Affairs, 2014.

Wood, Gordon S. *The Creation of the American Republic, 1776–1787*. Chapel Hill: University of North Carolina Press, 1998 (orig. 1969).

Zagarri, Rosemarie. *Revolutionary Backlash: Women and Politics in the Early American Republic*. Philadelphia: University of Pennsylvania Press, 2007.

Acknowledgments

The exhibition *Colonists, Citizens, Constitutions*, presenting historical documents from the Dorothy Tapper Goldman Foundation, has been years in the making. Numerous individuals and institutions have been instrumental in providing advice and guidance throughout the process of making this exhibition and its accompanying catalogue a reality.

First and foremost I would like to thank Louise Mirrer, President and CEO of the New-York Historical Society; Michael Ryan, Vice President and Director of the New-York Historical Society's Patricia D. Klingenstein Library; and the staff of the N-YHS for hosting the exhibition and allowing this collection of American constitutions, both state and federal, to reach a wide audience.

Fellow collector Mark Tomasko provided encouragement from the outset, and Kenneth Soehner, Arthur K. Watson Chief Librarian at the Metropolitan Museum of Art, not only helped find a fitting venue for this first major exhibition of the collection, but has also continued to serve as a faithful friend. Stephanie Stebich, Margaret and Terry Stent Director of the Smithsonian American Art Museum, generously contributed her ideas and support.

Art historian and curator Robert McD. Parker was brought on as Special Projects Director at an early stage to oversee the exhibition and its catalogue. It was at the suggestion of Gwen Roginsky, Associate Publisher and General Manager of Publications at the Metropolitan Museum of Art, that we approached Scala Arts Publishers to publish the exhibition catalogue. We are grateful to Jennifer Norman, Scala's Director of Publications, and Hannah Bowen, former Senior Editor, for their invaluable help and steadfast support. This fruitful collaboration has resulted in a beautiful publication, exquisitely designed by Miko McGinty and Rita Jules and skillfully edited by Kate Norment.

A special thanks goes to Elisabeth Hahn, the Dorothy Tapper Goldman Foundation's Collections Manager and Fine Arts Advisor, who for a number of years has overseen, catalogued, and cared for this collection. Her keen eye has ensured the proper recording of these important archival materials.

Ardon Bar-Hama created the captivating photographs of the documents seen in the preceding pages, which are of such high quality and resolution that readers can sense what it is actually like to hold such a piece of history in their hands—a privilege usually reserved for collectors and scholars.

I would like to acknowledge the late William Reese, the William Reese Company, and Nick Aretakis, manager of the Americana department, who all provided guidance and expertise as the collection evolved

over the years. For their generous support and recognition of the collection's historical significance, I would also like to thank the Supreme Court Historical Society and Sotheby's.

A major contribution to the success of the project was made by Ellen S. Dunlap, President of the American Antiquarian Society, who recommended the constitutional scholar James F. Hrdlicka as the author of this catalogue.

It is to Jim that we owe our greatest thanks. His dedication and commitment to the project have yielded an extraordinarily informative and engaging historical narrative that will be an enduring contribution to scholarship and to the American public's understanding of the important place these documents occupy in our nation's story—past, present, and future. His remarkable text will undoubtedly allow both specialists and general readers to learn about the documents from this collection long after the exhibition has closed.

We are also deeply grateful to Justice Ruth Bader Ginsburg for her inspiring foreword, which so eloquently reminds us of our American heritage and of our role as citizens.

Dorothy Tapper Goldman

I am grateful to everyone who enabled my contribution to *Colonists, Citizens, Constitutions*. I began preliminary work while serving as the Jack Miller Center Postdoctoral Fellow at the University of Pennsylvania's Andrea Mitchell Center for the Study of Democracy, and I would like to thank the Mitchell Center's directors, Rogers Smith and Jeffrey Green, for their encouragement. Peter Onuf not only brought the opportunity to my attention, but also provided his recommendation and inimitable guidance. Frank Cirillo, Dorothy Tapper Goldman, Elisabeth Hahn, Peter Onuf, Robert McD. Parker, Michael Ryan, and Elizabeth Varon each read part or all of the manuscript and offered crucial corrections and suggestions. Kate Norment's editing vastly improved the entire text. I am responsible, of course, for any interpretive shortcomings or errors of fact that remain. The book draws on the research of the many scholars whose works are cited in the notes or in the Selected Bibliography. Readers looking to learn more about any topic should consult these fine sources. Finally, I would like to thank Courtney Hrdlicka and my parents, Barbara and Donald Hrdlicka, for their constant support.

James F. Hrdlicka

Index

Tenth Amendment, 90
 see also elections; referendums
population growth, 17
presidential elections, 64–65, 91, 94,
 162, 163
 see also elections
presidents, *see* executive powers; *and*
 individual names
press freedom, 37, 40, 86, 91, 167
Proceedings and Debates (Louisiana State
 Constitutional Convention of
 1845), 114, *115–17*, 118–19
prohibition, 180–81, 188
public education, 170–72, 174
public institutions, 177–78
Puritans, 133

Quakers, 22, 44
Quebec Act, 30–31

Randolph, Edmund, 62, 64
Reconstruction period, 114, 167–74, 178
Reese, William S., 10–11, 12
referendums
 on constitutional amendments,
 168, 184
 on constitutional conventions, 101
 local, 188
 on Maine statehood, 144, 148
 ratification of constitutions, 109–10,
 111, 152, 160
 on state laws, 45, 114, 124, 125,
 185, 188
 voting eligibility, 114
 on women's suffrage, 184
religious freedom, 22, 25, 86, 111, 130,
 133–34
Republican Party, 157, 162, 168, 172
Republic of Texas Constitution,
 148–49, 152
Resolve of the Massachusetts General
 Court of May 5, 1777 (cat. 8),
 48–51, *49*, 194
Revolutionary War, 31, 48, 55, 58, 59, 94
Rhode Island
 charter, 50, 111, 133
 colonial government, 22–24, 111
 constitutional conventions, 111, 114
 People's Constitution, 111, 114
 religious freedom, 133
 state legislature, 111
Rhode Island Constitution of 1842
 (cat. 21), 110–11, *112–13*, 114,
 124, 195

rights
 religious freedom, 22, 25, 86, 111,
 130, 133–34
 in state constitutions, 40, 75, 82
 Virginia Declaration of Rights, 37, 40
 of workers, 188–89
 see also Bill of Rights; voting rights
Ryan, Edward G., 125
Ryerson, Richard Alan, 44

Sanford, John, 152
Santa Anna, Antonio López de, 148, 149
Scott, Dred, 152, *154*, 157
Scott, Harriet, 152, *155*
Scott v. Sandford, 152, *153*, 156–57, 166, 168
Second Amendment, 86
self-government, 15–16, 18, 33, 40
 see also constitutions; popular sover-
 eignty; state constitutions
Senate, *see* Congress
separation of church and state, 133
Seventh Amendment, 86
Shays's Rebellion, 76
Sherman, Roger, 62, 65
Siddali, Silvana R., 118, 125
Siebert, Frank T., 10, 13n3
Sixth Amendment, 86
slaveholders
 Constitutional Convention delegates,
 61, 64
 Native Americans as, 109
slavery
 abolitionist movement, 137–40, 157,
 160–62
 African colonization proposals,
 139, 140
 in colonies, 17, 24, 25, 45
 in Confederate constitution, 166
 Dred Scott case, 152, 156–57, 166
 Emancipation Proclamation, 167
 fugitive slave laws, 152, 163, 166
 gradual emancipation acts, 139, 140
 legacy, 170–74
 in new states and territories, 104, 140,
 143–44, 149, 152, 156, 157, 160
 number of slaves, 17
 in state constitutions, 101, 104,
 143, 149
 state laws abolishing, 64, 139
 in U.S. Constitution, 63–64, 139
slave trade, 64, 139, 152
Smith, Joseph, 133
Smith, Louise S., 184
social welfare institutions, 177–78

South Carolina
 colonial government, 24
 constitutions, 33, 37, 48, 63, 170, 178
 ratification of U.S. Constitution,
 81, 82
 secession, 162, 163
 slavery, 63, 64
South Dakota constitution, 178
Southern states
 racial violence, 172–74
 Reconstruction period, 114, 167–74,
 178
 secession, 162–63, 167
 slavery, 140, 143
 voting restrictions, 174
 see also Civil War; Confederacy; *and*
 individual states
sovereign immunity, of state governments,
 90
sovereignty, *see* popular sovereignty
Spanish speakers, 128–30, 188
Stamp Act of 1765 (cat. 2), 25, *26–27*,
 28, 194
state constitutions
 Adams on, 33, 37
 after Civil War, 167–74, 178
 amendment procedures, 100–101,
 185, 188
 antislavery, 160
 bills of rights, 40, 75, 82
 established churches, 133
 executive powers, 40, 45–48, 54, 64,
 99, 166
 judicial branches, 104–6, 152
 legislatures, 40, 44–45, 47, 48, 124
 prohibition, 180–81, 188
 ratification, 50–51, 54–55, 99
 revisions, 16, 100–101
 social welfare provisions, 177–78
 voting rights, 40, 80, 110, 114,
 168–70, 181, 184
 writing, 16–17, 33, 37, 48–50, 51, 54,
 55, 100
 see also constitutional conventions,
 state; *and individual states*
state governments
 banking regulation, 125, 128
 bankruptcies, 125
 capitals, 118–19
 debt, 124–25
 internal improvements, 119, 124, 178
 social welfare institutions, 177–78
 sovereign immunity, 90
 Tenth Amendment and, 90

For the Crest

Over the head of the Eagle

Escutcheon, a Glory, Or,

proper, and surrounding

Constellation, Argent, d

Reverse

A Pyramid unfin

In the Zenith an Eye